✓

MAY 2 1 1997

BOONE COUNTY LIBRARY

C0-AMX-219

AMERICA'S
5 & 10 CENT STORES

WITHDRAWN

AMERICA'S
5 & 10 CENT STORES

THE KRESS LEGACY

Bernice L. Thomas

Property of
Boone County Library
Harrison, Arkansas

Member of
North Arkansas Regional Library
Harrison, Arkansas

NATIONAL BUILDING MUSEUM
WASHINGTON, D.C.

PRESERVATION PRESS

JOHN WILEY & SONS, INC.
NEW YORK • CHICHESTER • WEINHEIM • BRISBANE • SINGAPORE • TORONTO

This text is printed on acid-free paper.

Copyright © 1997 by National Building Museum

The publication of this book was made possible through grants to the National Building Museum by the Samuel H. Kress Foundation.

Published by John Wiley & Sons, Inc.

A cooperative publication with the National Building Museum, a nonprofit educational institution created by an act of Congress in 1980 to celebrate American achievements in architecture, urban planning, construction, engineering, and design. It presents exhibitions and educational programs, collects artifacts of the building process, and publishes books and a quarterly journal.

All rights reserved. Published simultaneously in Canada.

Reproduction or translation of any part of this work beyond that permitted by Section 107 or 108 of the 1976 United States Copyright Act without the permission of the copyright owner is unlawful. Requests for permission or further information should be addressed to the Permissions Department, John Wiley & Sons, Inc., 605 Third Avenue, New York, NY 10158-0012.

This publication is designed to provide accurate and authoritative information in regard to the subject matter covered. It is sold with the understanding that the publisher is not engaged in rendering legal, accounting, or other professional services. If legal advice or other expert assistance is required, the services of a competent professional person should be sought.

Library of Congress Cataloging-in-Publication Data

Thomas, Bernice L.
 America's 5 and 10 cent stores : the Kress legacy / Bernice L.
Thomas
 p. cm.
 Includes bibliographical references and index.
 ISBN 0-471-18195-1 (pbk. : alk. paper)
 1. Variety stores—United States. 2. Store fronts—United States.
3. Store decoration—United States. 4. S. H. Kress & Co.
I. Title.
NA6227.V37T56 1997 97-4171
725'.21'0973—dc21

Printed in the United States of America

10 9 8 7 6 5 4 3 2 1

CONTENTS

NATIONAL BUILDING MUSEUM

BOARD OF TRUSTEES

KENT W. COLTON
Chair

SUSAN HENSHAW JONES
President and Director

HAROLD L. ADAMS
J. MAX BOND, JR.
CAROLYN SCHWENKER BRODY
WILLIAM F. CLINGER, JR.
WALTER D'ALESSIO
LEE A. DAYTON
GILBERT E. DELORME
CYNTHIA R. FIELD
EUGENE C. FIGG, JR.
ROBERT J. GENIESSE
M. ARTHUR GENSLER, JR.
GRAHAM GUND
DELON HAMPTON
JOHN W. HECHINGER, SR.
JOHN W. HYLAND, JR.
ELLIOTT H. LEVITAS
STUART A. MCFARLAND
ROBERT MCLEAN III
STACEY J. MOBLEY
ELIZABETH B. MOYNIHAN
ANGELO R. MOZILO
DONALD ORESMAN
STANLEY PRILL
WHAYNE S. QUIN
JULIE K. RAYFIELD
RICHARD M. ROSAN
DAVID M. SCHWARZ
LAWRENCE M. SMALL
JULIA M. STASCH
KATHRYN G. THOMPSON
MALLORY WALKER
LEONARD A. ZAX

FOUNDING TRUSTEES

HERBERT M. FRANKLIN
EDWARD T. HALL
MRS. ADLAI STEVENSON III
BEVERLY WILLIS

HONORARY TRUSTEE

TERENCE C. GOLDEN

TRUSTEES EMERITI

HOWARD M. BENDER
BRENDAN GILL
CHARLES A. HORSKY
THOMAS J. KLUTZNICK
MARILYN PERRY

EX OFFICIO TRUSTEES

THE HONORABLE BRUCE BABBITT
Secretary
U.S. Department of the Interior

THE HONORABLE HENRY G. CISNEROS
Secretary
U.S. Department of Housing and
Urban Development

THE HONORABLE JOHN H. CHAFEE
Chairman
Senate Committee on Environment
and Public Works

THE HONORABLE BUD SHUSTER
Chairman
House Committee on Transportation
and Infrastructure

DAVID J. BARRAM
Acting Administrator
General Services Administration

ROBERT A. PECK
Commissioner
Public Buildings Service
General Services Administration

THE HONORABLE JAMES H. BILLINGTON
The Librarian of Congress

JOHN W. CARLIN
The Archivist of the United States

WILLIAM L. ENSIGN
The Acting Architect of the Capitol

I. MICHAEL HEYMAN
Secretary
Smithsonian Institution

TERRENCE M. MCDERMOTT
Chief Executive Officer
The American Institute of Architects

RICHARD MOE
President
National Trust for Historic
Preservation

INTRODUCTION

When most people talk about the Kress Collection, they are referring to the Italian Renaissance paintings and sculpture donated to the fledgling National Gallery of Art in 1939 by Samuel H. Kress. But the National Building Museum has a Kress Collection of its own that is equally significant for scholars and enthusiasts of the built environment. Given to the museum in 1989 by Genesco, Inc., the successor to S. H. Kress & Co., this archive of building records documents the history of one of the twentieth century's largest chains of variety stores. The collection's thousands of blueprints, drawings, photographs, and documents tell the fascinating story of a company that helped enhance the nation's commercial architecture and played a vital role in shaping Main Street America.

The Kress Company's architectural philosophy was unique. While many retailers approached the construction of new stores on a piecemeal basis, Kress maintained an architectural division to oversee the design of everything from storefronts and office space to fixtures and furnishings. This commitment to architectural excellence dovetails perfectly with the museum's mission of celebrating American achievements in building, so we are especially pleased to be able to provide a home for this important collection and to share it with our visitors.

Over the years, the Samuel H. Kress Foundation has been unfailing in its support of the collection. Funds provided by the foundation have enabled the museum to conserve the materials and to support research in the Kress archives. One product of these efforts was the 1993 publication of a finding guide to the collection for researchers. Now the foundation has generously underwritten the publication of this book, which will bring public recognition to the architectural contributions made by Kress variety stores in communities across America.

We extend our sincere thanks to the Samuel H. Kress Foundation for its ongoing support of the National Building Museum and this project. Foundation President Dr. Marilyn Perry and Vice President Lisa Ackerman have been especially pivotal in making this book a reality. Here at the museum, the project was ably shepherded by Curator of Collections Alan Z. Aiches, as well as our former collections manager, Susan Wilkerson. We are also very grateful to author Bernice L. Thomas. With this book, she has helped shed light on a quintessentially American aspect of our architectural heritage.

SUSAN HENSHAW JONES
President and Director
National Building Museum
Washington, D.C.

FOREWORD

For much of the twentieth century, "commercial" was a dirty word in architecture. Branding a work "commercial" meant that it had been compromised by the demands of the marketplace, its designer selling out the ideals of art to the exigencies of the bottom line. Good modern architecture was not commercial, this argument went. Architects such as Gordon Bunshaft of Skidmore, Owings & Merrill or Ludwig Mies van der Rohe proved that one could create superb commercial buildings—office towers, apartment blocks, and the like—without succumbing to crass popular taste. "Commercial" meant superficial: the application of trendy elements or decorative motifs to catch the eye as opposed to developing a design in which all parts contributed to a purportedly immutable integrity. Art Deco, on the other hand, was "commercial" or "modernistic"—a term used with equally pejorative connotations. So was the work of Morris Lapidus. The architect Victor Gruen, who specialized in retail buildings, tried hard to bring a new set of design values to the real estate arena, but he too often lapsed into clichés, and so it was claimed that he too fell victim to commercialism.

The outlook today is little different in some circles. From the academy to professional journals, the idea that commercial architecture can be serious architecture is seldom accorded much credence. New examples, particularly in the retail field, do not help the situation when they are so often programmed to last a decade or less. Commercial architecture is now cast as a hallmark of impermanence as well as of compromise.

Yet our perspective on the past in the commercial sphere has changed significantly in recent years. From a historical vantage, much that was created during the first half of the twentieth century possesses aesthetic significance, and it has come to be valued for an ongoing usefulness as well. The buildings that line the Main Streets of hundreds of communities coast to coast have been rehabilitated, bringing new vitality and revenue to the traditional core. Once-great department store blocks have been transformed into mixed-use facilities, spearheading downtown renewal drives. Even early shopping centers, from Albuquerque to Washington, D.C., have been restored as catalysts to broader-based renewal efforts.

Bernice L. Thomas has contributed to our understanding of commercial architecture's rich legacy in an unusual way. She focuses on the variety store, which until now has been almost completely ignored by scholars. Even more to the point, her inquiry centers on a topic for which this type would seem to be among the least likely of candidates: artistic expression. Yes, *artistic expression*. This is not done tongue-

in-cheek or through the haze of nostalgia. Thomas is serious, and so is her subject.

During the 1930s especially, the S. H. Kress stores were conceived not just as efficient containers of merchandising and storage functions but also as works of art, civic art that would contribute to the urban landscape. American commercial centers were supposed to be handsome places that symbolized the progress and potential of their respective communities, but they were seldom entirely that. The retail landscape, in particular, was more often a hodgepodge than a visually coherent and agreeable destination for shoppers. The exceptions, such as State Street and North Michigan Avenue in Chicago, Fifth Avenue in New York, Union Square in San Francisco, or the Miracle Mile in Los Angeles, were nationally acclaimed as embodiments of great cities, not just as concentrations of fine stores. A relatively small percentage of merchants tried to do the same for the Peorias of the nation. They were for the most part locally based firms with intense pride in their hometowns. Chain-store companies took a more pragmatic view on the whole, particularly those dealing in low-cost goods.

Kress was a remarkable exception. Thomas's chronicle suggests that, once the company was well established as a major force in its field, enormous additional sums were spent on new buildings, each of individual design and far more elaborate than competing variety stores. Never mind that this campaign occurred during the Depression, when most retailers, even the most financially successful ones, were cutting back on expansion, if they were expanding at all. Throughout the 1930s Kress erected emporiums with elegant external appointments more suggestive of the finest clothing or furniture store built in a sizable city during the heady 1920s than a five-and-dime opening in hard times.

Why did Kress do this? Perhaps the program was justified as a means of pulling away from the competition, something many retailers sought to do in other costly ways as they were faced with a shrinking market. But altruism seems to have been at work here, too. The fact that Samuel H. Kress was a passionate collector of art and that his stores are rich in iconographical references, many of them regional in orientation, suggests that he saw the expenditures as his stores' gift to their communities—public art, as it were, that could be widely appreciated as well as attract the consumer's eye. Much like the traditional church or palace front, these store facades can be understood as expressions of faith in the system they represented. At a time when the underlying premise of capitalism was in greater doubt than ever before, Kress stores were beacons of faith in free enterprise as a beneficent as well as economically rewarding endeavor.

Kress stores are more than pretty designs. They are commitments to a better everyday world, to civic pride, to the bounties of democratic society. The modernist canon has helped make us more cynical. There is much to be gained from taking a few steps back in time and understanding the sophistication as well as the civility of our forebears.

RICHARD LONGSTRETH
George Washington University
Washington, D.C.

ACKNOWLEDGMENTS

I am indebted to three institutions, without whose help this book could not have been realized. Principal among these is the Samuel H. Kress Foundation, whose trustees voted generous grant support for research, writing, and publication of the book. I gratefully acknowledge my debt to the foundation's board. I especially want to thank the foundation's president, Marilyn Perry, who shared the vision right from the start and gave her personal support to the project when needed. Lisa Ackerman, vice president, worked tirelessly over a period of years to implement the project. She deserves special thanks for all of her efforts.

An affiliation with the Center for Advanced Study in the Visual Arts at the National Gallery of Art (CASVA), initiated by the Samuel H. Kress Foundation, facilitated the project in innumerable ways. Work space in the library provided access to the National Gallery and to the support of a fine staff. My thanks to Neal Turtel, chief librarian, and to Lamia Doumato, head of reader services, in particular. I greatly appreciate the help provided by Ruth Philbrick, curator of photographic archives; by the late Jerry Mallick; by William Taylor, former slide librarian; and by Maygene Daniels, director of the National Gallery's archives. The Department of Photographic Services, headed by Richard Amt, outdid itself in preparing illustrations, no small part of an architectural history book. People throughout the National Gallery went out of their way to assist with this project. I hope they know how deeply grateful I am.

Henry A. Millon, dean of the Center for Advanced Study in the Visual Arts, cannot be thanked sufficiently. In according me a place within the center, he allowed me to benefit from his knowledge and insights and from his unflagging support over five long years. While at the center, I had the additional opportunity of learning from and exchanging ideas with selected scholars from all over the world. Staff members at CASVA, including Curt Millay, who prepared a computer disk for the editor, were unfailingly helpful and gracious. Helen Tangires, in her alternate identity as an American studies scholar, gave freely of her own knowledge and her enthusiastic support throughout the project. It made a difference.

I am deeply grateful to the trustees of the National Building Museum and to the president and director, Susan Henshaw Jones, for publishing the book. My thanks to the former collections manager, Susan Wilkerson, for allowing me to work on the Kress archival materials while they were being processed and were unavailable to other researchers. She was also extremely helpful in arranging for many of the book's illustrations taken from the Kress Collection. The former Kress archivist, Hank Griffith, shared his knowledge of building practices and materials as well as the information he had gathered in the course of preparing and cataloging documents and photographs.

I wish to thank Cynthia Ware for editing the manuscript. The book is vastly improved because of her professional expertise, exercised with considerable tact and patience. I am doubly in her debt.

It would not have been possible for me to sustain a project of this duration, with its many pitfalls, without the support of friends and colleagues—a distinction that often blurred. Among the many were Judith R. Millon, N. Faye Powe, Prudence O. Harper, Carla Breeze, Carole Collins, Bernard Clemmons, and Eleanor Lombard. I would like to thank each of these people individually, and a longer list of people who will have to remain anonymous.

Finally, I thank my family. My brother, Sam B. Lippitt, Jr., assisted me in more ways than one. So did his son, Sam B. Lippitt III. My own sons, Aaron, Addison, and Owen, Jr., were constant in listening to their mother's travails while the book was aborning, often leavening the discussions with laughter. It helped.

PREFACE

"Across America, in any middle-aged downtown, a Kress
store is part of what makes it look like a downtown."

BETTY MARVIN
The Independent and Gazette,
Berkeley, California, 1979

The origin of this study of S. H. Kress five-and-ten-cent-store architecture goes back to a morning in 1984 and a trip to the old downtown in Albany, Georgia, the place where I grew up. Driving down the main street, letting the past merge pleasantly with the present, I was so struck by the sight of the Kress store that I stopped the car. My immediate reaction to the pale golden building—with its touches of bright-colored ornament glistening in the morning sun—was, "Why, you're beautiful. You look like a medieval reliquary." Nostalgia had been replaced by the artistic judgment of a historian of medieval art. A first visit to downtown Honolulu several months later and the sight of another Kress store—this time a handsome Mediterranean Revival building—combined with the memory of the Albany store and inspired the idea that Kress five-and-ten-cent-store architecture was worthy of serious study. In 1988 a proposal submitted to the trustees of the Samuel H. Kress Foundation, encouraged by the president, Dr. Marilyn Perry, led to a grant award for research and writing and for extended travel to see Kress stores all across America. The two stores that provided the nucleus of an idea, Albany and Honolulu, have both been demolished to make way for new development. Other Kress stores have suffered this fate since the company went out of business in 1980. I hope that this book, undertaken as an exercise in architectural history, will also inspire communities with former Kress stores in the heart of their downtowns to preserve and reuse them, instead of tearing them down.[1]

Unexpected surprises, some good and some bad, helped determine the course of the investigation. I knew before I started that the study would depend, to a large extent, on original research and source materials. There was very little published material on Kress stores and no in-depth scholarly study. I did not know until the study was under way, however, that there was no archival material from S. H. Kress & Co. itself. Genesco, Inc., which had owned and operated S. H. Kress & Co. as a subsidiary since 1963, had discarded all documents pertaining to Kress when they closed the company. Original source material would have to be found elsewhere. As the research progressed, my suspicions began to grow that there might be materials relating to Kress stores at Genesco's headquarters in Nashville. A trip to Nashville in 1989 and the cooperation of Jim B. Hale, buildings superintendent for Genesco, unearthed a cache of materials in the basement, unopened and forgotten for years. It was like discovering Ali Baba's cave. I had decided to limit my study to Kress stores designed by architects, which in turn limited the study to Kress stores erected on America's Main Streets up until World War II. The Genesco materials pertained to more than a third of the buildings in this category. Even so, they totaled approximately three thousand photographs, one hundred sets of architectural drawings, partial or complete, and an assortment of building records. These historic documents cast a new light on Kress architecture. Hap-

pily, they are now preserved and catalogued as the Kress Collection at the National Building Museum in Washington.[2]

The buildings, of course, would be the primary source material. They could and should speak for themselves. Fortunately, through a series of telephone calls to retired S. H. Kress & Co. executives, I found a complete list of Kress store operations in an unpublished volume compiled by J. S. Hudgins, called *We Remember Kress*.[3] The master list indicated Kress stores in more than 250 downtown locations, in twenty-nine states from coast to coast, as well as in Hawaii. Only the first store in a location was cited, however, along with the opening date. Kress stores had been listed on the National Register of Historic Places in Washington since 1979, individually or as part of historic commercial districts.[4] Queries to the state offices helped uncover more recent Kress stores and to eliminate ones no longer extant. Armed with this information, I set out across America in search of Kress stores in middle-aged downtowns. My intention was to see a representative sample of old Kress stores, since I could not see them all. In the end, I visited more than sixty Kress store sites in places as far apart as Santa Rosa, California, and Key West, Florida, with El Paso and Amarillo, Texas, in between.

The research had a decidedly informal air. Without prior introduction, I simply walked into each building with camera and tape recorder in hand. Once the occupants learned I was interested in their building, they always gave permission to look around. Frequently, the person most knowledgeable about the building was summoned to give assistance. An impromptu tour guide often took me from the basement to the rooftop, pointing out parts of the original fabric of the building, parts sometimes no longer in plain view. Repeated visits to Kress stores made old store interiors come to life. An empty store-manager's office with its teller's window gradually took form as a furnished interior in my imagination, after I had seen swivel desk chairs in one place, an office safe in another, and a machine for sorting and counting coins in a third. The same was true for the sales floor, whose appearance was fleshed out by old display counters or light fixtures put aside in storage.

People other than the occupants of the buildings also became a means of recapturing Kress architecture. Former customers encountered by chance happily volunteered a description of some portion of a Kress store that was particularly meaningful to them. The retired head of Kress's building division, F. Edgar Kerby, helpfully explained his department's procedures, and other former associates of the last architect to design for Kress provided insight into this architect's work. In the end, interviews with people scattered across the country, some of which were planned and some that occurred by happenstance, added as much to an understanding of Kress store architecture as store visits and archival materials.

My journey to Main Street in search of Kress stores has come to an end, leaving behind the memory of a rich and rewarding experience. Nostalgia for repeated trips to Kress stores in dozens of downtowns, for the buildings and the people met en route, has replaced the original nostalgia that once led to a visit to an old downtown and a singular encounter with a Kress store.

KRESS AND DIME-STORE ARCHITECTURE

1

S. H. Kress & Co. began to build five-and-ten-cent stores on America's Main Streets shortly after the turn of the century. By World War II, Kress stores formed a distinctive part of the downtown streetscape in more than two hundred towns and cities in thirty states, including what is now the state of Hawaii (fig. 1.1). By the war, more stores had been erected in California than in any other state, with Texas as the runner-up. During times of peak construction, the company employed as many as one hundred architects and draftsmen in its architectural division at the company headquarters in New York.[1]

Fig. 1.1. *Downtown shopping street, Fort Smith, Arkansas, 1938. Courtesy National Building Museum, gift of Genesco, Inc.*

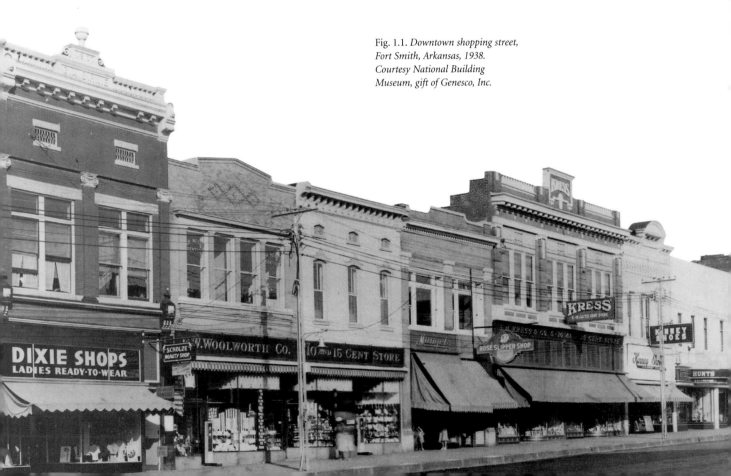

After the war, the company stopped building stores designed by company architects in downtown areas and concentrated its new construction in outlying shopping centers. A building division replaced the company's architectural division in 1944, and the company's period of architectural distinction was over. What remains is a huge architectural legacy in America's downtowns, representative of a bygone era.

A study of Kress five-and-ten-cent stores has larger ramifications. They are an example of a new type of American architecture, called forth by a new type of retail venture developed in the United States: the five-and-ten-cent store, part of the burgeoning chain-store movement. They both reflected and helped to define American commercial architecture in the first decades of this century. Kress buildings chronicle changes in taste, technology, and building practices as they move from simple commercial structures to more elaborate period-style architecture to modern designs. They changed from buildings with weight-bearing walls to ones built of steel (see fig. 4.5) and concrete sheathed with brick and terra-cotta and occasionally other materials. Kress stores show a progressively more sophisticated use of glazed terra-cotta for cladding and ornament.[2] In 1930, before a general call went out for "the modernization of Main Street,"[3] the company made a conscious switch to a new, modern style for its stores. By placing stores of modern design in downtowns from coast to coast, sometimes as the first and often as the finest example of modern architecture in town, Kress contributed to the rapid dissemination and acceptance of a brand-new commercial style.

S. H. Kress & Co. was a pioneer in establishing a company identity by means of a "signature storefront." It gave strong impetus to the idea of the building as advertisement. Each Kress store combined an original design with standardized parts, inside and out. In some ways, the stores reflect the assembly-line mentality prevalent in America, especially between the two world wars. In other ways, they show continuity with an older craft tradition. As such, they represent an early-twentieth-century phenomenon that merits further investigation.

With few exceptions, S. H. Kress & Co. used company architects. A head architect signed the plans, but presumably the designs were a collective effort. The one Kress architect about whom anything substantive is known is Edward F. Sibbert, who joined the architectural division in 1929 and headed the division from 1932 on. The only information we have about office procedures comes from Sibbert's answers to questionnaires submitted to him late in his life, when he was seventy-eight and eighty years old:

> I would make a very rough thumb nail sketch, I called it an "esquese" [sic] and the Ach. [sic] designer would develop the set of sketches which we played with until the right effect was found. The final sketch then went to the draftsmen who made the working drawings with plenty of supervision. Large scale details were part of the working drwgs. When a contractor was selected he was required to submit full size details, color samples etc. These when approved were used by manufacturers and workmen to produce what we "imagined" when the problem first came to us.

When asked if there were any other interesting sidelights on this part of his work, Sibbert wrote, "Nothing unusual—we functioned as any reputable Architect of that era —Today's offices are something else."

The buildings tell us, when looked at in chronological sequence, that continuity accompanied by regular change was strong in Kress store design. Each architect in charge of the office left an imprint on the design of the buildings, but at the same time each clearly built on the work of his predecessors.

One constant in the history of Kress store architecture, from its inception to World War II, is the patron, Samuel H. Kress (1863–1955), president of the company until 1934 and then chairman of the board (fig. 1.2). He was actively engaged in running the company until illness overtook

him in 1941. His brother, Claude W. Kress (1876–1941), who had been vice president, was president for seventeen years. Another brother, Rush H. Kress (1877–1963), vice president and treasurer for many years, was president from 1941 to 1945 (figs. 1.3, 1.4). Samuel Kress had considerable artistic interests, one of which was a concern for the appearance of the stores his company was building. He was especially interested in the storefronts. No plans left the home office without his approval, often signified by the initials SHK on the outside.[4] He was known on one occasion to fire a head architect.

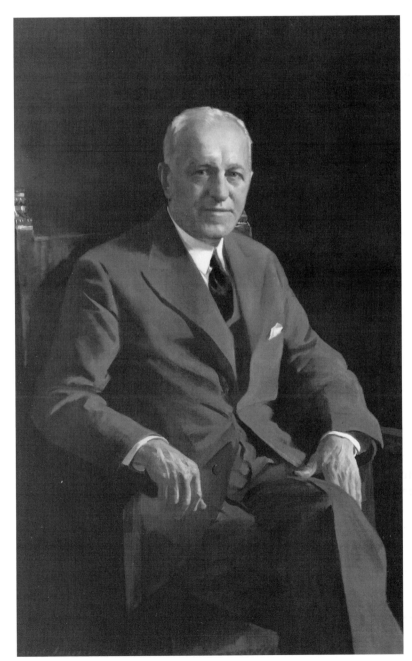

Fig. 1.2. *Leopold Seyffert,* Samuel Henry Kress, *oil on canvas, Samuel H. Kress Collection, National Gallery of Art, Washington, D. C. ©1996 Board of Trustees, National Gallery of Art.*

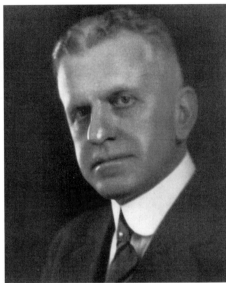

Fig. 1.3. *Claude Washington Kress, portrait reproduced in Karl Frederich von Frank zu Doefering and Charles Rhoads Roberts,* Kress Family History, *1930. Courtesy Samuel H. Kress Foundation.*

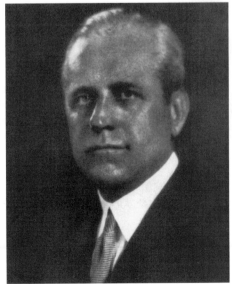

Fig. 1.4. *Rush Harrison Kress, portrait reproduced in* Kress Family History, *1930. Courtesy Samuel H. Kress Foundation.*

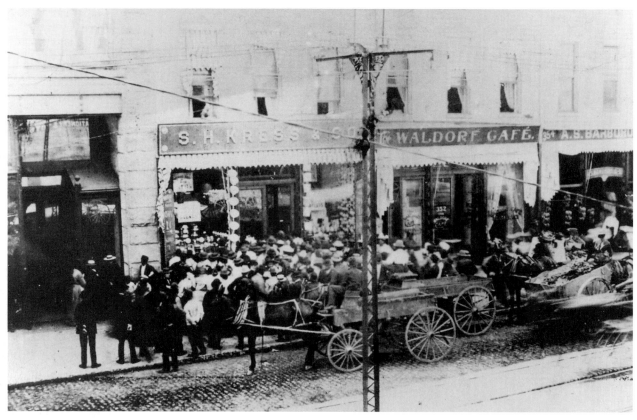

Fig. 1.5. *First S. H. Kress & Co. five-and-ten-cent store, Memphis, Tennessee, 1896. Courtesy National Building Museum, gift of Genesco, Inc.*

Likewise, both Claude and Rush Kress concerned themselves with Kress store design.[5] In assessing S. H. Kress & Co. five-and-ten-cent-store architecture, one has to pay close attention to the client as well as to the architects the company employed.

Samuel Kress founded his chain in Memphis, Tennessee, in 1896 by opening a modest retail store bearing his name (fig. 1.5). Before then, he had taught school for several years, beginning at age seventeen, after educating himself to pass the teacher's examination. He reportedly walked three miles each way to the schoolhouse near his home in Cherryville, Pennsylvania. By 1887 he had saved enough from teaching to purchase a stationery and novelty store in Nanticoke, Pennsylvania. In 1890 he added to his holdings a wholesale business of stationery and toys in Wilkes-Barre, Pennsylvania, turning it into the Kress Stationery Company. Kress's father, John Franklin Kress, had also been active in retailing, having operated a drugstore and, later, two commissary stores at the Slatington, Penn-

sylvania, mines. Claude Kress, Sam's junior by thirteen years, assisted his brother with the Pennsylvania businesses and later with the Memphis store. For a time, another younger brother, who later became a doctor, Palmer J. Kress, was involved with the Pennsylvania ventures. He managed the Nanticoke store for Sam for three years between his first and final years in medical school.[6]

Samuel Kress chose a location in the South for starting a variety-store chain, despite the fact that it would have been more convenient to open a chain in Pennsylvania. He had great confidence in the South, as he explains in his autobiographical statement in the *Kress Family History,* published in 1930. An article celebrating the Kress Company's fiftieth anniversary in 1946 explains the decision more fully: the South not only had no five-and-tens, it was vastly understored. As "The Kress Story" puts it, "Memphis was picked because it was a thriving cotton port and it appeared, after careful appraisal, to offer the maxi-

mum potential and minimum risk for the introduction of the Kress idea."[7] The Kress idea, as the article says, was to go beyond available low-priced goods, working toward a merchandising force that would compel the production of merchandise at values not then available. This approach, the company contended, separated Kress from the rest of the five-and-ten-cent-store chains.

Samuel Kress's decision to launch a variety-store chain in Memphis proved to be a wise one, for he was prosperous enough by 1900 to own twelve variety stores in four southern states and in Texas (fig. 1.6; see also fig. 2.1). He then took the ambitious step of moving the company headquarters to New York City. Rush Kress joined his brothers in the New York office in 1900. Kress established a second company headquarters in Texas in 1907, the year the company became incorporated in New York state. By 1916, the two headquarters had been combined.[8] When the founder died in 1955, S. H. Kress & Co. owned 262 stores with an annual gross income of $167.9 million.[9]

Kress built his chain on a selling strategy devised by Frank W. Woolworth in 1879. It was to offer a wide choice of quality merchandise at extremely low prices, with nothing costing more than a nickel or a dime. Kress kept to this commitment until 1901, when he added items selling for a quarter. Woolworth's formula for success had already been copied in 1882 by John G. McCrorey (who dropped the "e" from his name); others, such as Sebastian S. Kresge, followed soon after Samuel H. Kress.[10] The idea of starting a five-and-ten-cent-store chain continued to gather momentum, as later entries—G. C. Murphy, J. J. Newberry, and W. T. Grant—attest. Despite the competition, all these organizations grew and prospered, even during the Great Depression. They provided necessary goods as well as luxury items at prices many people could afford.

Five-and-ten-cent stores were similar in concept to department stores in offering a variety of merchandise under one roof. But in limiting their prices to a nickel or a dime, at least in the beginning, and in

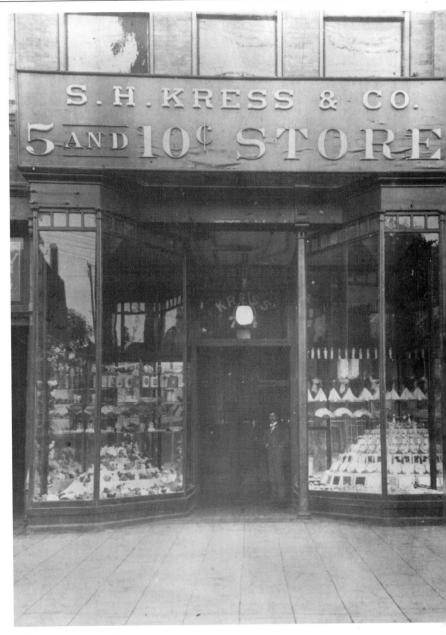

belonging to chains, they were decidedly new and different. Their profit came from buying in bulk and selling the same products in a large number of stores, contenting themselves with low markups because of their volume of business.

The architecture of five-and-ten-cent stores had much in common with that of other retail stores on America's Main Streets in the first half of the twentieth century: they were narrow, deep buildings designed to utilize entire urban lots. The height of the

Fig. 1.6. *Augusta, Georgia, 1899. Courtesy National Building Museum, gift of Genesco, Inc.*

Fig. 1.7. *Sidewalk scene, East Orange, New Jersey. Courtesy National Building Museum, gift of Genesco, Inc.*

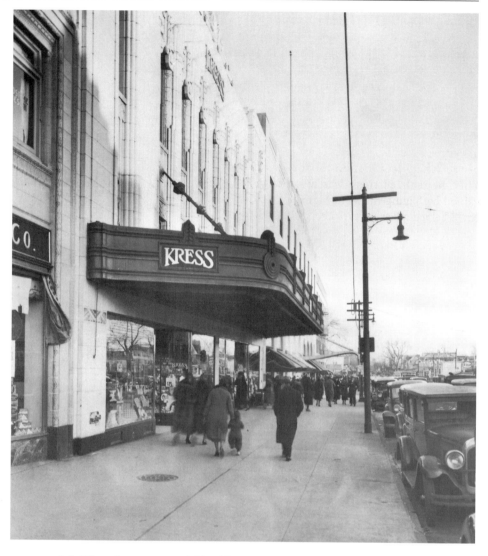

stores varied. Like other commercial buildings, dime stores were flush with the sidewalk, and primary architectural attention was given to the front elevation. The rear of the store, which often faced an alley, was plain by comparison. The side walls were either partially or totally obscured by abutting buildings, or were party walls. Except when the design of the front elevation continued around the corners as returns, any visible portions of the side walls were also plain and nondescript. The storefront, with its public entrance doors and large glass show windows, was clearly all-important. The facades were linked together down the sidewalk for a common end: to appeal to shoppers and entice them inside. It was

architecture aimed primarily at pedestrians or at people driving slowly down the street (fig. 1.7).

Among the design features characteristic of a five-and-ten-cent store, signage was perhaps the most conspicuous. Each store had a sign across the front, just above the display windows, made of shiny gold letters against a bright red background. The sign gave the name of the company followed by the explanation "5–10–25 Cent Store" (plate 1). A uniformity among five-and-tens had already been established by the choice of company name; each used the founder's name in the title, set forth as two initials and a surname. A sign saying "S. H. Kress & Co. 5 & 10 Cent Store" in a particu-

lar color combination in a particular position on a store facade immediately identified the store, its type, and the store chain. Moreover, it identified the store as belonging to a larger group of chain stores of the same type. Frank W. Woolworth was the first to use signs of this description on his stores. When his competitors began to follow suit, he was initially upset and contemplated taking legal action to stop them. Then he realized there was more to be gained by having the same signage. Each chain helped advertise the others. The red-and-gold signs were "a nickel and dime logo."[11] Similar signage in a similar location on the building did create a problem for two dime-store chains: S. H. Kress and S. S. Kresge. People tended to confuse them. To eliminate the problem, Samuel H. Kress and Sebastian S. Kresge made a deal to stay out of each other's territory.[12] A Kress's and a Kresge's never appeared on the same Main Street.

The display windows of a five-and-ten-cent store had a special look—but this was because of movable elements rather than anything fixed. The windows were apt to be filled with merchandise, either multiple examples of a single item or items from a single department within the store. This style of display contrasted with that of higher-priced department stores, where only a few selected items were usually on view. Windows piled high with articles emphasized sales capacity, reflecting, in Ada Louise Huxtable's words, "the five-and-ten merchandising creed—more is more."[13] The show windows themselves were thus a form of advertisement. By 1925 at the latest, S. H. Kress & Co. was exploring this potential by adopting "Watch Kress Windows" as an advertising slogan (figs. 1.8, 1.9). Like posters outside a movie theater, the windows told you what you would see inside: repeated examples of similar articles laid out for the customer in crowded but orderly array. The prices were marked on each item in the window, just as they were marked in the store. The contents of the windows changed frequently, but the look of the windows remained constant.[14]

KRESS
5-10 AND 25 CENT STORE

The new Kress store will be open for business on Thursday, May 26, 1932. This, we feel sure, will be welcome news to the thousands who have known Kress stores in other cities and who will appreciate having one in Bakersfield.

So that you may have an opportunity to look over this new store and to give our friends a chance to see what a modern Kress store is like, we will have an

INFORMAL OPENING
Next Wednesday, May 25
Afternoon, 3:00 to 5:00 o'Clock
Evening, 7:00 to 9:00 o'Clock

MUSIC BOTH AFTERNOON AND EVENING
BY EARL SHAW AND HIS
"SMILES JAMBOREE" ORCHESTRA

On This Day Nothing Will Be Sold

We especially call your attention to the Candy Department where not only the quality of candy sold must be the best at the price, but where sanitary methods of display and handling are supreme.

"WATCH KRESS WINDOWS"

Fig. 1.8. *Advertisement in the* Bakersfield Californian, *May 23, 1932. Courtesy the* Bakersfield Californian.

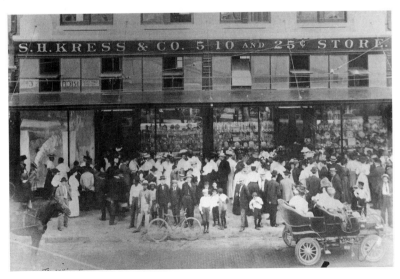

Fig. 1.9. *"Watching Kress Windows," Tampa, Florida. Courtesy National Building Museum, gift of Genesco, Inc.*

Fig. 1.10. *Construction of wooden counters and frames for pier mirrors, San Pedro, California, 1938. Courtesy National Building Museum, gift of Genesco, Inc.*

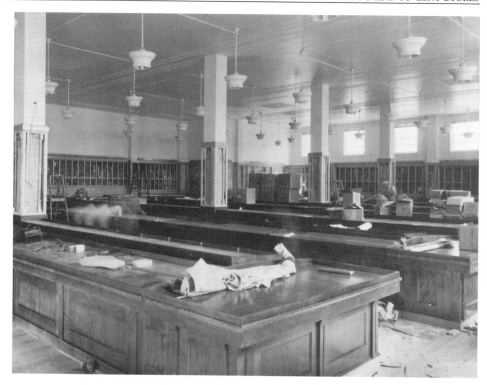

Fig. 1.11. *Main sales floor, Nashville, Tennessee, 1936. Courtesy National Building Museum, gift of Genesco, Inc.*

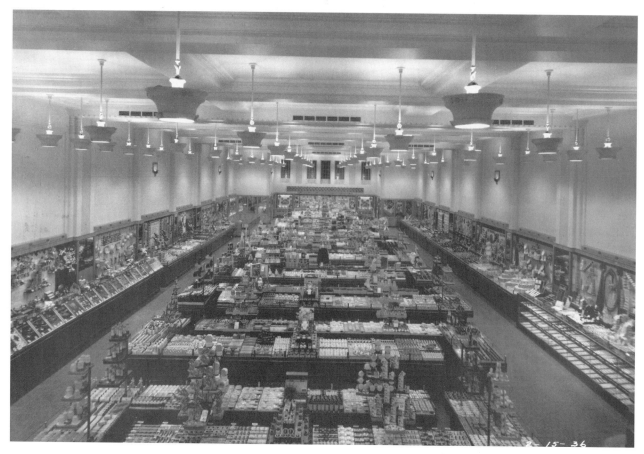

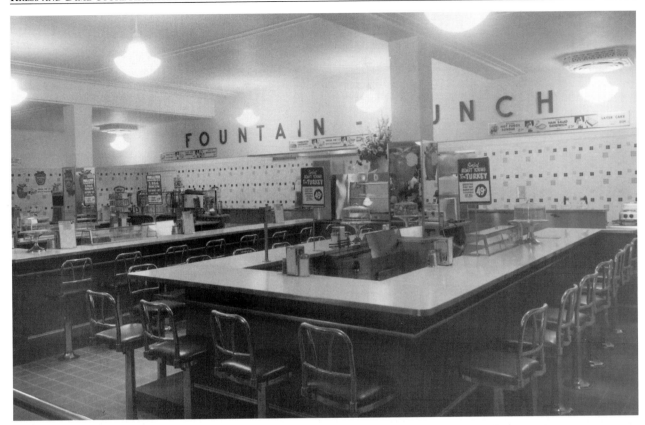

Fig. 1.12. *Lunch counter, Greensboro, North Carolina, 1958. Courtesy National Building Museum, gift of Genesco, Inc.*

The interior of a dime store was a vast open space defined by solid wooden counters on the floor and against the walls (fig. 1.10). Support columns or piers were usually deemed structurally necessary, but other interruptions of the floor space on the selling floor were kept to the minimum. The idea was for the customer to see all the merchandise at once. Kress architects always indicated the exact disposition of the counters—or display fixtures, as they called them—on store plans. These constituted the significant divisions of the oversized room. The counters, which were arranged to form aisles down the length of the store, were placed crosswise and not lengthwise. This way, they would funnel customers through the store from front to back, yet encourage them to detour past counters of merchandise en route (fig. 1.11). Examples of everything for sale in the store were laid out on these counters: cornucopias of merchandise displayed in repetitive, geometric configurations. By 1934 S. H. Kress & Co. could declare that "4,275 articles are offered to shoppers" when a new store opened.[15] Related types of merchandise on individual counters were grouped together into sections or departments. Signs, such as "Toys" or "Housewares," identified departments. As an advertisement for the Kress Company stated, "All Kress merchandise is arranged to insure ease of selection."[16] Light was distributed uniformly by rows of hanging ceiling fixtures so that all articles could be easily seen.

Dime-store customers were encouraged to handle objects that they might consider purchasing, in the belief that this stimulated business. Thus counters and ceiling lights were part of an architectural interior planned to facilitate the rapid turnover of merchandise essential to the financial success of a five-and-ten. One department that was a standard component of a five-and-ten-cent store of any size was the lunch counter and soda fountain, designated by S. H. Kress & Co. as the "Soda and Lunch Department" (fig. 1.12). Food prices were modest, consistent with the overall selling

policy. A readily accessible eating facility drew customers into the store and was part of the shopping experience.

As they proliferated on Main Street, dime stores became a familiar and beloved institution. Crowds of people crossed their thresholds, particularly on Saturday afternoons. They became meeting places as well as places to buy necessities and modest luxury items, such as inexpensive jewelry. S. H. Kress & Co. was perfectly aware of this function and erected signs in front of stores under construction urging, "Meet Your Friends at Kress" (fig. 1.13). Newspaper advertisements coinciding with new store openings repeated the slogan. The sights and smells in a five-and-ten-cent store and the bustle of the crowds created an atmosphere of excitement. Going downtown to the five-and-ten to browse, buy, or see other

people was a form of entertainment (fig. 1.14). As Ada Louise Huxtable put it, "What the bazaar was to the Middle East, Woolworth's was to America."[17] Five-and-ten-cent-store architecture and furnishings provided a stage set for a scenario repeatedly enacted in hundreds of communities all over the nation. The stores became an architectural background for a collective social experience.

Kress took pride in its store buildings[18] and was known in the dime-store community for preferring to build rather than to lease its stores (fig. 1.15). Moreover, within the category of five-and-ten-cent-store architecture, S. H. Kress & Co. stores had certain design elements that made each one identifiable as a Kress. Early in its building program, the company adopted design features that would persist, with modifications,

Fig. 1.13. *Memphis, Tennessee, Kress store under construction, 1926. Signs with Kress slogans: "Stores from coast to coast" and "Meet your friends at Kress." Courtesy National Building Museum, gift of Genesco, Inc.*

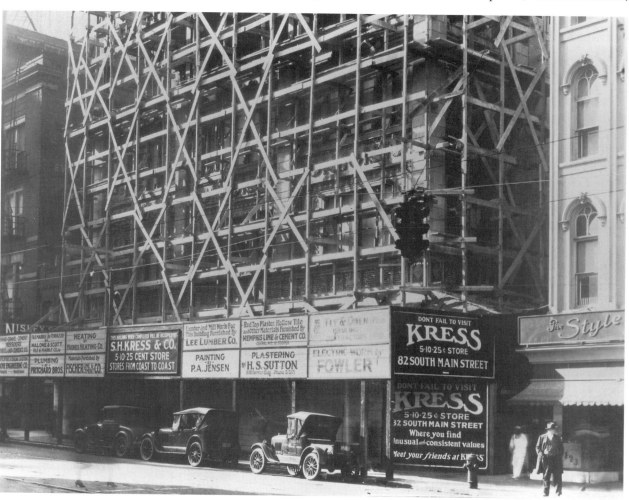

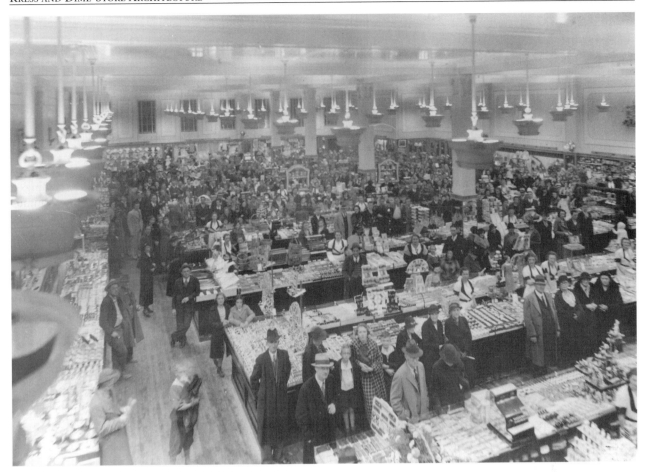

Fig. 1.14. *Preview reception before new store opens in Anniston, Alabama, 1935. Courtesy National Building Museum, gift of Genesco, Inc.*

Fig. 1.15. *Building a Kress store in Brownsville, Texas, 1928. Courtesy National Building Museum, gift of Genesco, Inc.*

throughout its building history. Others were introduced and then repeated for a time, becoming canonical for Kress store architecture during a certain period, but a basic skeleton undergirded a wide variety of Kress store designs. The color of choice for a store's exterior was buff or some similar tone, regardless of the building material. The facades were symmetrically disposed, with the word Kress in bold capital letters centered at the pinnacle. In contrast to the sign across the storefront below, whose letters matched the typography of signs on other dime stores, the name Kress on the upper facade was rendered in distinctive lettering. The letters were aligned at the top and were stretched or compressed below to form an arch (see fig. 1.1). The name in the stylized format became a trademark or company logo and was the most notable component of the Kress architectural canon.

Another characteristic feature of the outside of the store was a row of transom windows made of prismatic glass below the long store sign (fig. 1.16). These mezzanine windows related to set conditions inside the store: the ceiling of the main floor of a Kress store was exceptionally high, accommodating a mezzanine balcony. The row of transom windows, along with glass entrance doors, allowed for more natural light on the selling floor and for extra ventilation. Kress's show windows of polished plate glass were distinguished by having end sections of curved glass leading toward recessed entrance doors (fig. 1.17). In the early stores, the display windows rested on bases of cast iron perforated with grilles for ventilation. These were soon changed to bulkheads faced with Verde Antique marble, polished granite, or occasionally ceramic tiles for stores of a lesser rank in the chain. Whatever the material, the bases under the rounded plate glass were also rounded. The floor of the vestibule in front of the doors was ornamented with the Kress logo, first in marble mosaic and later in bronze letters set in travertine marble (figs. 1.18, 1.19).

Fig. 1.16. *Webb City, Missouri, mezzanine windows of prismatic glass furnished by S. H. Kress & Co. Courtesy National Building Museum, gift of Genesco, Inc.*

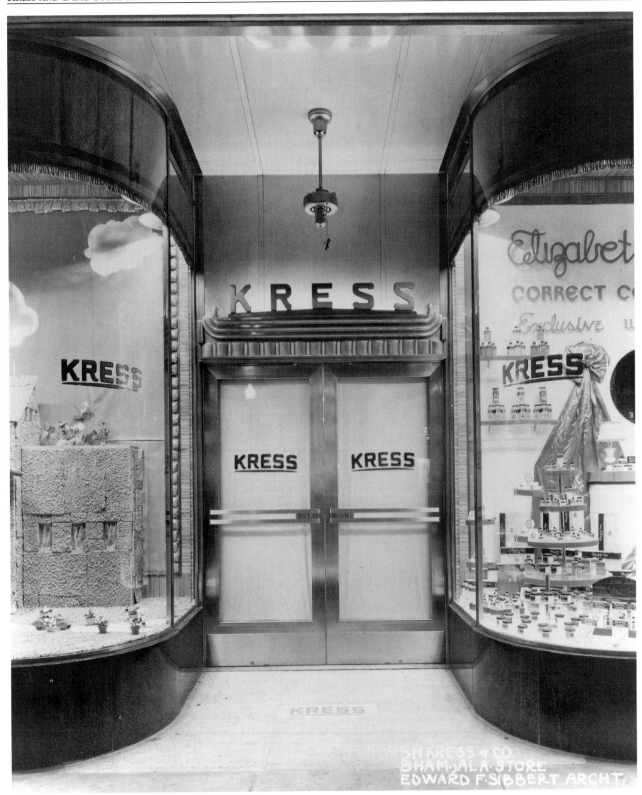

Fig. 1.17. *Typical recessed entrance with bent plate glass show windows on curved bases, Birmingham, Alabama.*
Courtesy National Building Museum, gift of Genesco, Inc.

Fig. 1.18. *Plan for Kress vestibule name panel. Courtesy National Building Museum, gift of Genesco, Inc.*

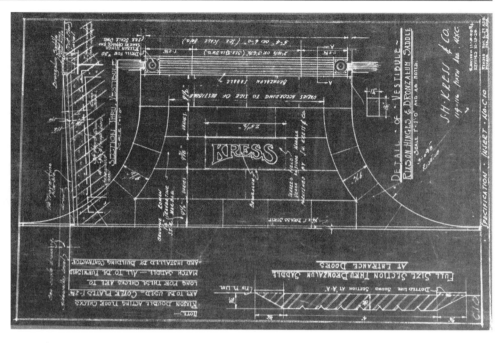

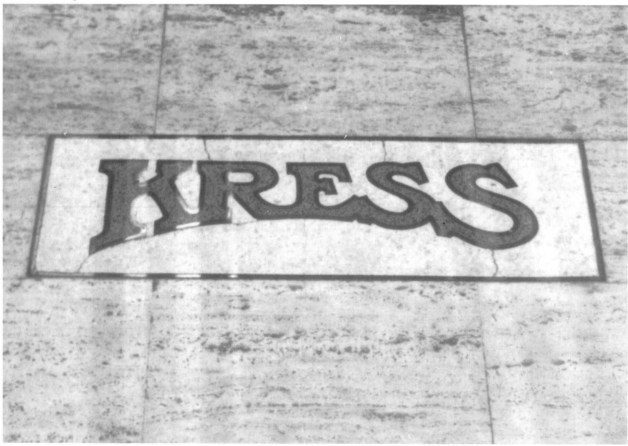

Fig. 1.19. *Kress name panel in bronze, set in travertine marble. Photograph by author.*

These characteristic features served the company's interests. The rounded show windows were gently directional, encouraging the pedestrian shopper to make the transition from the sidewalk to the doors. The eye-catching floor plaque in front of the doors drew the shopper closer to the store entrance. Signage, too, worked toward the same end. The name Kress appeared in gold following the curvature of the windows and again on the glass doors and overhead transoms directly facing the customer. These recessed entrances were illuminated at night, as were the display windows and inside sales floor. Window-shopping was a common evening pastime in America in the first half of the twentieth century, and a view through the windows and glass doors of a Kress store would entice more customers in the next time the store opened.

Kress claimed to use more wattage than its competitors in lighting store interiors; combined with extra natural light from the mezzanine, this ensured a brighter selling floor. On the upper floors, more space than usual was devoted to architect-designed storage bins because Kress believed strongly in warehousing on the premises (fig. 1.20). In this way a store could avoid having a display counter run out of an individual item. The public spaces in a Kress store all had the same color scheme: tan-and-cream-colored walls with ivory trim. Uniformity was assured by the fact that contractors had to buy the paint from Kress (fig. 1.21).[19] The choice of neutral colors let the colorful array of merchandise stand out. For the same reason, Kress saleswomen wore harmonizing light-tan uniforms trimmed in brown (fig. 1.22). The walls of the better stores had wainscots of Napoleon Blanc Mélange marble, an attractive veined marble of pale rose. The floors, when not hardwood, were marble terrazzo inlaid with strips of bronze. The three kinds of marble to be blended, the amount of each, and the size of the chips were all specified in writing by the company (fig. 1.23).[20] The globes of the light fixtures were almost always the same. When they changed, they changed uniformly in every Kress store, whether as new construction or as part of a remodeling (fig. 1.24).

Fig. 1.20. *New storage bins await Kress dime-store merchandise, Wilshire Boulevard, Los Angeles, 1938. Courtesy National Building Museum, gift of Genesco, Inc.*

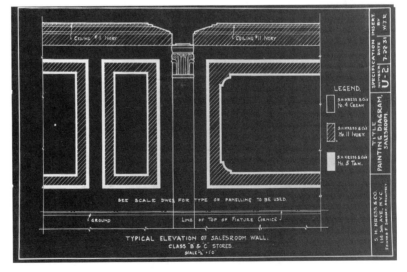

Fig. 1.21. *Plans for typical elevation of salesroom wall for smaller, Class "B" and "C" stores. Areas indicated for standardized colors, using paint provided by the Kress Company, Hilo, Hawaii, 1931. Courtesy National Building Museum, gift of Genesco, Inc.*

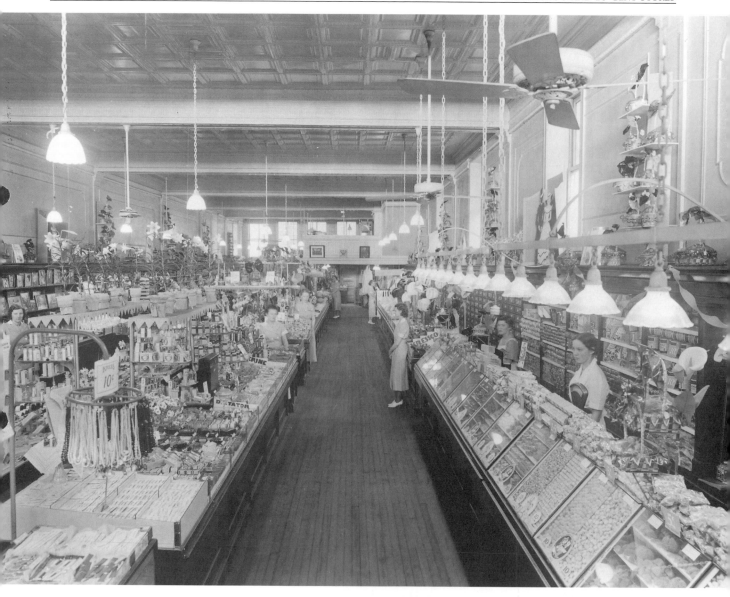

Fig. 1.22. *Uniformed saleswomen in place before the doors open, Anderson, South Carolina. The store has typical wooden floors and pressed-metal ceilings. Courtesy National Building Museum, gift of Genesco, Inc.*

Fig. 1.23. *Hollywood Boulevard, Los Angeles, 1934. Basement sales area with marble terrazzo floor. Courtesy National Building Museum, gift of Genesco, Inc.*

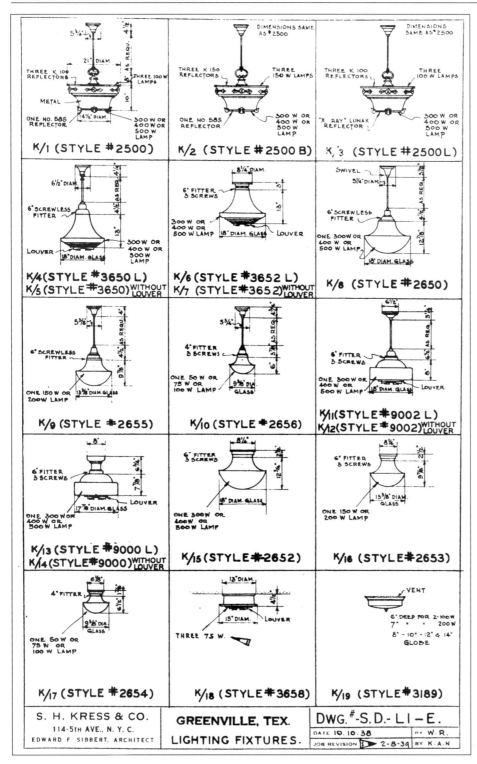

Fig. 1.24. *Standard lighting fixtures for Kress store, Greenville, Texas, 1938. Upper row shows fixture providing direct and indirect lighting favored for the main sales floor in the late 1930s. Courtesy National Building Museum, gift of Genesco, Inc.*

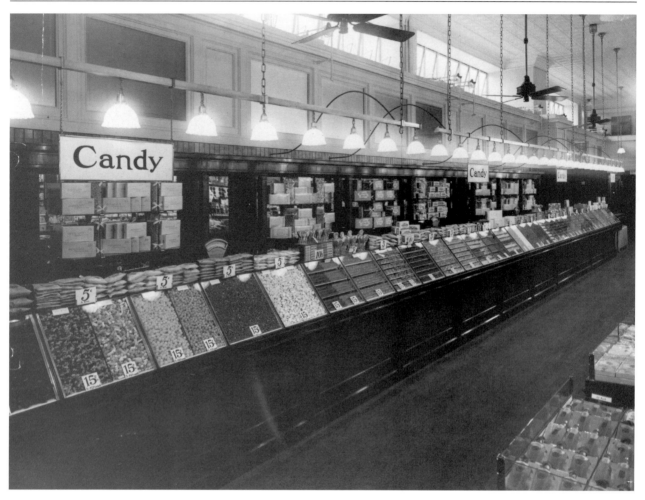

Fig. 1.25. *Kress-designed candy cases with overhead lighting, Third Avenue, New York City, 1926. Courtesy National Building Museum, gift of Genesco, Inc.*

Kress patented its design for a candy counter, which always took pride of place against the wall near the entrance to the store. Candy was a best-selling item at Kress's as it was at other five-and-ten-cent stores. Sometimes it even made the difference between profit and loss in an individual store. The company made a point of describing in its newspaper advertisements the way candy was handled in a Kress store: the candy was kept in sealed, wax-lined containers inside the showcase to ensure proper hygiene. At night the candy supply was sent by dumbwaiter to the candy room, a rat-proof and vermin-free space where the temperature was kept between 68 and 70 degrees. In the morning the candy was

transferred back to Kress's uniquely designed sanitary candy counter. In order to call attention to this built-in feature as well as to facilitate selection, Kress had another row of lights, shaded downward, over each of its candy counters (fig. 1.25). On occasion, the jewelry counter was also illuminated with special overhead lighting (fig. 1.26).

The many matching details in each Kress store and the basic architectural formula gave buildings in this chain a special distinction among dime stores. They had other distinctions as well. Although Kress built expensive buildings using fine materials before the 1930s, America's Great Depression evidently provided an opportu-

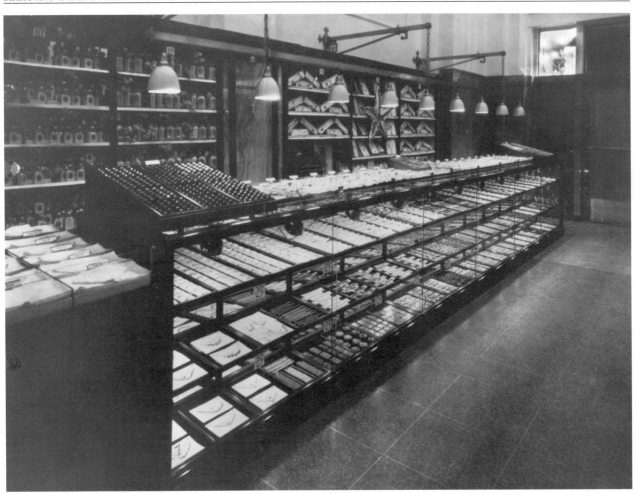

nity to build some of the chain's finest stores. Class A stores, or Superstores as they eventually were known, became the talk of the trade.[21] Edgar Kerby, former head of Kress's building division, explained it this way in 1983:

> Samuel H. Kress fully realized that the depression would not last forever, and he, more than any of his competition, took advantage of the extremely low cost of labor and construction materials to embark on a large construction program—building what we then considered Class A store buildings in many cities including the flagship store at 444 Fifth Avenue.[22]

In turn, building substantial stores during the Depression created good will for Kress, since such large construction projects, involving local labor and materials, often made a critical difference when a local economy was suffering. Often, as in Fort Worth, Texas, a new Kress store was one of the few new buildings constructed in the downtown by private commercial interests during the Depression.[23]

Whether Superstores or more modest stores, Kress buildings were distinctive. Sibbert wrote, "We wanted our stores to stand out, but not too much," and they did just that. Kress stores were manifestly five-and-ten-cent stores, and at the same time, each was manifestly "a Kress's."

Fig. 1.26. *Jewelry counter with individual lighting, Montgomery, Alabama, 1929. Courtesy National Building Museum, gift of Genesco, Inc.*

BEGINNINGS

The story of S. H. Kress & Co. architecture does not begin, strictly speaking, until some years after the founding of the chain. Initially the company leased or bought existing buildings and turned them into Kress stores simply by extending Kress's red-and-gold sign across the facades. This happened for the first time in Memphis in 1896 and continued for almost a decade, as in the Tampa store (fig. 2.1). In Pensacola, Florida, in 1902, the company took space in what had been a market stall in an open arcade—a fitting location, since markets of this sort were precursors of the variety store. By about 1905, the first recorded Kress company architect, Julius H. Zeitner, was engaged in modifying old buildings for Kress stores with some regularity. Records show a store opening in Cairo, Illinois, in 1905, and Zeitner as having made renovations on a building in the same location. Presumably the two events were connected. A similar deduction can be made for a store that opened in Parsons, Kansas, in 1906.

Fig. 2.1. *Typical Kress practice of painting signs on side walls, Tampa, Florida. Courtesy National Building Museum, gift of Genesco, Inc.*

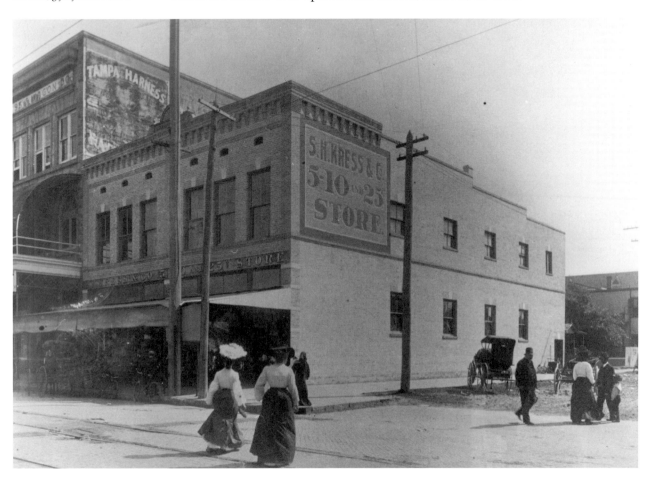

EARLY BUILDING HISTORY

Samuel Kress embarked on his career as a builder around 1909, when the company began to construct its own stores (fig. 2.2). Zeitner signed plans for stores in Bartlesville, Oklahoma, and Lawrence, Kansas, in that year (fig. 2.3). In 1910 Seymour Burrell joined with Zeitner in designing new buildings for S. H. Kress in Goldsboro and Salisbury, North Carolina (fig. 2.4; see also fig. 2.14). By 1911 Burrell was designing buildings by himself. Zeitner's name appears one more time, in 1913, as co-architect with Burrell for a building in Houston, Texas. Burrell designed new Kress stores every year up until 1918, along with an occasional remodeling.[1]

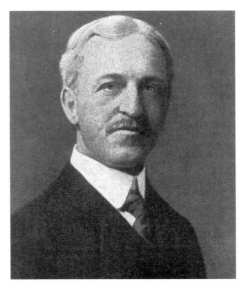

Fig. 2.2. *Samuel H. Kress, "Facsimile of Programme" for the dedication of the G. A. R. memorial to his namesake killed in the battle of Gettysburg,* Kress Family History. *Courtesy Samuel H. Kress Foundation.*

Fig. 2.3. *Drawing for front elevation of a Kress store in Lawrence, Kansas, 1909, designed by the first Kress company architect, Julius H. Zeitner. Courtesy National Building Museum, gift of Genesco, Inc.*

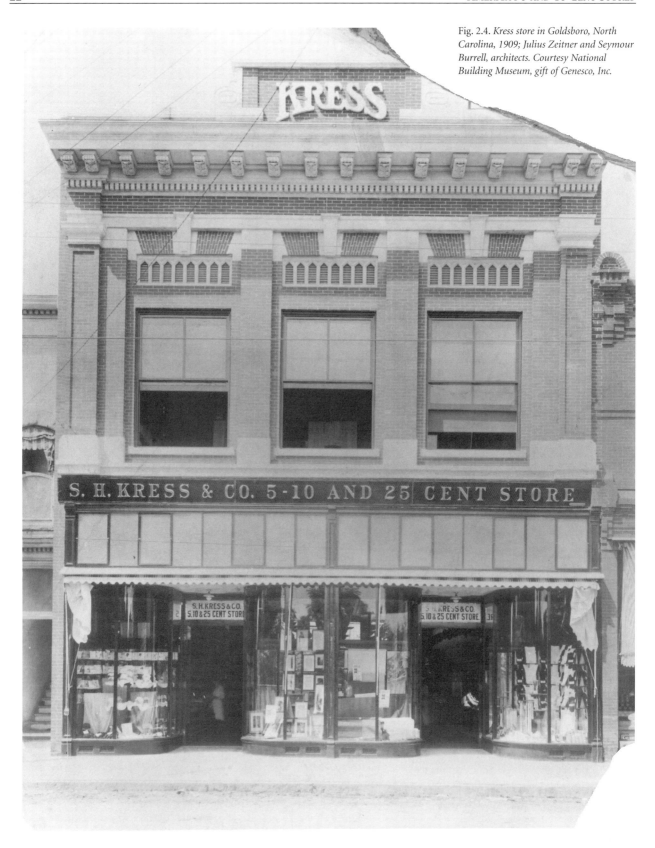

Fig. 2.4. *Kress store in Goldsboro, North Carolina, 1909; Julius Zeitner and Seymour Burrell, architects. Courtesy National Building Museum, gift of Genesco, Inc.*

Fig. 2.5. *Masonic building with Kress store, Trinidad, Colorado, 1911. Courtesy National Building Museum, gift of Genesco, Inc.*

At the same time that Kress was starting to build its own buildings, it was following another practice: renting one or more floors of a larger building to house a Kress store. In 1909 Kress opened a store in the McEldowney Building, the tallest building in Winchester, Kentucky. In 1911 the company rented the basement and ground floor of a building in Trinidad, Colorado, that had been designed for the Freemasons (fig. 2.5); in 1913, in Pueblo, Colorado—a short distance north of Trinidad—it leased space in an 1880s building that had been purchased four years before by the Masonic Association. Samuel Kress was a dedicated Freemason, which no doubt facilitated these arrangements.[2] The company reserved the right to do extensive alterations to make the rented spaces look like and function as Kress stores. A ten-year lease signed with a landlord in Corpus Christi, Texas, in 1913 sheds light on the company's design specifications. Along with show windows of bent and plate glass, with prism glass and ventilating transoms above, went marble tiling in the entrance (see fig. 1.19). The lease also specifies metal ceilings of a design to suit the Kress store on the first floor and ceilings of plain metal on the second.[3] Ornamental metal ceilings in the public spaces in Kress stores had given way to plaster ceilings by the 1920s, but plain metal ceilings of repeated square coffers on the upper stories remained constant. Kress planned ahead in leasing two stores in the Masonic Temple Building in Wilmington, North Carolina, in 1907. Only one was used as a Kress store in the beginning, but by 1914 Burrell had remodeled the rented space in its entirety, doubling the size of the Wilmington store.

Fig. 2.6. Bartlesville, Oklahoma, a composite Kress store. The section on the right was initially built as rental property. Courtesy National Building Museum, gift of Genesco, Inc.

Fig. 2.7. The Kress Building, Main Street, Houston, Texas, 1913; Seymour Burrell, architect. Courtesy National Building Museum, gift of Genesco, Inc.

Many of the first buildings the company erected included rental space on the upper floors, as did Zeitner's Bartlesville, Oklahoma, store, where one section of the building designed for leasing had its own distinctive appearance (fig. 2.6). The 1910 Salisbury, North Carolina, building was designed to accommodate a Kress store on the ground floor and basement levels and a sizable apartment house on the second floor (see fig. 2.14). More often, the upper floors were planned for professional offices; in some cases the building's primary identity and look were those of an office building. This occurred on a small scale in the

1910 Trenton, Missouri, store and on a grander scale in 1913 in Houston, Texas, where Seymour Burrell designed a handsome eight-story corner building facing Main Street (fig. 2.7). The Kress Building, as it was called, had a store on the ground floor and offices on the upper floors.[4] As the chain grew, multipurpose buildings became less common. Eventually, buildings serving solely as five-and-tens became the norm. There were always exceptions: as late as 1938, a new store in Miami, Florida, was designed to accommodate other retail establishments on either side of a central S. H. Kress.

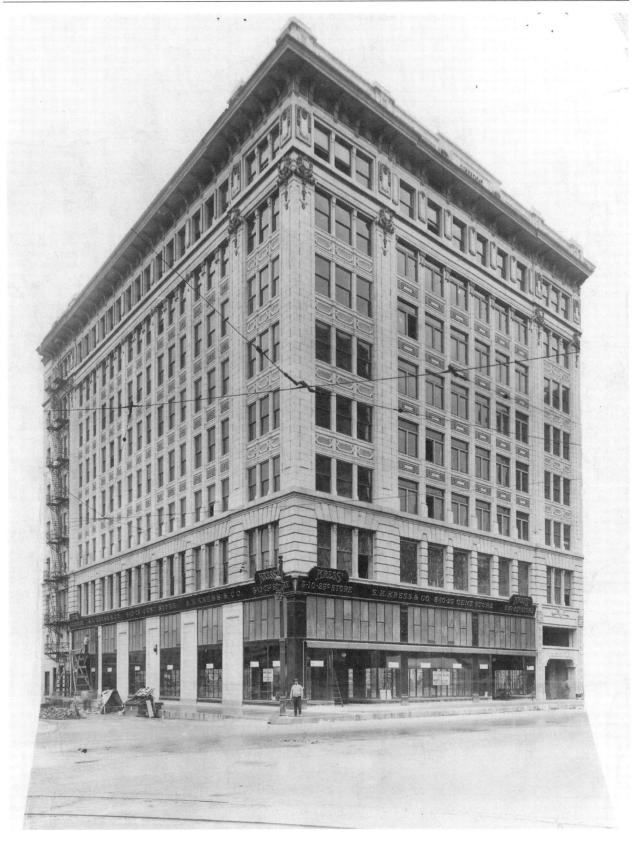

AN EXCEPTIONAL CASE
IN NEW ORLEANS

In 1912 Kress took the exceptional step of going outside the company for an architect to design a store in New Orleans. Although Seymour Burrell worked on some interior details, the building as a whole was entrusted to Emile Weil, a prominent New Orleans architect.[5] The store, which opened in 1913, was Weil's only design for Kress. The principal elevation on Canal Street (figs. 2.8, 2.9) is five stories faced with white terra-cotta, while the other elevations, on Iberville and Burgundy Streets, are three stories faced with buff-colored brick (fig. 2.10). Although Weil had designed other buildings clad with terra-cotta, his use of the material here was apparently proposed by the Kress Company.[6] Kress would later use terra-cotta along with brick or as trim for brick fronts; when both were used, as in New Orleans, terra-cotta took precedence over brick and denoted a store's higher rank in the Kress chain.

Fig. 2.8. *Drawing for a Kress store in New Orleans, Louisiana, Canal Street elevation, 1912; designed by Emile Weil. Courtesy National Building Museum, gift of Genesco, Inc.*

Fig. 2.9. *Canal Street, New Orleans. Courtesy National Building Museum, gift of Genesco, Inc.*

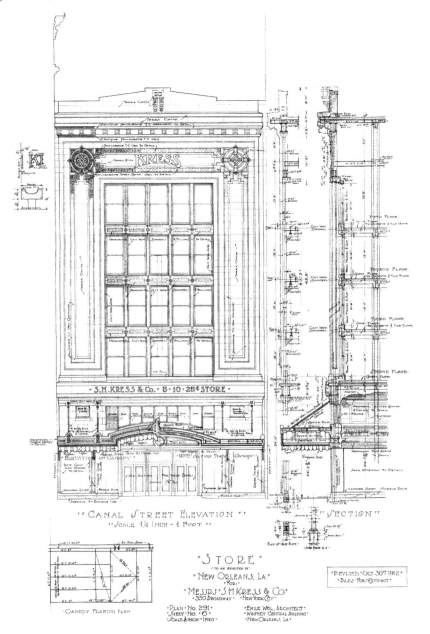

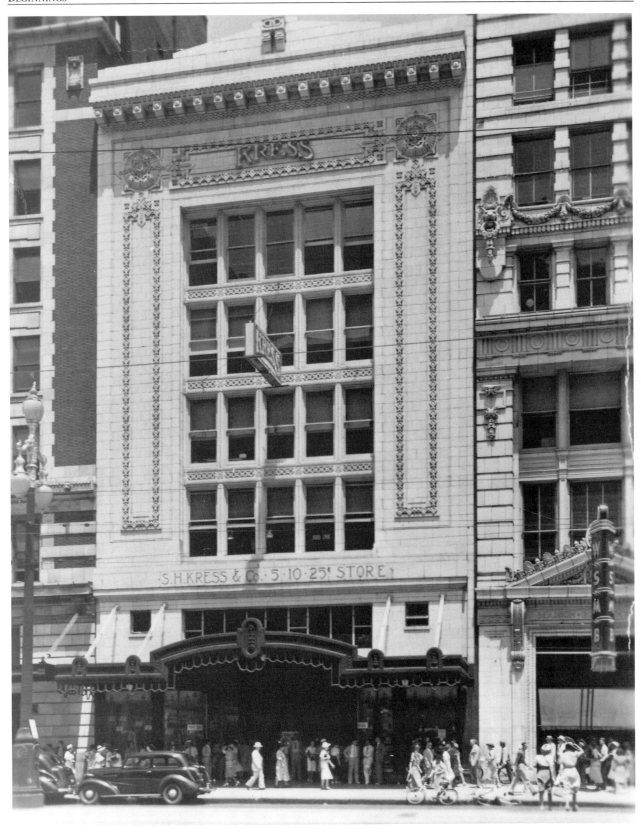

Fig. 2.10. *Corner of Burgundy and Iberville Streets, New Orleans. Courtesy National Building Museum, gift of Genesco, Inc.*

Fig. 2.11. *Kress name panel in floor mosaic, Canal Street entrance, New Orleans store. Courtesy National Building Museum, gift of Genesco, Inc.*

The Canal Street entrance to the New Orleans store is through a long arcade with continuous plate-glass display windows on marble bases and a marble mosaic floor. A few small concessions, such as a Western Union office, shared space with the show windows on the way into the store. The architect had recommended that a small silent-movie theater be installed on the right-hand side as well.[7] This idea was rejected by the client, however. The deep entryway was basically devoted to S. H. Kress show windows, and a marble mosaic name panel in the floor near the sidewalk marked the building as a Kress store (fig. 2.11). The view from inside the doors was past a staircase to a great center court (fig. 2.12). The space had a balcony with a cast-iron balustrade and a ceiling of coffered skylights. Plaster columns with ornate Corinthian capitals further enhanced the grand interior atrium, reminiscent of this building's illustrious antecedents—the great Parisian department stores.[8]

The design was appropriate for New Orleans—the most French of American cities—and for the store's site on the edge of the old French Quarter.[9] The Canal Street facade also echoes French department-store architecture with its prominent entrance of three sets of doors beneath the overhead swell of a copper canopy crested with ornament. The storefront is clad with glazed white terra-cotta, recalling the idea of department stores as marble palaces, which influenced American department store design.[10] The Kress store's imposing next-door neighbor, the Maison Blanche department store, had already made the statement. Kress's white storefront on Canal Street is lower and less conspicuously Parisian than the abutting Maison Blanche. In the manner of Parisian department store designs, which reflected the class of clientele, the Kress store facade announces itself as an emporium for nickel-and-dime customers.[11]

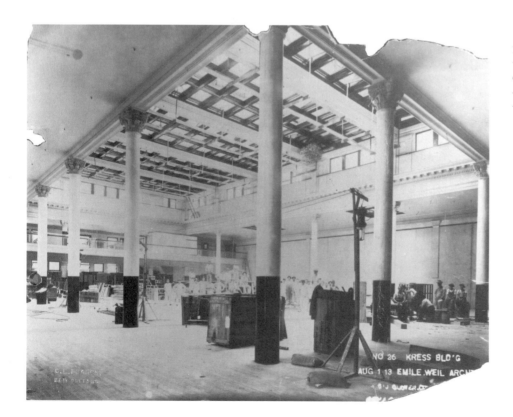

Fig. 2.12. *New Orleans sales floor with skylights and Corinthian columns. Courtesy National Building Museum, gift of Genesco, Inc.*

The wall of sash windows above the first floor with cast-iron mullions and spandrels in a decorative terra-cotta frame—no doubt to provide as much interior light as possible—and the style of the ornamentation also call to mind the work of Louis Sullivan. Some of Weil's own aesthetic is revealed in the cubic formations inset with tile-like motifs on the store's rear elevations, reminiscent of his 1909 Touro Synagogue in New Orleans.[12]

AN ARCHITECTURAL TRADEMARK: THE YELLOW BRICK STORE

At the very outset, when Kress began building its own stores, the company did more than establish a canon of set features that would apply throughout its building history. Right away, it adopted a basic store-

front design for its buildings, to be repeated as theme and variation all over the country until the end of the 1920s. The basic format was a buff or pale yellow brick facade with off-white trim in a simplified neoclassical style (fig. 2.13). A projecting cornice and coping outlining the silhouette of a brick parapet were standard features. The Kress logo was at the summit, as always, rendered to conform to the color scheme in painted metal or glazed terra-cotta. These brick elevations were flat and conceived primarily in terms of straight lines. They were enlivened by the brickwork and the contrasting trim, often including ventilation grilles forming geometric patterns beneath the cornice. These buildings had a solid and dignified appearance, and the interiors were as predictable as the outsides. Many had oiled

Fig. 2.13. *Kress's signature yellow brick storefront, Kingsport, Tennessee. Note perpendicular store sign with incandescent bulbs. Courtesy National Building Museum, gift of Genesco, Inc.*

hardwood floors and pressed metal ceilings, with cast-iron columns on the selling floor (see figs. 1.22, 2.12). These "yellow brick stores" formed a considerable subgroup of S. H. Kress architecture, although the company used other designs as well. More than fifty examples can be documented at present. Presumably there were others among the two hundred stores in the Kress chain at the end of the 1920s.

The basic elements of a yellow brick store facade were evident in 1910 in Burrell's and Zeitner's buildings in Goldsboro and Salisbury, North Carolina. However, these elevations include more architectural segments, less well proportioned and less well integrated, than those that appear later on. The Goldsboro storefront is top-heavy, with its overhanging cornice and modillions. Different decorative elements are applied on this elevation. A row of ventilation grilles over each window adds interest to the design, but these elements are inconsistent in a neoclassical context. The Salisbury store is more successful, with a conspicuous three-sided parapet to balance the cornice and other architectural members (fig. 2.14). This multipurpose building originally had a gabled portico at the upstairs entrance to the apartments and a generous oriel window at the side. S. H. Kress & Co. later removed these parts of the building, making it look more like later stores in the group.

When Burrell began designing by himself, the store facades became smoother and better integrated in terms of design and scale. His 1913 store in Helena, Arkansas, is extremely simple. Brickwork plays a major role in the design of the facade, forming repetitive courses between stories and frames for the windows and spandrels. The same is true of the slightly more complicated two-story building in Key West, Florida, also from 1913 (fig. 2.15). This large corner store on Duval Street is anchored at each end by long, horizontal bands of brickwork that create quoins, helping guide the eye around the corners and down the sides of the upper half of the front elevation. Keystone lintels and recessed grilles above the windows break up the monolithic brick surface. The stone trim works together with the contrasting yellow brick. Where the side windows are embedded in bands of alternating brick, the lintels are without keystones in order to blend with the horizontal flow. Kress logos of galvanized metal on the parapets mark the building as belonging to an early period. When it was new this Kress store would have been distinctive as one of the few brick buildings in a small seaport town of predominantly wooden architecture. Today it is still an imposing presence on the main thoroughfare of Key West.

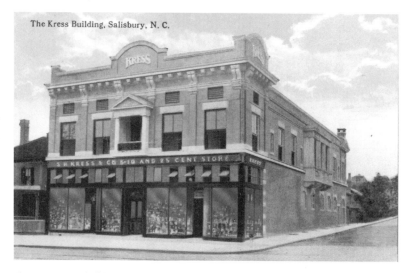

Fig. 2.14. *Postcard of the Kress Building, Salisbury, North Carolina, 1910; Seymour Burrell, architect. Lake County, Illinois, Museum/Curt Teich Postcard Archives.*

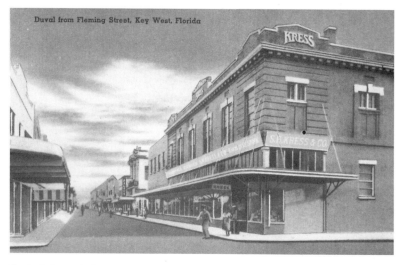

Fig. 2.15. *Postcard of a 1913 Kress store in Key West, Florida. The marquee is a later addition. Courtesy National Building Museum, gift of Bernice L. Thomas.*

Fig. 2.16. *Columbus, Georgia, 1918,*
oldest Kress store listed on the
National Register of Historic Places,
Washington, D. C. Photograph by
author.

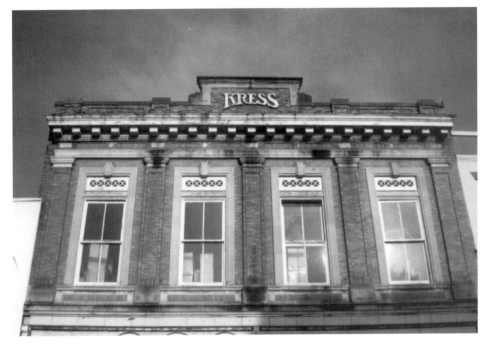

The 1918 Columbus, Georgia, store—the oldest Kress store listed on the National Register of Historic Places—also has a yellow brick facade (fig. 2.16).[13] It was probably one of Burrell's buildings. The store is smaller but more elaborate than the one in Key West. More surface area on the facade is given over to metal and stone trim. The windows on the second floor, for instance, have stone surrounds that include keystones and sills; within the stone enclosures are decorative metal grilles. Brick pilasters with stone bases and capitals divide the area above the mezzanine into four equal bays. Extensions of the brick pilasters rise up above the cornice to break through the horizontal parapet. Small ornamental consoles bracket the raised brick center portion capped by stone, which displays a metal Kress logo.

Burrell's signature disappeared from Kress store plans after 1918, to be replaced by that of E. J. T. Hoffman.[14] Hoffman continued to design the basic store type inaugurated by Zeitner and Burrell with a good deal of versatility. At least a dozen of Hoffman's yellow brick stores appeared on Main Streets from coast to coast. His 1927 storefront in Port Arthur, Texas, is highly remi-

niscent of the Columbus, Georgia, store with elements rearranged. It has the same straight, elevated section of parapet flanked by consoles at each end. An imperceptible change is a Kress logo of limestone rather than metal painted to resemble stone. More noticeable is the change from cast-iron bases to more elegant Verde Antique marble bases with bronze ventilation grilles.

A fine example of Hoffman's work is the big, two-story corner store on New York's Third Avenue, dated 1925 (figs. 2.17, 2.18). The walls are patterned by alternating rows of long and short bricks, and terra-cotta is used extensively. A large backing for the Kress logo and the letters themselves are now made of off-white terra-cotta. Blue marble diamonds inset beside air grilles over each bay of windows add a colorful touch. This storefront moves away from inferences of Greek classicism to a suggestion of classical Rome, or, more accurately perhaps, of the Italian Renaissance. The change is accomplished primarily through the ornamentation: terra-cotta reliefs of fasces at intervals below the cornice, paired volutes surmounting the Kress logo, and marble intarsia.

In 1926 the Kress Company played an

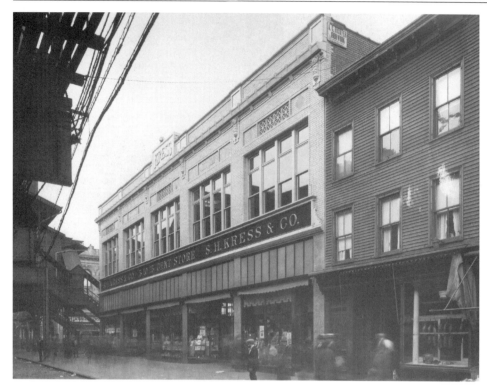

Fig. 2.17. *Third Avenue and 106th Street, New York City, beside stop on the elevated train. Courtesy National Building Museum, gift of Genesco, Inc.*

Fig. 2.18. *Aerial view of the Third Avenue, New York City, Kress store. Courtesy National Building Museum, gift of Genesco, Inc.*

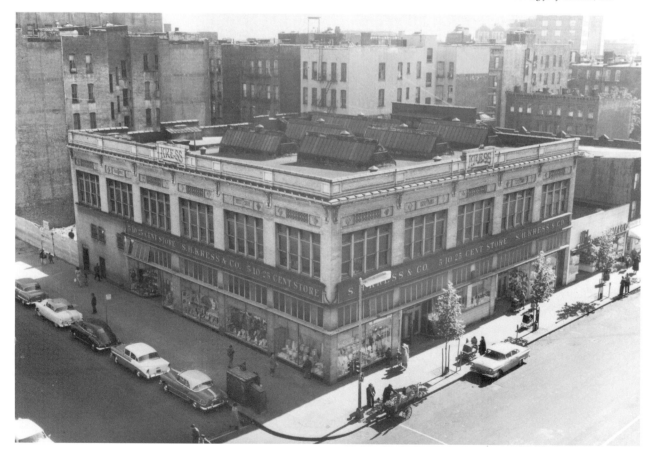

active role in altering the appearance of a downtown by engaging in a development plan with two local businesses in Boise, Idaho. Kress agreed to purchase a lot on Idaho Street for $30,000 and to put up a new building if another company would erect a department store from there to the corner and if a bank would move into the first floor of a building Kress already owned on the other corner. Hoffman's contribution to the development scheme was an elaborate three-story yellow brick store with a heavy cornice rising above the long, low department store adjacent to it (fig. 2.19).[15]

In 1928, the last year of his tenure, Hoffman designed one of his most sophisticated basic brick stores: North Birmingham, Alabama (fig. 2.20). Its flat, three-story elevation, kept to three shallow planes, is carefully ordered by geometry and planned contrasts between materials, horizontal and vertical accents, and alternating decorative motifs. The geometry is evident, for example, in the recurrent use of rectangles. The large, rectangular terra-cotta background for the name Kress on the parapet is repeated three times just below as backing for floral garland reliefs. The garland reliefs and the diamonds with which they alternate in a straight line across the brick are framed in thin terra-cotta rectangles. A strong horizontal emphasis comes from a terra-cotta frieze underlining the cornice, matched by similar courses of terra-cotta above and below the mezzanine. Other touches of terra-cotta, evenly distributed across the facade, continue the same directional thrust. Tall brick pilasters and seven bays of vertically aligned windows and

Fig. 2.19. *Boise, Idaho, drawing of the front elevation, 1927; E. J. T. Hoffman, architect. Courtesy National Building Museum, gift of the Boise City Building Department.*

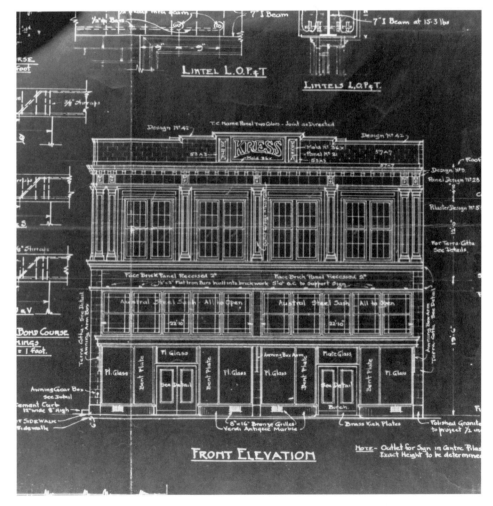

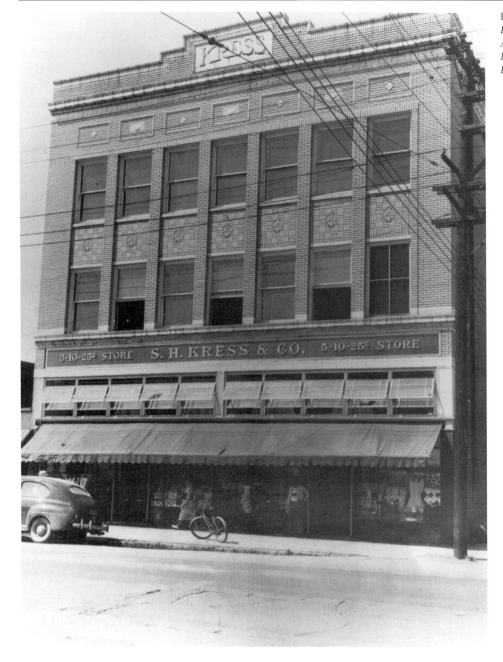

Fig. 2.20. *One of Hoffman's last Kress stores, North Birmingham, Alabama, 1928. Courtesy National Building Museum, gift of Genesco, Inc.*

spandrels with alternating motifs above counterbalance the horizontal stress. The large white rosettes in the center of each spandrel are conceived as two crossarms in a circular frame within a perfect square of checkerboard brick. The geometry of the design as a circle and a square, together with the design of the smaller components, allows and encourages each section to read two-directionally.

The architecture of the yellow brick stores reflects an operating principle of the company. One can better understand why so many of these buildings were designed in the same basic style if one sees this pattern as a response to a rapidly growing company concern with maximizing efficiency and economy in every aspect of its operation. Repetition was a proven method of achieving these values. Kress built its

series of yellow brick stores during the period of American history that Richard Guy Wilson, Dianne Pilgrim, and Dickran Tashjian have characterized as the Machine Age: the years from 1918 to 1941, the period between the two world wars.[16] As many aspects of the business as possible were standardized and regulated by the home office in New York. All store trainees, for example, took tests from the same company manuals. Store managers could be moved to another location at a moment's notice. Window displays were designed in New York and copied in the stores, first in a practice room and then in the store windows. Display counters exhibited some variation in displaying local "sellers."[17] In a newspaper article announcing the opening of a new store in Spokane, Washington, in 1931, the company used words that recall Henry Ford and his assembly-line methods: "The Spokane store is the latest model adopted by the Kress Company."[18] Like

Ford, who turned out the Model T repeatedly at a high profit, the Kress Company was content to produce yellow brick stores for some years. In the same way that Ford decided it was time for a new model and brought out the Model A, the company updated its design in 1930 and continued with the new type of Kress store throughout the decade. The company history published in *Chain Store Age* in 1946 stated, "The Kresses were no less zealous than Henry Ford in the desire to reduce each motion of their retail transmission belt to its highest point of efficiency . . . thereby eliminating expense-mounting waste."[19]

Repetitive yellow brick stores also had symbolic implications. The nomination form placing the Albuquerque, New Mexico, yellow brick store (1925) on the National Register speaks of the "signature" storefront as an early attempt to achieve quick public recognition through the use of a standardized design (fig. 2.21).[20] The

Fig. 2.21. *Albuquerque, 1925, the first Kress store in New Mexico. Courtesy National Building Museum, gift of Genesco, Inc.*

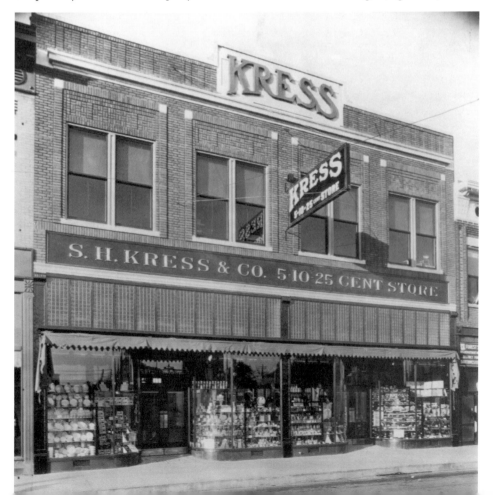

1930s version has likewise been recognized as the Kress signature.[21] H. H. Richardson designed a series of waiting stations for the Boston and Albany Railroad with the same objective beginning in 1881, when he was at the height of his career.[22] When Richardson died in 1886, his partners, Shepley, Rutan, and Coolidge, continued to design buildings for the railroad company in the same mode. As with S. H. Kress, architects changed but the basic design did not. Each well-built building was a means of advertising and a way to generate new business. Each yellow brick dime store embodied the prestige of S. H. Kress & Co. and helped the organization grow.

OTHER DEVELOPMENTS IN THE 1920S

E. J. T. Hoffman's tenure as head of Kress's architectural division (1918–1928) was a time of prosperity in retailing as in other businesses. S. H. Kress & Co. expanded into nine new states, and the number of stores grew from 145 to 193. While the basic brick storefront assumed an established format, variations in detailing were apparent from one store to another.

During this period the company introduced overall illumination of storefronts at night and added new features to interiors— Napoleon Blanc Mélange marble veneers, mirrors on piers, and ornate plaster capitals—that gave Kress sales floors a new elegance. Hoffman's meticulous instructions for stores in Memphis and Seattle specified that ornamental plasterwork should be finished in gold bronze paint with a glazing coat of raw umber wiped to show the highlights, using as many coats as necessary. This must be done, he stated, by an experienced decorator.[23] Design features introduced at this time persisted beyond Hoffman's tenure, while the use of the materials themselves would have an even longer life in later, more modern designs.

Southern California was a significant area for S. H. Kress & Co. The first store opened in San Diego in 1918, and by 1928 there were twenty-eight stores in the region. A West Coast office of S. H. Kress was established in San Diego in 1921 to

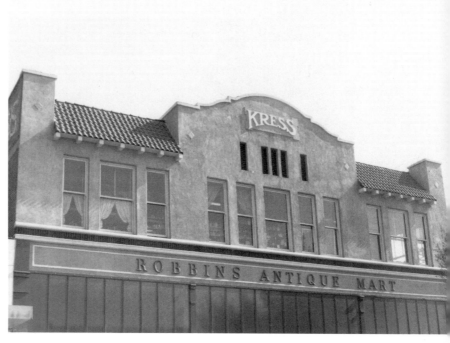

Fig. 2.22. *Spanish Mission style in Pomona, California, 1927; E. J. T. Hoffman, architect. Photograph by author.*

help direct the company's business. Although Kress continued to construct stores with familiar architectural elements in Southern California, such as the 1927 Los Angeles store on South Central Avenue, the company also built stores in a Spanish Revival style. Rather than import something distinctly Kress to Southern California, the company took its cue from the region. More specifically, Kress accommodated the wishes of local planners who had called for a uniform Spanish Revival architecture for Los Angeles and the region.[24] Hoffman's corner store in Pomona (1927) is a result (fig. 2.22). The front and right side elevations are sheathed in adobe-colored stucco, and both elevations have curvilinear parapets rising in the middle, recalling the facades of Spanish missions. Sections of red tile roof on either side complete the allusion. Hoffman's use of a Mission Revival style was in fact current with the times. Far from being perceived as retardataire, the store was described in the *Pomona Progress-Bulletin* as "resplendent in newness" at its opening. Among the features the article extolled was the intricate system used to illuminate the store at night, a system invented and patented by S. H. Kress.[25]

Hoffman's 1926 store in Asheville, North Carolina, was unusual in several respects (fig. 2.23). A rectangular, four-story building with three sides abutting public sidewalks and front and back entrances, its appearance implied freestanding architecture. The building is also a hybrid of yellow brick with an off-white cornice, like a yellow brick store, but it has a frieze around the top and around the window bays composed of orange and blue rosettes against an off-

white background. The Kress logo at the summit, unlike those on the yellow brick stores of this period, is realized in blue terra-cotta instead of off-white. A Kress store that opened in Tacoma, Washington, the year before had made an innovative step with signage in the form of a huge metal sign on the roof spelling out KRESS in incandescent bulbs. In Asheville the electric signage took the form of two signs placed catercorner on the roof above the front and rear elevations. Like floodlighting, electrified signage high in the sky enhanced the building's function as advertising.

In 1926 Kress announced that it would erect a store in Portland, Oregon, at a cost of nearly $500,000.[26] By then this was not an unusual expenditure for the company. The overall design of this five-story corner edifice was somewhat reminiscent of the Asheville store, but Portland was significantly different in being realized completely in cream-colored terra-cotta. Hoffman used all-white terra-cotta cladding and ornament in 1925 in Knoxville, Tennessee (fig. 2.24), and again in 1926 in Youngstown, Ohio. The Atlantic Terra Cotta Company, which supplied the material for Knoxville, gave the building a full-page spread in its company bulletin in 1926[27] and included the building among eight Kress stores in a 1933 advertisement (fig. 2.25). Pure white storefronts sheathed in terra-cotta recall Emile Weil's New Orleans store, although Weil did use touches of red to outline the logo and to emphasize the ornamental medallions. The Youngstown store is one of a number of all-white terra-cotta buildings constructed in downtown Youngstown during the city's "golden age" of commercial construction, the Kress building being by far the most decorative.[28]

One of architectural terra-cotta's earliest functions was to create the illusion of stone, which it had begun to replace. It was in fact called "artificial stone." The Knoxville store simulates Gothic structure and ornamentation through terra-cotta cladding resembling stone building blocks, ornamental shields, and quatrefoil moldings. The grandest example of a commer-

Fig. 2.23. *Kress Building, Asheville, North Carolina; E. J. T. Hoffman, architect. Lake County, Illinois, Museum/Curt Teich Postcard Archives.*

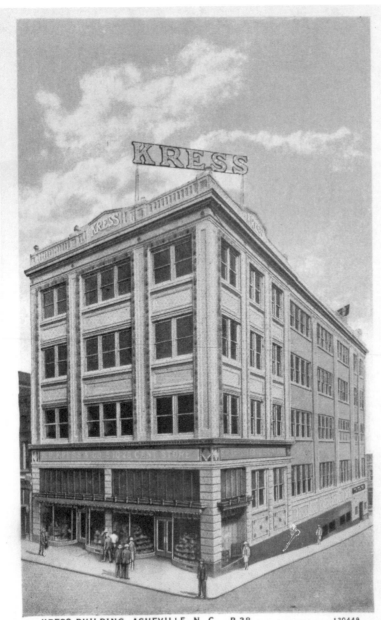

KRESS BUILDING, ASHEVILLE, N. C. B-38 120449

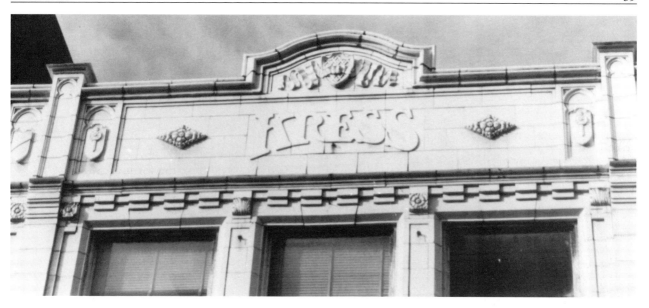

PENCIL POINTS FOR JULY, 1933 1

A BUILDING MATERIAL

UNIQUE

IN ITS POSSIBILITIES

Nearly fifty of the Kress chain of stores, from coast to coast, are faced completely or extensively decorated with Atlantic Terra Cotta. Other large chain organizations such as F. W. Woolworth, Montgomery Ward, McCrory, Kresge, W. T. Grant and Sears Roebuck have used Atlantic Terra Cotta for their buildings.

Companies of this type do not buy haphazardly; merchants themselves, they purchase value for every dollar expended, so the fact that these people use Atlantic Terra Cotta is indeed a testimonial as to its quality.

Atlantic Terra Cotta, with its adaptability to design, its extensive palette of permanent colors, its resistance to fire and weather and its great economy appeals to the architect and owner as a building material that is unique in its possibilities. Send for further information.

ATLANTIC TERRA COTTA
C O M P A N Y
19 West 44th Street, New York, N. Y.

Southern Branch: ATLANTA TERRA COTTA COMPANY, Glenn Building, Atlanta, Ga.; Philadelphia Office:
Architects' Building, 17th & Sansom Streets; Southwestern District Office: 807-8 Praetorian Building, Dallas, Texas

■ *Reading from left to right and from top to bottom, the eight Kress Stores pictured here are located at: Queensboro, North Carolina; Durham, North Carolina; Daytona Beach, Florida; Tampa, Florida; Wichita, Kansas; Knoxville, Tennessee; Dallas, Texas; Spokane, Washington. All are faced with Atlantic Terra Cotta. Mr. E. F. Sibbert is the present architect for the Kress Company.*

Fig. 2.24. *Detail of Gothic Revival Kress store, Knoxville, Tennessee; E. J. T. Hoffman, architect. Photograph by author.*

Fig. 2.25. *Advertisement in* Pencil Points, *July 1933. Courtesy the American Institute of Architects Library and Archives, Washington, D. C.*

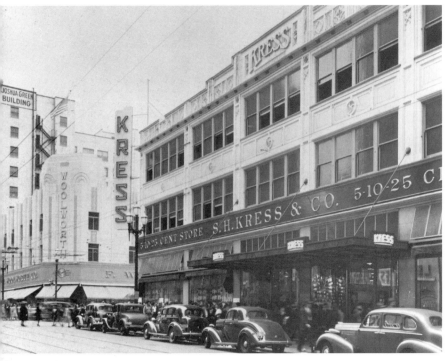

cial building emulating Gothic forms and materials through the use of white terra-cotta is the Woolworth Building (1913) in New York. Hoffman had designed another Kress store with a Gothic flavor in Seattle, Washington, in 1924 (figs. 2.26, 2.27). He achieved the effect for the large corner store with pale brick and terra-cotta cladding, accented by Gothic motifs in pastel shades of green, blue, peach, and purple. Hoffman focused attention on the parapet atop each five-bay elevation, front and side, by dividing it into sections framing displays of colorful ornament.

In *The Machine Age in America*, Richard Guy Wilson, describing the high esteem accorded to business in the 1920s, recalls Frederick Lewis Allen's description of a "new veneration" for American business and observes, "Businessmen, previously considered crass and undignified, now ranked with clergymen or even above."[29]

Fig. 2.26. *Kress store, Pike Street, Seattle, Washington; E. J. T. Hoffman, architect. Woolworth's store was on the opposite corner. Courtesy National Building Museum, gift of Genesco, Inc.*

Fig. 2.27. *Kress store, Seattle, drawing of Gothic details on the front elevation. Courtesy National Building Museum, gift of Genesco, Inc.*

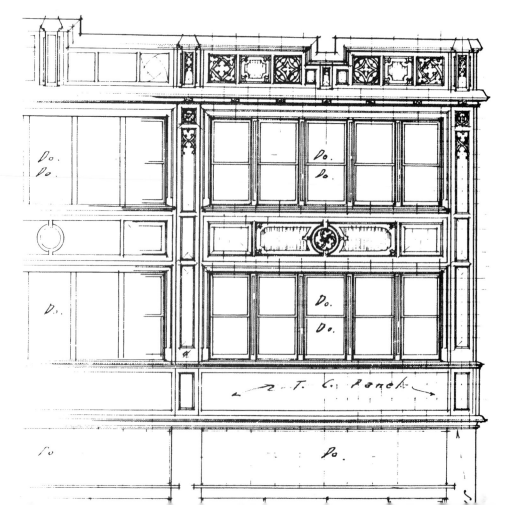

Architecture referring to the Middle Ages, the Age of Faith, conferred a quasi-religious status on a business. A Gothic Revival Kress store served to announce the nobility of both the businessman-owner and the enterprise.

"Old No. 1" and the Renaissance

The Kress store in Memphis was always referred to in the company as "Old No. 1." It held a special place in the affections of the Kress brothers, as Rush Kress stated in an interview when he was vice president of the company.[30] The store had moved three times since Samuel Kress had put up his first store sign at 321 South Main Street, first to other locations on South Main, and then to 9 North Main Street. When Hoffman designed a new store in 1926, buildings at 7, 9, 11, and 13 North Main were razed to make room for a larger, finer store, which opened in May 1927.

Hoffman's four-story building topped by a cupola is in the style of an Italian Renaissance palazzo or villa, ablaze with colorful terra-cotta ornament (fig. 2.28 and plate 2). Granitex, a form of terra-cotta facing simulating granite, implements the architectural reference in such details as "granite blocks" that create quoins and pilasters. Over the piers at ground level, lions' heads with bright red tongues add a dramatic note. The upper facade is covered with lush Renaissance ornamentation—cornucopias and garlands of fruits and flowers. Cartouches in the spandrels between the third and fourth stories have highly glazed, jewel-like cobalt-blue centers. The polychrome decoration is primarily a variation on two colors, blue and yellow, with touches of green. Even the Kress logo follows this scheme, with yellow lettering on a light blue background, flanked by deeper blue rosettes. Yellow fleurs-de-lis on four sides of prominent finials at the ends of the parapet make reference to the Italian Renaissance and specifically to the city of Florence. The ornamentation on the facade further invites association with the work of the famous Florentine family of Renaissance sculptors, the della Robbias.

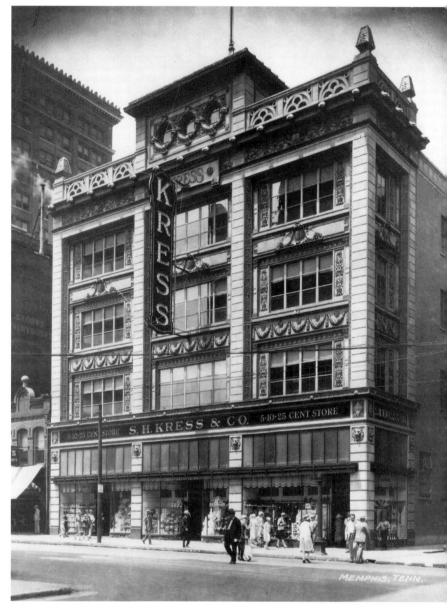

Della Robbia sculptural motifs in architectural terra-cotta were popular when the Memphis store was erected. The Atlantic Terra Cotta Company advertised its "della Robbia model" in 1924, for instance.[31] Archival materials of Gladding, McBean & Company in Lincoln, California, a supplier of terra-cotta, shed light on the use of terra-cotta in Hoffman's 1926 store in Oakland, California. Correspondence regarding its manufacture indicates that it was carefully custom-made, involving a number of skilled craftsmen. The process began on the

Fig. 2.28. *Fourth Kress store in Memphis, Tennessee; E. J. T. Hoffman, architect. Courtesy National Building Museum, gift of Genesco, Inc.*

architect's drawing board in New York. Letters, telegrams, and photographs went back and forth from the home office in New York to the plant in Lincoln. Once the models were made and the photographs approved, samples of glaze were exchanged until the architect in New York was satisfied.[32] The contractor on the site had his say, too: if individual pieces did not meet exact specifications, they had to be done over. Despite its popularity in other kinds of architecture, multicolored della Robbia ornamentation was unusual for dime stores. Indeed, Memphis and Oakland are two rare examples, even in the Kress store chain. Thus something other than precedent and common practice is necessary to account for the design of "Old No. 1."

Samuel H. Kress amassed one of the world's finest collections of Italian Renaissance art, which he eventually bestowed on the National Gallery of Art for its opening in 1941 as well as on other museums and colleges around the country (fig. 2.29).[33] The process began in about 1920, when he met a collector and dealer, Count Alessandro Contini-Bonacossi, in Rome. Contini-Bonacossi introduced him to the eminent authority on Italian Renaissance art Bernard Berenson, after which Kress became a frequent visitor to Berenson's home outside Florence, the Villa I Tatti. Berenson encouraged Kress to concentrate on collecting Italian Renaissance painting and sculpture. Other dealers,

notably Joseph Duveen, helped Kress build his remarkable collection. Kress loved the art he acquired and surrounded himself with it in his Fifth Avenue apartment, which was remodeled to accommodate architectural elements brought over from Italy, including carved wooden ceilings and other features created in a Renaissance style, such as sculpted marble seats. The most fashionable decorator of the day, Ernest L. Brothers, helped this modern-day merchant prince realize an Italian Renaissance setting in New York City (fig. 2.30).[34] Kress bought an Andrea della Robbia ceramic, a plaque depicting Saint Peter in an arched frame of leaves and fruit, from Contini-Bonacossi in 1927, the year the new Memphis store opened.[35] It seems reasonable to suppose that two preoccupations of the client, his dime stores and his collection of Italian Renaissance art, are reflected in the design of the Memphis store.

It is more difficult to account for the row of three-dimensional heads of American bald eagles extending from the wall all across the storefront just below the parapet. These large terra-cotta heads are accurately modeled with the correct coloration for this bird. Another eagle, this time with outstretched wings, tops the flagpole rising above the cupola.[36] Perhaps Samuel Kress, who was intensely patriotic, as his memberships in various organizations show,[37] was celebrating America through its national

Fig. 2.29. *President Franklin Delano Roosevelt speaking at the dedication of the National Gallery of Art, March 17, 1941. Samuel H. Kress is at far left. Harris & Ewing Collection, Stock Montage, courtesy of the Archives, National Gallery of Art, Washington, D. C.*

symbol even while paying homage to the art of Renaissance Italy. The specifics of the situation point to another possible explanation. Bald eagles came to winter at a lake north of Memphis every year. The Reelfoot Sanctuary, where these birds were protected, was and is a popular tourist attraction in the area. Samuel Kress took an active interest in city parks. During the period when the Memphis store was being built, he was serving on a commission promoting public parks and beaches in the Los Angeles area.[38] The locations of several Kress stores across from city parks would seem to reflect this interest, as would the flock of eagles, naturalistically described in some detail, arrayed high up under the sheltering ledge of the Memphis storefront.

In their variety, Hoffman's stores, including the imposing storefront in Memphis, reveal themes that would become part of Kress five-and-ten-cent-store architecture: the concerns of the founder of the chain, including his own self-perception, and allusions to unique or significant aspects of the stores' locales.

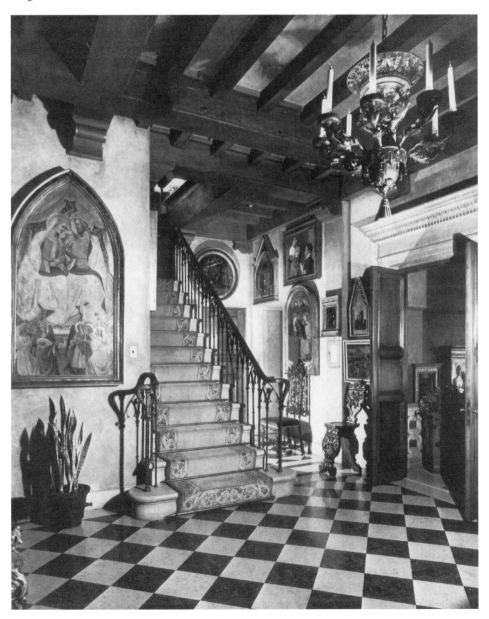

Fig. 2.30. *Samuel H. Kress's apartment, Fifth Avenue, New York City. Courtesy Samuel H. Kress Foundation.*

3 GRAND ALLUSIONS

When George E. Mackay succeeded E. J. T. Hoffman as head of Kress's architectural division in 1928, the stores assumed a particularly aristocratic mien. Mackay designed revival-style buildings based on palaces and temples, in a recognizable Beaux-Arts tradition. He embellished these stores with elegant marquees, harking back to an architectural feature used in Weil's New Orleans store but then abandoned. He added a row of swiveling floodlight projectors atop the store marquee to illuminate the upper stories, along with others on the upper side of the cornice that could be adjusted and aimed to light the parapet (fig. 3.1).

Fig. 3.1. *Tampa store at night with strategic floodlighting above marquee and the cornice to illuminate the parapet; George E. Mackay, architect. Courtesy National Building Museum, gift of Genesco, Inc.*

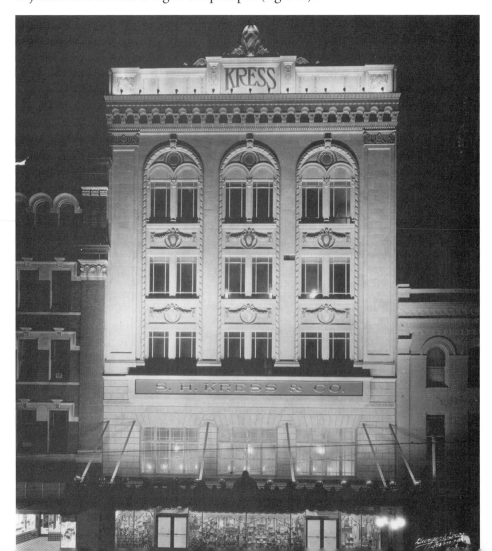

The flexible lighting scheme, which Mackay specified should be adjusted to floodlight the name Kress on the parapet, enhanced the effect and beauty of these storefronts at night.[1] He also introduced a new kind of window treatment—clear panels of glass surrounded by lancets in thin metal frames—but this did not outlast his brief, two-year tenure. Other new interior features, including the Kress Company wall sconce, did survive (fig. 3.2). Consequently, Mackay's work resulted in a collection of dignified, imposing buildings.[2]

LAKELAND, FLORIDA:
AN ENGLISH COUNTRY HOUSE

The Lakeland, Florida, Kress store resembles a neoclassical English country house realized in pale yellow terra-cotta (plate 3). The stately building appropriately faces a city park with large trees. Here, Mackay employed an extensive classical vocabulary with delicate precision. One example is a cornice with running courses of dentils and acanthus leaves interrupted by a similarly framed center gable. A balustrade at the roofline with repeated balusters in high relief continues the staccato patterning. Four large aquamarine urns sit atop the balustrade, matching the patina of the copper gable roof. They respond to four gigantic fluted pilasters on the surface below the well-modeled Corinthian capitals and bases. Garlands of dark green leaves bound with metallic gold ribbons and bows with light blue rosette centers hang beneath large gold rosettes with red centers in each of three panels to the side of the legend S. H. KRESS & CO. above the mezzanine windows. The same beribboned garlands form part of an ensemble in the pediment in which the name Kress is treated honorifically. KRESS is embossed in gold on an open two-handled scroll surmounted by a blue palmette over volutes, with the garlands flowing out to the sides.

The Kress logo and other details in metallic gold integrate the facade coloristically. At the same time, the name Kress, rendered in shining gold letters, carries connotations of great value. The terra-cotta

logo was literally glazed with gold, pulverized and held in suspension. The metallic gold logo that Mackay introduced to Kress store design would be taken up and repeated by succeeding Kress architects. Mackay also translated the store sign above the transom into red and metallic gold terra-cotta. This design would also be followed by other Kress architects, but not as consistently as in the shiny gold logo high up on the Lakeland store's parapet.

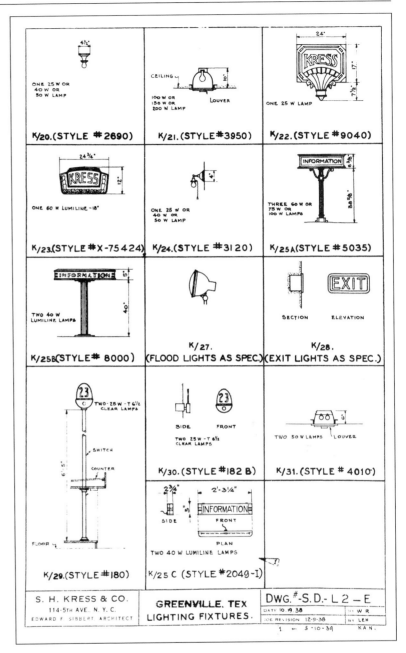

Fig. 3.2. *Lighting fixtures for Greenville, Texas, store, showing Kress wall sconce, upper right. Courtesy National Building Museum, gift of Genesco, Inc.*

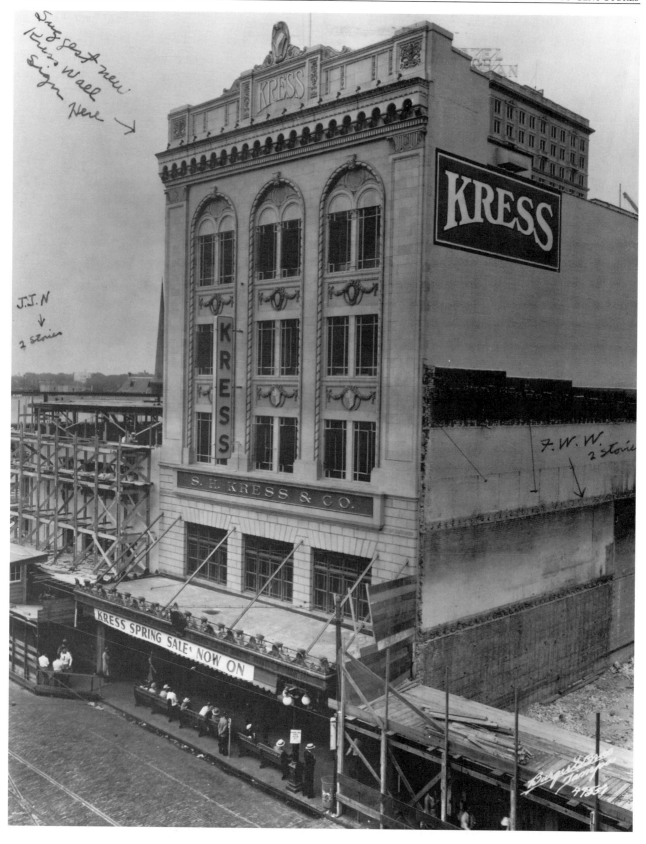

KRESS

KRESS

S. H. KRESS & CO.

KRESS SPRING SALE NOW ON

TAMPA, FLORIDA:
A SPANISH *PALACIO*

The Kress Superstore in Tampa is doubly imposing, with its two nearly identical facades on parallel streets, North Franklin and Florida (fig. 3.3, plate 4; see also fig. 3.1).[3] These vertically disposed elevations, four stories tall, have the aspect of a Spanish Renaissance or Spanish Colonial palace, a fitting reference for the city of Tampa.[4] Above the marquee the transom windows and store sign are encompassed by mock rusticated stone. The upper walls have a smoother appearance and are articulated as three bays of windows encircled by cable molding, with colossal pilasters at the sides. A projecting cornice takes the form of an interlacing arcade, with each arch sheltering a colorful heraldic emblem. A high parapet crowns the tall building, finished off in a manner one associates with Mackay: a roofline interrupted at the center by a strong decorative element. In this instance, scroll brackets help build toward an upright escutcheon silhouetted against the sky above the Kress name in gold terra-cotta. Bright orange and blue disks displaying squares forming eight-sided stars suggest Spanish Moorish ornamentation. Both facades have ornate bronze marquees crested with a wave of large and small palmettes and volutes, converging at the center on a taller cartouche crowned by a palmette displaying the letter K on a shield. Mackay's distinctive metal-framed windows appear on the upper floors. On the main floor he used panes of glass with heraldic shields interspersed with clear glass panes. The glass is no longer extant, but old company photographs show these windows in Lakeland and Tampa; in Wichita, Kansas; in Elizabethton, Tennessee; and in Spartanburg, South Carolina (fig. 3.4). Despite their prevalence in Mackay's buildings, windows with heraldic imagery disappeared from Kress store architecture after 1929.

Fig. 3.3. *Tampa, Florida. Company photograph noting J. J. Newberry's and F. W. Woolworth's under construction at either side, and place for a new Kress wall sign. Courtesy National Building Museum, gift of Genesco, Inc.*

Fig. 3.4. *Spartanburg, South Carolina, Kress store, 1929; George E. Mackay, architect. Stained glass panels in windows include examples of Kress heraldry: shields emblazoned with diagonal swords. Courtesy National Building Museum, gift of Genesco, Inc.*

MONTGOMERY, ALABAMA: A GREEK TEMPLE

The Kress Superstore in Montgomery, Alabama, takes the form of a Greek temple, a design unique in the Kress chain in 1929 and probably in dime-store architecture in general. Temples do belong to the tradition of American department stores; examples in New York City are R. H. Macy's 34th Street entrance, with its outsized caryatids, and the old department-store buildings along the so-called Ladies' Mile on the Avenue of the Americas.[5] Also in New York, the 1896 Siegel-Cooper dry goods store— "The Big Store," as it was known—was billed as "a magnificent temple of commerce."[6]

The Montgomery Kress store runs through the block from Dexter Avenue to Monroe Street. Its unusually long expanse

(325 feet) is balanced by an extremely high ceiling (31 feet) on the selling floor. The front elevation is appropriately on Dexter Avenue (fig. 3.5), a wide thoroughfare leading down from the state capitol to an intersection of six streets marked with a tiered, sculptured water fountain. The rear elevation (fig. 3.6) is a schematic reduction of the more imposing Greek temple front on the main boulevard.

The outstanding feature of the principal facade is a pair of colossal fluted, freestanding columns, made more conspicuous by deeply set windows and spandrels with linear ornamentation that tends to coalesce as a screen (plate 5). The facade reads as a pronaos, or Greek temple front, with columns *in antis*, that is, between extending side walls. The facade is articulated with a high degree of verisimilitude, resembling a

Fig. 3.5. Montgomery, Alabama, Kress store, Dexter Avenue facade; George E. Mackay, architect. Courtesy National Building Museum, gift of Genesco, Inc.

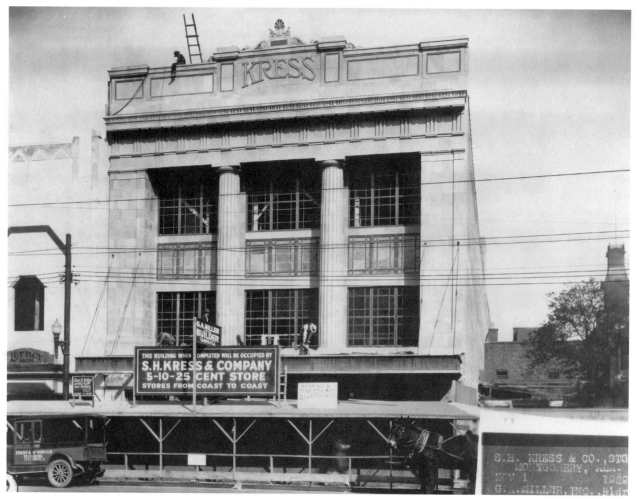

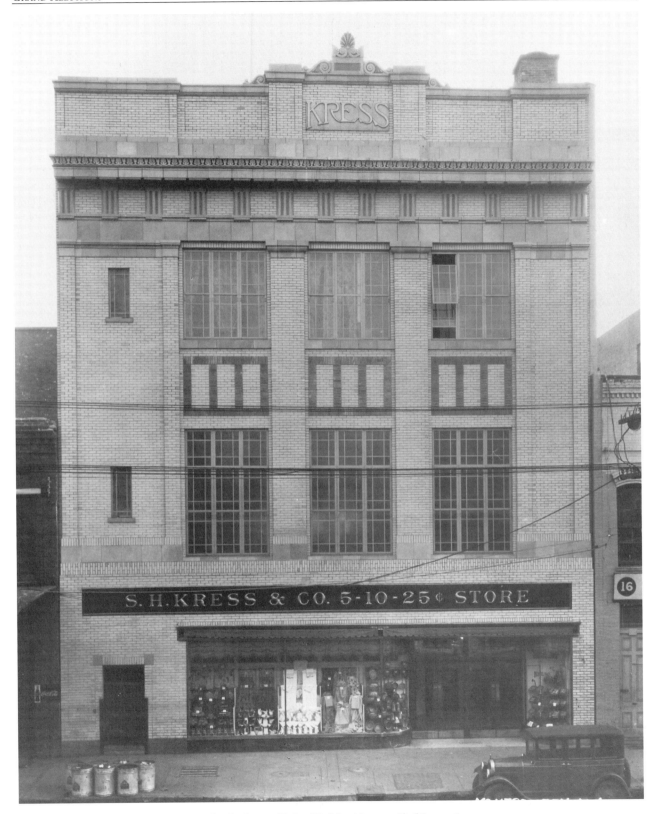

Fig. 3.6. *Montgomery, Alabama, Monroe Street facade. Courtesy National Building Museum, gift of Genesco, Inc.*

Fig. 3.7. *"Kress Section,"* The
Montgomery Advertiser, *December
5, 1929. Courtesy Alabama
Department of Archives and
History, Montgomery, Alabama.*

classical Greek temple porch of the Doric order. The pale yellow terra-cotta suggests square blocks for the walls and layered drums for the shafts of the fluted columns. The tapered shafts, with linear decoration at the neck of the flutes; the flat, cushionlike echinus; and the slightly overhanging abacus reproduce in some detail the Doric architecture of the ancient Greek cities of Selinus, in Sicily, and Paestum, in southern Italy. Moreover, the blue and white triglyphs and band of palmettes and lotus plants on the overhanging cornice, and the orange and blue dentils beneath, are correct for early classical Greek architecture not only in terms of color but also in terms of material.[7] In contrast, the wall surface on the Monroe Street side is brick instead of terra-cotta, with flat terracotta pilasters substituting for the gigantic freestanding columns. Dexter Avenue alone has a copper marquee, embossed with a meandering Greek pattern and a lacy trim of classical palmettes.[8]

Classical Greece played a part in the presentation of the Kress store at its opening. The title page of a special twelve-page section celebrating the opening, published in the Sunday, December 5, 1929, edition of the *Montgomery Advertiser,* shows the building as viewed from Dexter Avenue against a scroll held by a female figure in classical Greek dress with a fillet of laurel leaves binding her hair (fig. 3.7). The theme is taken up again in a full-page advertisement in the text flanking the same photograph of the building. Under the title "Like the Phoenix of Ancient Mythology," the text explains that the new Kress store rises from its own ashes (a disastrous fire had destroyed its predecessor the year before).

Despite the Greek inferences, the text explained the style differently:

> To conform with the type of architecture that through the years has been associated with cities of the Old South, a Colonial design was employed by George E. Mackay, supervising architect. Mr. Mackay showed understanding and insight by choosing the Colonial style to interpret the spirit of the South.

The Old South—the Confederate South—was very much alive in 1929 in Montgomery, the first capital of the Confederacy, at least among white residents. Although Kress had operated in Montgomery since 1897, it was no doubt good business for the company to align itself with the Old South through its architecture. Implications of an antebellum storefront would allay any fears of Yankee outsiders. The newspaper supplement pictured the new store's two predecessors in Montgomery—identifying the earlier one as the third store in the Kress chain—as well as the founding store in Memphis. Thus Kress history and Montgomery history were presented as intertwined in the heart of the Old South.

In fact, antebellum architecture in Montgomery is pure white, with no additions of color. The buildings, whether public or residential, are Corinthian, not Doric, with a few uses of Ionic. This storefront, with its archaeological veracity—from its details to the color of marble it simulates, and especially the prominence given to the columns—suggests another rationale for the Montgomery store design. In the year the store was designed and built, Samuel Kress made a donation to the Italian government to conserve historic monuments, an act for which he was made a *cavaliere,* or knight, by the king of Italy. An announcement of the gift in the Italian newspaper *Il Messagero,* reprinted in Samuel Kress's autobiographical entry in the *Kress Family History,* lists the monuments to be conserved, beginning with a Doric column from the pronaos of the sixth-century BC Temple of Hera at Cotrone in southern Italy. Surely the well-conceived pronaos of the Montgomery storefront, with its emphasis on huge columns, was a statement on behalf of the company president.

Related interests of the owner seem to be revealed in the newspaper supplement on the Montgomery store under the heading "Materials from Everywhere." The article states that Italy, France, Spain, and Egypt are represented in beautiful marble and woodwork. Travertine, which forms part of the floor, was quarried at Vanielli, which

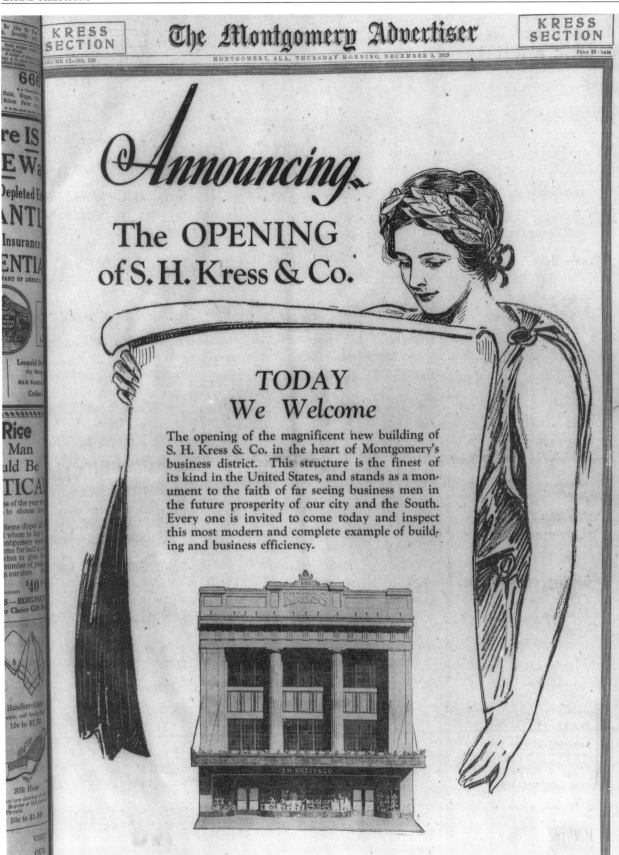

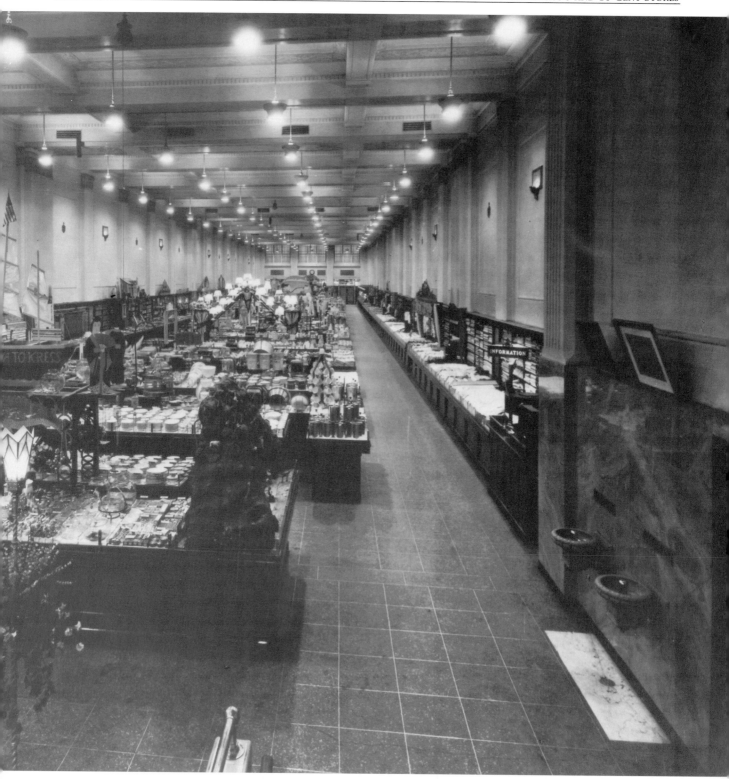

Fig. 3.8. *Montgomery, Alabama, main sales floor looking toward Dexter Avenue, with two water fountains marked "Colored" and "White," lower right. Courtesy National Building Museum, gift of Genesco, Inc.*

furnished material for the thirty-three monolithic shafts, or columns, for the royal palace at Caesarea. The same marble was used in building the Colosseum in Rome, by the king of Naples to beautify the royal palace at Portica, and for many other notable buildings throughout the world. It goes on to say that famous Egyptian gold-and-black marble is used extensively in the store's candy section—the same marble used by Cleopatra for her baths. The interior of the store was indeed sumptuous by any standards. The soda and lunch department, for example, had walls faced with tile in gradations of pale green, trimmed with patterned molding. This kind of facing, which served to set the eating section apart from the selling sections, was repeated in subsequent Kress stores.

The architecture of the Montgomery store does mirror the Old South in less than admirable ways by reflecting the former division between races in Montgomery and the unequal treatment of blacks. In 1929 Dexter Avenue was the principal shopping street for whites in Montgomery, and Monroe Street was the street for shops catering to blacks and black businesses. The Kress store straddled the dividing line, with entrances on both streets. The company aimed its business at both groups; however, the Monroe Street facade is a somewhat inferior version of the one on Dexter Avenue. Inside the store, only whites were allowed to eat at the lunch counter. A take-out counter near Monroe Street, marked "Colored Only" in neon, was added in the early 1940s. Two marble drinking fountains built into the wall side by side with marble backsplashes are identical in every respect, except that one has "Colored" carved overhead and the other has "White" (fig. 3.8). These twin marble fountains were standard in southern Kress stores for many years. (Stores outside the South had only one drinking fountain.)

Things have changed since a local bus boycott, strategized at meetings just up the street at Dexter Avenue Baptist Church, helped launch the civil rights movement. Now blacks and whites eat together at the Kress lunch counter.[9] The marble water fountains are boarded over and have become a pilgrimage site; people of both races come to see them and to show their children what it used to be like. (The fountains were intensely symbolic because they were the only place in the hot downtown where one could get a cold drink of water.) No built-in signs declare "Colored Only" in the store today, which is still operated as a Kress by the present owners, McCrory Stores.

CASTLES OF COMMERCE IN KANSAS

Mackay's five-story corner store in Wichita, Kansas, is a Gothic monument in a down-town area where this type of architecture is uncommon.[10] Mackay's somewhat smaller Kress store in Emporia, Kansas, is another such exception. Rather than conforming to a regional style, S. H. Kress & Co., which had already shown a predilection for Gothic Revival architecture in Knoxville and Seattle, imported its own stylistic preference.

In Wichita, Mackay handled Gothic style with more artistry than had Hoffman, realizing a uniform edifice of warm, cream-colored terra-cotta (plate 6). The elevations are organized into bays of multipaned windows divided by vertical piers, with the windows at the top beneath encompassing arches. Like the windows, the spandrels are sectioned into units of three in the front and four at the side, ornamented by quatrefoils and four-part circular moldings. The parapet, highlighted at regular intervals with colorful red-orange shields, is crenellated, giving the building the image of a fortified medieval structure. The thematic inference continues below in ten medieval-style lanterns of the same red-orange hue between the window bays on both elevations. A squared-off castellated building, with elevations consisting of repetitious units grouped together to make larger wholes, points to an English architectural tradition and especially to English Perpendicular. The flag flying high above the prominent battlement, like a standard topped with a soaring eagle, creates the illusion of a medieval castle, even though the flag is American and rises from an enormous Kress logo. The building is labeled all

around by a continuous terra-cotta store sign in tomato red with golden letters, repeating the colors of the row of red-orange shields with touches of gold at the top. The elements combine to create a "castle of commerce" in downtown Wichita, as opposed to the "cathedral of commerce"—the Woolworth Building—in New York City.[11]

In Emporia, Mackay created another castle, this one in a Tudor Revival style (fig. 3.9). As in Wichita, a crenellated parapet is a significant feature of the theme. The two facades of the two-story corner store are beautifully orchestrated in light earth-toned brick and cream-colored terra-cotta. Face brick of this hue represents a slight change of the Kress color scheme to facilitate a historical reference. The dominant focus at center front is a tall group of windows with sets of panes nine-over-nine surmounted by rosettes framed as diamonds, all encased by blocks of simulated stone. The diamond shape is echoed in the diaper patterning of darker brick on the second-story walls. The same window arrangement, along with the same patterned brickwork, is repeated at each end of the long side elevation. The Kress logo and the heraldic shields in the parapet, the parapet coping, and the beltcourses that section the elevations are all in matching terra-cotta. With only minimal descriptive features these two-toned facades manage to call to mind the architecture of Tudor England.

Castle architecture had served as a motif for chains of hamburger stands, in particular the White Castle chain, which originated in Wichita in 1921. The White Tower chain, using a fortified medieval tower as its signature, followed this example, opening its first stand in Milwaukee, Wisconsin, in 1926. These buildings were modest in comparison to the Kress stores in Kansas, but the symbolic intent was equally exalted. Paul Hirshorn and Steven Izenour note about White Tower architecture that the minimal medieval fortress suggested by the tower was an important symbolic choice to reinforce a desired image. The tower and its motifs "evoked the social and gastronomic prominence of royalty."[12] The building types that the Kress company chose to emulate during Mackay's tenure and the manner in which they were executed made a grandiose statement for the chain.

Fig. 3.9. *Kress store, Emporia, Kansas; George E. Mackay, architect. Courtesy Kansas State Historical Society.*

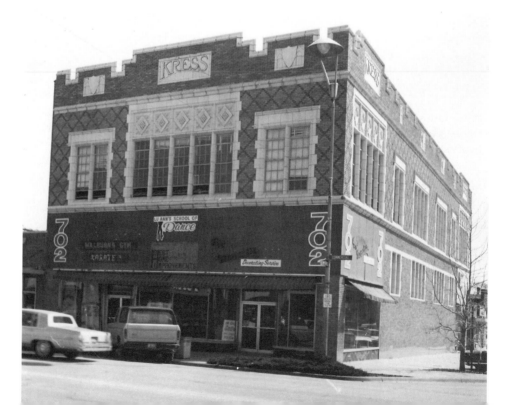

KRESS HERALDRY

One element in the design of Kress stores that reinforced the company's architectural image was the use of Kress heraldry. Mackay was the first Kress architect to depict the Kress coat of arms fully and accurately, both inside and outside buildings. The practice continued after his tenure, until 1932, and was unique among five-and-ten-cent-store chains.

The Kress family in America claimed descent from a branch of the Kress family in Nuremberg, Germany, that could be traced back to the thirteenth century, and the design of the Kress coat of arms derives from a woodcut by Albrecht Dürer, who rendered arms for a number of noble German families. Both the Dürer woodcut and a full-color image of the Kress coat of arms are pictured in the *Kress Family History* (plate 7). Mackay's image was correctly colored, with "a silver sword on a crimson field" for the shield. The crest consists of a

helmet with a coronet studded with five peacock feathers. A half-figure, similarly crowned and holding a sword in its teeth, completes the image. The crest coronet with peacock feathers was an armorial augmentation received from the Holy Roman emperor Charles V in 1530.[13]

Technically, only the eldest son had the right to display arms; arms did not belong to a family. Thus the Kress coat of arms spoke for Samuel Kress first and foremost, but it seems also to have reflected the interests of the other Kress brothers involved in the business. Rush Kress was a member of the New York Genealogical Society, and Claude Kress had an intense interest in genealogy and heraldry.[14]

Hoffman used Kress heraldic motifs and mock heraldry, such as a cartouche embossed with KRESS in gold letters in the Oakland store, and he came close to rendering correct Kress shields on the storefront in Knoxville (fig. 3.10; see also fig.

Fig. 3.10. *Model for terra-cotta ornament on the Oakland, California, Kress store, 1926, with "Kress" embossed on cartouche. Gladding, McBean Collection, courtesy California History Section, California State Library, Sacramento, California.*

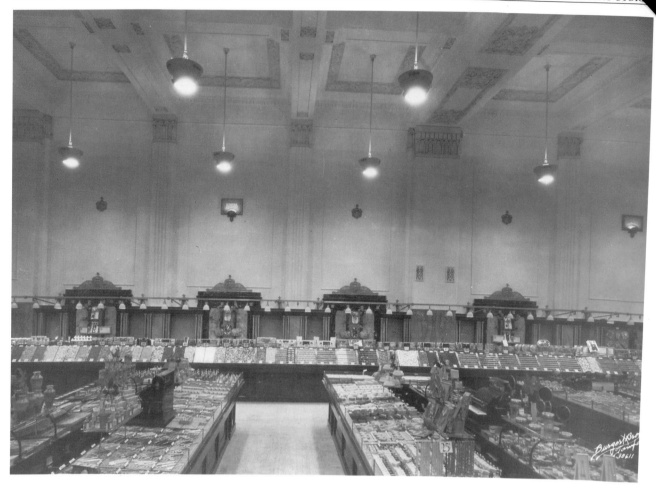

Fig. 3.11. *Kress coat of arms on walls and atop display cabinets, along with custom-designed Kress light sconces, Tampa, Florida, Kress store, 1929. Courtesy National Building Museum, gift of Genesco, Inc.*

2.24). Mackay had used the shield by itself among the mock-heraldic shields on panes of glass in his store windows. He first used the entire coat of arms—shield, crest, and armorial embellishment—inside the store, in two forms: as a plaque in the center of the frame molding on the walls of the main selling floor, and as an ornament attached to the top of built-in display cabinets (fig. 3.11). Only with his last store, in 1930 in Pueblo, Colorado, did he bring the arms out to the front as images in bright polychrome terra-cotta, heraldically supporting the name Kress at the top of the facade (plate 8). Mackay's successor, Edward Sibbert, used similar reliefs on a storefront in Greensboro, North Carolina, in 1930 (see plate 9). Plans for the 1930 Durham, North Carolina, store show the arms divided in two and depicted in another medium: the shield with the sword as a running frieze on

the copper marquee and the crest standing by itself at intervals (see plate 10). (In the execution the shield frieze appeared, but palmettes were substituted for the crests, possibly because of technical difficulties.)

The use of arms as decoration suggests that other motifs were borrowed from the vocabulary of Kress heraldry. For example, a ram's head appears on both the Pueblo and Greensboro elevations in concert with the Kress coat of arms (figs. 3.12, 3.13). In Pueblo the head, with its distinctive curled horns, could be a reference to an animal native to the region, the Rocky Mountain sheep; but the ram motif cannot be as easily identified with the North Carolina locale. A ram's head appears several times in illustrations in the *Kress Family History* as an appendage to the principal image, serving to identify a branch of the family from which a certain person is descended. In one instance,

a ram's head on a shield and a tripartite shield with the parts graded in shading fill the corners of a page with a portrait of Albrecht Kress, member of the Greater Council of Nuremberg. The shields are arms identifying his grandparents.[15] A similar tripartite motif in three shades of terra-cotta ornaments the Gothic storefront in Seattle.

One of the earliest heraldic emblems associated with the German Kress family is a fleur-de-lis.[16] It is possible that the fleur-de-lis prominently displayed on the Memphis store referred to Kress family history as well as to Renaissance Florence. A fleur-de-lis also accompanies the name Kress on the cartouche on the Oakland facade. Another type of flower, a rosette with four petals and a small round center, occurs repeatedly on Kress store facades in the 1920s. It adorns interior plaster capitals in Memphis, and sizable renditions of the floral motif

ornament the bronze marquees on the Tampa store along with the letter K in a shield. A flower closely resembling these rosettes is illustrated in the *Kress Family History* as a possible source for the family name: a cress, which grows wild in swampy areas.[17] The depiction of a cress flower on a Kress store might have been intended as a "canting" device, following the practice in heraldic design of letting an object with a different spelling but with the same sound "speak" a name.[18] The rosettes on a store facade would depict the name Kress in the language of heraldry. The Kress arms would specifically illustrate the name S. H. Kress as clearly as the signage would spell it out in letters.

A coat of arms is unique in dime-store decor, but it is not without precedent in commercial architecture. Joseph Siry calls attention to a coat of arms decorating the

Fig. 3.12. *Pueblo, Colorado; George E. Mackay, architect. Courtesy National Building Museum, gift of Genesco, Inc.*

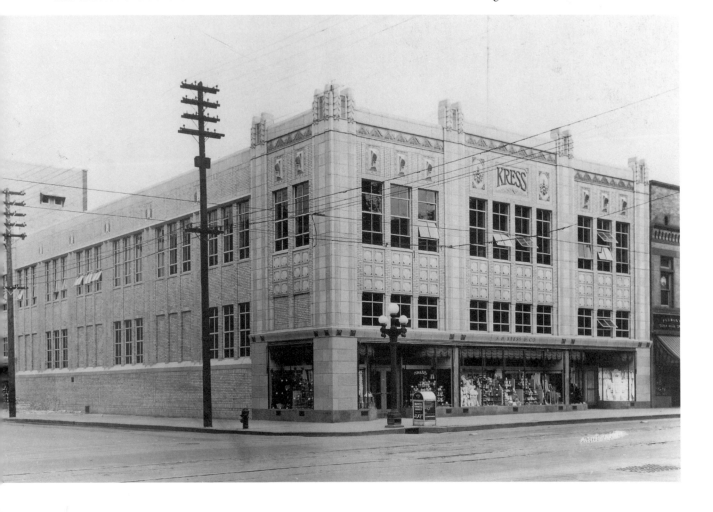

Fig. 3.13. Terra-cotta ornament of Rocky Mountain sheep, side elevation, Pueblo, Colorado. Photograph by author.

facade of the small dry goods store Louis Sullivan designed in Clinton, Iowa, between 1913 and 1915 for John D. Van Allen and Son.[19] Like Kress, Van Allen took pride in his lineage, tracing his ancestry back to forebears in the Netherlands. On the Van Allen store, the arms are rendered as bronze plaques just above the awning on two sides of a corner pier, and below each plaque is another one displaying a facsimile of John D. Van Allen's signature, a close analogue to the imagery and signage on an S. H. Kress store.[20]

Siry offers an interpretation for the heraldically conceived motifs in terra-cotta on the Van Allen storefront. At the base of three mullions of the upper stories, the initials V. A. occur on a stylized base suggesting an escutcheon. The luxuriant foliage around the monogrammed shield is like mantling in heraldic imagery. The foliage here and at the top of the mullions is rendered carefully in natural color: the green leaves distinct from the brown-yellow branches.[21] As Siry notes, "When this mercantile house was built, its success was linked to the prosperity of surrounding farmlands." The terra-cotta ornament could be a way of acknowledging the interdependence of agriculture and commerce in this Iowa locale. On the Kress

store in Greensboro, North Carolina, green-brown foliage above the Kress coat of arms in the spandrel functions visually as mantling for the shield and the crest. The stylized foliage takes the form of a traditional design motif, the tobacco leaf pattern. On days when tobacco auctions were held, the Kress store had special sales to attract buyers who had just been paid for their crop. In a community where tobacco was essential to the economy and thus to the prosperity of S. H. Kress, the terra-cotta ornament may have declared interdependence and commitment.

For Kress as for Van Allen and Son, armorial bearings indicated pride in a family of noble lineage and pride in the building the arms adorned. The building and the enterprise it housed received the same accolade. The gesture indicates a close identification between a man and his company. A section of the *Kress Family History* entitled "The Commercial Connections of the Kresses" describes the Kresses' history as wholesale traders and merchants from the fourteenth to the sixteenth centuries. Commercial activity is presented as befitting the aristocracy.[22] No doubt Samuel Kress thought of himself as a merchant continuing a noble family tradition. As already

mentioned, Kress had been made a *cavaliere* in the Order of the Crown of Italy by the Italian king. He was later raised to the rank of a grand officer of the order—the equivalent of a knight, as explained in a footnote to his entry in the family history. Thus he could, by his own rights, claim to be a nobleman himself and was, therefore, doubly entitled to display arms.

This identification with aristocratic ancestors also implied, in Samuel Kress's case, a sense of obligation, of noblesse oblige. His willingness to serve on boards, such as those of the Georgia Warm Springs Foundation and the Metropolitan Museum of Art in New York, evidences his sense of civic obligation.[23] The foundation he set up in 1929 bearing his name was intended "to promote the moral, mental, and physical well-being and progress of the human race." He gave his vast collection of paintings and other works of art to the people. His commitment to sharing his privileges with others carried over into his business endeavors. Service was a recurrent theme in the company's official statements. When new Kress stores opened in Fort Worth and El Paso in the mid-1930s, promotional literature referred to "points of Kress service in Texas."[24] A large newspaper advertisement for a store opening in Bakersfield, California, in 1932 devoted a section to "Serving the Public."[25] After explaining what service means, including good values and limited profits, the section concludes, "This company has been successful and will continue so only as long as we serve the public well in all details of Service." The building itself was represented as a service to the people. "It would be unwise to construct a building of such character," the advertisement stated, and then to offer the public inferior value or unsatisfactory service. The advertisement continues with a building metaphor: "The foundations of every building built by this Company have to be solid, and every principle of our operation has to be on this same basis. Any weakness in any foundation weakens the entire structure." The same theme was repeated for subsequent Kress store openings.[26] Fine architecture, high-quality merchandise, and low prices were all consistent with the concept of noblesse oblige. The company history published in 1946 states, "The Kresses were particularly eager to introduce items that would make for better living." Items mentioned include not only better coffeepots and teakettles, but also reproductions of art masterpieces that sold for twenty-five cents.[27] Customers might get reproductions rather than the originals Samuel Kress gave to museums, but the idea was the same.

In 1929 Kress dismissed George Mackay.[28] Exactly why is not known, but a change of direction suggests a reason. Mackay had served the company well with his elitist architectural allusions to palaces, temples, and castles. His buildings were consistent with the American public's perception of highly successful businesses and their owners and suited to a multimillionaire owner who had adopted an aristocratic persona and lifestyle. Things changed after 1929, and another kind of architecture seemed to be required. A 1929 article by Shepard Vogelgesang in *Architectural Forum* describes a change in storefronts on New York City's Fifth Avenue. For a long time commerce had taken refuge in palazzi or behind columned arcades, the better to hide an association with commercialism. Vogelgesang disdained this type of storefront, calling these buildings "shells vacated by a phantom aristocracy." They gave the impression of places "where some inflated European aristocracy seemed to dwell, but glory had departed." In fact, he said, the Medici type of storefront had become a poor public attraction. Customers were drawn by a distinctive storefront like the one Joseph Urban designed for the Bedell Company, which showed the influence of the Exposition International des Arts Décoratifs et Industriels Modernes held in Paris in 1925.[29] By the beginning of the 1930s Kress Company architecture had begun to move in new directions. The company chose other architects to lead it away from period-style stores toward stores that were distinctly modern.

KRESS MODERNISM

The year 1929 marked a transition in Kress Company architecture, as the buildings moved away from designs based on classical or historical European models toward the new, modern style the company announced it had adopted. Three architects overlapped in the architectural division (fig. 4.1) and signed plans for Kress stores during 1929: George Mackay (until his dismissal), Edward Sibbert, and John G. Fleming, whose work was confined to California and Hawaii.[1]

Fig. 4.1. *Modernized version of a Corinthian capital used by three Kress architects in the early 1930s, Selma, Alabama. Photograph by author.*

Sibbert made it clear that he was responsible for the company's new look; when asked by questionnaire in 1979 if any Art Deco buildings were designed or built before he started working for Kress, he replied with a simple "no." To the question, "Was the general design type of the 1929–1930s Kress stores established by a previous architect, by you, or by Mr. Kress?" he underlined "by you" and stressed the choice with a check mark. Mackay's only contribution to a more modern design was the Pueblo, Colorado, store, the last he designed for S. H. Kress. Fleming's last store opened in Sacramento, California, in 1932. After that, Sibbert had sole responsibility for taking Kress architecture through its modern phase (1929–1941).

It seems possible that Sibbert had a hand in designing Mackay's store in Pueblo, especially the terra-cotta ornament (see figs. 3.12, 3.13). The tall, thin, angular mullions on the front elevation and the unusual three-dimensional forms at the top are characteristic of Sibbert's work. As will be seen, Sibbert also used ornamental details to go beyond general architectural allusions to relate a store more specifically to its locale. Besides the colorful ram's heads already mentioned, ornamentation on the Pueblo store includes terra-cotta panels of yellow flowers with wide green leaves and purpled-red flowers resembling beets. The stylized mullions resemble abstract renditions of stalks of wheat. Beets and wheat were both major crops in the Pueblo area, where agriculture was all-important.

STOCKTON, CALIFORNIA

John Fleming's Kress store in Stockton, California, designed in 1929 and opened in October 1930, is in some ways a continuation of the yellow brick store and in other ways comparatively modern (fig. 4.2). The two facades of the L-shaped building are not dissimilar to Hoffman's designs for North Birmingham, Alabama, and the ventilation grilles that figure so prominently on the Stockton facades, paired at each side of the Kress logo and used as tall insets at each end of the mezzanine windows, relate

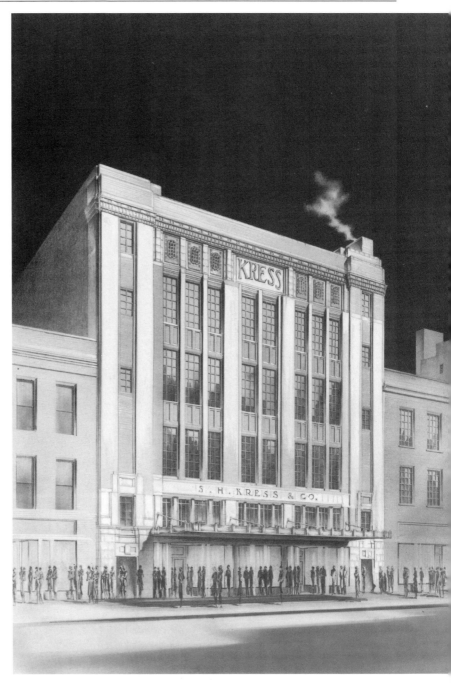

Fig. 4.2. *Rendering of Kress store, Stockton, California, Main Street elevation; John G. Fleming, architect. Courtesy National Building Museum, gift of Genesco, Inc.*

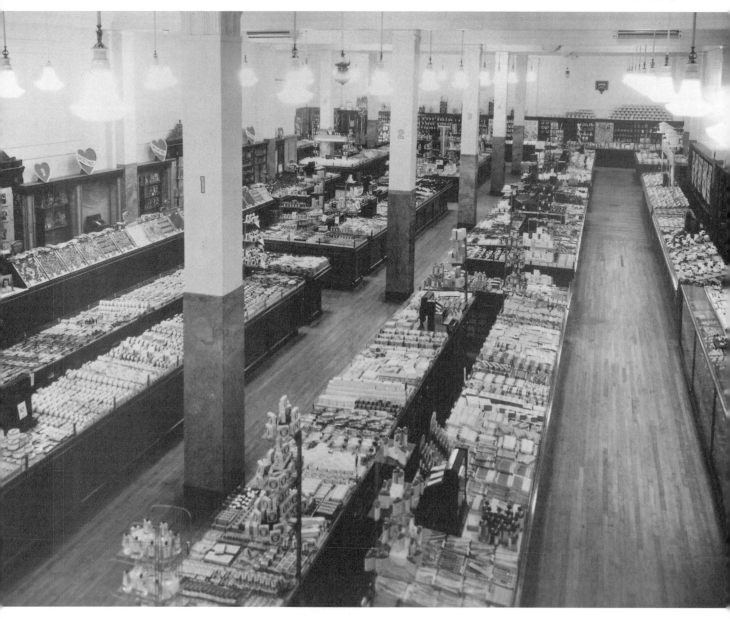

Fig. 4.3. *Stockton, California, main sales floor. Courtesy National Building Museum, gift of Genesco, Inc.*

these storefronts to the earliest of the yellow brick stores, Zeitner and Burrell's building in Salisbury, North Carolina. The Stockton facades retain only the faintest hint of neoclassicism, however. Where an earlier store might have had an overhanging cornice, there is instead a flat surface of brick and terra-cotta blocks. Inside, too, are vestiges of the old, in the hardwood floors on the ground floor (fig. 4.3). The basement has newer-style marble terrazzo floors designed to Kress specifications. The building might have had a more contemporary look if the tall, flat, white pilasters seen in a company rendering prepared for publicity purposes had, in fact, been installed. One note of modernity comes from two copper marquees over the windows and doors at ground level. Unlike Mackay's, these marquees make no historical references. They are simply long, straight expanses broken up with vertical linear ornamentation, following the lines of the elevations. The Stockton store casts the old yellow brick Kress store in a new mold, stripping it down and simplifying it.

RIVERSIDE, CALIFORNIA

Fleming revived the Kress tradition of all-white terra-cotta storefronts in a design for a store that opened in Riverside, California, a few months before the one in Stockton. The company's photographs show a Kress logo in what must have been a contrasting color, but this has since been removed (fig. 4.4).[2] A copper marquee, suspended by hanger rods secured to the wall behind copper wall plates, is embossed S. H. KRESS & CO. The walls above are clad with terra-cotta blocks framing a tripartite arrangement of windows and spandrels, three to a bay. Flat pilasters with flat capitals of recessed panels and simple volutes divide the window bays, and pilasters without ornament mark the outsides. Three ornamental plaques serve as lintels over the windows, corresponding to the spandrels decorated with shields and vertical strips down below. Simple motifs of circles and lines flank the Kress logo on the parapet, and tall floral patterns inset in the walls mark the outside ends. A straight roofline with stepped ends and one setback finishes off the modest, boxlike facade.

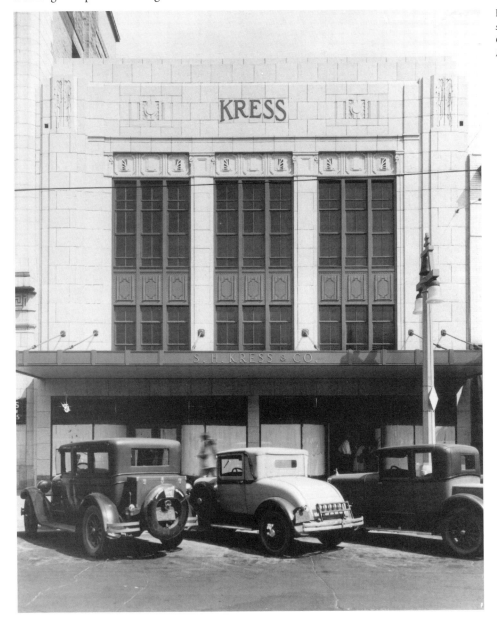

Fig. 4.4. *Riverside, California, Kress store; John G. Fleming, architect. Courtesy National Building Museum, gift of Genesco, Inc.*

HONOLULU, HAWAII

S. H. Kress & Co. took what it described as a bold step when it made a half-million-dollar investment in a Class A store outside the continental United States, in the territory of Hawaii, in 1931, a step that eventually resulted in Kress stores on four of Hawaii's major islands. To accommodate the move the company was willing to construct houses for its store managers in Honolulu and Lihue, built in a Hawaiian bungalow style (fig. 4.5). The Kress store was the islands' first mainland-type five-and-ten and Hawaii's first department store (fig. 4.6). It was described before its demolition in 1988 as the "grande dame of Hawaii retailing."[3]

The local business community was evidently resistant to Kress's moving into Hawaii. News releases issued before the opening of the Honolulu store seemed to be speaking to some of the objections when they stated that the company had adopted a policy of not hiring people already employed by Honolulu businesses. As a consequence, unemployment in Honolulu would be considerably lessened. In response to another local concern, the news releases stressed that every nationality would be represented on the payroll.[4] On opening day, March 23, 1931, the customers were described as women of the East and the West: "All nationalities to be found in this melting pot of the Pacific were represented."[5] The same points were reiterated when a store opened in Hilo the following year. An article called attention to the large number of employees, including "more than 155 local saleswomen, selected from the same nationality groups as which the shoppers are composed."[6] The

Fig. 4.5. *Lihue, Hawaii, Kress store manager's residence on the island of Kauai; Edward F. Sibbert, architect. Courtesy National Building Museum, gift of Genesco, Inc.*

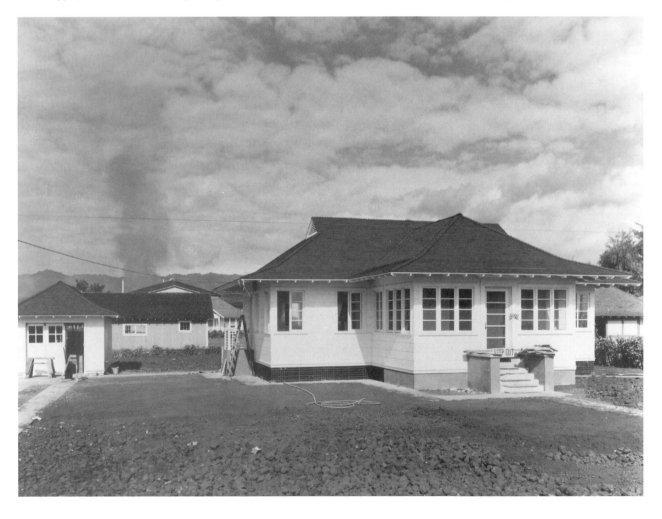

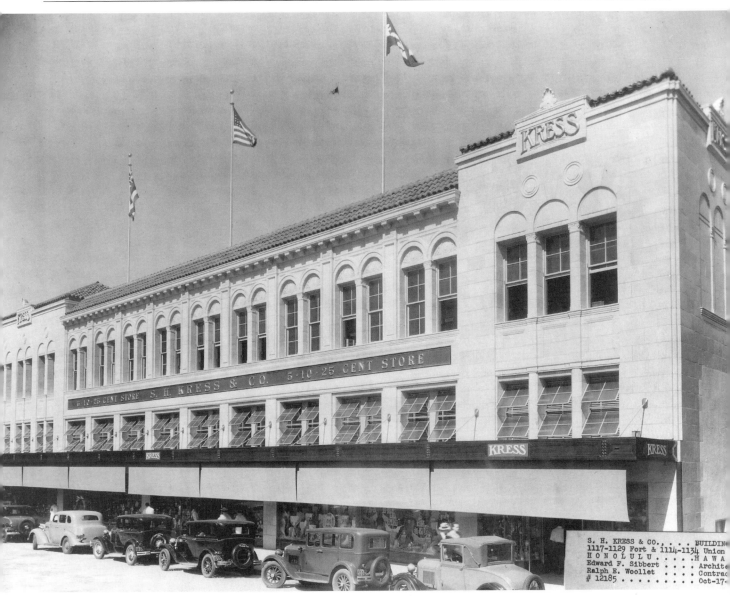

S. H. KRESS & CO., . . . BUILDIN
1117-1129 Fort & 1114-1134 Union
H O N O L U L U H A W A
Edward F. Sibbert Archit
Ralph E. Woollet Contra
12185 Oct-17-

Fig. 4.6. *Honolulu, Hawaii, Kress store, designed by Fleming (1932) and Sibbert (1935) (now demolished). The United States flag flies between flags of the Territory of Hawaii, 1935. Courtesy National Building Museum, gift of Genesco, Inc.*

company made other nods to things specifically Hawaiian. The standard promotional item, a "special turkey dinner," offered for twenty-five cents during the first week of a new store's operation, included a "Kress Hawaiian Salad." At lunchtime during opening week, customers in the soda and lunch department (fig. 4.7) could enjoy the Kress special while listening to native music played by Joseph Kamakau and his Popular Quartet.[7] The Hawaiian group also played during two preview receptions the day before the store opened its doors for business.

A preliminary viewing—to the accompaniment of a local orchestra—the day before a store's opening had become standard procedure for Kress. As far back as 1916 the company held an evening open house for citizens of Corpus Christi, Texas, to view a new store and its merchandise. On this occasion "the Bradley orchestra played and the staff presented 'souvenirs for the ladies.'"[8] By 1929, the company had adopted this procedure and followed it consistently thereafter—although by 1931 the viewing hours had been extended and the souvenirs for the ladies had been elimi-

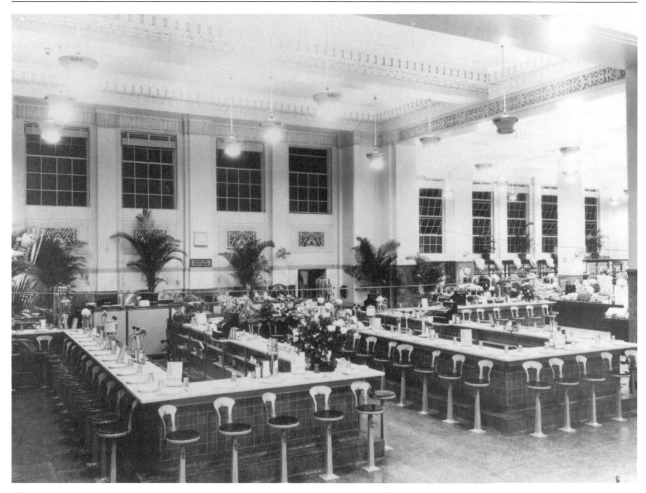

Fig. 4.7. *Soda and lunch counter, Honolulu, Hawaii, Kress store. Courtesy National Building Museum, gift of Genesco, Inc.*

nated.[9] The celebratory event provided excitement and entertainment for the public each time a new Kress store opened. The preview showing also extended the role of the building as advertisement.

Within a few years the Kress store in Honolulu was grossing more annually for the company than any of its 225 stores on the mainland. The growth of the building maps the store's success. What began as a two-story building with a basement that could be adapted as another selling floor was enlarged the year after the store opened. Fleming added a third story above the substantial bracketed cornice, with a mansard roof covered with glazed dark-green tiles. In 1935 the store was expanded again by extending the store fronting on Fort Street all the way back to Union Street. The two-story addition, designed by Edward Sibbert, almost doubled the size of the store.

Like his store in Stockton, Fleming's Honolulu design showed traces of modernism while continuing with tradition. The long, low storefront, faced with light, sand-colored terra-cotta and with pairs of windows beneath arched surrounds and ornamental wrought-iron balconies, was in a Mediterranean style consistent with the architecture of Honolulu. Bertram Goodhue had designed a similarly low, tiled stucco building in 1927 for the Honolulu Academy of Arts. Honolulu's most imposing building of this nature, the Abraham and Baldwin Building, designed by local architect C. W. Dickey, was made of terra-cotta. The style but not the material was common in Hawaii. When the Kress store was built, it and the Abraham and Baldwin Building were the two largest terra-cotta buildings in the Hawaiian Islands.[10]

The original store took the Hawaiian climate into account by allowing for side alleyways so as to have windows on all four sides to catch the trade winds. The glass was specially designed to cut glare, and the windows were shaded with venetian blinds. The marble terrazzo floors, standard by now for Kress stores of this caliber, were "the first such in Hawaii," according to a man who helped lay them,[11] as was a complex system for providing fuel for the machines in the kitchen—"the only fully automatic oil burning system of its kind in the Islands."[12] The Honolulu store was one of the first Kress stores to be equipped with a new type of jewelry display case developed by the company's engineering department and advertised as "one of the most modern selling display fixtures that have been produced by any merchandising concern."[13]

SACRAMENTO, CALIFORNIA

The 1932 Kress store in Sacramento, California, brought a new look to Kress store design. Characterized aptly in a California inventory as "Zig Zag Moderne,"[14] the tall, compact, four-story building reflected some of the newest trends of the time in American design while maintaining a basic Kress formula (fig. 4.8). The all-buff terra-cotta storefront is streamlined, not in smoothly curved forms but in straight running lines. Two large, striated pilasters—dividing the facade into three bays—and thin, angled mullions between tiers of vertically stacked windows rise straight up from the marquee in an unbroken sweep, accentuating the height of the building. The pilasters alone terminate above the straight roofline in stepped setbacks or zigzags. That preeminent feature of early Art Deco design, the zigzag, is used again to ornament the broad face of the overhanging marquee in different configurations (fig. 4.9). The marquee is modernized in other ways as well. It is made of a popular contemporary metal—aluminum—and the whole face is strung with glass panels to accommodate backlighting. The marble sheathing beneath the show windows and

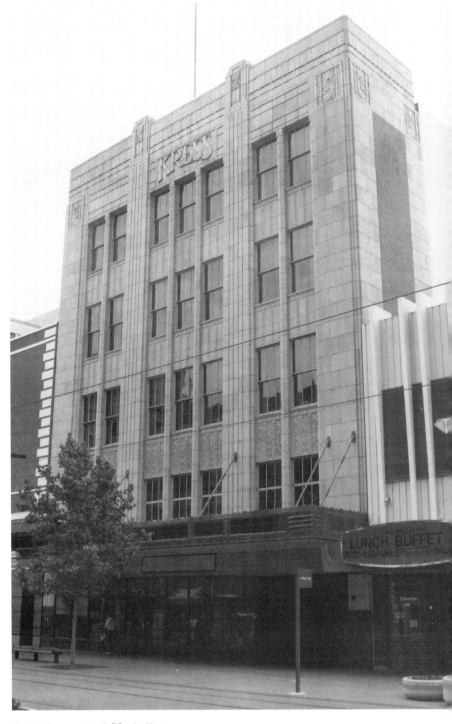

Fig. 4.8. *Sacramento, California, Kress store; John G. Fleming, architect. Photograph by author.*

Fig. 4.9. *Sacramento, California, detail of streamlined marquee with glass insets and interior lighting. Photograph by author.*

on the side piers has been changed from dark green to dark gray to coordinate with the marquee.

The storefront is vertically linear, containing panels of stylized floral motifs. Sunken panels of Deco-style ornament carved away from the surface plane take the place of capitals at the tops of the twin pilasters. Similar panels of stylized flowers and foliage are situated in stepped fashion at the far sides of the building just above the windows, and again at the sides of the deep returns. Partial blossoms and leaves of a different design appear in square frames beneath the canopy on the side piers. There is a single row of recessed spandrels above the mezzanine windows. These tall spandrels are filled with lacy cutouts of stalks of hanging blossoms separated by flat, grooved columns echoing the lines of the striated pilasters and overhead bar of zigzag ornament. The rest of the spandrels have

only the two columns and the narrow strip of zigzagging, thus lightening the decorative load as the building rises and inviting the eye to move upward.

Built into the concept of streamlining was the notion of speed. The architecture of the Sacramento store speeds up the reading, so to speak, in several ways. The raised line of identically patterned blocks running across the brow of the facade in a staccato rhythm increases the directional flow of a plain horizontal stringcourse. The crisply cut edges of the continuous straight forms, such as the edges of the layered pilasters, speed up the movement of the linear design. In the 1930s designers were developing a semiotic shorthand to indicate dynamic flow. In this instance, this was indicated by a set of three lines, one above the other. By 1940 the editors of *Architectural Forum* could refer to "the curious cult of the 'three little lines,'" adding that "few

objects have escaped the plague of this unholy trinity." The horizontal speed lines had become ubiquitous.[15] This coded motif figures prominently at both ends of the Sacramento store marquee. Rather than being historically referential or making exalted inferences, the storefront reflects qualities essential to the company's well-being. It bespeaks speed and efficiency, which were fundamental to the success of a chain of five-and-tens. In a Kress advertisement for another store opening a few months after the one in Sacramento, the word *efficiency* is used repeatedly in capital letters. In a text provided by the company, the word *employee* ends with one "e," a company policy to promote speed in the operation of its business.[16]

Fleming's Sacramento store, more than Mackay's building in Pueblo, shows a close affinity with Sibbert's work. The overall formulation and many details of the Sacramento facade bear a close resemblance to Sibbert's slightly earlier Greensboro storefront (see fig. 4.11). The design is so similar to what Sibbert was doing at the time that one wonders whether he might have been the principal designer for Sacramento. There is no way of knowing, and Fleming did sign the plans. If the Sacramento store is Fleming's work, however, it represents a radical departure from his other Kress buildings.

EDWARD F. SIBBERT, KRESS ARCHITECT

In 1929 Edward F. Sibbert answered an advertisement in a New York newspaper offering a position in the architectural department of S. H. Kress & Co. (fig. 4.10).[17] Thus began an association that lasted for twenty-five years. Although information about Sibbert is sparse, some facts are known from both written and oral sources.[18] Born in Brooklyn on July 1, 1899, Sibbert was well educated, first in structural engineering at the Pratt Institute (1919–1920) and then in architecture at Cornell University (1921–1922). He was a member of both the American Society of Civil Engineers and the American Institute

Fig. 4.10. *Edward F. Sibbert at Cornell School of Architecture, 1921 or 1922. Courtesy Frederic C. Wood.*

of Architects. He also belonged—as an artist member—to the Salmagundi Club in New York after 1935. He began his career by doing large alteration projects in New York with a firm he helped to establish, Heesch and Sibbert, Inc. He then spent a year as a draftsman for W. T. Grant and Co., the dime-store chain. In 1924 he moved to Miami Beach to work with a Cornell classmate, Russell T. Pancoast, during that resort's building boom (Pancoast was a grandson of John S. Collins, the original developer of Miami Beach).

Sibbert and Pancoast worked together for the firm of Kiehnel and Elliott before setting up their own partnership. Their practice consisted primarily of building costly winter residences for northern visi-

tors. Among their commissions was a waterfront estate in a Spanish Mediterranean style for John S. Collins's son Irving in 1924. It was, interestingly enough, next door to a residence in a similar style built for Sebastian S. Kresge.[19] The successful partnership was cut short by the 1926 hurricane. Sibbert's wife, Bertha, did not want to stay in Miami Beach after living through a storm that left a foot of water on the first floor of their house. Moreover, the disastrous hurricane effectively ended the Miami Beach building boom. The Sibberts returned to their original home in Brooklyn, and Edward Sibbert worked in New York as an architect for E. H. Faile and Company until he responded to the Kress Company's advertisement.

Sibbert designed some fifty new Kress stores in the 1930s and early 1940s, as well as directing numerous remodelings. He was there when the company made the transition from quality stores in downtown areas, to less architecturally ambitious ones, and then to stores in outlying shopping centers. Sibbert's position with S. H. Kress changed accordingly. In 1944 he became company vice president in charge of the buildings division (formerly the architectural division). As he recalled, his responsibilities included "locations, buildings, fixtures and equipment, and maintenance of physical properties."[20] He was no longer principally a designing architect, and he resigned from the company in 1954. The first half of his tenure with Kress was the final stage in the company's long history of constructing architect-designed Kress stores on Main Street. It was also the height of his career as an architect.

The number of stores Sibbert designed for Kress, as well as his longevity with the company as its architect and as a company executive, justify taking a closer look at Sibbert. His designs reveal that he never stopped exploring the Kress store as an architectural problem, one that he continued to approach with imagination and creativity to the end of his tenure. No building was without some artistic or intellectual interest, regardless of size. Sibbert's

corpus of Kress stores accounts in large measure for the value of S. H. Kress & Co.'s architectural legacy.

He explained his approach to design as following "no specific style." He continued:

> We did lean toward simplified modern (not modernistic). Tried to have our building stand out in the community but not too much. Avoided classical styles. . . .
>
> We tried to use good composition, simple ornamentation and coloring which [we] thought significant of a Kress store, in average American towns.[21]

In Sibbert's day, the word *modern* connoted the use of good architectural principles; *modernistic* was a pejorative term. Cornell professor Allen R. Kramer pleaded the case for distinguishing the two in a *Pencil Points* article in 1940. He argued that one should not confuse the "Buck Rogers" type of confection, *modernistic*, with *modern* architecture, as the public was still apt to do. Modern architecture, he contended, "has reminded the architect that simplicity, sound structure, and efficient planning are the essentials of good architectural design."[22] Sibbert's dissociation of his work from the modernistic reflected a theoretical distinction made in defense of a new kind of architecture. The term *modernistic* had been applied to several of Sibbert's earlier stores,[23] but the word was dropped from the company's press releases after 1934. Sibbert's self-imposed criteria of good composition and simple ornamentation and coloring indicate a comparable line of thinking. However, the qualifying phrase, "which [we] thought significant of a Kress store, in average American towns," indicates a certain specificity and a special point of departure.

GREENSBORO, NORTH CAROLINA

Sibbert's three-story Superstore in Greensboro, North Carolina, opened in 1930 on the site of Kress's first (1903) Greensboro store, at 208 South Elm Street (fig. 4.11). This was the first store for which Sibbert signed the plans, at the time when he was sharing the architect's role with Mackay and Fleming. Although this storefront is

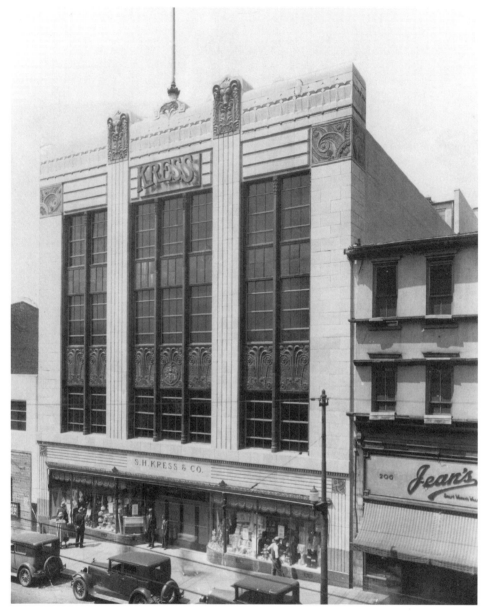

Fig. 4.11. *Greensboro, North Carolina, Kress store. Courtesy National Building Museum, gift of Genesco, Inc.*

closely akin to Fleming's contemporary storefront in Sacramento, it shows some notable differences. The Greensboro facade, like the one in Sacramento, is sectioned into three bays by large, unbroken pilasters and capitals that extend beyond the horizontal roofline. The divisions they create are the same: three tiers of windows and spandrels in the center, with tiers of paired windows and spandrels at either side. The buildings use the same off-white terra-cotta cladding, granitized to coordinate with deeper-toned granite facing at the ground level, but the Greensboro building has contrasting greenish-brown mullions, spandrels, and window surrounds as well as vivid multicolored ornament (plate 9). The flagpole emerges from a polychrome terra-cotta base rather than directly from the parapet. This arrangement recalls one of Mackay's designs, although here the base is a discrete architectural element. In Greensboro, as in Sacramento, rows of plain and patterned terra-cotta blocks serve to underline the straight line of the parapet. The patterned blocks are identical on both

stores, but the overall design of alternating rows of blocks is not.

Sibbert gave the most significant feature of a Kress storefront, the logo, a new interpretation in his first storefront design. He used bronze letters against a panel of Monel metal, highlighting the name Kress with backlighting. A metal logo had been used since the beginning of Kress store design, when the name was rendered in galvanized tin, later to be realized in stone and then more frequently in terra-cotta. But the metal Sibbert used in Greensboro, known by its trade name, was decidedly new and modern. Mackay had specified that the floodlights on Kress facades should be aimed to shine on the logo. Sibbert solved the problem in Greensboro by providing the Kress name with its own illumination while using lighting in a new way as a design element.

Metal, real or illusory, is an integrating factor in the design of this storefront. The spandrels, mullions, and window trim, the color of oxidized copper, could easily pass for metal construction, blending in tone and idea with a copper awning box lower down as well as with the metal logo panel above. The overall organization of the facade, along with the suggestion of metal frames and spandrels, calls to mind Louis Sullivan's tall office buildings, and the treatment of the Kress coat of arms, in a circular medallion with stylized tobacco leaf mantling, had an earlier counterpart in Sullivan's Iowa dry goods store.

The terra-cotta ornament on the Greensboro storefront forms a complex and closely interwoven sculptural statement. One of Sibbert's contributions to Kress storefront design was the rendering in exterior ornamentation of items sold in the store. These depictions usually resided at the tops of the piers flanking the show windows, where they were easily seen from eye level. In Greensboro exuberant portrayals of stemmed narcissus with yellow petals and orange cups decorate the piers beside the display windows. It is possible that these not only depict merchandise but also pertain to family interests. Claude Kress

owned Buckfield Plantation in Yemassee, South Carolina, where he grew paperwhite narcissus and other kinds of bulbs commercially, and bulbs grown there were for sale in the Greensboro store when it opened.[24] His statement in the *Kress Family History* recounts how he demonstrated that rice fields could be reclaimed and made to produce narcissus bulbs, formerly imported from France. Clemson Agricultural College presented him with a testimonial in 1926 for his services to the agricultural development of the state of South Carolina.[25] The stylized but botanically correct narcissus on the Greensboro store represent an achievement of which he would justifiably have been proud.

DURHAM, NORTH CAROLINA

The Kress Superstore in Durham, North Carolina, built according to plans drawn in January 1930, was constructed on a site a few doors down from Kress's original location on West Main Street, incorporating about twelve feet of the lot of the 1912 Queen Anne structure housing the first Kress five-and-ten (fig. 4.12 and plate 10). The new building, fronting on West Main, had an even better location, a corner site at a busy intersection. Trolley cars not only went up and down West Main Street past the entrance to the store; they also turned at this juncture to service traffic to and from North Durham. While passengers waited for the trolley, they could occupy themselves by gazing into Kress's show windows.

Sibbert's Durham store shares many similarities with its neighbor in Greensboro, although it is decidedly an individual creation. Common elements include a narrow front elevation and a blocklike form, emphasized by finished reveals on the sides above, suggesting more three-dimensionality than would a simple screen facade. Sibbert repeated the electrified logo on the Durham store and the flagpole on a terra-cotta base, although the design of the base is different. He also used terra-cotta blocks to underline the horizontal parapet, but in another pattern and only on the slightly depressed side sections. Outsized pilasters

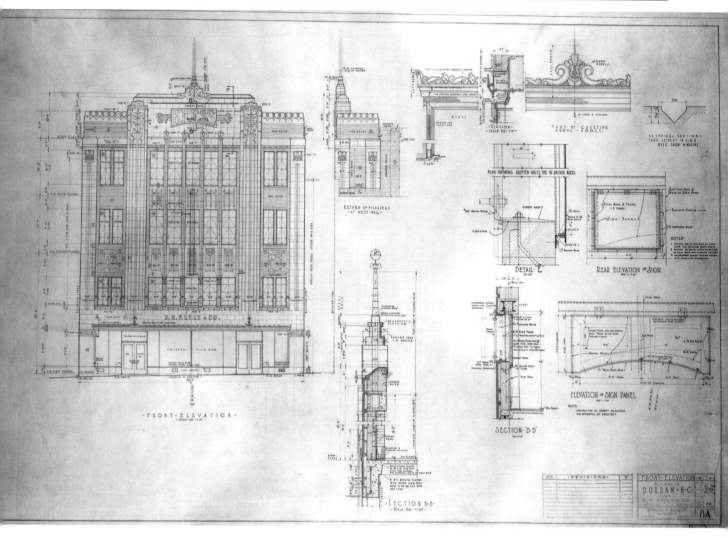

and thin mullions divide this facade in a similar fashion while stressing its verticality.

The Durham store is finished on the exterior with brick as well as terra-cotta, although more brick cladding is used on the long side elevation than on the front. In general the terra-cotta cladding and ornament are the same hue as the brick, creating a unified appearance. Sibbert used color sparingly on the Durham elevations—just to highlight the sculptural ornament and to clarify the overall organization. For example, reliefs resembling capitals atop repeated flat piers down the side elevations are emphasized with patches of orange and blue. The same treatment, with touches of orange, is accorded large reliefs of stacked, stylized

plant forms on the front of the building. The sculptural motifs better serve the function of drawing the eye to the Kress logo because of the subtle additions of color.

When Sibbert was asked about the sources of his designs, he mentioned numerous books and prints as well as such models as the Bauhaus, Mayan temples, and Egyptian architecture, adding, "most ornamentation . . . other than classical." He continued, "Designers had a free hand to actually DESIGN from published inspirations."[26] The front elevation of the Durham store blends a decidedly Egyptian cast with a modern tone. The succulent plant forms flanking the logo are reminiscent of the green buds and open blossoms of a papyrus

Fig. 4.12. *Durham, North Carolina, Kress store, drawing of front elevation, January 1930, showing metal Kress logo with electric backlighting. Courtesy National Building Museum, gift of Julius Verwoerdt.*

plant. The simple three-part capitals with overturned petals atop the mullions resemble papyrus capitals. The thematic inference is not carried solely by the ornamentation. The monumental aspect of the facade—with its cubic massing, stepped toward the center, and its terra-cotta cladding conceived as blocks—works with the ornamentation to suggest Egyptian Revival architecture. Large Art Deco floral reliefs, strategically situated on both elevations, stress the building's modernity.

Although Sibbert introduced Egyptian and Mayan themes to Kress architecture, he probably should not be given sole credit for their adoption. Samuel Kress was known for his love of travel and exotic places. He was also a tireless armchair traveler, faithfully attending Burton Holmes's Travelogues, lectures given in Carnegie Hall illus-

trated with lantern slides.[27] A trip to Egypt is recorded in a photograph of Kress seated on a camel in front of the Sphinx and the Great Pyramid (fig. 4.13). Materials described as Egyptian had been used and their illustrious lineage publicized in advertisements for the Montgomery store.

Sibbert used ornamentation freely on the Durham store on both the front and the side elevations (fig. 4.14). Sixteen different models were required for fabricating his designs in terra-cotta. This resulted in reliefs of stylized butterflies made of many parts and exquisite little sculptures interspersed throughout the two elevations. Sibbert used variations on this butterfly motif again and again, inside and outside his Kress stores. All the ornamentation at Durham serves to illustrate Sibbert's practice of combining repetitive parts in larger configurations.

Fig. 4.13. *Samuel H. Kress on a trip to Egypt. Courtesy Samuel H. Kress Foundation.*

Fig. 4.14. *Durham, North Carolina, Kress store, detail of drawing of side elevation. Courtesy National Building Museum, gift of Julius Verwoerdt.*

Inside the building, Sibbert treated the area around the store entrance with special consideration (fig. 4.15). He focused attention on the entire front wall and its individual parts, while pulling the parts together into a larger composition in Napoleon Blanc Mélange marble, the standard material for better store interiors. He encompassed the bronze doors, also standard, with polished plate glass panels and the overhead transoms with stepped marble frames ending in a deep overhead gable. The marble frames are enhanced by parallel grooves at the sides and with three horizontal lines incised in the gables. Angular steps between the jambs and the lintel are filled with fragments of floral ornament. The marble compositions are further enhanced by the con-trast between polished marble and incised areas left unburnished. A generous facing of Napoleon Blanc Mélange marble links the two doorways together and extends the design out to the side walls. The marble panels serve as surrounds for bronze doors leading into the show windows and for a row of acid-etched and polished plate glass panels above the doors. The glass expanse and the open exhaust grilles in decorative patterns above the marble add more interest to the elaborate ensemble. Striated pilasters rise from the peak of each marble panel, drawing attention to the double doors below while serving to separate the center and side bays of windows.

A Telechron clock in a round, dark frame was an established feature on the wall

inside the entrance to a Kress store. The company provided the clock for each contractor. Sibbert took this fixed, utilitarian item, improved its appearance, and incorporated it into the larger decorative ensemble, encircling it with an octagonal case set on a wide, angular base, ornamented primarily with chevrons. This in turn sits on a ledge underlined with a plaster frieze of running chevrons interlaced with flowers. The ledge and the frieze delineate the center bay of five mezzanine windows, and similar ones do the same for the two windows at either side. The wider ledge beneath the clock forms the base of a slightly raised plaster frame for the five middle windows, angling inward toward the top in the manner of the transom windows above the bronze doors.

The entire store operation centered on the clock and on clockwork efficiency.

Employees got to work on time and put in their hours; breaks away from their positions behind the counters were monitored carefully and timed by the store manager to ensure the rapid turnover of merchandise. A wall clock in full view of all store personnel was a practical necessity and a reminder of company policy. Sibbert's contribution was to add an aesthetic dimension to the timepiece. He would do this in various ways in all future store designs (figs. 4.16, 4.17).

Since the facilities needed for a Kress store operation had already been determined, Sibbert's task for the Durham store was to situate them in workable spaces. A boiler room and a coal storage room in the subbasement and blowers and other machinery in the penthouse took care of the basic functions of heating, cooling, and ventilating. One important change made after Sibbert took charge, beginning in

Fig. 4.15. *Durham, North Carolina, drawing of main floor, detail of side elevation. Courtesy National Building Museum, gift of Julius Verwoerdt.*

Fig. 4.16. *Main sales floor, Kress store, Hollywood Boulevard, Los Angeles. Courtesy National Building Museum, gift of Genesco, Inc.*

Fig. 4.17. *Columbia, South Carolina, Kress store, drawing of clock at front entrance. Courtesy National Building Museum, gift of Genesco, Inc.*

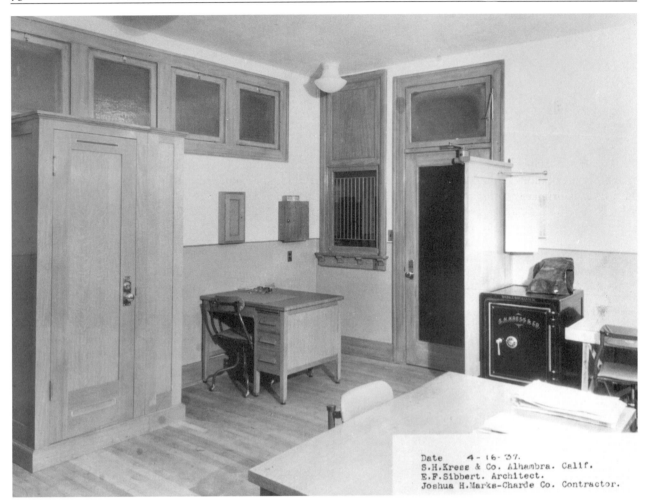

Date 4-16-37.
S.H.Kress & Co. Alhambra. Calif.
E.F.Sibbert. Architect.
Joshua H.Marks-Charde Co. Contractor.

Fig. 4.18. *Manager's office, Alhambra, California, 1939. Note teller's window and company safe. Courtesy National Building Museum, gift of Genesco, Inc.*

Durham, was the relocation of the soda and lunch department to the basement, which also had floor space for selling as well as rooms for behind-the-scenes equipment and activities to support the food service. Each piece of equipment for the modern kitchen had an allocated space on the floor plan. A pantry, a garbage room, and a machine room, with equipment such as an ice crusher and a carbonator for soft drinks, were part of the support system. The syrup room in Durham was converted into an ice cream room in 1936, complete with hardening cabinet and freezer. From then on, ice cream was an advertised Kress specialty.

The second floor was divided into a sizable stock room, a trash room, a fixture room, and a candy room across the front end, separated from the rest by special "rat-proof partitions." The all-important office

from which the store was run—extremely modest by today's standards—was also on the second floor (fig. 4.18). All management personnel worked in one room. On the plans, desks are drawn in for a manager, an assistant manager, a cashier, and an assistant cashier. Plans also indicate a long "clerical table" with two chairs and a smaller table with one chair designated for a typist. Files are placed against a wall, and in one corner is a coat closet. A wood partition to the ceiling makes another closet for office supplies. A door leads from this room to a smaller room behind a glass-and-stud partition, which contains a "money counting table," a safe, and an electric coin-counting machine. From here, a store that would gross thousands upon thousands of dollars in nickels and dimes was operated. All movable items marked on the plans

were standard issue, furnished by the Kress company for the contractor. The tables indicated on the plans were actually screwed into the floor in exact locations. Outside the office the plans show a corridor leading to adjacent rooms marked "Locker Room (Female)" and "Lunch Room (Female)" and a bathroom labeled "White Female." A bathroom on another part of the floor is for "Colored Females" and one in another area is for "White Males." The third floor is primarily a storeroom, as is the less spacious fourth floor. The only addition to the third floor is more toilet facilities for white and black males. The great amount of space allotted for storage reflects the volume of merchandise necessary for stocking a five-and-ten-cent store, as well as Kress's policy of warehousing on the premises to ensure the quick availability of every item.

The interior arrangement of the Durham store maps the social organization of the enterprise. It reveals the organizational divisions of management, sales force, kitchen help, and janitorial assistants. Kress had only white male store managers; the much larger sales force was composed entirely of white females. The more menial services were done by blacks. The arrangement of the coat closets, locker rooms, and toilet facilities diagrams the distinctions of race, gender, occupation, and class. The location of the lunchroom on the second floor, in close proximity to a bathroom for white women, suggests that only white women ate there. Only women brought lunches; the store managers were likely to eat out with their business associates on Main Street. Where the black male janitorial staff were meant to eat lunch is a mystery. The separate employee bathrooms and coatrooms and the gradations in terms of location in the store are as much an index of racial segregation as are the twin water fountains for customers. In the Durham store Sibbert repeated the design of Mackay's two drinking fountains against a marble backsplash (see fig. 3.8). Conformity with Southern law and custom as they existed in 1930 was built into the architecture.

CHARLESTON, SOUTH CAROLINA

Another Kress Superstore designed in 1930 opened in Charleston, South Carolina, in 1931, at the same location on King Street where Kress had had a store operation since 1913. The King Street elevation, a rich butterscotch terra-cotta with color accents of orange and gold, is a variation on those in Durham and Greensboro; greenish-brown lintels and spandrels, coordinating with a copper marquee, add more subdued coloration (plate 11). The Charleston store, however, has a more monumental quality than the others. The terra-cotta facing simulates large building blocks, and the end sections projecting forward are disposed as pylons. The solidity of the ends is emphasized by generous returns at the corners wholly covered with the terra-cotta blocks and by the single bay of windows in the pylons, whose depth is marked by several reveals stepped inward. The terra-cotta cladding across the brow of the broad center section is arranged as triangular blocks put together to form crisscrossing diagonal lines. The enormous pilasters or mullions separating the tiers of windows and spandrels, as well as the split versions of these at the sides, are like bundled shaft columns. The whole surface of the storefront is strongly modeled, including the roughly faceted terra-cotta logo, whose metallic gold surfaces actively reflect the light (fig. 4.19).

The store's monumental aspect helps set forth its Mayan theme. Flat valances carrying Deco-style flowers on the uppermost windows in the center section create the impression of corbeled arches. The floral designs and the multicolored chevrons on lintels above these help specify the storefront as Mayan. A chevron motif, typical of Mayan design, is used repeatedly—in the bronze-colored spandrels, on the face of the marquee, and in the bronze grilles set in the granite bases beneath the show windows patterned in double chevrons. The three-dimensional flagpole base slightly overhanging the parapet is especially suggestive of Mayan sculptural motifs.

Although Sibbert acknowledged only one contemporary source, the Bauhaus, as the

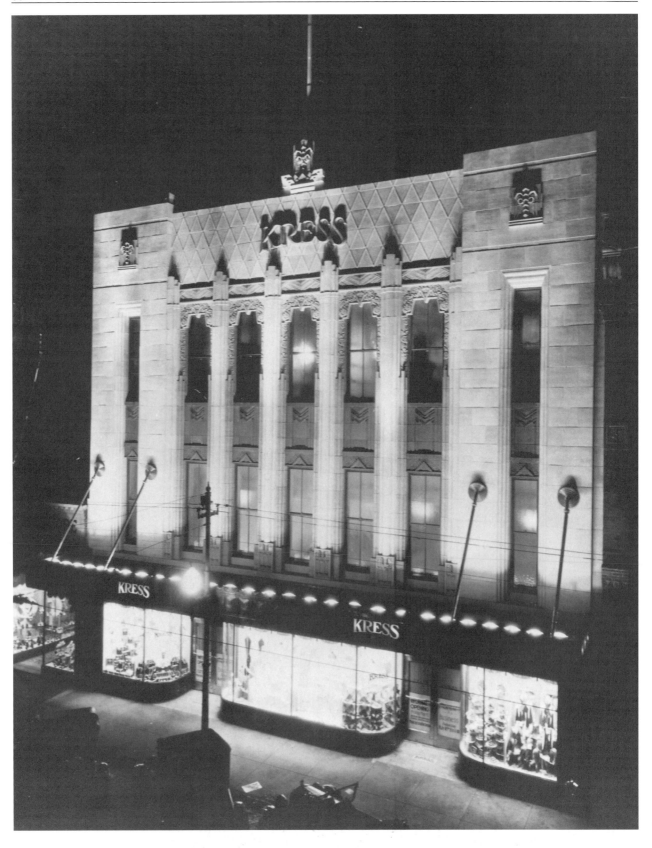

basis for his designs, it is clear that Frank Lloyd Wright was another inspiration, as was Louis Sullivan. The ornamental blocks Sibbert used to emphasize the rooflines in Durham and Greensboro call to mind Wright's well-known textile blocks, as does the diagonal patterning on the upper facade. Sibbert built on Wright's already-established notations for Mayan Revival architecture to support the same idea in Charleston. In Sibbert's time, to be Mayan was to be modern. His detailing shows the ease with which the two could be blended: stepped bundled shafts with smooth round ends qualify as streamlined, and chevrons are zigzags by another name. There were no precedents for

Mayan-style design in Charleston, so the building really did stand out on King Street.

For the inside of the Charleston store Sibbert created a dramatic front wall by using some of the same components he had in Durham—Napoleon Blanc Mélange marble, ornamental grilles, and etched glass panels—and by adding others. The most eye-catching addition was a long, gilded bas-relief over the entrance's double doors separated by a tall, fixed panel of polished plate glass (fig. 4.20). The design features a fountain motif centered on a field of flowers and enrolled leaves or ferns. The rest of the rectangular panel is filled with grape leaves and bunches of grapes. The choice of

Fig. 4.19. *Charleston, South Carolina, store at night. Courtesy National Building Museum, gift of Genesco, Inc.*

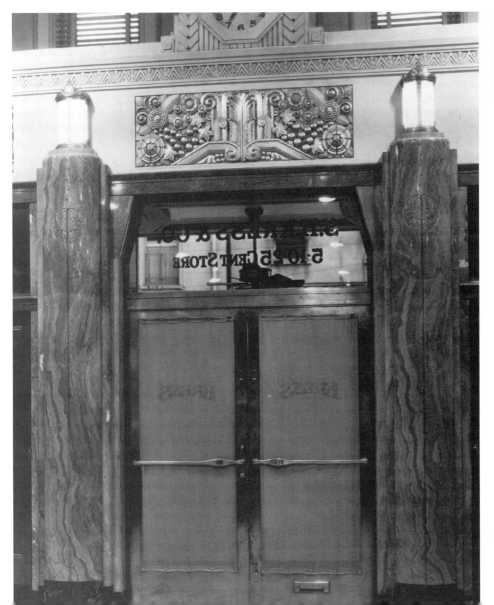

Fig. 4.20. *Charleston, South Carolina, store, interior view, front entrance with overhead relief and marble doorposts topped with lanterns of opaline glass. Courtesy National Building Museum, gift of Genesco, Inc.*

motifs and their sculptural treatment is typically Art Deco. Another note of glamour comes from curved marble pilasters with setbacks beside the doors. These posts are reminiscent of the composite pilasters on the outside. They are etched with linear versions of a single blossom on a long, straight stem. Bronze lanterns with lights of opaque glass sit atop the marble posts or jambs. The clock over the doors rests on a foundation of chevron molding. The plaster casing of the clock also features chevrons, thus continuing the integration of the design inside and out.

The design of the chevron frieze and the casing of the clock had been used previously in Durham, and the gilded reliefs, though original, would be used again in 1933 on interior walls in Phoenix, Arizona, as would the lanterns on marble posts flanking the doorways (fig. 4.21). (By 1933

these lights were standard Kress fixtures. A note on the plans for the Phoenix store tells the contractor that the lamps, with white opal glass, will be furnished by S. H. Kress & Co.) While reusing parts, Sibbert always adapted to circumstances. Charleston and Phoenix posed different problems, in that Charleston had a center entrance and Phoenix had two doorways separated by a wall. In Charleston, Sibbert chose to build up the center by placing a golden relief over the doorway and an ornamental clock over that. In Phoenix, he used reliefs to accent the two doorways and positioned the clock on the wall midway between them. Then he filled the long stretch of wall at either side of the clock with an elongated plaster ornament of special design. Here as elsewhere Sibbert made his own contribution to speed and efficiency by reusing designs that had once been time-consuming originals.

Fig. 4.21. *Front entrance, Phoenix, Arizona. Courtesy National Building Museum, gift of Genesco, Inc.*

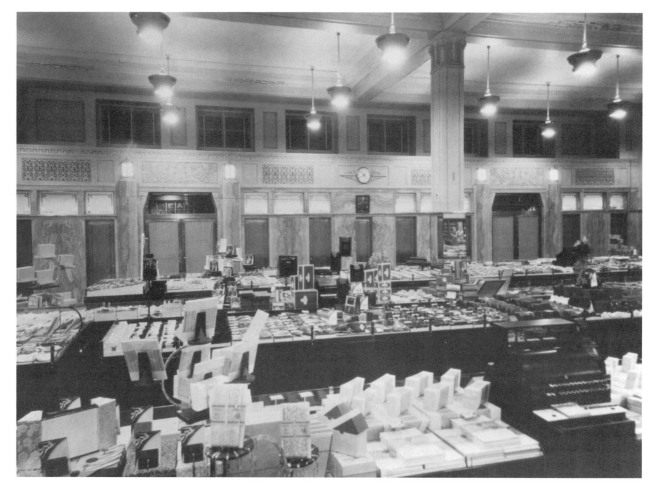

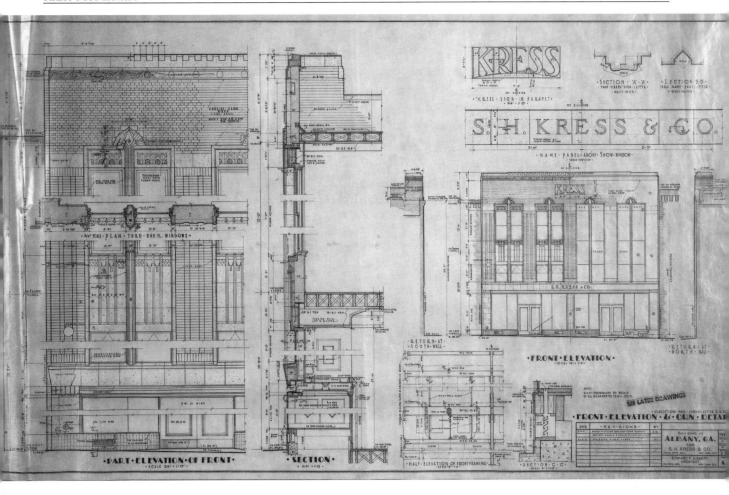

SMALLER STORES IN THE EARLY YEARS

Along with Superstores, Sibbert designed more modest stores in his first years as a Kress architect. Two-story structures in Albany and Atlanta, Georgia, both built from plans drawn in 1931, are examples (figs. 4.22, 4.23). The store in the small town of Albany succeeded a 1916 yellow brick store across the street. The Atlanta store on Peachtree Street, just above the famous Fox Theater, was a supplement to the downtown store on Broad Street, a Kress location since 1911. (The company had been operating in Atlanta since 1902.) Each represented a different design approach by Sibbert. The Albany store was demolished in 1985; Atlanta's Peachtree store met the same fate in the early 1990s. The two stores differed in design, materials, and aesthetic.

The Albany store had a relatively flat, squared-off front elevation made up of a number of geometric patterns. The bases below the show windows beside two recessed entrances were faced with small, square tiles instead of panels of marble or granite. Larger terra-cotta blocks, the same sand color as the upper brick walls, circumscribed the lower level of the facade. In place of the traditional long red-and-gold store sign, "S. H. Kress & Co." was incised in the terra-cotta blocks. Four identical bays of windows were evenly distributed across the upper storefront. The window bays were flanked by sections of brick wall imitating pilasters. Two sunken tiers of header bricks laid lengthwise created the illusion of grooved pilasters. Two blocks of terra-cotta at the top of each shaft, flush with the brick, functioned as capitals.

Fig. 4.22. *Albany, Georgia, Kress store, drawing of front elevation and ornamental details (store now demolished). Courtesy National Building Museum, gift of Genesco, Inc.*

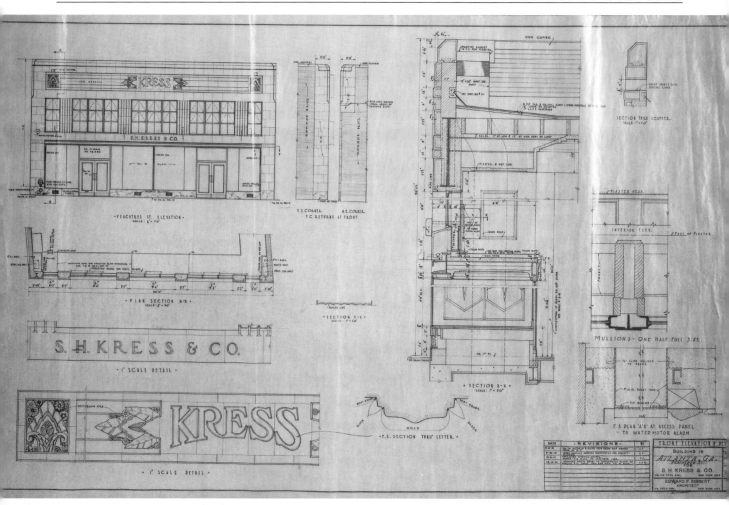

Fig. 4.23. *Atlanta, Georgia, Kress store, Peachtree Street, drawing of front elevation and details. Courtesy National Building Museum, gift of Genesco, Inc.*

The rest of the brick up to the edge of the parapet was laid in alternating layers of stretchers and headers in a pattern of English cross bond. Above the brick a band of glazed polychrome terra-cotta chevrons and flowers crested by a thin line of buff terra-cotta was surmounted by a row of larger buff blocks. This row, somewhat shorter in length than the parapet, had small terra-cotta squares on the face of each block. The elaborate detailing continued in the terra-cotta spandrels, a shade deeper than buff. Three parallel strips of terra-cotta ran up the center of each spandrel, and at the top of each, patterns of angled chevrons ornamented the blocks. Larger and more colorful reliefs of chevrons and flowers sat above each tier of windows and spandrels, eight in a row. Crisply modeled mullions the length of the windows expanded into stylized pal-

mettes on the brick wall above, each open fan or palmette set off by a stepped section of buff terra-cotta. The terra-cotta plaques behind the splayed palmettes took the shape of three arms of a cross. Thus a pattern in the brickwork was partially repeated in another medium. As Albany demonstrates, a store did not have to have major status in the Kress chain to merit Sibbert's meticulous attention.

In contrast to Albany, the Atlanta storefront was strikingly simple. The building was faced with large blocks of buff terra-cotta mottled with brown to simulate granite. Much of its beauty came from the texture of the blocks and their warm butterscotch tone. Additional color and texture were added by the veined, dark-green marble bulkheads, a reversion to a more usual Kress format. The elements of the store-

front were few and often outsized. The gold logo on this squat elevation was proportionately quite large. The sprays of leaves beside the logo and the framed leaves and flowers above the windows at either side formed big splashes of color, all the more noticeable because they were the only polychrome ornament on the facade.

Rather than being a flat, busily patterned, screenlike facade, the Atlanta storefront appeared solid and three-dimensional. The notion was reinforced by the continuation of the system of granitelike blocks up to the coping and around the corners to create deep returns. The coping and the corners were sharply beveled, increasing the sense of three-dimensionality. Sibbert eliminated the usual mezzanine windows, limiting himself to one row of windows across the facade— three bays of three windows each, and a single window at each end. The bays were articulated by grooved pilasters between the windows, equal in height to the window openings. The expanse of upper windows was matched by the width of the display windows and by glass doors with glass transoms on the first floor. So much glass in the long, low storefront helped counter the weightiness of the building, real and implied, and created a balance between solids and voids. The impression the Atlanta store gave of being composed of heavy building blocks links this building to Sibbert's other stores, especially the one in Charleston. In contrast to Charleston and also to Durham, however, the Atlanta store made no overt references to the architecture of an ancient civilization.

In 1932, when Kress built a second store in Hawaii (in Hilo on the island of Hawaii), Sibbert reworked his design from the storefront in Albany, translating it into terracotta (fig. 4.24). He substituted ashlar blocks for patterned brick and extended the facing around the sides of the building, thus giving the Hilo store a monumental aspect like that of the Atlanta and Charleston stores. As in Charleston, he added a two-tone bronze marquee, using aluminum Kress nameplates between horizontal striations.

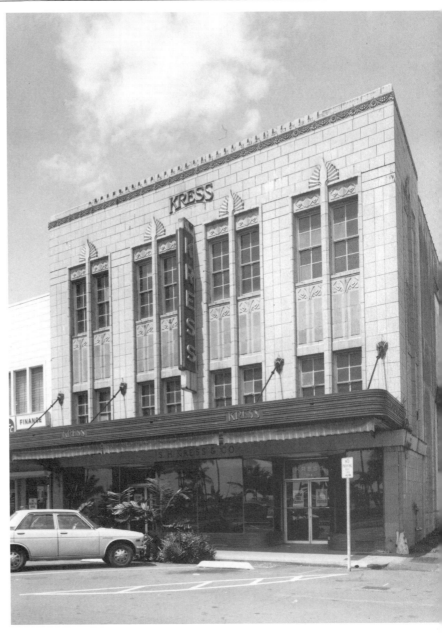

Fig. 4.24. *Hilo, Hawaii, Kress store. Photograph © 1981 David Franzen.*

At the same time, he adapted the look of the Hilo store to its location facing Hilo Harbor, specifying shell-pink terra-cotta cladding and trim and ornament of pale aquamarine that recalled the color of the Pacific Ocean. The tall mullions opening out into fans or palmettes on the upper wall are identical with those in Albany. In this context, however, they are highly suggestive of palm trees. They also recall the tall, branched standards used ceremonially by the Hawaiian monarchy, whose first

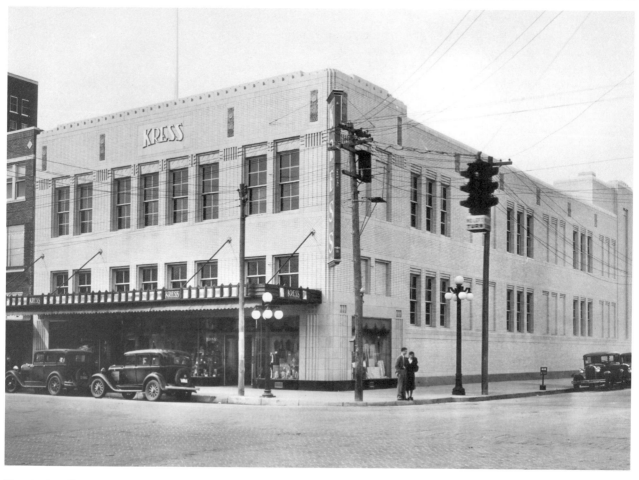

Fig. 4.25. Amarillo, Texas, Kress store. Courtesy National Building Museum, gift of Genesco, Inc.

king, Kamehameha I, is commemorated in the name of the avenue where the store is located.

Sales floors without columns or piers first appeared in some of Mackay's finer buildings and later in Sibbert's Superstores in North Carolina and Charleston. The Hilo store also was designed with a clear-span selling floor. The Hilo newspaper noted this feature when the store opened.[28] S. H. Kress & Co. obviously took pride in its engineering; a newspaper report on a later store opening, based on material furnished by the company, elaborates on the system of trusses used to create an unimpeded sales floor and on the benefit of such a layout: a full view of the interior from the entrance.[29] Claude Kress is said to have wanted the company's flagship store, in New York City, to be the most modern and exemplary five-and-ten-cent

store ever built, and he wanted no support columns on the main floor.[30] Perhaps he provided some of the impetus for this engineering feat.

Although Kress had long been established in Texas, the 1931 store in Amarillo was the first Kress store in that city (fig. 4.25). The two-story corner store is the most purely brick structure of any of Sibbert's buildings. There is some terra-cotta trim and facing, particularly on the front elevation, where the ground-level walls are clad with this material. However, most of the terra-cotta is kept flat and unobtrusive, colored and textured so as to blend with the pale yellow brick. Low-modeled polychrome floral reliefs distributed at intervals at the top of both elevations are the only exception. Even the metallic gold logo has been flattened against a panel of terra-cotta squares that is hard to distinguish from the brick.

The building gives every sign that it is of solid brick construction. Stepped brickwork at an angle where the front and side elevations come together helps make the turn at the corner, so that the front and side read as continuous brick construction. On the side elevation, the notion of thick walls is asserted and measured for the viewer by lintels above alternating windows and recessed panels composed of four rows of brick in descending layers, moving progressively inward. The store gives evidence, not through ornamentation as in Greensboro but through its building material, of an allegiance to the locale. During the first third of the twentieth century, production of a yellow buff brick was important to Amarillo's economy. The Kress building uses this local product.[31] Inasmuch as yellow buff brick had long been emblematic of S. H. Kress & Co., it was a happy confluence of symbolism.

Sibbert struck a modern note in this Kress store, highlighted to a large degree by signage and an electrified marquee. Up-to-date 1930s lettering was used for the logo, as it was in Albany and for a store in Everett, Washington, designed the same year. The face of the thin, streamlined marquee is composed of opaline glass squares in copper framing interrupted by Kress name plaques with letters of the same glass, coordinating with the larger vertical sign at the corner. The glass squares and letters were originally backlighted with incandescent bulbs, which called attention to the store after dark.

A yellow brick store with strong signs of modernity fit into a scheme then being promoted by the Amarillo Chamber of Commerce, which encouraged a modern style and the use of Amarillo brick for new commercial buildings in the downtown. The person most likely to have spearheaded the move for a new look was a local architect, Guy A. Carlander, who was also a director of the Chamber of Commerce.[32] In Amarillo, Kress was helping to create a new civic image and a new company image simultaneously. Levine's department store, built in 1936 on a comparable corner site one block north of Kress's, is a near-copy of the Kress store.

Four prominent reliefs on the front elevation of the Amarillo store depict a full-faced orange flower resembling a zinnia, surrounded by leaves and parts of smaller blossoms of a deeper orange, growing out of a purple, latticed flowerpot. This motif may depict merchandise, since the company began to sell potted plants in the stores in the early 1930s.[33] The floral motifs are a variant of those used on the Greensboro storefront with the same advertising function. Kress sold plants in decorative ceramic holders and the planters themselves as a separate item.[34] McCoy Pottery Company was a supplier. In the 1930s roadside florist shops displayed enormous images of flowerpots overhead as advertising for what was sold inside.[35] Sibbert adapted this practice from vernacular commercial architecture to his more sophisticated and complex visual statements on the exteriors of Kress stores.

VARIATIONS ON A SPANISH THEME

Three 1932 stores, in Daytona Beach and Sarasota, Florida, and in Lubbock, Texas, made reference to Spanish heritage in their locations, as Hoffman's Pomona, California, store and Mackay's grander *palacio* in Tampa had done. Despite their common theme and materials, the 1932 stores are all highly individual in form and idea. The two Florida stores were classified as Superstores.

The Daytona Beach store has an appropriately substantial appearance (fig. 4.26). The block-shaped building, with its large corner piers, sits in a choice location facing a park and the Halifax River. A local architect, who remembered watching the building's pilings being driven into the ground, remarked, "Daytona Beach had never had anything that sophisticated."[36] The solidity of its construction is no illusion and was part of its thematic orientation. It is meant to suggest a fortified structure or castle, just as Mackay's buildings did in Kansas. However, the fanciful ornamentation and its profusion, even on the bronze canopy, as well as the pale yellow coloration, relate to the fortified structures of sixteenth- or seventeenth-century Spain. Sibbert's "castle" in

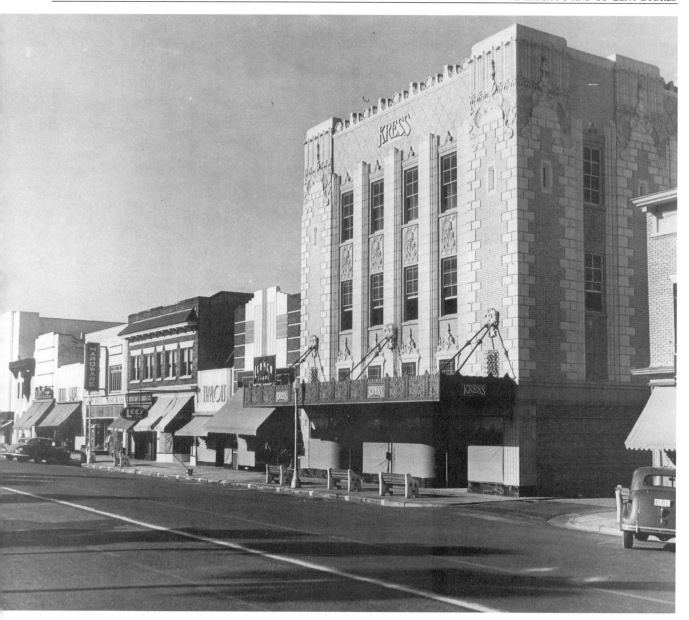

Fig. 4.26. *Daytona Beach, Florida, Kress store. This store is an Art Deco "castle" with arrow-slit windows, or archeria. Courtesy Halifax Historical Society, Daytona Beach, Florida.*

Florida is given a rather free interpretation, blending notions of old Spanish architecture and new architecture relevant to Florida. The mock crenellation on the parapet is formed in part by seashells, emblematic of both Spain and Daytona Beach. The architectural allusion to a historical type might well be lost in the modernism of the design (which includes a large Art Deco relief on the side of the building comparable to those in Durham) were it not for the arrow-slit windows, or archeria, high up on the lateral pylons, elements of a fortified castle. Intricately interrelated patterns of brick, terra-cotta, and wrought iron, which cover the enormous surface area, help to counteract the weightiness of the building. The busy nature of the design is contained and balanced by an overall format that is clear and simple.

When the Sarasota Kress store opened, the *Sarasota Herald* stated that the building "clearly defines the modern trend in architecture."[37] However, the definition was couched in a generic format of historic Spanish or Spanish Colonial architecture

(fig. 4.27). The flat, expansive storefront, spread wide between adjoining buildings, was faced with alternating header and stretcher bricks and repetitive window bays under ornamental arches. The screenlike facade—stretching along the sidewalk, with its fully extended, streamlined marquee completely underlit through opaline glass panels—made a perfect backdrop for the flow of pedestrian traffic on Sarasota's Main Street. With its touches of Old Spain and of modernism, this Kress store brought romance and glamour worthy of a 1930s movie set to this shopping street.

Sarasota echoes its Kress forebear in nearby Tampa in some design aspects as well as in its Spanish inspiration (see figs. 3.1 and 3.3 and plate 4). The rhythmic arches organize the upper facade into identical bays similar to the Tampa elevations.

Here the tiers of windows and spandrels are outlined in buff-colored bundled colonnettes meeting buff-colored arches of terracotta blocks instead of cable molding. The lunettes of the arches are also filled with polychrome reliefs. Escutcheons, which proliferate on the Tampa store, are an important item in Sarasota, too, as the central motif beneath each arch and again at the top of the parapet. The parapet swells in the center to form a graceful arch ornamented with flattened scrolls as well as the shield. Just beneath is a metallic gold terra-cotta logo rendered in the older style of letters used in Tampa, against the same kind of buff-colored panel. It is possible that Sibbert meant to demonstrate a continuity in Kress store architecture on the west coast of Florida, while at the same time manifesting its newness.

Fig. 4.27. *Kress store on Main Street, Sarasota, Florida. Courtesy Florida State Archives.*

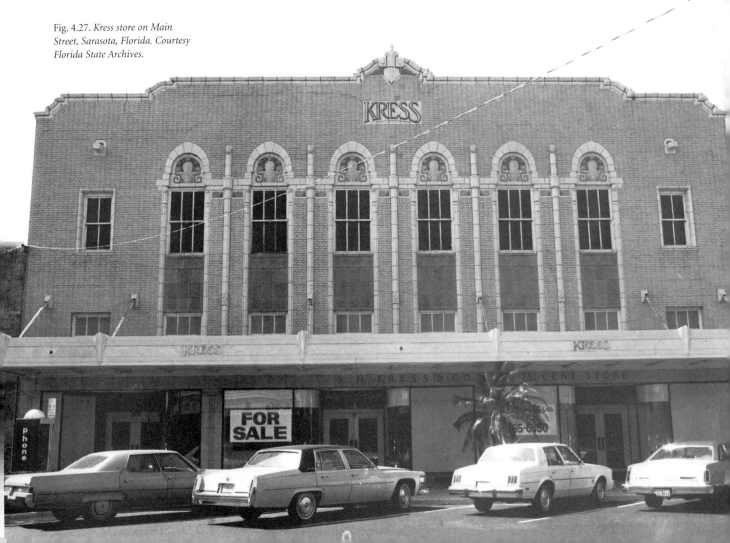

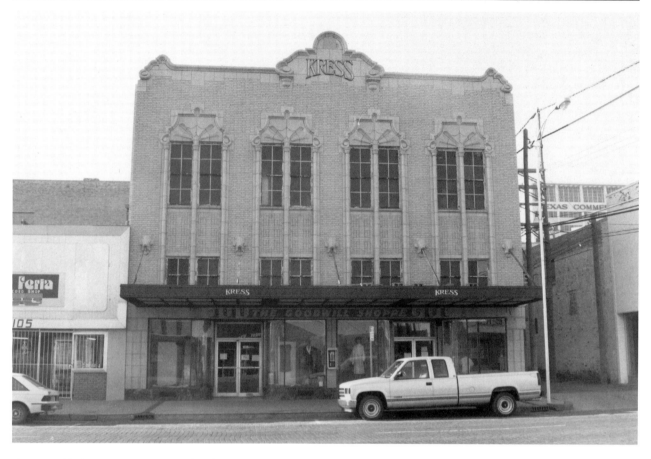

Fig. 4.28. *Lubbock, Texas, Kress store. Photograph by author.*

The shields that figure so prominently on the Sarasota facade invite more than one interpretation. In the context of Spanish Revival architecture, they read as heraldic emblems, simplified into a modern format. They are clearly the focus of the sculptural ensembles, surrounded by orange S scrolls and multicolored leaves and flowers. Within a mixture of high and low relief, they are sculpturally the most prominent. In an interesting reversal, however, the shields are left in plain light buff while the rest of the relief is brightly colored. In color and shape the forms resemble arrowheads, swelling down the middle with jagged edges and coming to a point at the bottom. Moreover, the surface is faceted in such a way as to suggest the surface of a flint arrowhead fashioned with a stone tool. These prominent arrowhead motifs signify the Seminole Indians who once occupied the region. Seminole arrowheads could still be found in abundance around Sarasota in

1932. The motifs are like the rough-hewn logo on the Charleston store, which suggests traces of a primitive tool from another early civilization. Chevron motifs in orange and buff at each side of the show windows and the numerous chevrons inside can also be read as contextual references to Florida's Native American heritage. A more explicit allusion of this sort appeared in 1930 on Robert Law Weed's Mahi Shrine Temple in Miami in the form of standing figures of Seminole Indians on the corners of the facade.[38] In Sarasota, Sibbert simply used a representative artifact, well-modeled arrowheads that read alternatively as heraldic emblems.

The Lubbock, Texas, store differs from those in Albany and Atlanta, and, indeed, from all of Sibbert's brick and terra-cotta buildings, in being monochromatic (fig. 4.28). The brick and terra-cotta match perfectly, and no polychrome terra-cotta appears on the facade. Deep-green marble

bulkheads add some color, as does a dark copper marquee with silver-colored aluminum nameplates. A metallic gold logo shines from the top of the facade, which has a simple elegance that comes from a play of forms. Rich, cream-colored terra-cotta is used like piping to outline the flat elevation and its separate parts. Four sets of double tiers of windows and spandrels spaced equally across the front in the manner of the Albany and Hilo stores are outlined with tubular molding used again as mullions. The same molding creates Spanish-style frames over each double bay with enrolled terminals that encompass splayed, sunken rays in a panel of terra-cotta. The parapet rises in the middle to form a Spanish-style gable highlighting the logo and slightly raised brackets ending in flattened scrolls at each end. The contours of the terra-cotta molding and mullions enhance the beauty of the monochromatic facade. This arrangement, with the shell-like niches over the windows and the design of the storefront overall, recalls a Spanish mission special to all Texans: the Alamo.

The three-dimensional wall plaques masking the transition between the marquee's hanger rods and the wall to which they are attached make another reference to Texas, one that was possibly more localized (plate 12). These five sculptural pieces are unmistakably Art Deco shapes and ornament. They are also recognizable as stylized heads of cattle—which Carla Breeze further identifies as Hereford cattle.[39] In Lubbock, cattle raising was the principal economic activity and one that determined the well-being of both the town and the Kress store. Depicting heads of cattle was thus an excellent way to localize this Kress store. The ornament becomes a canting device, speaking the phrase "head of cattle." This kind of witty reference device would recur in different guises in Sibbert's work.

The Lubbock, Sarasota, and Daytona Beach stores all used a new kind of support member on the main selling floor. It appeared again the following year in Bakersfield and Berkeley, California, after which it seemed to disappear from Sibbert's repertory (fig. 4.29). The support is a smooth, round shaft surmounted by a circular capital divided into three zones. Broad leaves unfurl in the wider middle zone in the manner of an Egyptian lotus capital, and a narrow frieze of chevrons makes up the lower zone. The upper zone is a band of flattened pyramid shapes formed by four stylized acanthus leaves highlighted with drill holes, alternating with squares of layered chevrons. In using acanthus leaves, Sibbert broke with his stated preference for avoiding classical styles, but he maintained continuity with earlier Kress designs that used acanthus-leaf columns in a traditional Corinthian format. However, Sibbert chose to puncture his arrangement of acanthus leaves with drill holes, imitating marble carving in classical antiquity—a characteristic device for emulating in plaster and terra-cotta the tool marks and process of marble and stone carving.

Fig. 4.29. *Capital, Berkeley, California, Kress store, Sibbert's choice for several store interiors in 1932. Photograph by author.*

BRICK AND TERRA-COTTA STOREFRONTS: THE LAST OF A GENRE

Sibbert continued to design brick and terra-cotta storefronts for several more years. Included among these are Bakersfield, California, in 1932 (the same year as Daytona Beach); Berkeley, California, which opened exactly one year later; and finally, Meridian, Mississippi, which opened in 1934 (see plate 1). After this, Sibbert discontinued the use of face brick as a building material until the end of his tenure.

"This building's in Berkeley. And Bakersfield. And . . ." So reads the title of Betty Marvin's 1970 article in a Berkeley newspaper discussing the Kress store as part of the city's architectural heritage.[40] To Marvin, the Berkeley store was one of many nearly identical Kress stores across America dating from the 1930s that she grouped under the rubric of "Kress moderne design." While recognizing their commonality, she failed to see the differences in conception among these "Kress moderne" buildings.

Both the Bakersfield and Berkeley stores are boxlike corner buildings with brick-faced walls and terra-cotta ornamentation. They both have copper marquees that turn

Fig. 4.30. Bakersfield, California, Kress store. Photograph by author.

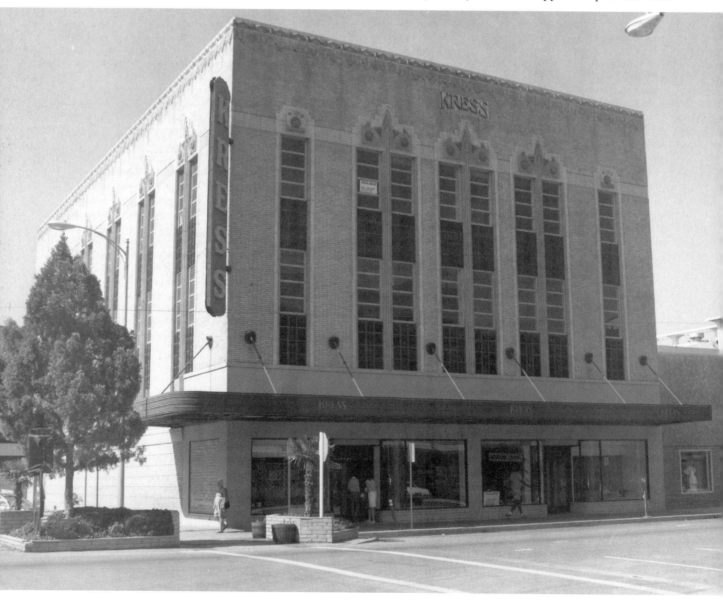

a corner to shelter an additional show window on the side. Bakersfield is manifestly modern in design, with no historical implications (fig. 4.30). The marquee is streamlined by horizontal lines broken in three places by small insets of the Kress name in aluminum letters. The whole marquee is underlighted through white opaline panels. Berkeley, on the other hand, has a traditional red-and-gold store sign spelling out in full, "S. H. Kress & Co. 5–10–25 Cent Store," empaneled in the face of the otherwise up-to-date marquee (see fig. 4.32). Bakersfield, like Amarillo, has a long store sign at the corner of the building, but the letters here are in neon.

A delicate linearity characterizes the Bakersfield store, as seen in a thin cresting of polychrome chevrons and flowers backed by a plain horizontal coping and, underneath, a frill of large and small chevrons in raised brick that reinforces the straight lines of the roof. The principal ornamentation on the Bakersfield store is a striking and original bas-relief in an Art Deco style above tall window bays on the front and side elevations. Shiny orange balls stacked in inverted triangles in these reliefs, flanked by segmented orange blossoms, are reminders that orange groves were the basis of the economy in Bakersfield in 1932 (plate 13).[41] Orange-juice stands dotted the road leading down the San Joaquin Valley to Bakersfield, inspiring imaginative roadside architecture. Blowups of oranges appeared on top of the stands, and sometimes a whole stand would take the shape of an orange.[42] In Kress candy departments, a major seller was an orange-flavored candy shaped like an orange slice. A former store manager recalled selling a ton of orange-slice candy at a special price of twenty-nine cents a pound during a Saturday promotion.[43] The year the store opened in Bakersfield, the office in New York devised a window display to promote the candy, sending out photographs and directions for setting it up to all the stores. The display showed whole oranges made of candy slices, with a placard that read, "As Natural as a Real Orange" (fig. 4.31).

Fig. 4.31. *Learner's display window, featuring Kress's popular orange-slice candy, 1932. Courtesy Hudgins, ed.,* We Remember Kress.

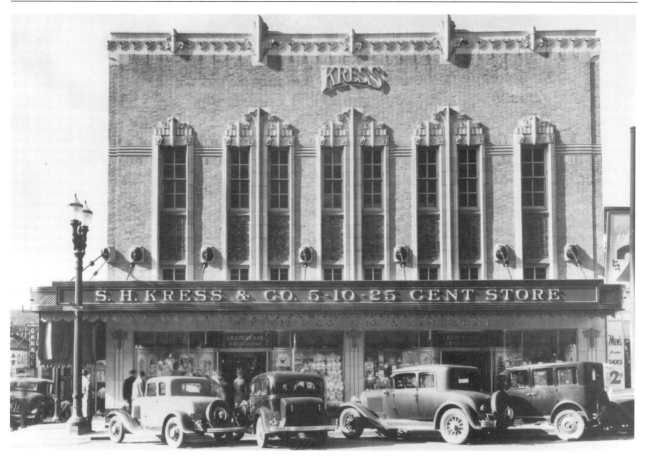

Fig. 4.32. *Berkeley, California, Kress store, front elevation, Shattuck Street, with long store sign incorporated on marquee. Courtesy National Building Museum, gift of Genesco, Inc.*

The Berkeley store (fig. 4.32) is larger than the one in Bakersfield and has a longer side elevation (see fig. 4.35). The Berkeley and Bakersfield stores had similarly reinforced construction because of their locations. The building contractor stated that the walls of the Berkeley store were "especially designed and braced to withstand earthquake shocks and tremors."[44] Part of the lore of the Kress building in Bakersfield is that it withstood an earthquake in 1957. Berkeley has a more solid appearance primarily because the basic brick is richly glazed in brown and buff hues and the terra-cotta trim is more highly modeled. The treatment is consistent with the theme of Mayan architecture insinuated throughout the ornamentation, in part through a single, oversized terra-cotta motif at the sides of the display windows. References to Mayan architecture are more appropriate here than in Charleston, since California was once a part of Mexico.

Seventy-three tons of baked clay were required to make Berkeley's pale terra-cotta ornament, brushed lightly with pale glazes in selected places to make it stand out against the variegated walls of a deeper earth tone (plate 14). The ornament above the windows is a complex configuration of parts, half Mayan and half Art Deco. It is not unlike some of the more delicate embellishment on the Durham store. Pairs of butterflylike sculptures are encompassed by taller reliefs above the three middle tiers on the front elevation. Similarly conceived sculptures rise like Mayan headdresses above the roofline at regular intervals—twice at each side of the logo and seven times down the side elevation. They animate the roofline, along with smaller intervening sculptures and a continuous band of chevrons. The crest, which unfolds in steps, is brushed with yellow-gold, darkening slightly with each receding layer, while touches of green

and orange appear intermittently along with gold lower down on the face of the walls. The motifs on the side piers are, by contrast, completely covered with a mottled glaze of olive green.

Archival materials of the terra-cotta supplier, Gladding, McBean & Company of Lincoln, California, as well as photographs of models there and in the Gladding, McBean Collection in the California State Library in Sacramento, help reconstruct some of Sibbert's approach and the role he played in designing the Berkeley Kress store. Sibbert provided written instructions that the polychrome work "was to be put on lightly so that the body color of buff shows through it. That is, the general effect will be mottled and the colors will not be vivid and strong."[45] In the same letter he stated, "We cannot give you any definite information as to what the body color will be or what the trim colors will be until we receive samples of the face brick with which the terra-cotta will be laid up." He would wait to have both brick and terra-cotta samples in hand "so that we may give consideration to the whole color ensemble of the facades at the same time."

Sibbert recalled using terra-cotta "because it was durable, easy to clean, colorful, and liked by Mr. C. W. Kress, President."[46] He approached the facades as both a sculptor and painter and was equally meticulous on both counts. He rejected as too light three panels of dark-tan terra-cotta for facing the base of the side elevation. He made notations by hand on photographs of terra-cotta models indicating that ornamentation over the windows was "too flat." On models for the crest of the building, Sibbert noted that a chevron was too wide and reshaped the wings of the principal form above the roofline. For the distinctive Mayan-inspired ornament on the first-floor piers (figs. 4.33, 4.34), he drew on the model and supplemented this with a marginal sketch of the desired result. Finally, after much refining, he initialed his approval of the models. In the end, there was satisfaction all around.

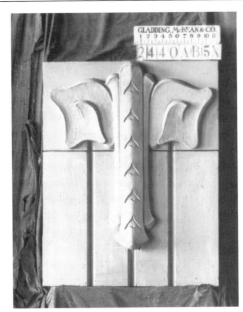

Fig. 4.33. *Berkeley, California, model for terra-cotta ornament. Gladding, McBean Collection, courtesy California History Section, California State Library, Sacramento, California.*

Fig. 4.34. *Ornament on side piers, Berkeley, California. Photograph by author.*

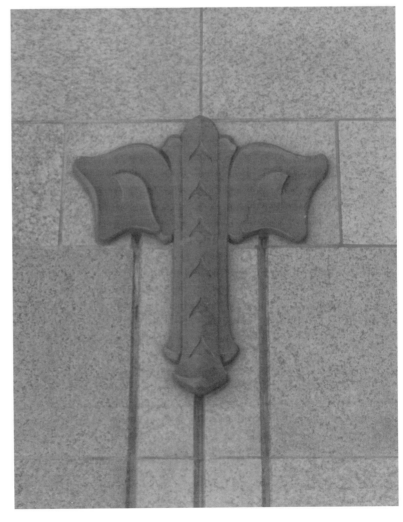

Atholl McBean reported in a memorandum to M. F. Johansen, who dealt with Kress for the company:

> Mr. Smith of the Dinwiddie construction Company . . . said this was the best Terra Cotta he has ever seen; that it is very straight and true and jointed up nicely Mr. Kress was here from the East, as well as his architect, and that they both were favorably impressed.[47]

Fig. 4.35. *Berkeley, California, Kress store, Addison Street elevation. Courtesy National Building Museum, gift of Genesco, Inc.*

Sibbert also incorporated ironwork into his design in Berkeley, as he had done in Day-

tona Beach, where he turned a necessary grille guard on some first-floor windows into a consistent decorative element. In Berkeley he made the fire escape on the side of the building an attractive feature, with two balconies whose openwork repeated the terra-cotta shapes, but in a geometricized Art Deco format (fig. 4.35). The whole cast-iron structure was painted ivory to conform to the color scheme.

Kress storefronts alternated between brick and terra-cotta until 1934, after which all–terra-cotta storefronts became the norm. However, stores with more than one street elevation would not be realized totally in terra-cotta until 1937–1938 in a corner store in Birmingham and in an exceptional design for El Paso (a store with three sidewalk elevations and three separate public entrances).

PHOENIX, ARIZONA

The Superstore in Phoenix, designed in 1933, gives evidence of a growing preference for terra-cotta over brick. A drawing of the front elevation shows both brick and terra-cotta cladding, but the latter material was used (fig. 4.36). Marcus Whiffen and Carla Breeze described the store in their book *Pueblo Deco* (1984) as an Art Deco building of distinction.[48] Regrettably, the building was torn down the year their book was published.

The Phoenix store presented a restrained facade, with a generous allotment of wall space faced with flat terra-cotta blocks and six narrow tiers of windows and spandrels gathered together across the middle (fig. 4.37). The terra-cotta was a pale rose color, an appropriate choice for a city in the desert. The facade was conceived in terms of linear geometry and thinly stepped layers, from the roofline to the octagonal soffits for double hanger rods supporting the canopy. The large, thin, fanlike motifs that dominated the roofline evince the same aesthetic. Much of the beauty of this facade lay in the six geometric orange-and-green butterfly forms overhanging the upper-story windows.[49]

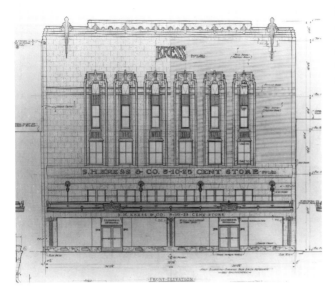

Fig. 4.36. *Phoenix, Arizona, Kress store, drawing of front elevation offering face brick as an alternative to terra-cotta. Courtesy National Building Museum, gift of Genesco, Inc.*

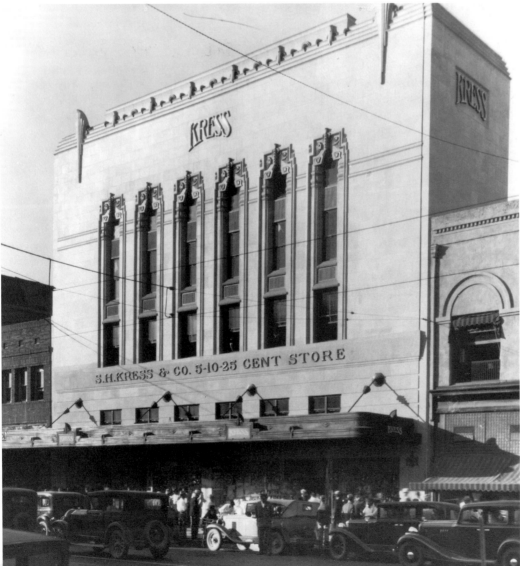

Fig. 4.37. *Phoenix, Arizona, Kress store (now demolished). Courtesy National Building Museum, gift of Genesco, Inc.*

The facade reads as an abstract Art Deco design and as a schematic interpretation of Mayan sculpture and architecture. These distinct ideas were layered and yet blended into one. The Mayan references were particularly strong in the window bays, which narrowed as they rose, like stanchioned walls, terminating in corbeled arches created by the butterfly ornament. The setback parapet at each end and the butterfly shapes and coloration contributed to the configuration.

Whiffen and Breeze comment on the elongated forms stretching up from the parapet wall to a height above the stepped parapet, forms "which from a distance look like nothing so much as huge lizards clinging to the top of the wall, although in fact they are composed of abstract forms."[50] Sibbert's choice of terra-cotta blocks for the wall instead of bricks works with this interpretation. Lizards would be found clinging to walls of stone blocks or steps of a pyramid, and lizards in a stylized format are part of the sculptural vocabulary of Mayan art. More than this, lizards scuttling up walls or over steps, or clinging to them immobilized, are a common sight in desert locales. They also let go on occasion, falling straight down, as the vertical lines and thin, pointed tails of these lizardlike sculptures suggested. The implied movement—or absence of it—fits both readings of the storefront. A reptile with evolutionary roots far back in time, frozen in motion on a sun-baked wall, evokes the mood of an ancient civilization. A long, thin lizard dropping straight down the wall in an uninterrupted descent fits nicely with the idea of speed and efficiency implicit in an Art Deco facade. Thus this reptilian ornamentation served much the same purpose as Sibbert's plant forms. The implicit motion straight up and down intensified the formal vertical stress. It is also possible that live lizards were sold in the store in Phoenix. They were for sale in Aberdeen, Washington, in 1962, where they and a number of parakeets were reported to have survived a serious fire in the Kress store.[51] Perhaps the Phoenix lizards were, once again, an allusion to Kress merchandise.

EAST ORANGE, NEW JERSEY

Sibbert's 1932 storefront for East Orange, New Jersey, like the Greensboro store, was white terra-cotta with polychrome embellishment. In East Orange, however, the basic material was pure white, not granitized or mottled. The combination of white terra-cotta and black marble bases struck an appropriate note of modernity and sophistication for this wealthy bedroom community, many of whose residents worked in New York City. This Kress Superstore was one of thirteen buildings constructed between 1925 and 1933 along a two-block stretch of Central Avenue. The buildings are all either neoclassical or Art Deco in style; they are all low-rise with a pronounced horizontality; and they are all very light in color, creating a distinctive, homogeneous streetscape that suggests adherence to development guidelines (fig. 4.38). Kress's wide, two-story facade sheathed in white terra-cotta would have fit in perfectly. A 1932 aerial survey of downtown East Orange in the Kress archives, along with a 1931 photograph of the building directly across from the future Kress store, shows that Kress's architectural division took into account the new store's immediate environment. The resultant Kress store both conforms to and stands out from the other buildings as the most imposing on the block.[52] The Kress store also influenced the appearance of other stores in the group that later adopted the same black serpentine bulkheads.[53]

The quality of the design of the East Orange store has been recognized from the beginning. Shortly after it opened in 1933, the Federal Seaboard Terra Cotta Company, which supplied the terra-cotta, pictured the building on the cover of an advertising brochure.[54] *Chain Store Age*, celebrating S. H. Kress & Co.'s fiftieth anniversary in 1946, published a half-page photograph of the store. The Samuel H. Kress Foundation's sixtieth-year annual report, published in 1989, showed Sibbert's plans for the front elevation of the East Orange Kress store on the cover (fig. 4.39).

The facade of the Superstore in East Orange is like those of Superstores in Charleston and Daytona Beach. It is organized as a wide, slightly recessed center section between somewhat higher end sections or pylons. The East Orange storefront contrasts with those of the other Superstores in being lower and wider, having two stories instead of three, and having seven bays of windows and spandrels between colossal pilasters in the center section. The breadth of the facade is accentuated by the staccato rhythm of identical units side by side and similar window bays in the pylons. The long sweep of the copper marquee, requiring seven hanger rods, seems even longer because of the flowing horizontal lines on the face—two single lines and a middle group of three. East Orange shares an aspect of monumentality with the other Superstores, which is supported by its own individualized theme.

The East Orange storefront is predominantly Egyptian in style, with possible Mayan accents. The theme is established by colossal pilasters befitting an Egyptian temple, topped with stylized Egyptian palm-leaf capitals. Enrolled angular forms emanating from the bundled shafts at the base of collarettes create corbels across the topmost window panes, suggesting canted wall openings or corbel arches. The notion of an Egyptian temple persists inside, on the selling floor, where open capitals mimic the papyrus columns of the great temple at Karnak.

Sibbert's taste for organic forms is evident in the East Orange store. A stylized green and orange palmette crests the center of the parapet, and stalks of a desert plant climb the center of the pale green spandrels in the pylons, moving toward layered chevrons. In the windows above, other plant forms begin as white keystones, growing up the wall to blossom in a pair of orange flowers and continuing beyond to sprout stacked green leaves. The movement generated by the organic ornamentation provides a dynamic contrast to the solid massing of forms on the facade.

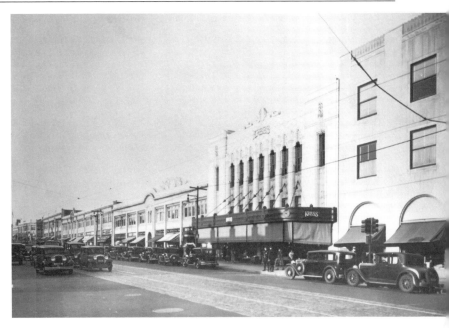

Fig. 4.38. *East Orange, New Jersey, Central Avenue shopping district. Courtesy National Building Museum, gift of Genesco, Inc.*

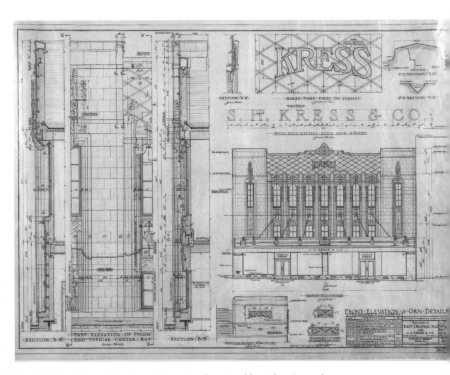

Fig. 4.39. *East Orange, New Jersey, Kress store, drawing of front elevation and ornamental details. Courtesy National Building Museum, gift of Genesco, Inc.*

COLUMBIA, SOUTH CAROLINA

The 1935 store in Columbia, South Carolina, like the store in East Orange, is a wide, two-story building faced with white terra-cotta (fig. 4.40).[55] Columbia's facing of mottled white terra-cotta blocks is suggestive of limestone or granite and contributes to its monumental quality. An alley runs beside the building, allowing for a finished block wall several feet deep down to the marble bulkhead. The whole elevation is aligned on a single surface plane, broken slightly at each end by wide, convex-reeded pilasters. The window treatment is simple: one row of eight double-hung windows separated by smooth pilasters with flat, undulating capitals that step where the windows stop.

Terra-cotta blocks play an ornamental role on this storefront. Blocks highlighted with two small, angular accents are set beneath the second-story windows and above those on the mezzanine, and others near the roofline are formulated as cavetto moldings with overturned lips, similar to those on the side sections in Durham and Daytona Beach. The coping is another row of blocks that build slowly in height toward the center, creating a gently curved roofline compatible with gently curved pilasters. A block forms the backing for each gold letter of the long store sign—S. H. KRESS & CO. 5–10–25 CENT STORE—which helps to incorporate the sign into a storefront organized around the unit of the block. The metallic letters, like those of the logo, are outlined in

Fig. 4.40. *Columbia, South Carolina, Kress store. Vertical sign is later addition. Courtesy National Building Museum, gift of Genesco, Inc.*

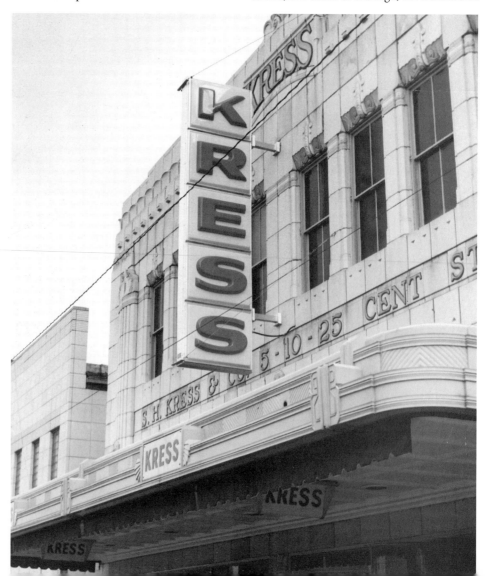

black. A simple floral composition in pastel shades of orange, blue, and untinted terra-cotta provides an ornamental crest above the logo. Variations of the floral motif appear on the upper sides of the building, more prominently atop the reeded pilasters, and again beside the show windows. Flowers and leaves in stronger tones of orange and green provide lintels for the second-story windows, in the midst of which a single plant stalk arises, blending in color with the blocks. The rather inconspicuous vertical stalk is by now recognizable as one of Sibbert's standard design motifs.

One of the most striking parts of this storefront is the two-tiered copper marquee, similar in outline to those in Berkeley and Phoenix. However, Columbia's marquee is distinguished by two outsized butterfly shapes at either end, a linear adaptation in metal of a familiar terra-cotta motif. Here, the butterfly motif could be read as a monogram incorporating the letters EFS. If the reading is intended, the architect has discreetly signed his work.

Octagonal wall plates for the marquee's hanger rods (a detail also used in Phoenix) coordinate with the shape of the eight-sided support members inside on the selling floor (figs. 4.41, 4.42). They recall similar ones in East Orange, but here the faces of the wide, splayed capitals are covered with graceful branches in low relief and banded with stemmed buds and small open spaces. These decorative capitals, which add much to the beauty of this interior, also provided air vents for the heating and cooling system. This other purpose accounts for the cutout portions of the reliefs. The engineering function was disguised by painting the background areas behind the branches dark brown to accord with the naturally dark empty spaces.

The capitals, sitting on octagonal columns, run straight down the middle of an open space 155 feet long. Engaged columns and capitals of the same design run down the walls at each side. The free and engaged architectural members stand tall among rows of hanging lights suspended from octagonal coffers in the ceil-

Fig. 4.41. *Columbia, South Carolina, Kress store, with standard bell-shaped globes and custom-designed capitals on the main selling floor. Photograph by author.*

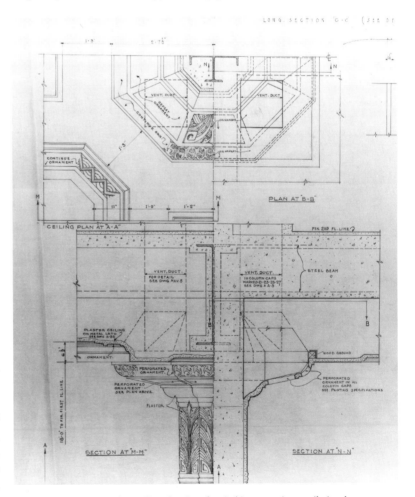

Fig. 4.42. *Columbia, South Carolina, drawing of capital incorporating ventilation ducts. Courtesy National Building Museum, gift of Genesco, Inc.*

ing, traced inside with corresponding orna- ment and plain, stepped strips. When the great room is lighted with the 300-watt bulbs used in these chandeliers, it seems more like an elegant ballroom than a five- and-ten.

When this Kress store was nominated to the National Register in 1979, a request was made that the fifty-year age requirement be waived because it was "the best example of the Art Deco style in Columbia and . . . therefore of exceptional importance as a city landmark."[56]

ANNISTON, ALABAMA

In the near-white terra-cotta front of the Anniston store, which opened in 1935, there is no suggestion of the architecture of an ancient civilization, only that of mod- ern times (fig. 4.43). The facade was actu- ally a new front for a 1917 Kress store that, in turn, had replaced a 1905 Kress store on the same site. Like the storefront, the main

selling floor was radically altered to appear up to date (see fig. 1.14). The basement sales floor showed signs of age in its thin, cast-iron columns, which were not replaced. The sash windows on the front could also be relics of a previous design. But the metal standards at the bases of five tall pilasters separating the windows, each car- rying one letter of the name Kress, were new in Kress store design, having appeared only once, the year before, in truncated form as part of a copper awning box in Hollywood, California.

The facade has a golden sheen, created by a glaze containing tiny gold flecks on the terra-cotta and by roughly textured win- dow panes tinted with gold. The decorative ornamentation is generously glazed with yellow gold. A long store sign runs between the mezzanine and upper windows; the full complement of metallic gold letters and the prominent logo in high relief contribute to the effect.

Fig. 4.43. Anniston, Alabama, Kress store, 1935. Courtesy National Building Museum, gift of Genesco, Inc.

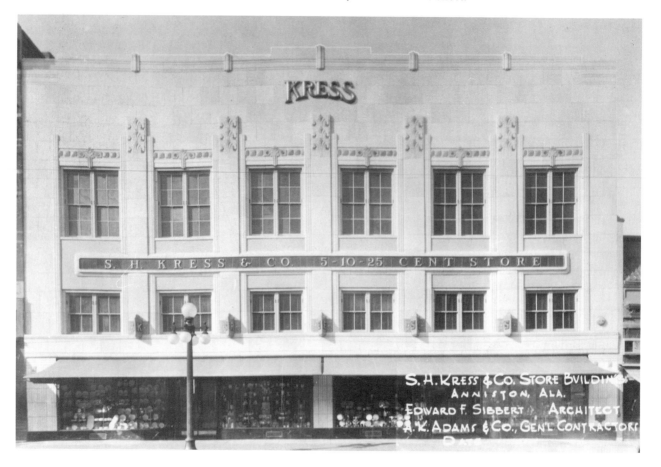

The principal ornament at the top of each pilaster, a three-tiered design with centers of glistening gold, calls to mind a tiered stand on a counter displaying false eyelashes. The lids, as it were, are underlined in black or dark brown, suggesting eye liner and mascara. The gold-luster forms in the lintels might read as compacts, and, beside them, the flowers in squares with red concave centers also suggest face rouge in such containers. The store's cosmetics department was of some consequence in the Kress Company and may be the key to this imagery.

In the 1930s S. H. Kress & Co. had its own brand of cosmetics, called Elizabeth Post, which it advertised as "Exclusive with Kress." Cosmetics had become a major industry in the United States by 1935. Women had started to adopt a new, modern image, aided by makeup, which it was now acceptable to wear in public places. The new look involved "pencil-thin, highly arched eyebrows, long false eyelashes blackened with thick mascara," rouge, powder, and lipstick.[57] With the help of cosmetics, the average American woman could aspire to be as glamorous and sophisticated as a movie star. For many American women in the 1930s, the process began in a Kress store.

HOLLYWOOD, CALIFORNIA

The Hollywood Kress store, which opened in December 1934, departed from the Kress canon by having a cast-concrete facade (fig. 4.44). The building had other exceptional features. The three-story facade was massed so as to build toward a stepped, recessed tower that displayed the name Kress in outsized neon letters on the three faces seen from the street. The sign itself echoed the huge Kress sign angled on the rooftop of the store in Asheville, North Carolina (see fig. 2.23). This time, however, the electrified sign was incorporated more closely into the architecture. In turn, a conspicuous logo in the center of the parapet was eliminated.

When the Kress store was built, its Hollywood Boulevard location was synonymous with glamour and fame as the shopping street for the film capital of the world. It was

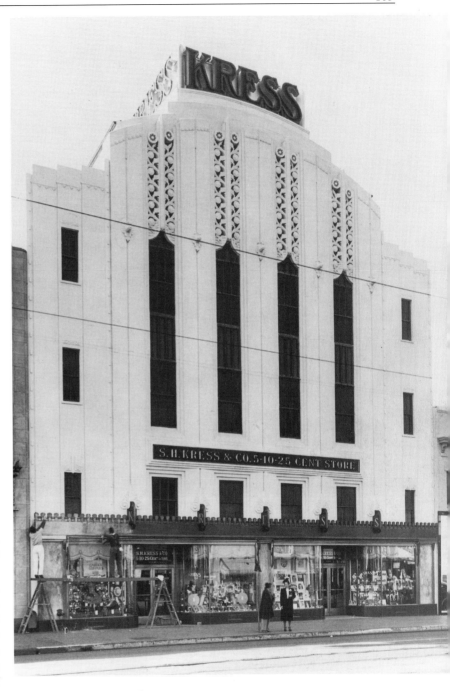

Fig. 4.44. *Hollywood Boulevard, Los Angeles, 1934, among the few Kress stores made of cast concrete. Courtesy National Building Museum, gift of Genesco, Inc.*

lined with elegant shops, famous restaurants, and premiere movie theaters, which were themselves fabulous stage sets, inside and out.[58] The white Kress building—soaring above most of the surrounding two-story buildings, with its middle section ornamented with stalks of flowers in the form of backlighted concrete grilles, and with its neon-lit tower—held its own on the shopping street of the stars. The store was clearly planned to stand out from the low, expansive storefront of its abutting neighbor and rival, J. J. Newberry, with its turquoise and gold ornamentation. On a company photograph surveying the site, two notations appear: "JJN," with an arrow pointing to the Newberry building, and "dark blue-green terracotta."[59] Kress's simply massed, vertically oriented white storefront is ornamented primarily by its dramatic flowers, with very few touches of color.

Inside, the Kress store contributes its own glamour to the Hollywood shopping experience. The surfaces of the main selling floor and an auxiliary sales floor in the basement are awash with polished marble, mirrors, and shiny bronze trim. The materials were not unusual for Kress, but they were used abundantly in the Hollywood store. One of the most glamorous features is the staircase leading down to the basement (fig. 4.45). The customer descends marble steps beside a wall faced with polished marble, holding on to a gleaming bronze handrail. The effect of this polished expanse is enhanced by the marble's decorative, figured patterns. On the staircase wall, paired marble slabs from the same crosscut, reversed and carefully joined, create larger decorative patterns all the way down the staircase.[60] The marble-clad walls of the front of the store and the marble

Fig. 4.45. Hollywood Boulevard, Los Angeles, Kress store, staircase to basement sales floor. Courtesy National Building Museum, gift of Genesco, Inc.

Fig. 4.46. *Hollywood Boulevard, Los Angeles, Kress store, photograph of Samuel H. Kress over elevator doors. Courtesy National Building Museum, gift of Genesco, Inc.*

piers topped with lanterns beside the doors are details borrowed from the designs for the Charleston and Phoenix stores. The interior and exterior are integrated in other ways as well. The rows of curlicue wrought-iron balusters supporting the inside bronze handrails accord with the row of stemmed filigree ornament on the facade. The double elevators in the rear have stepped marble embrasures like the terra-cotta reveals on the outside windows. A framed photograph of Samuel H. Kress originally hung above the marble elevator enclosure (fig. 4.46; see also fig. 1.1). A portrait of the founder and multimillionaire philanthropist smiling down on customers would have added an elitist aura to the dime-store interior.

America's fascination with Hollywood and the stars who lived there translated into nickels and dimes for S. H. Kress & Co. The display counters were full of photographs of actors and actresses in modern-style frames (fig. 4.47). Anything featuring Shirley Temple sold well among Kress's younger clientele. So did items connected with cowboy movie stars.[61] It was appropriate, therefore, that Kress should open an exceptionally fine store in Hollywood, one that helped to maintain a particular image.[62]

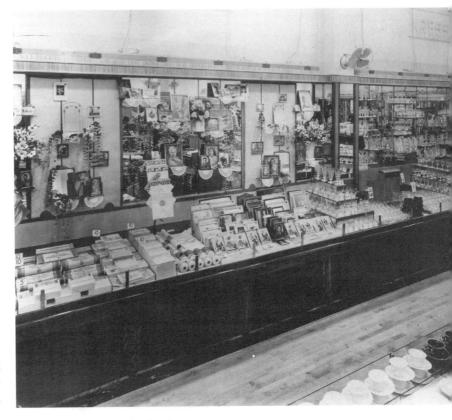

Fig. 4.47. *Framed photographs of movie stars, Kress store, Wilshire Boulevard, Los Angeles, 1938. Courtesy National Building Museum, gift of Genesco, Inc.*

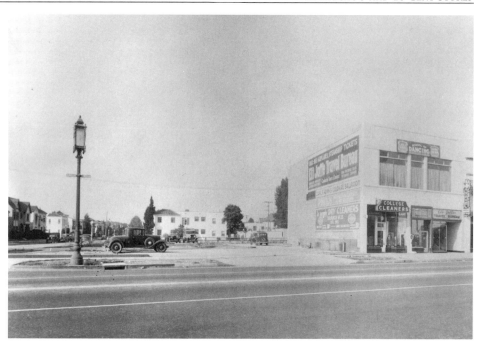

Fig. 4.48. *Empty lot, Wilshire Boulevard, Los Angeles, June 1, 1937. Courtesy National Building Museum, gift of Genesco, Inc.*

The question arises, what prompted Sibbert to use cast concrete (Cemelith) for the storefront in Hollywood? One reason may have been an ordinance, passed after the San Diego earthquake of 1933, that restricted the use of unreinforced masonry, especially brick. Cast concrete had begun to interest architects, most notably Le Corbusier, a leading architect of the Machine Age. Perhaps Sibbert wanted to explore its possibilities and saw his opportunity in Hollywood, given the building restrictions. He used it again in 1937 for a store on Wilshire Boulevard and a third time in San Pedro, just south of Los Angeles, in 1939 (figs. 4.48–4.50).

Cast concrete may also have been intended as an allusion to Frank Lloyd Wright's off-white stucco Hollyhock House, built for Aline Barnsdall and located not far from the Kress store in a park setting on Hollywood Boulevard (fig. 4.51). Wright designed the house between 1919 and 1923, and the building was well known to architects by 1934. Barnsdall is said to have chosen the name after seeing her favorite flower, hollyhock, growing wild on the site.[63] Wright took the name as an emblematic motif, basing his designs for the house's ornament on stylized hollyhock blossoms.

The name Hollyhock House was also a play on words, connecting the house with Hollywood.

The Kress store recalls Hollyhock House as seen from the west. Designed as a large central block above an expanse of plate glass at ground level, flanked by lower wings at the sides, the house has a smooth, canted upper section trimmed at the base with a frieze of conventionalized hollyhocks. The side blocks are similarly adorned with proportionately smaller motifs. All the shapes are rigorously geometric. Wright's Hollyhock House suggests a Mayan temple.[64] Sibbert's Kress store has similar references to Mayan architecture in its massing, in its corbeled arches over the upper-story windows, and in ornamentation such as the Mayan-inspired motifs on the wall around the metal stanchions holding the letters of the Kress name.

The most revealing correspondence between the Kress store and Hollyhock House is the use of stylized hollyhocks as ornament. The four tall stalks of hollyhock in a row over the tiers of the store windows are given special emphasis. They are the only conspicuous ornament on the facade, huge by comparison to anything else and highlighted at night with their own indirect

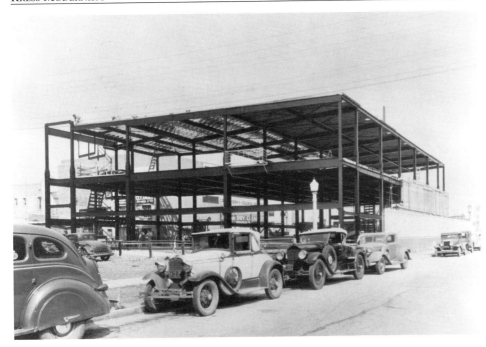

Fig. 4.49. *Steel frame for a new Kress store, Wilshire Boulevard, Los Angeles, October 1, 1937. Courtesy National Building Museum, gift of Genesco, Inc.*

Fig. 4.50. *Kress store, Wilshire Boulevard, Los Angeles, nearing completion, February 15, 1938. Courtesy National Building Museum, gift of Genesco, Inc.*

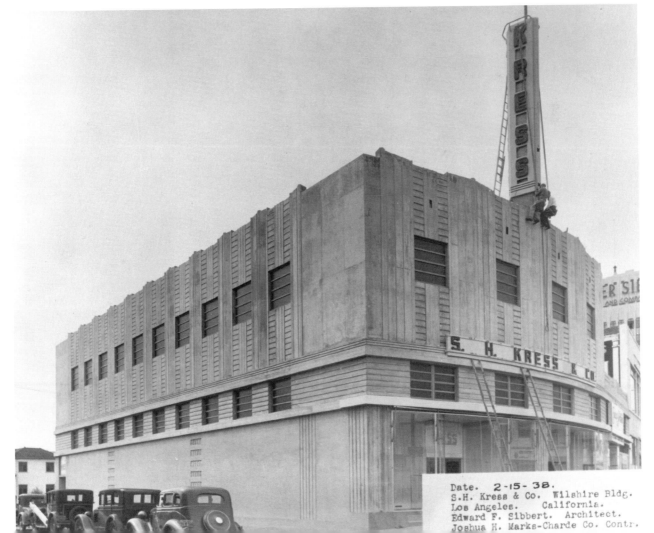

Date. 2-15-38.
S.H. Kress & Co. Wilshire Bldg.
Los Angeles. California.
Edward F. Sibbert. Architect.
Joshua H. Marks-Charde Co. Contr.

lighting. The hollyhock stalks are botanically correct, with leaves and closed blossoms moving up the stem and two open blossoms at the top. The flowers are circular in shape, but slightly irregular, indicating overlapping petals with round centers.

Sibbert contended that he never copied another building, and he did not do so here. Rather, he abstracted the essence of Wright's building, using this as a basis for a Kress store, as he had done with the Alamo in Lubbock. He alluded more specifically, though circuitously, to the locale of the Hollywood Kress store through an architectural quotation of a building on the same street. An allusion to the Alamo would have been easily recognizable to shoppers. Aline

Barnsdall's house would have been less familiar to the general public, even in Hollywood. The architectural implications of the Hollywood store would be understood best by architects and others interested in the work of Frank Lloyd Wright. It was a personal and somewhat private statement, one architect's homage to another.

A recognizable Kress store no longer exists on Hollywood Boulevard; the building's signage was removed and the store was painted purple when it was converted to Frederick's of Hollywood. However, one can see a replica of the old Kress store at Universal Studios in Orlando, Florida, as part of a vintage movie set of the famous Hollywood Boulevard.

Fig. 4.51. *Frank Lloyd Wright, Hollyhock House, Hollywood Boulevard, Los Angeles, circa 1920. Courtesy The Frank Lloyd Wright Archives.*

PLATES

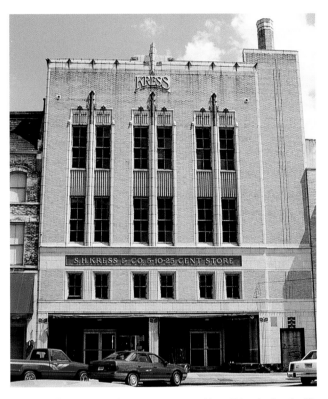

Pl. 1. *Meridian, Mississippi, Kress store, 1934, with traditional red and gold store sign. Photograph by author.*

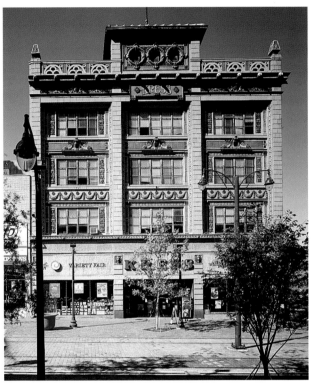

Pl. 2. *Memphis, Tennessee, Kress store, with ground floor alterations. Photograph © 1993 Allen Mims.*

Pl. 3. *Lakeland, Florida, Kress store, designed by George E. Mackay, now a courthouse. Photograph © Bob Braun.*

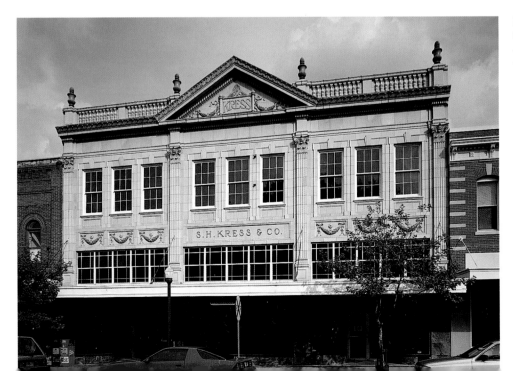

Pl. 4. *Tampa, Florida,
Kress store; George E.
Mackay, architect.
Photograph © Bob
Braun.*

Pl. 5. (below)
*Montgomery,
Alabama, Dexter
Avenue facade, detail
of freestanding
columns. Photograph
by author.*

Pl. 6. *Kress store,
Wichita, Kansas;
George E. Mackay,
architect. Photograph
by Warren Denning.*

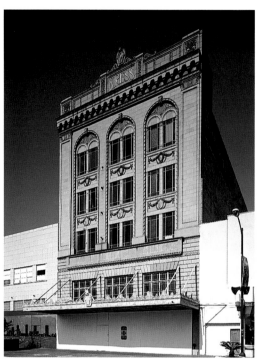

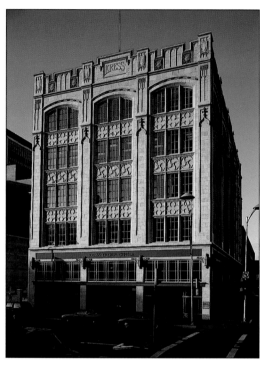

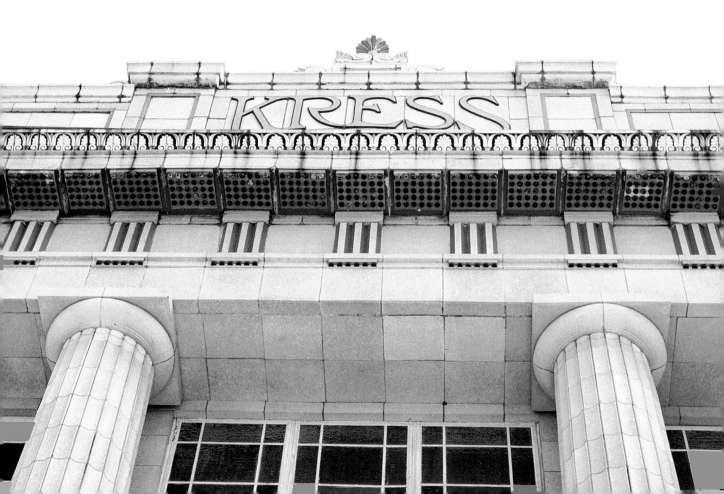

Pl. 7. *Kress coat of arms,* Kress Family History. *Courtesy Samuel H. Kress Foundation.*

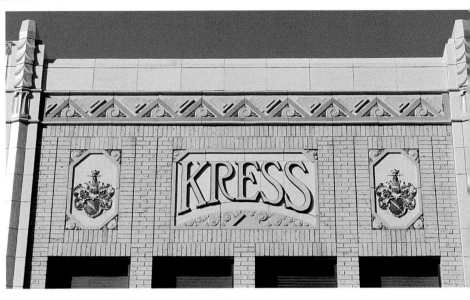

Pl. 8. *Kress coat of arms on a 1930 storefront, Pueblo, Colorado. Photograph by author.*

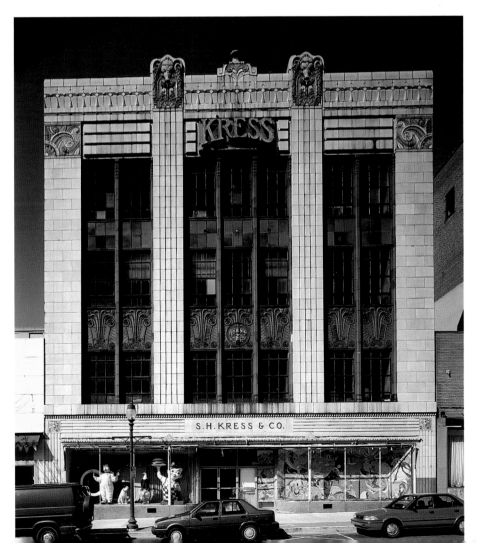

Pl. 9. *Greensboro, North Carolina, Kress store, displaying Kress coat of arms on center spandrel. Photograph by Bob Donnan.*

Pl. 10. *Old Kress store as the BB&T bank, Durham, North Carolina. Photograph by Bob Donnan.*

Pl. 11. *Charleston, South Carolina, Kress store. Photograph by Jack Alterman.*

Pl. 12. *Lubbock, Texas, detail showing ornament's visual pun: "heads of cattle" as anchors for the hanger rods. Photograph by Carla Breeze.*

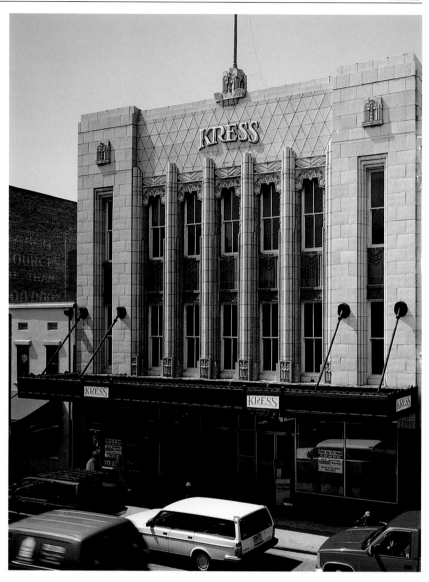

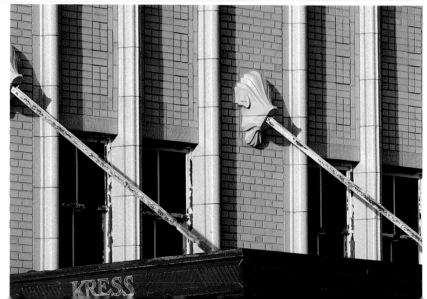

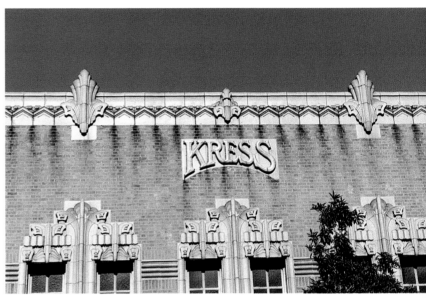

Pl. 13. *Bakersfield, California, Kress store, detail of ornament with orange balls. Photograph by author.*

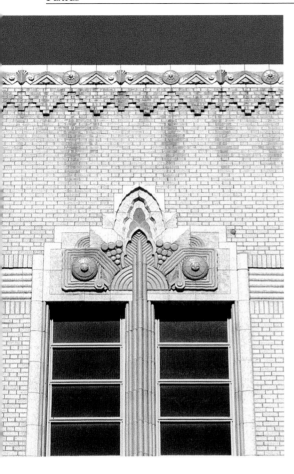

Pl. 14. *Berkeley, California, detail of storefront. Photograph by author.*

Pl. 15. *Male Greek figure, upper facade, Nashville, Tennessee, Kress store. Photograph by author.*

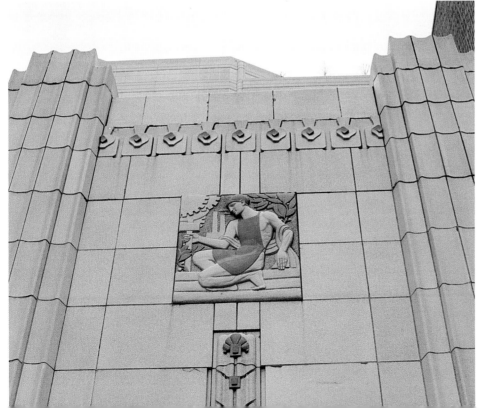

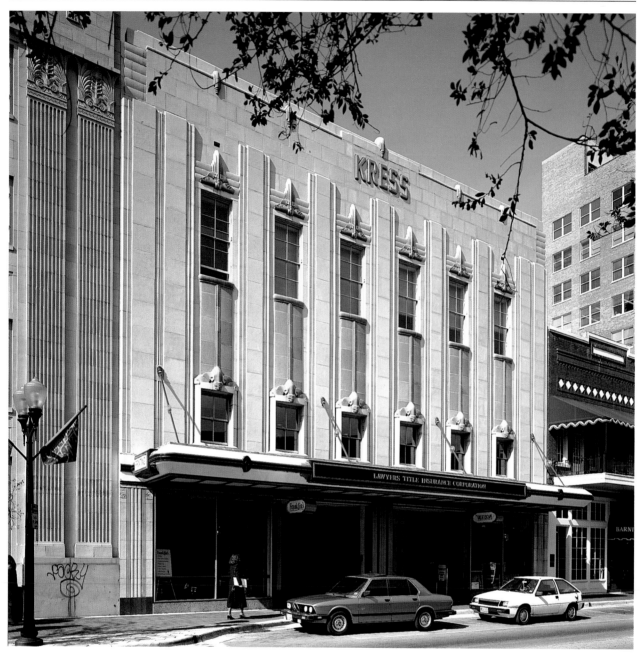

Pl. 16. *Orlando, Florida, Kress store.*
Photograph © Bob Braun.

Pl. 17. *Birmingham, Alabama,*
Kress store. Photograph by author.

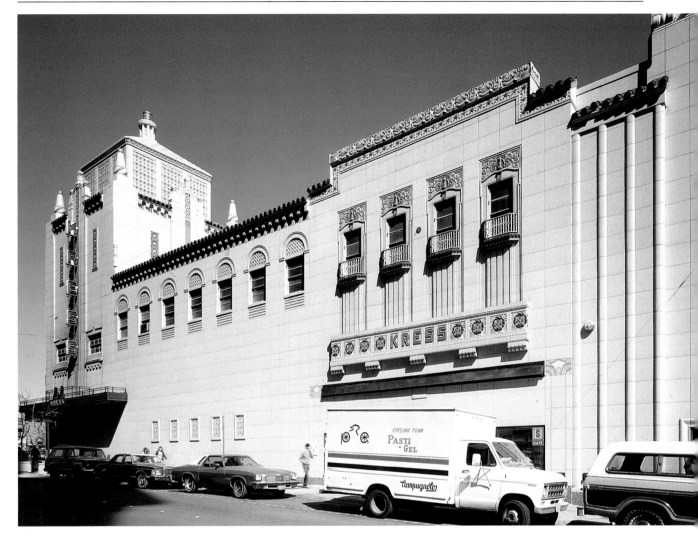

Pl. 18. *El Paso, Texas, Kress store, Oregon Street elevation. Photograph by Carla Breeze.*

Pl. 19. *El Paso, Texas, window with balcony, Oregon Street. Photograph by Irene Soriano.*

Pl. 20. *San Antonio, Texas, Kress store. Photograph by Brent Bates.*

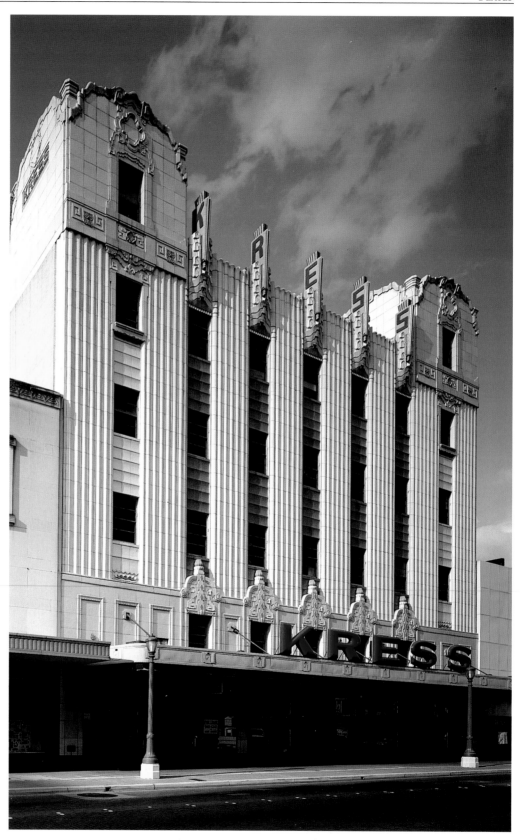

New York/ Fifth Avenue 5

On October 28, 1935, Kress opened a store in New York at 444 Fifth Avenue, at the corner of 39th Street. Described in an advertisement as the "Showplace of the Nationwide Chain," Kress's flagship store was, appropriately enough, on America's premier Main Street.[1] Edward Sibbert designed the store with its function as the company showplace in mind. Seven stories high and sheathed in white marble, it was larger, more lavish, and more technologically advanced than any store in the company's history (fig. 5.1).

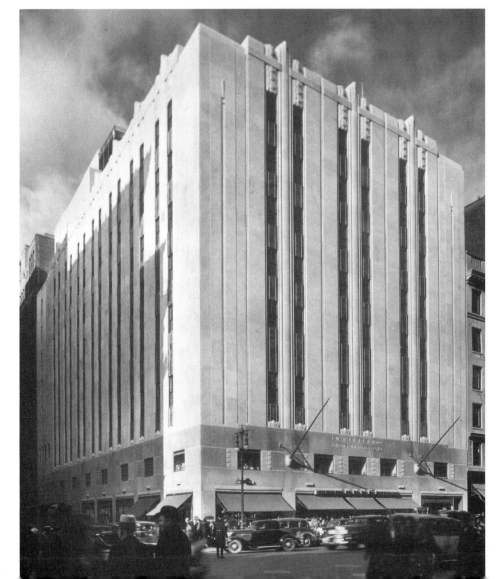

Fig. 5.1. *Kress Company's flagship store, 444 Fifth Avenue, New York City (now demolished). Courtesy Fay S. Lincoln Collection, Historical Collections and Labor Archives, Pennsylvania State University.*

Fig. 5.2. *Edward F. Sibbert, studio portrait, 1930s. Estate of Edward F. Sibbert.*

A critic writing about the store in 1936 in the *Architectural Forum* noted that the building was "the most imposing structure ever built for the exclusive use of a 5-10-25 cent store."[2] Privately within the company, the store on Fifth Avenue was referred to as "Mr. Kress's monument to himself." F. W. Woolworth had built a monument to himself and his dime store chain in the form of the world's tallest building—an office building on lower Broadway, with space for company headquarters. Samuel Kress simply built the world's largest, grandest five-and-ten-cent store.

Sibbert was awarded a gold medal for the Fifth Avenue store at the Pan American Congress of Architecture in 1940 (fig. 5.2).[3] The building also received praise when pictures of it were shown at a joint exhibition of the Architectural League of New York and the American Institute of Decorators in celebration of the league's fiftieth anniversary in 1936. A critic for the *New York Sun,* Charles Messer Stow, called it "one of the good modern buildings in the show," in contrast to generally ultraconservative entries.[4] Another writer concluded, "Mr. Sibbert is apparently one of the coming architects of the U.S."[5] Nonetheless, the Fifth Avenue store was demolished in 1980, having failed to become a New York City landmark.[6]

There is very little original documentation of the lost building; only one company photograph has surfaced to date.[7] During the course of the demolition, a few fragments were salvaged and some were deposited in the Frieda Schiff Warburg Memorial Sculpture Garden at the Brooklyn Museum (fig. 5.3).[8] Bronze trim from the store is now incorporated into the fifth-floor lobby at 60 Hudson Street, where the New York City Buildings Department is located. The Republic National Bank, which bought the Kress store to replace it with a building of its own, reinstalled bronze relief panels from the outside of the

Fig. 5.3. *Architectural fragments of polished dark gray and rosy marble and limestone from the Fifth Avenue Kress store, now in the Frieda Schiff Warburg Memorial Sculpture Garden, The Brooklyn Museum. Courtesy The Brooklyn Museum.*

store on its own Fifth Avenue facade (see figs. 5.5, 5.6). Moreover, the ghost of the Kress building is still apparent in outline in the new bank building—99 feet on Fifth Avenue and 185 feet down the side on 39th Street. The architect chose to keep the skeletal frame of the Kress store and built around it.[9]

In the flagship store, S. H. Kress & Co. finally got its own "white marble palace," reflecting its department store heritage. It was faced above the first floor with white South Dover marble. The ground level was faced with Mount Airy granite, close to the color of the marble, rising above bulkheads of a darker Quincy granite. Tall spandrels between the windows contrasted with the marble in being highly polished, deep-gray granite with roseate streaks, known in the trade as Clark's Oriental granite. The front elevation had a wide center bay, slightly higher than the narrow side wings. The only fenestration was in the middle section, which was filled with three double bays of windows and spandrels separated by uninterrupted, convex mullions ending above the parapet. The window panes were tinted, corresponding to the deeper-toned spandrels between them, so that together the window bays created six darker vertical strips or accents. The same paired windows and mullions breaking through the roofline alternated rhythmically down the long side elevation with marble panels. The intervening panels, front and side, were grooved with a line down the middle. Except for the engaged colonnettes or mullions, the walls were all kept to a single surface plane. The sleek, flat, white marble edifice with strong vertical accents fit into its environment as a New York Art Deco building, Skyscraper Style, to use Cervin Robinson and Rosemarie Bletter's distinction.[10]

Discussing the Kress store in the *New York Sun,* Stow approved of the refreshing absence of tradition in the sparse ornamentation and admired the splendid unity of the building above the second floor. He did not understand, however, why the unity was broken by the strong horizontality of the second story. Stow evidently mistook the mezzanine windows above the entrances and show windows for another story. He did not know that it was considered desirable in Kress store architecture to express the difference between the ground floor sales area and the upper floors, which were devoted to other purposes. For the Fifth Avenue store, the distinction was made apparent by differences in materials and color, and by the lower floors' stress on the horizontal, rather than on the vertical. The large mezzanine windows, for instance, three together at the center and one at each side, had rectangular panes turned lengthwise between layered bands of ornament.

Sibbert redesigned the signage for the New York store, giving it a contemporary look by making the bars of the letters equal in width and the ends of the letters blunt. The company name, in gold lettering, embellished the glass transoms, doors, and show windows at the entrances. Lettering disappeared altogether from the top of the building, to be concentrated in the center of the lower facade above the principal entrance. In a repeat of a design that had been used in the Hollywood store, each letter in the name Kress was mounted on a low standard attached to a metal awning cover, helping to accent the recessed entrance. The familiar sign, S. H. KRESS & CO. 5–10–25 CENT STORE, was given a new treatment, broken into two lines bunched together over the mezzanine windows. The polished granite wall was cut away to reveal the letters against a rough, unpolished ground showing the marks of the chisel, a design that recalls the marble piers beside doorways inside Sibbert's stores, which bear incised decoration on a contrasting unfinished ground. The carved signage on Fifth Avenue assumed an ornamental aspect as well as an informative one, much like the lettering on other retail stores in New York.

At the ground level on both elevations, Sibbert used bronze more extensively than he had before. One manufacturer contended that the fine new Kress store belonged on Fifth Avenue because of its bronze front, since metal fronts were very much in vogue there. Bronze also exemplified "Fifth Avenue

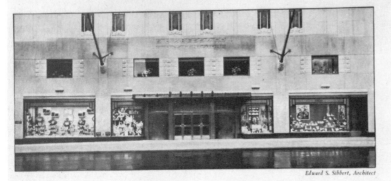

Another far-sighted merchant selects

BRONZE

to exemplify "Fifth Avenue Quality"

Edward S. Sibbert, Architect

IN THE new S. H. Kress & Co. store on Fifth Avenue and 39th Street, New York City, each window was designed as an attractive, refined and unobtrusive frame for the display of merchandise. Each window is of bronze . . . Anaconda Architectural Bronze in extruded shapes from *stock.*

This fine new store "belongs" on Fifth Avenue where bronze fronts are very much the vogue. And it would attract and impress customers on any other avenue in any other city. For metal work of bronze is always in fashion

and up to date . . . yet it need not be costly.

From the standpoint of lower original cost through the use of standard shapes which short cut die costs, Anaconda Extruded Bronze offers almost endless possibilities for the faithful execution of even the most original designs. Thousands of *standard* extruded shapes may be had in Architectural Bronze and Nickel Silver, while Copper and various Copper alloys are available in a wide range of standard *drawn* shapes. These various metals offer interesting possibilities wherever contrast or close color harmony is desired.

THE AMERICAN BRASS COMPANY

General Offices: Waterbury, Connecticut
Offices and Agencies in Principal Cities

ANACONDA EXTRUDED SHAPES

Fig. 5.4. *Advertisement in American Architect,* January, 1936. ©1936 by the McGraw-Hill Companies. All rights reserved. Reproduced with the permission of the publisher.

Quality," an accolade extended to the Kress store (fig. 5.4).[11] Indeed, the abundance of bronze ornament and trim at ground level did make Kress's Fifth Avenue store appear to be of its time. The windows and doors were all framed in natural bronze. Two flagpoles of the same metal angled out over the sidewalk from bases of carved marble drums. The main entrance had a complex arrangement of two sets of revolving doors with a double set of swinging doors in between. For protection at night and whenever the store was closed, there were additional curved bronze enclosures for the glass and bronze doors. A smaller door to the

north of the main entrance had another bronze protective cover. The entrance on West 39th Street was a sleek, streamlined bronze ensemble. A cantilevered marquee sheltered the revolving door. The doorway was encased in a streamlined surround, embossed overhead with the redesigned legend. The ensemble was completed—and the entrance secured—by bronze roll-away doors ornamented with triple vertical lines. A bronze service panel in the wall to the left and five display windows trimmed in bronze on the right expanded the bronze decor in both directions.

The cover for the single door to the north on Fifth Avenue was part of a sculptured triptych—three hinged panels that served as ornament during the day and were converted to ornamental door covers at night. Two panels have the same image: a schematized version of the new Kress building. The middle relief depicts the building the Kress store replaced, the Wendel Mansion, coupled with a lengthy inscription (figs. 5.5, 5.6). The noted New York sculptor René Paul Chambellan was responsible for the bronze reliefs and for all of the ornament on this Kress building. Chambellan had executed decorative bronze grilles and allegorical figural reliefs for the lobby of the Chanin Building (1927–1928) and a series of three-dimensional allegorical figures in bronze for the descending pools in the Rockefeller Center Promenade, put in place the same year the Kress store opened. He was also an accomplished medalist.[12] His relief of the Kress store viewed from the front is on a plain field with a grid of lines emphasizing the height of the building in one direction and the horizontal lines of the grid extending to connect with lines on the adjacent panels. In the reliefs, the building sits on a stylobate of three steps, an imaginary architectural addition. The view of the building from the sidewalk on Fifth Avenue would have ended with the ornamental parapet, but the building actually had a tall brick penthouse set toward the back that was visible only from above.[13] Chambellan pictured this brick addition to the top of the store in the bas-relief.

Fig. 5.5. *Bronze panel reinstalled on the Republic National Bank, built on site of the Fifth Avenue Kress store. Photograph by Bruce Parker.*

Fig. 5.6. *Bronze relief panel of the Fifth Avenue Kress store, reinstalled on the Republic National Bank. Photograph by Bruce Parker.*

The bronze relief of the Kress store on its Fifth Avenue facade had a precedent. Shreve, Harmon, and Lamb's 1930 skyscraper just up the street at 500 Fifth Avenue has a gilded architectural image at the feet of a classical Greek female figure seated above the entrance. The tall office building contained spaces for rent, which an attractive rendition of the building would have promoted. In the same way, an image of the Kress building in golden bronze at eye level would have invited pedestrians to look at the building and venture inside.

The combination of an elaborate inscription with paired images of the new building and its predecessor on the site is uniquely Kress, however. The middle panel is actually composed of two images, one above and one below a long inscription in attractive raised letters of varying sizes interrupted by epigraphical flourishes. The inscription on the panel reads:

> Upon this site for more than seventy years stood the home of John D Wendel Esquire and his family. On the death of Rebecca A D Wendel Swope and of Ella V von E Wendel, the last surviving members of the family, the property passed by will to Drew Theological Seminary of Madison, New Jersey, which, by this tablet, makes grateful acknowledgment of the gift.

The phrase "by will to" on a line by itself, bracketed by enrolled documents with ties and seals, gives a legal aspect to the inscription. Drew Theological Seminary had recently received the gift of the house and land on the corner of Fifth Avenue and 39th Street on the death of the two elderly Wendel sisters. The mansion was one of the last private residences on lower Fifth Avenue, which had become increasingly commercial. Once the Wendel sisters died and the will was probated, Drew leased the land to Kress and allowed the company to demolish the house and to build on the site. Drew's right to do so is recorded on the bronze tablet. At the top of the panel is a realistically rendered view of the Wendel Mansion, not as it would have looked in

1934, but as it would have appeared in the nineteenth century, set in a grove of trees with strollers in period dress and a horse and carriage in the foreground. At the bottom of the panel is an Art Deco design on a stippled background suggesting a sunrise, or a combination of the sun, water, and plant life. The borders of the tablet up to its midpoint contain overlapping fans with fluted edges that, along with the Deco relief, imply upward movement.

The bronze reliefs are better understood in conjunction with decoration inside the store, namely, a series of oil paintings on the walls of the cafeteria (fig. 5.7). These murals consisted of twenty-eight scenes of Old New York executed by one of America's foremost muralists, Edward Trumbull, assisted by architect Maurice Gautier.[14] One of Trumbull's earlier commissions was an elaborate painting on the ceiling of the lobby of the Chrysler Building that includes an exterior view of the building. Trumbull's murals in the Kress cafeteria were taken from artist's sketches borrowed from historical sources and adapted to the shape of the walls. Tinted reproductions of the original sketches were gathered into a booklet entitled *Old New York,* to be "presented to those interested in New York's earlier history with the compliments of S. H. Kress & Company."[15] One of the sketches is identified as "THE JOHN D. WENDEL HOUSE, BUILT IN 1856 on the northwest corner of Fifth Avenue and Thirty-Ninth Street. Now the site of the S. H. Kress & Co. building." This sketch, the source of the bronze relief on the storefront, is closely related in content to one labeled "CROTON COTTAGE IN 1855 at the southeast corner of Fifth Avenue burned during the draft riots." The caption explains, "The site was afterwards occupied by the residence of W. H. Vanderbilt and now by the Arnold Constable & Co. store." The Kress Company had chosen to note that another New York store replaced one of Fifth Avenue's mansions. The sketches show more old views of Fifth Avenue in proximity to the Kress store, including an 1842 view of the Croton Reservoir, on the present site of the New York Public Library.

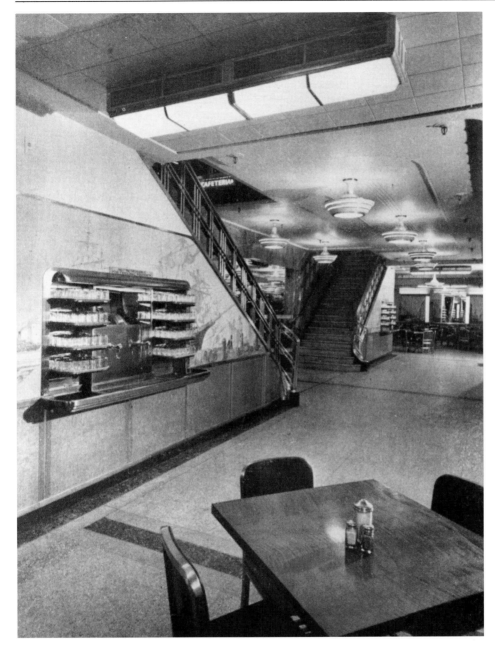

Fig. 5.7. *Basement cafeteria with Edward Trumbull murals, Fifth Avenue store, New York City. Courtesy Fay S. Lincoln Collection, Historical Collections and Labor Archives, Pennsylvania State University.*

With the reservoir is a vista of five private residences aligned on the street, one of which is the Wendel residence. The social, cultural, and mercantile histories of New York are thus shown as interwoven through selected scenes involving changes in architecture. The tableau of New York history begins with New Amsterdam in 1651, showing an old fort on "the site of the present custom house,"[16] and concludes in the present with a final image of the bronze plaque depicting the Kress store. Thus the new building is shown as part of the ongoing history of midtown Fifth Avenue. The preface to the booklet speaks of the striking readjustments that New York experienced in its growth from a struggling Dutch village to a world metropolis. "The character of these changes is forcibly pressed upon us," it states, by the mural paintings on the walls of the Kress store.

teenth-century residences to survive on midtown Fifth Avenue. Every newspaper story based on data furnished by S. H. Kress & Co. begins with this fact (fig. 5.8). The large announcement of the opening of the store in the *New York Times* ends with the phrase "on the site of the old Wendel home."[18] Associating the new building at 444 Fifth Avenue with the one that previously occupied the site was a means of associating S. H. Kress & Co.'s five-and-ten-cent-store operation with the fashion and good taste of an era that was ending. The company could lay claim to social respectability through continuity of site. The commissioning of the booklet, murals, and bronze reliefs, which lent prestige to a Kress commercial enterprise, was not very different from commissioning a Kress family history in which a section was devoted to the commercial connections of aristocratic Kress ancestors.

Samuel Kress asked Dr. Ezra Squier Tipple, president emeritus of Drew Theological Seminary and close friend of the Wendel family, to say a few words about the house and its occupants to friends and employees at a private ceremony before the store opened. His remarks were printed and distributed along with the *Old New York* booklet.[19] After reminiscing about the palatial four-story brownstone, built in what was a near-wilderness setting in 1856, Dr. Tipple concluded, "There is something deeply significant in the erection of this superb modern structure on the site of the Wendel home." He quoted Calvin Coolidge's observation that when the last Wendel died, almost all of the family's vast fortune was distributed to charity "with the sole purpose of attempting to benefit the public." He then added, "This great business is also for the people, for the benefit of the public." Presumably this idea underlay the juxtaposition of images of the old and new structures on the New York storefront, thereby making a loftier statement than respectability by association. The message encoded in the bronze reliefs may be that although the new order replaces the old, service to the public will continue.

The preface is introduced by a quotation from Alfred, Lord Tennyson: "The old order changeth, yielding place to new." The dramatic rising-sun motif at the base of the relief on the Fifth Avenue store could allegorically represent the coming of the new order. This is well within Chambellan's artistic vision, as revealed in a bronze grille for the inside of the Chanin Building. One of the motifs in Art Deco style is a circular form filled with half-circles or waves and outlined in flames, allegorized as "Achievement."[17] What the new order demonstrably entailed at 444 Fifth Avenue was the replacement of the Wendel Mansion with the Kress store.

One wonders why it was so important to stress that the Kress store stood on the site of the Wendel House, one of the last nine-

The New York building had three selling floors: the street floor; a basement, where the soda and lunch counter was located; and a subbasement, where the cafeteria shared space with a flower shop. The *Architectural Forum* liked the last arrangement, noting that displays of potted plants and cut flowers at the foot of the stairs provided "a most refreshing contrast to the metallic hardness of the surroundings." The building descended two more levels, accommodating auxiliary rooms for the food services, including a laundry and an ice cream plant, and, on the lowest level, the heating plant. As usual, the penthouse contained machinery: the elevator machinery, the cooling equipment, and the recording instruments room. The cooling equipment in this case was for central air conditioning—a first in the Kress store chain and an innovative feature for the time.[20] Steps in the rear of the main sales floor led up to a commodious women's lounge with walls covered with a curly maple wainscot and mirrors above. The offices were on the second floor, along with some space for storage. The number of desks marked on the plans indicates the larger staff needed in New York City. Along with such facilities as a "purse room," where saleswomen left pocketbooks for safekeeping, and a counting room, was a new facility, an employment room, showing that hiring was a considerable activity in this operation. The rest of the floors up through the sixth were principally for warehousing. On the third floor were facilities for porters, adjoining bathrooms for women and men, and a men's locker room. This would indicate a somewhat higher status for this type of employee in New York than in Durham, for example, and it also means that the New York store had a janitorial staff large enough to warrant a separate facility. The entire seventh floor was given over to full-size model show windows and shops for designing, setting up, and photographing displays.

Some standard features were changed in this Kress store. Travertine marble, a material previously limited to the outside vestibule, was substituted for marble terrazzo floors on the main selling floor.[21] The

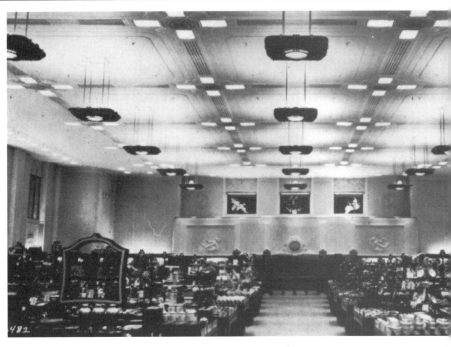

Fig. 5.9. *Interior of the main sales floor, Fifth Avenue store, New York City. Courtesy Fay S. Lincoln Collection, Historical Collections and Labor Archives, Pennsylvania State University.*

two basement floors were covered in marble terrazzo with the addition of inlaid designs that marked the divisions into departments and also helped direct traffic. Columns were eliminated on the main selling floor by a system of trusses extending from the third to the fifth floors with hangers supporting the ceiling.

Kress had long been concerned with good lighting for the sales floor, and here the goal was achieved by well-diffused indirect lighting coupled with direct lighting to produce "more than six times the brightness of the average department store." The hanging lamps with horizontal square shades and rounded corners were unique to this building (fig. 5.9).[22] Natural light from mezzanine windows was no longer a necessity. Here the panes, like the ones above, were somewhat darkened but still transparent. Tinted window panes that served a formal function on the exterior were also intended to help cut out sunlight and thus protect warehoused merchandise. The colored mezzanine windows also served an unplanned function, in that employees would often congregate on the mezzanine to watch a parade go down Fifth Avenue, confident that they could not be observed by passersby on the sidewalk.[23]

The mezzanine also housed the "music machine," installed so that Kress customers could shop to uninterrupted music, probably for the first time. Blueprints for the 1913 New Orleans store indicate an "antiphonic organ room" hidden by grilles on the mezzanine, and an organist is said to have played rapturously on the mezzanine in the San Francisco store on Market Street in the 1930s,[24] but in neither case would music have been continuous all day long. Music by machine was advanced for 1935, one more sign of the elegant modernity of the New York store.

In 1935 revolving doors were still quite new for Sibbert. He had substituted two sets of revolving doors for ordinary swinging doors at the last minute in the East Orange store in 1933, noting the change on the drawing of the front elevation. Ely Jacques Kahn, who remodeled A. T. Stewart in 1930 to convert it to Bonwit Teller, explained his use of revolving doors at opposite corners of an outside vestibule as a means of deflecting customer traffic through various aisles of the store.[25] Center doors opening on an aisle ahead would create a mere runway. In Bonwit's, the doors were placed directly in front of aisles formed by counters arranged lengthwise, so that revolving doors were a helpful deflection device. Sibbert had a somewhat different solution. The revolving doors let a customer into the store near the ends of counters turned sideways. The customer was apt to be directed out to the sides past an extended display of merchandise. At the end of the counter on the right was direct access to the basement sales floor via a large staircase. Meanwhile, if someone chose either set of swinging doors in the middle, there was an invitation to go straight ahead, although enough space was left before the counters began to allow for a pause to survey the scene. A walk straight back to the rear of the store ended in front of the elevators, which took the shopper down to other sales floors. Another staircase to the right of the elevators offered an alternate route downstairs. The single revolving door on 39th Street, where the traffic was lighter,

spilled the customer into the rear of the store in a space surrounded by stairwells. Sibbert actually made provisions for several ways of entering and circumambulating the store, which worked together to direct the customer to the merchandise, encouraging a rapid turnover. Katherine French Pancoast remembers that one of Sibbert's concerns as an architect was circulation.[26] In New York he dealt with a volume of traffic far greater than ever before, assisted by the addition of revolving doors.

In the Fifth Avenue store, ideas embodied in the bronzes and murals pertaining to Old New York and to earlier buildings on or near the site are subsidiary to the theme of Mayan art and architecture transferred through a modern-style Kress store. Parts of the ornamentation inside and out made the Mayan reference clear: bas-reliefs of a Mayan god and goddess on walls inside the front entrance and Mayan hieroglyphs bracketing the mezzanine windows on the facade. There were less explicit signs as well, such as spandrels "with Maya glyph-like incised motifs"[27] and geometricized "non-Mayan motifs—organized in lines and stacks, similar to hieroglyphs on a Mayan stela."[28] The marble forms on the ledge at the base of each tier of windows were reminiscent of Mayan headdresses or segments of enrolled feathered serpents. Most explicitly Mayan, however, were the hieroglyphs on the exterior and the images of Mayan deities on the interior of the store.

The exterior reliefs beside the mezzanine windows consisted of four hieroglyphs, one above the other, with knobs at the side, just as they might appear on Mayan monuments. The glyphs extended out in the direction of the window through linear flourishes. On the walls beside the middle windows, the sculptural flourishes projected out to either side, adding formal emphasis at the center. As Marjorie Ingle has pointed out, the ornamentation on the Kress store is really a subtle play on words, because it is a Mayan pictograph that represents various types of merchandise sold in the store. "For instance, an ornamental panel of an outstretched hand with ring communicates

that jewelry and gloves are sold within as well as representing the Mayan hieroglyph for completion or zero" (fig. 5.10).[29] In all, there were thirty-two reliefs depicting items sold in Kress stores, although some were duplicates. On close examination, one can discover an axe, a padlock, and a bolt of cloth, unrolled just as these bolts were displayed inside the store and in the show windows (figs. 5.11, 5.12).

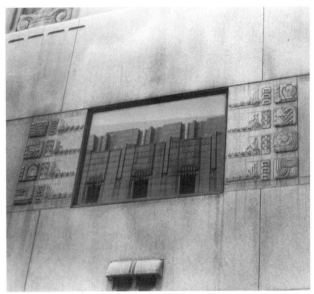

Fig. 5.10. *Carved glyphs with Kress store merchandise, including gloves and padlocks, Fifth Avenue, New York City. Courtesy New York City Landmarks Preservation Commission.*

Fig. 5.11. *Carved glyphs with Kress store merchandise, including pottery and yard goods, Fifth Avenue, New York City. Courtesy New York City Landmarks Preservation Commission.*

Fig. 5.12. *Arrangement of yard goods in show window, Rockford, Illinois. Courtesy National Building Museum, gift of Genesco, Inc.*

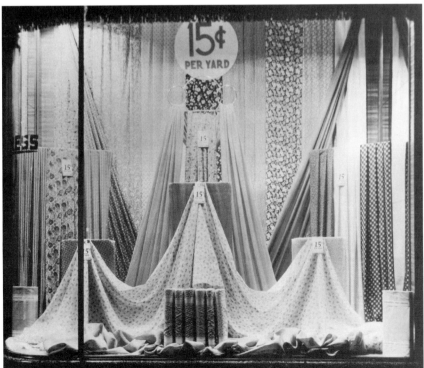

Fig. 5.13. *René Paul Chambellan, wall relief, main sales floor, Fifth Avenue, New York City. Courtesy Fay S. Lincoln Collection, Historical Collections and Labor Archives, Pennsylvania State University.*

A stack of cups stands beside an ample, ornamented vase on another block. The vase and cups had a special place in Kress company lore. The company worked hard to procure large, decorative vases that could be sold for ten and twenty-five cents, and they made special efforts to lower the price of a cup and saucer, which other dime-store chains were selling for twenty-five cents (see fig. 4.47). "By working with the potteries and paying top prices, Kress was able to introduce the first 5¢ cup and saucer."[30] Thus the pottery illustrates a method of doing business that Kress took credit for and that constituted part of "the Kress idea." By eliminating the jobber and providing inducement for manufacturers to create quality merchandise to its specifications, Kress claimed to be doing a unique service for the public. Thus the Mayan ornament on the mezzanine level was related in content to the bronze bas-reliefs further down. Padlocks,

too, figured in the company's collective memory. In 1912 the Little Rock, Arkansas, store was reputed to have the best padlocks in town. This led to a pilferage problem until the store manager linked all of the displayed padlocks together with very fine wire. The next lad who lifted one found a whole clanging chain of padlocks trailing behind him.[31] Ingle assesses the Kress building's use of Mayan forms as playful, "almost literary, a play on words," showing "a high level of inventiveness."[32] The inventiveness extended to more merchandise than has been recognized. More than this, the form of wordplay, involving pictographs, extended Sibbert's penchant for wordplay through images in an entirely new direction.

The advertising of merchandise on the Kress store facade has roots in the Parisian department store practice of affixing signs to the exterior spandrels to advertise certain departments such as *dentelles* (lace) or

chaussures (shoes). Thus the department store's primary asset, a wide diversity of wares organized for the shopper by departments, was publicized on the facade.[33] That many items could be found similarly organized under one roof also constituted much of the appeal of a dime store. Sibbert continued the Parisian tradition and intent with picture writing borrowed from an ancient civilization. He turned signage attached to the wall into relief carving built into the fabric of the wall. Sibbert also continued an American tradition of commercial imaging in less sophisticated architecture. By 1935 expensive, architect-designed buildings in a modern style hinted at what went on inside while exterior sculptural reliefs referred to objects related in some way to that activity. Close in spirit to Sibbert's glyphs is a cluster of flowers on a 1930 Bell Telephone Building in Cincinnati, Ohio, in which a telephone dial mechanism

and the screw that affixes it serve as the center of each blossom. The design reads as a flower and as a flower incorporating a piece of a telephone.

Evidently the Fifth Avenue store deserved a special kind of decoration: figural imagery, which, except for the half-figures in the coats of arms, had never before been seen in a Kress store. Large reliefs of a Mayan god and goddess inside the front entrance were paired like bookends on plain surfaces at either side of an oversized clock in an elaborate embrasure (figs. 5.13, 5.14). Reeded pilasters made divisions between the figures and the clock and intervening sections of wall surface.[34] The prominence of the figures and their exalted subject matter seem appropriate for the flagship store. Photographs show the male and female figures, nude above the waist and scantily clad below, with sheer drapery looped in the front and falling in pleats

Fig. 5.14. *René Paul Chambellan, wall relief, main sales floor, Fifth Avenue, New York City. Courtesy Fay S. Lincoln Collection, Historical Collections and Labor Archives, Pennsylvania State University.*

between their legs, which are arranged in a running pose. Matching capes with the same pleated folds spread out behind the figures. Both wear feathered headdresses and jewelry befitting Mayan deities. Although the figures appear to be running forward, their heads are turned back in profile toward objects they held out with extended arms. The goddess holds a small piston engine with serrated gears. Her counterpart gazes back at a wheel with wings attached. His right arm is bent to mirror his companion's as she balances a torch in her palm. His hand is empty, however, and angled with fingers closed and palm facing outward, as if giving a directional signal. Circular disks appear behind the figures, forming a background for the bent knees and elbows. The circular form accompanying the female is surrounded by flames, with an outpouring of waves at the bottom. The disk behind the male figure is a Mayan or Aztec solar calendar.

These sculptural compositions are complex, referring to an ancient civilization and modern technology at the same time. The cosmic and mythic implications in the water emerging from the flaming disk, for instance, and in the general notions of fire, water, and air embodied in these images contrast with the explicitly rendered modern machinery. In addition, the figures are looking backward while speeding ahead, as the straight lines of the clothing make clear. Despite the movement, there is a solemn stillness about the portrayals. The headdresses are not windblown. The solar calendar conveys a notion of time that is different from that represented by the clock that the figures rush toward and different, too, from the swiftness of their implicit movement. The Mayan deities are bringing the Machine Age products forward from behind in a reversal of the normal understanding of evolution over time.

The meaning of these images is difficult to untangle. The female figure on the left wall holds a piece of machinery that looks like something that might have driven the store's heating and the air-conditioning systems, thus calling attention to the building's

advanced technology. The winged wheel that the male god examines brings together two designs on the nearby Chrysler Building: the swirling wheels in the brickwork with protruding hubcaps and wings at the corners that resemble parts of Chrysler radiator ornaments.[35] This quotation of the ornament on the outside of the Chrysler Building is not merely an allusion to a well-known, nearby example of contemporary architecture, however. Kress sold replacement parts for automobiles (that is, items that cost no more than fifty cents), and this was a source of pride to the company.[36] It thus makes sense to view the object in the male figure's hand both as a part of a car such as appeared on the Chrysler Building and as a car part, possibly a Chrysler part, sold in the Kress store.[37]

WHY MAYAN?

Other five-and-ten-cent-store chains were not predisposed toward Mayan Revival architecture, and few commercial buildings in New York City used Mayan motifs. The Kress store was considered exceptional.[38] Why was a Mayan theme chosen for the company's flagship store in New York City, and why did S. H. Kress & Co. show such a strong predilection for Mayan themes? Some clues lie in the building's sculptural ornament. The carved glyphs, the image recalling the Great Calendar Stone, and the figures with facial features and headdresses like those represented in Mayan sculpture indicate an attention to pre-Columbian art.[39] Like the classical references embodied in the Montgomery, Alabama, store, the Mayan motifs may reflect Samuel Kress's interests, which he shared with others. Archaeological expeditions and their new discoveries had captured the imagination of many Americans. Books such as George Oakley Totten's *Maya Architecture* (1926) helped disseminate designs of Mayan buildings and ornament and stimulated interest in the ancient Mesoamerican civilization. The 1893 World's Columbian Exposition, with its reconstructions of Mayan ruins and artifacts, and Chicago's 1933 Century of Progress International

Exposition, with its full-scale reproduction of a section of the Nunnery at Uxmal, embellished inside with a mural from the Temple of Warriors at Chichén Itzà, created more publicity and enthusiasm for Mayan monuments.[40]

Moreover, in the 1920s and 1930s Mayan civilization was connected with Freemasonry. In 1896, an explorer and Mason, Augustus Le Plongeon, had published a book, *Queen Moo and the Egyptian Sphinx,* in which he put forth the idea that the Maya were the fountainhead of Masonry. James Churchward promoted Le Plongeon's notions in his own immensely popular books, *The Lost Continent of Mu* (1931) and *The Sacred Symbols of Mu* (1933). Churchward's mythology traced all civilization, including that of ancient Egypt, back to the land of the Maya. Freemasons and other groups that had a "sacred mystery" orientation were especially susceptible to such interpretations.[41] As a Mason, Samuel Kress might well have been exposed to ideas linking Masonry to the Maya. His own Masonic lodge in New York was associated with lodges in Mexico, which could have made him more alert to such a possibility.[42]

Chambellan's paired sculptural reliefs of male and female figures and their accoutrements might have related to this new mythology. One interpretation might be that the female image represents Mu, or Moo, queen of the lost continent of Mu, adapted from Plato's lost continent of Atlantis. The companion relief represents her brother and consort, Prince Chaacmol. According to the mythology, Mayan civilization came into being when the queen and this powerful warrior were united. The prince and the queen formed the cradle of civilization in the isthmus linking North and South America, "the land that first emerged from the bosom of the deep."[43] The female figure's empty circle, from which waves emerge, and her exposed bosom may represent this. Her profile headpiece has a well-formed appendage of a circle and a tassel falling down to her shoulder, a frequent motif in Mayan art. However, it is close in outline to a schematic diagram from the 1930s, the Cosmogonic Diagram of Mu, which summed up complicated rites and beliefs associated with Queen Mu. None of these artistic correspondences is conclusive, but collectively they are suggestive. Samuel Kress might have subscribed to some version of this view of history.

The Kress store on Fifth Avenue was modern as well as Mayan. One assumes that the president of the company gave the modern design of his flagship store his enthusiastic endorsement. This must say something about Samuel Kress's personal taste, which has never before been associated with modern art and architecture. Yet he gave his approval to Chambellan's reliefs, with their Art Deco and machine-part motifs. In 1936 the Kress company offered Fernand Léger $10,000 to design window displays for the Fifth Avenue store for a five-month period. After some reflection, the famous artist refused the invitation.[44] The fact that an avant-garde artist, who favored machines and machine parts in his compositions, was invited to dress Kress store windows suggests that Samuel Kress had learned to appreciate contemporary art in his later years. Kress modernism was not the result of business expediency alone.

THE PICTURE IN THE WINDOW

An event that took place at the Fifth Avenue store at Christmastime 1938 has become part of Samuel Kress's and the Fifth Avenue store's history. The story was recounted in Samuel Kress's obituary in the *New York Times* seventeen years later and has since been retold by several writers.[45] Samuel Kress exhibited one of his finest Old Master paintings, Giorgione's *The Adoration of the Shepherds,* newly acquired from Joseph Duveen, in a display window on Fifth Avenue during the 1938 Christmas season (fig. 5.15). The action created something of a sensation, at least within the art world. By then it was known that the Kress Collection was to be given to the National Gallery of Art in Washington.[46] The chief curator of the National Gallery, John Walker, and its

Fig. 5.15. *Giorgione,* The Adoration of the Shepherds, *Samuel H. Kress Collection, National Gallery of Art, Washington, D. C. © 1996 Board of Trustees, National Gallery of Art.*

director, David E. Finley, met with Kress several times during that Christmas week to make plans for the receipt of the Kress Collection, at which time they were told of the new acquisition. Walker wrote, "We presumed that Mr. Kress wished his greatest masterpiece to be a surprise to celebrate the opening of the National Gallery. We were wrong. Its debut was in the window of the Kress store on Fifth Avenue to celebrate Christmas week."[47]

In his biography of Duveen (1952), S. N. Behrman gives a humorous account of the event, embellishing it with his perception of the dealer's reactions. The display of the picture that he had sold to Kress broke one of his cherished principles: Duveen never

unveiled any of his great paintings publicly. Behrman tells us that "no Duveen was ever visible in the Duveen windows at the Ministry of Marine [the location of his gallery in Paris] during his lifetime, even though the building was a copy of a wing of a building that had been designed by Jacques-Anges Gabriel, the illustrious architect who served Louis XV." Then, as Duveen was walking down Fifth Avenue one day, "his eye was caught, at the corner of Thirty-Ninth Street, by a picture in a window. He stopped to stare at it incredulously. . . . It was one of the greatest and most costly—both in price and in emotional tribulation—of all Duveens." Duveen had persuaded Kress to buy the painting to

give to the National Gallery, a gift that was still a closely kept secret. "And here it was, the lovely thing, quite naked, in the window of a building whose architect not only was not French but was, as far as Duveen was concerned, non-existent."[48]

Kate Simon embroidered on the story in 1978, describing the painting in the window as "surrounded by spikes of cloth poinsettia, tinsel, tin angels and shining tree ornaments."[49] No photograph of the show window has been found to determine whether the author based her description on personal recollection, hearsay, or imagination.

Simon raises the question of why *The Adoration of the Shepherds* was put in the Kress store window. "Clever merchandising? A gesture for public enlightenment? Perhaps it did impart the proper religious touch to those who saw the painting as a Christmas chromo." All three of these suggestions seem valid. Although the painting was not for sale, it would have drawn attention to the Kress store windows. Moreover, Samuel Kress believed very strongly in the elevating influence of works of art, as he said at the dedication ceremony for the National Gallery of Art in 1941. He presented his collection to President Franklin D. Roosevelt "for the benefit and enjoyment of all the people, to be preserved as part of that spiritual heritage which is our greatest and most treasured possession."[50] The same view must have led him to share his great Italian masterpiece with the people of New York at Christmastime. Kress had already shared his paintings with the public in other locations. Between 1932 and 1934, he had sent Italian paintings selected from his collection to twenty-four locations around the country, to be shown in local museums,

art schools, colleges, and civic organizations. This traveling exhibition, which brought Old Master paintings to communities that, unlike New York City, had no great collections, was a resounding success.[51] With one exception the communities where his paintings were exhibited all had Kress stores. He had built buildings and provided quality merchandise for the people in these locations. Now he was enabling them to view original works of art, if only temporarily. Kress made another gesture for public enlightenment in 1939–1940 when he lent several of his paintings for the "Masterpieces of Art" exhibition at the New York World's Fair.

Kress had a precedent for exhibiting his painting in a retail-store setting. The department-store founder John Wanamaker had acquired *Christ on Calvary,* a large-scale painting by the Hungarian artist Mihály Munkácsy, in 1888. The painting was exhibited annually at Easter in the Grand Court of the Wanamaker store in Philadelphia, beginning in the mid-1920s. This seasonal showing of a religious painting could be understood, in part, as a statement about the founder's commitment to Christianity.[52] Kress was also a Christian; he never failed to mention his membership in the Lutheran Church among his affiliations. No doubt he was quite comfortable having a Methodist clergyman and seminary president dedicate his flagship store. Perhaps Kress put a Nativity scene in the window during Christmas week to "impart the proper religious touch." For more than one reason, it seems perfectly natural that Kress would put his newest and finest painting in the window of his finest store for Christmas.

6 BUILDING TO THE END

The Fifth Avenue store was followed by major Kress stores in other cities during the second half of the 1930s. Seven stores were built in the Southeast and in Texas, all with highly individualized designs uniquely adapted to their locations. The Kress Company continued to advertise its mission as public service supported by the most up-to-date buildings. As its agent, Edward Sibbert continued to explore design possibilities, moving in the directions of sophisticated simplicity and comparable complexity.

Fig. 6.1. *Illustration entitled "The New Kress Store at Fort Worth" from a Kress company pamphlet, 1936. Courtesy National Building Museum, gift of Ms. Alice S. Lewis.*

FORT WORTH, TEXAS

Just before Kress opened its fourth store in Fort Worth, Texas, in August 1936, an advertisement chronicled the company's history in Fort Worth by picturing the city's three earlier Kress stores, progressively larger in size, dated 1905, 1911, and 1924, beneath the heading "growing with FORT WORTH for 31 Years!"[1] The company pamphlet issued for the store opening in Fort Worth notes that Kress service had begun in Dallas in 1901 (fig. 6.1). The text goes on to praise the modern merchants of Texas for giving Texas citizens the opportunity to buy necessities and luxuries at extremely low prices.

The four-story Fort Worth store has an elegance derived from its restrained design, its materials, and some of its handsome details. Its two tall, slim facades, on Houston Street and Main Street, are faced with flecked charcoal gray–brown polished granite beneath the display windows, moving to a lighter tone around the windows and entrances. The upper facades and their deep returns are clad with glazed mottled terra-cotta blocks in the topmost range of the same color spectrum, becoming near-white, while the spandrels and overhead ornament of the three window bays on each facade are in the middle range. An addition to Sibbert's repertory is a bronzed iron balcony with openwork across each facade, in lieu of a metal canopy (fig. 6.2). The openwork consists of linear key motifs and stacked chevrons. The balconies serve more than sheltering and decorative functions, since their floors can be let down as ladders when necessary.

There are no brightly colored accents of any sort on the Fort Worth facades. Color, including that of the copper and bronze trim at ground level, is muted. The ceilings of the entrance vestibules are lavishly trimmed in bronze, and the Main Street elevation has a service door composed entirely of golden bronze in a sophisticated copper bronze surround, embellished with an ornamental appliqué. Sibbert has simply rung changes on the colors in the speckled granite bases in terra-cotta, granite, and metal.

Judith Singer Cohen has observed that, while there are definite stylistic relationships among a number of Kress stores built in the Moderne style, the New York City Kress building and the building in Fort Worth exhibit remarkable similarities.[2] It

Fig. 6.2. *Downtown Fort Worth, 1937. Photograph by Byrd Williams III, reproduced by Byrd Williams IV.*

Fig. 6.3. Pictograph carved in granite beside display windows, Fort Worth Kress store. Photograph by author.

would seem that Sibbert intended the Fort Worth store to resemble the building in New York.

Fort Worth's store is a paraphrase of the Fifth Avenue store. The facades have the same smooth, simple lines and the same overall coloration. The Fort Worth store is manifestly a boxlike structure, narrow at the ends, with the same long, sweeping sides. This effect is achieved in Fort Worth with walls of matching face brick continuing the pale side walls of terra-cotta. The fenestration is kept to the center section of the storefronts, reduced to single tiers of windows and spandrels, with grooved separations between the center and end sections. A single long convex strip up the middle of the side sections substitutes for the New York facade's long indentations capped with thin ornament.

The Fort Worth store distills the essentials of the New York store, highlighting certain stylistic features. The three Mayan-inspired forms above the window bays in Fort Worth are variations on three carved Mayan sculptures at the top of the three bays of the Fifth Avenue facade. New York's polished gray granite spandrels are translated into gray Granitex terra-cotta blocks in Fort Worth. Fort Worth has the same generous use of bronze at ground level as the New York store, with flat bronze service-door panels and curved doorjambs echoing both the front and the side entrances in New York. Other details, such as the same kind of signage over three mezzanine windows in the middle section and the use of polished granite with incisions left rough in the exterior ornament, parallel what was seen in New York. Inside, ceiling lamps with satellite shades suspended from double hanger rods are comparable to the lighting in New York.[3] One aspect of the interior was a direct copy of the New York store—namely, the main selling floor's paving of Italian travertine marble.

The incised ornament on the granite piers beside the show windows, a schematic design with chevrons and a shield with pointed wings in a Mayan or Aztec Revival style, echoes the carved Mayan hieroglyphs

on the front of the New York store (fig. 6.3). The small shield with thin, pointed wings is recognizable as the logo of the Chevrolet Motor Company. The little emblem is part of a larger configuration suggesting the stylized monogram of Chevrolet's parent company, the General Motors Car Corporation. In 1936 the Chevrolet Motor Company was one of Fort Worth's most successful industries. The city had been the home of a number of automobile-parts manufacturing concerns for at least a decade.[4] The motif also reads as a schematic rendition of a contemporary Chevrolet automobile seen from the front, including oversized headlights. The winged logo appears at the top of the radiator grille and beneath a flat hood streamlined by curved corners. This pictograph, carved in stone, is a caricature of a Chevrolet car incorporated with the initials of the General Motors Car Corporation. The notion of automobile parts, seen or implied, connects the motif with the Mayan figure inside the New York store who holds an assemblage of automobile parts in the form of a wheel and pointed wings. However, in Fort Worth, an automobile—or an automobile in parts—was an even more accurate advertisement of what was for sale inside the store. One could look at the incised motif with the prominent headlights and be reminded that headlight bulbs were on sale inside at a cost of twenty cents each.[5]

Once oil was discovered in the area, Fort Worth began to change from a small town into a prosperous, growing city. By the late 1920s, the surge of growth and prosperity had altered Fort Worth's image of itself. It began to identify with the great commercial centers on the eastern seaboard, especially New York City. In 1928 the Fort Worth Chamber of Commerce initiated a five-year program to create a new image of the city. One means of doing so was to encourage new building in the latest modern style. For the chamber and for prosperous Fort Worth citizens, this entailed importing a building type associated with New York: the modern skyscraper. The Chamber of Commerce even had an artist envision a future Fort Worth with a skyline dominated by

skyscrapers.[6] The design of Sibbert's Kress store in Fort Worth, reflecting his own sky-scraper-style building in New York City, is consistent with the new symbolic architecture Fort Worth adopted. It simultaneously demonstrated allegiance to the city and company pride. The fact that the New York Kress store, with its Mayan theme, was not truly representative of New York skyscrapers was not important. On the contrary, several tall buildings with Mayan or Aztec detailing had already been erected in downtown Fort Worth.[7] A distillation of the New York store, a definite outside import, happened to accord with a local style.

NASHVILLE, TENNESSEE

Samuel Kress had chosen Nashville as the site of the second store in his chain, which opened at 420 Union Street in 1897, a year after his initial venture in Memphis. When the 1936 Kress store opened in Nashville, the local paper stated that Samuel Kress "was well known to the older generation of Nashville business men, having operated the local store for a time."[8] The company moved to two larger stores on Nashville's Fifth Avenue North before building on the same site what a newspaper advertisement hailed as "the finest type of mercantile building known to modern engineering." In support of its claim the advertisement showed Kress's first store along with its latest one, pictured in the evening with lighted display windows and spotlights on the marquee illuminating the building.[9] According to the advertisement, the new store was Kress's way of expressing gratitude to the citizens of the Tennessee Valley "for their enthusiastic acceptance of his merchandising principles."

S. H. Kress & Co. distributed another pamphlet related to a store's location, this one a one-page leaflet headlined, "Nashville. Gateway to the South."[10] The Kress Company is not mentioned in the text. It simply recounts the history of Nashville's founding and the city's growth into a great industrial metropolis, complete with a splendid system of city parks and excellent educational institutions. The pamphlet Kress chose to

FEDERAL SEABOARD

ARCHITECTURAL
TERRA COTTA
AND
WALL ASHLAR

F S T C

FEDERAL SEABOARD TERRA COTTA CORPORATION
10 EAST 40TH STREET · NEW YORK, N.Y.

FACTORIES
PERTH AMBOY, N.J. ~ WOODBRIDGE, N.J. ~ SOUTH AMBOY, N.J.

Fig. 6.4. Nashville, Tennessee, Kress store shown on the cover of the Federal Seaboard Terra Cotta Company brochure. Avery Architectural and Fine Arts Library, Columbia University, New York.

distribute functioned as "boosterism" for the city of Nashville. Obviously, an informed appreciation of a Kress store's locale made good business sense.

Nashville's newest Kress store was a five-floor building—four stories with a basement sales floor and cafeteria (fig. 6.4). The building stood in the middle of the block and was taller than any of its neighbors when it was first constructed. Its flat facade is covered primarily with off-white or light cream terra-cotta blocks, with bulkheads of slightly darker Minnesota granite. Terra-cotta of the same color is used for the ornamental lintels over the recessed mezzanine windows and upper-story spandrels. A deeper-toned copper marquee with matching hanger rods continues the harmonious

color scheme. There are touches of color on the upper facade in the small, flat blossoms of a frieze below the roofline and in flowers atop small stalks of leaves rising from the mullions. The most important note of color occurs in two figural panels on a line with the large golden logo. A band of terra-cotta blocks above the mezzanine windows holds a built-in store sign with large gold letters on a red background. The organization of the facade above the two recessed entrances and flanking display windows is a familiar three-part division, with four tiers of windows and spandrels in the center and two tiers at the sides. Four large fluted pilasters, which help create the three sections, actually rise higher than the roofline, but they terminate at the same height. The pilasters themselves are relatively flat, as are the thin mullions between them. The result is a facade of classic beauty and pronounced modernity.

After New York, all major new Kress stores had air-conditioned sales floors free of supports. The main floor in Nashville had both direct and indirect lighting, not from glamorous, outsized fixtures but from hanging lamps of a kind used since at least 1933, which resembled suspended flowerpots and which directed light up toward the ceiling and down onto the floor simultaneously (see fig. 1.11). The store had its own staff of artists and a carpenter for the construction of various fixtures and displays. It also engaged an engineer to maintain the air-conditioning system. In the absence of other documentation, contemporary newspaper accounts help convey what the store interior was like. Along with the standard Kress cream-colored walls and ivory ceiling went ten-foot dadoes trimmed in light brown zebrawood, satinwood, and French walnut of matched and contrasting grains. As in other Kress stores, all saleswomen wore specially designed uniforms in colors harmonizing with the interior. Inside the front door were huge bronze facings trimmed in imported Italian marble. The stair railings to the downstairs sales floor were also bronze. The floors were color-coordinated tan marble terrazzo with thin bronze strips (still in place).

Sibbert's source for the Nashville facade was classical Greek architecture, not unusual for architects in the 1930s, especially those doing modern-style public buildings. (Paul Philippe Cret is a notable example.) But the Nashville store is Sibbert's only Kress building in this style. As already noted, Sibbert stated that the sources for most of his ornamentation were not classical. Yet here he quoted classical Greek columns of the Doric order in fluted pilasters set against walls of blocks. In Nashville, figural reliefs are the principal ornamentation. The paired plaques show a man and a woman with classical Greek hairstyles and simple garb kneeling on a platform of three steps, with modern buildings in the background. The figures, with their strongly colored skin and red-orange hair and clothing, dominate the compositions, almost filling the square frames. The other strong coloration occurs in the plaque on the right in the overlapping leaves with yellow berries simulating a grove of trees (plate 15). This plaque depicts a male figure wearing a bibbed apron with his outstretched arm clutching a stylized hammer. The hammer culminates in large, layered disks with serrated edges like gears. With a series of smokestacks behind him in the distance, he could represent a modern-day Vulcan. His counterpart on the left contemplates a winged helmet atop a pole that she holds with an arm similarly extended. The winged helmet is a recognizable attribute of Hermes, the Greek god of commerce. On the other hand, it also resembles a type of woman's hat that was in vogue in the 1930s. Hats like this might well have been displayed on stands in Kress's hat department.

It is possible that René Paul Chambellan was responsible for the figural plaques in Nashville. He had sculpted simpler figural plaques on the upper facade of the Bonwit Teller store in New York. The Nashville reliefs resemble those plaques in figural style and, to some extent, in content. With no company documentation and only preliminary research in the archives of this sculptor, the matter stands unresolved.

Sibbert's inspiration for the building seems to have been the full-sized replica of the Parthenon in Nashville's Centennial Park (fig. 6.5). The tall, fluted pilasters across the facade recall the rows of fluted Doric columns on the Parthenon, and the classical figures in square plaques recall the building's painted metopes. The staccato frieze of small terra-cotta shapes across the parapet might substitute for the row of painted anthemia along the Parthenon roof, just as three plain terra-cotta strips on the spandrels aligned in a row suggest the Parthenon's unpainted triglyphs. The figures reposing on three long steps, a stylobate, with trees in evidence, help make the reference to a classical Greek temple in a park. A modern skyline in the distance in the relief of the female, as well as the industrial smokestacks in the relief with the male figure, put the classical temple and the greenery in a context of modern technology and a modern city: Nashville, "the Athens of the South."

The Nashville Parthenon in Centennial Park was first built in brick, wood, and plaster as the centerpiece of the Tennessee Centennial Exposition of 1897, held in Nashville while Samuel Kress was working there. The building was an instant success, and Nashvillians protested plans for its demolition at the end of the fair. It was thus let stand until 1921, when a replacement was begun in more durable concrete with a coating of granulated cement. The permanent full-sized replica was completed in 1931. The Nashville Parthenon took on additional meaning for Samuel Kress in 1934, when he lent a selection of Italian paintings to the Nashville Board of Park Commissioners to be shown in the Parthenon in Centennial Park, according to the catalog of this traveling exhibition (fig. 6.6).[11]

Fig. 6.6. *Exhibition catalog for paintings lent by Samuel H. Kress, shown in the Fine Arts Gallery, Balboa Park, San Diego, California, 1934. Courtesy Samuel H. Kress Foundation.*

Fig. 6.5. *Parthenon in Centennial Park, Nashville, Tennessee. Photograph by author.*

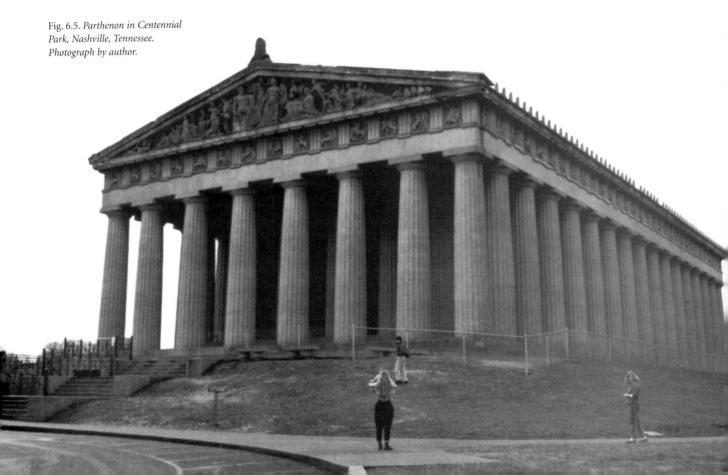

ORLANDO, FLORIDA

The Superstore that opened in Orlando in 1936 was Kress's first store in that location (plate 16). The company had operated a store in Florida as early as 1900, in Jacksonville, but with the exception of the 1929 store in Lakeland, the stores had always been in communities near the seashore, which were the basis of Florida's prosperity. By the mid-1930s, however, the fast-growing community of Orlando seemed to justify a Superstore in central Florida.

The Orlando store is a large, L-shaped construction with two sidewalk elevations. The principal elevation, on South Orange Avenue, is two stories tall and sixty feet wide, while the side elevation on West Church Street is only fifty feet wide, with a third, penthouse story to accommodate machinery. The design of the two storefronts is virtually the same, but the primary elevation is realized in off-white terra-cotta cladding and the secondary elevation in similarly colored brick. Each has an expansive, streamlined marquee, underlighted through white opaline glass panels.

The Kress store in Orlando had its own streamlined aesthetic, involving a smooth sense of aerodynamic flow, better achieved on the front, where the terra-cotta edges are gently turned and the overall surface is uninterrupted by bricks and mortar. The facades are organized by six tall pilasters bracketing five tiers of windows and spandrels, with wider pilasters at the corners. The smooth, convex spandrels and the reeding on the facades, and even the tubular letters of the golden logo, all seem slightly inflated. This, coupled with swiftly flowing straight lines, clearly expresses the notion of aerodynamic flow. The long, tapered forms of the cantilevered marquees, reminiscent of an airplane's wingspan, suggest much the same idea. Pairs of smoothly curved, golden-bronze wings emanating from the Kress panels at either end help to convey this impression. The Kress store in Orlando is making a statement. As Tony P. Wrenn and Elizabeth D. Mulloy remind us, the aerodynamic, streamlined style was more than a mode of

Fig. 6.7. *Orlando, Florida, detail of marquee with feathered wings and cloud motif on side pier. Photograph by author.*

ornamentation; it became "an architectural symbol for the progressiveness of commerce and industry."[12]

The terra-cotta ornamentation on these off-white facades is strikingly colorful. The orange and green sculptural motifs, with touches of yellow and off-white, differ in design from row to row but are related in color and shape. Each motif, for example, has a raised, elongated center section that helps accent the verticality of the facade, especially as the polychrome forms are arranged in vertical alignment. The exception is the one small tubular form at the top, which marks the center of the storefront and emphasizes the logo. The six identical colored shapes across each story and the four in a line on the parapet direct the flow in a perpendicular direction and help to balance the strong vertical orientation. The multicolored reliefs read as abstract, streamlined forms, appropriately enriching the two elegant, streamlined facades. At the same time, these polychrome reliefs read as stylized renditions of parrots. In fact, the golden wings on the overhanging marquees are more akin to feathered wings than to airplane wings (fig. 6.7).[13] In form and idea they match the segments of yellow "feathers" contributing to a larger wingspread over the mezzanine windows.

The colorful parrots above the windows of the upper story hold their heads down and their tails straight up, with their wings fully extended at the sides. They seem to soar downward. The six birds down below are disposed differently. They are perched on a ledge supplied by the top of the window surround, holding on to the sides with their wings while bending their bodies to peer over the ledge. A conspicuous aspect of the forms bending over the window frames is a wavy green band in three slightly overlapping layers, like the fleshy cere at the base of a parrot's upper mandible overlapping the nostrils.

One could look at these depictions as a series of actions or as different parts of a single action whereby a flock of parrots has flown down and landed. The smaller, mini-

mal shapes descending from the parapet, with single wings close to their bodies, indicate where the action first becomes visible. The action is completed in the fuller, more expansive forms perched on the lower ledges. The sequence is similar to the frames in a motion picture. Birds flying swiftly through the air or making a rapid descent, creating their own airstream, give new definition to aerodynamic flow.

Small terra-cotta plaques at the tops of the side piers on each elevation play their own part in the larger configuration. The flat, overlapping shapes suggest cloud formations. The dominant color is pastel blue, with one layer of yellow and a curved strip of orange. The ornament is evocative of a blue sky and sunshine, apt images for the "Sunshine State." A blue sky with puffy clouds is the habitat of winged birds as well as airplanes. Parrots, too, would have been emblematic of Florida and of the area's developing tourist industry at this time. "Parrot jungles" were a tourist attraction, and caged parrots of all sorts were displayed and sold to out-of-state visitors. Beyond this, images of parrots probably relate to Kress store merchandise. A 1941 photograph of the Denver store shows birdcages on display (fig. 6.8), and a 1959 chart listing assignments for buyers and assistant buyers in the home office in New York shows "birds and accessories" as a category.[14] Parrots, including the smaller parakeets, may have been sold in the Orlando store in 1936.

Fig. 6.8. Pet department, Denver, Colorado, Kress store, 1941. Courtesy National Building Museum, gift of Genesco, Inc.

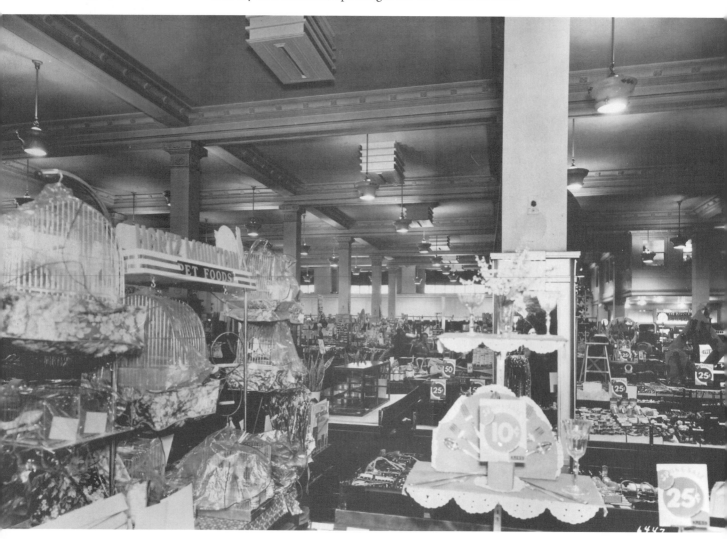

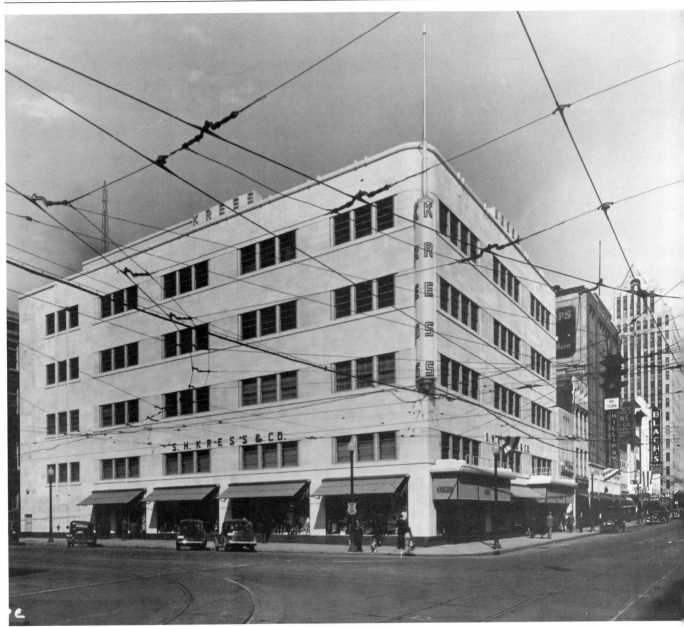

BIRMINGHAM, ALABAMA

Kress built a truly monumental Superstore in Birmingham, Alabama, in 1937, erected at a cost of $750,000 (fig. 6.9). When the new store opened at the corner of Third Avenue and 19th Street, Rush Kress called it "Kress' monument to Birmingham."[15] The entire surface of the 100-by-150-foot building, comprising four stories with a penthouse and two basements, is faced with creamy, mottled terra-cotta blocks. As in Fort Worth, the mottled terra-cotta

coordinates with the variegated marble base, which extends all around the building. The brown flecks in the terra-cotta glaze and the darker marble bulkhead blend with the extensive copper trim around the display windows and the long, overhead copper awning boxes. The interior of the building reflects the expense lavished on this store, including specially designed metal water fountains and a women's lounge, restricted to use by white women (figs. 6.10, 6.11).

Fig. 6.9. *Birmingham, Alabama, Kress store, 1937. Courtesy National Building Museum, gift of Genesco, Inc.*

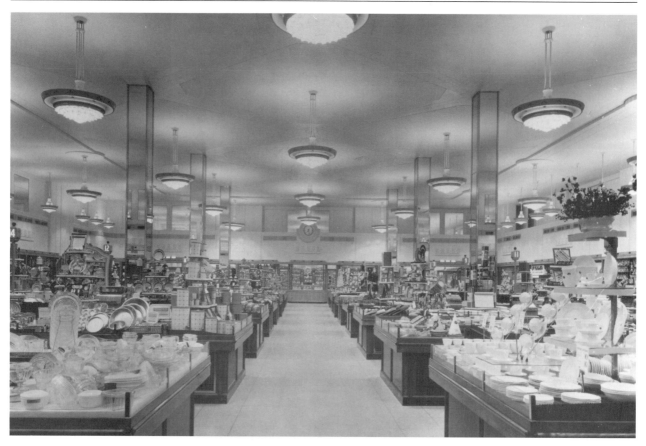

Fig. 6.10. *Birmingham, Alabama, main sales floor. Courtesy National Building Museum, gift of Genesco, Inc.*

Fig. 6.11. *Birmingham, Alabama, women's lounge. Courtesy National Building Museum, gift of Genesco, Inc.*

The design of the store broke with Kress architectural traditions, revealing the Bauhaus influence that Sibbert later acknowledged as well as the impact of the emerging International Style. It also shows an awareness of the work of Louis Sullivan in the United States and of Erich Mendelsohn in Germany, both of whom switched from a vertical orientation to a pronounced horizontality in department store design, as can be seen, for example, in the upper windows of Sullivan's Carson Pirie Scott store, in Chicago, or in Mendelsohn's designs for Schocken department stores. The window arrangement of the Birmingham store is not quite the same as in these department stores, however, in that sections of wall intervene between the longer sections of windows. But the front and side of the Birmingham store read as a continuous whole, joined in a graceful curve. A thin terra-cotta coping flows across the top of the building in an unbroken straight line. The upper structure of the Kress store seems to sit on a single expanse of glass, thanks to the repetition of horizontal display windows across the front and down the side, except for the final rear section of the building. The long sweep of plate glass is interrupted only by recessed doorways and

relatively narrow side piers. The two front entrances on Third Avenue are protected by cantilevered overhangs with balconies made of cast-iron piping that curves at the ends, emulating the lines of the building as well as the curving edges of the flat overhang. Here, as in Fort Worth, the balconies incorporate ladders in their floors.

Vertical elements in the design help organize the elevations and provide some balance for the overriding horizontality. The strongest of these is the large cylindrical form at the corner of the building, which is partly a backing for three vertical renditions of the name Kress and partly a flagpole. The whole element is outlined in neon. Sibbert had used neon to highlight the Kress sign in Hollywood, but here an architectural element as well as the name is circumscribed in neon, providing the building with its most dramatic detail (fig. 6.12).

In an unprecedented step, all sculptural ornament is eliminated from the upper elevations. In the manner of the Bauhaus, however, oversized signage assumes the function of ornament: metallic gold letters spelling KRESS appear above the roofline on both elevations, and the company's full name appears on the walls lower down (plate 17). Some ornament appears above

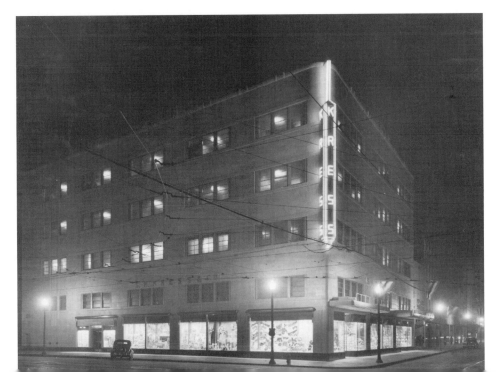

Fig. 6.12. *Birmingham, Alabama, night view showing neon store sign. Courtesy National Building Museum, gift of Genesco, Inc.*

the entrances in the form of long and short parallel lines and, most notably, in the form of horizontal tubing with bent ends reminiscent of the balcony piping. The layers of tubing with upturned ends serve as the base for an outsized KRESS underlined with a stroke and backlighted. The letters and the ornament merge into a decorative ensemble that is realized entirely in metallic gold.

Sibbert appears to be following Le Corbusier's advice to architects to look to the engineering aspects of an ocean liner as a basis for design. His Birmingham store is reminiscent of a seagoing ship. Here, however, the reference to ship design is used to make a typically Kress gesture of allegiance to locale. Birmingham is on a waterway leading to the Gulf of Mexico and is a port of entry in the Mobile customs district. The ships regularly going to and from Port Birmingham are not ocean liners but cargo ships—long vessels with very little superstructure. The flat hulls are often reinforced around the upper edge with a narrow strip. The bow of such a ship has a pilot's cabin with a continuous row of windows to ensure good visibility, and decks with iron-pipe railings.

Birmingham's economy was largely based on the iron industry. Cast-iron pipes were a leading manufactured product and were shipped from Birmingham in great quantities. The Kress Company itself had a vested interest in the iron and steel industry, since its stores were of steel-frame construction, and a good deal of miscellaneous ironwork went into the buildings. An engineering company listed items it furnished for the Nashville store in an advertisement, and these included everything from steel stairs and fire escapes to steel lintels, a trash chute, and even housing for a dumbwaiter. The advertisement appeared in the same column as a news story reporting that for the new Kress store in Nashville "fifty tons of steel in excess of what would otherwise have been necessary were used in making possible the elimination of the customary supporting columns."[16] Sibbert seems to have taken representative aspects of a cargo ship and absorbed them in the structure and detailing of his Kress store design. Lest this be overlooked, the store has cast-iron–pipe railings—Sibbert's only use of these—over the two front entrances to underscore the nautical reference.

Fig. 6.13. *Venetian Building, Flagler Street, Miami, Florida, before Kress Company remodeling. Courtesy National Building Museum, gift of Genesco, Inc.*

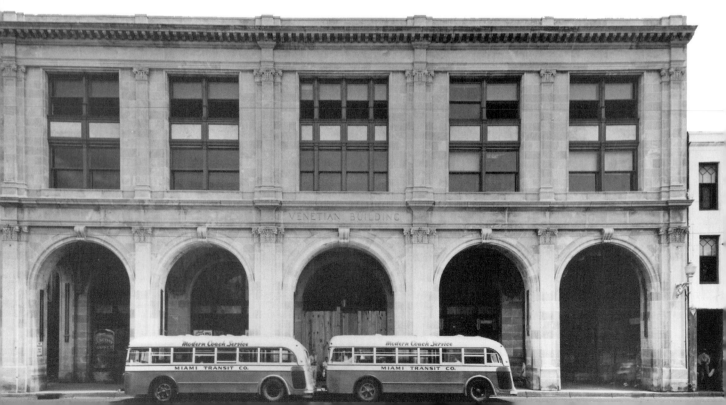

MIAMI, FLORIDA

Sibbert's extensive remodeling of an older building in Miami, known as the Venetian Building and alternatively as the Venetian Arcade, turned it into a modern, boxlike Superstore that opened in February 1938 (fig. 6.13). A rendering of a possible front elevation dated 1936 shows that the Miami store was in the planning stage the same year that the drawings were made for Birmingham; Miami's all-white elevations, devoid of sculptural ornament and inset with horizontal bands of windows, do have something in common with those in Birmingham (figs. 6.14, 6.15; see also fig. 6.9). Some of the building's original definition was kept intact (space for other retail stores was incorporated into the building), and it still provided pedestrian passage from Flagler Street, Miami's principal shopping street, to Southeast First Street. The front elevation, on Flagler Street, was clad in mottled white terra-cotta, while the rear had a stucco surface, made of Gunite, or Cemelith (fig. 6.16). The secondary storefront was kept extremely simple, its main appeal being plain, repetitive arches at the ground level, forming a sidewalk arcade.

Kress had had a store in this prime location since 1916, starting with a substantial yellow brick store that was succeeded in 1924 by a five-story terra-cotta–clad building. The 1938 store was a few doors down from the second building, abutting and towering above a modern Woolworth's. A handsome movie theater, the State, was directly across the street, and Miami's finest department store, Burdine's, was located a few blocks up on the same side as the newest Kress's. Thus Kress continued to occupy what had come to be called by the late 1920s "a 100 percent location." The new store also helped to define what a 1938 government survey called a "Class A subcenter," the measure being the presence of certain kinds of businesses, including a five-and-ten-cent store.[17] Miami's 1938 Superstore has since been demolished.

Although the building housed retail establishments other than Kress in spaces at each end, the design left no doubt that this was

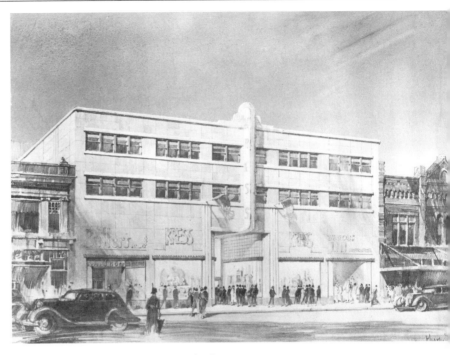

Fig. 6.14. *Sketch for a Kress store in Miami, Florida, 1936. Courtesy National Building Museum, gift of Genesco, Inc.*

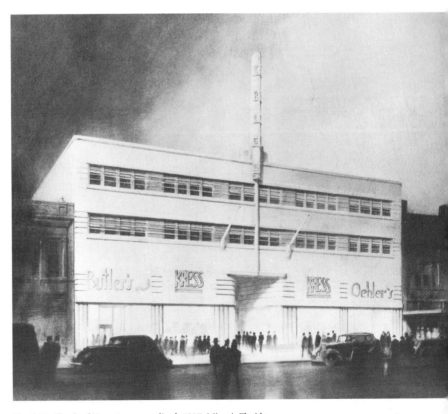

Fig. 6.15. *Sketch of Kress store as realized, 1937, Miami, Florida. Courtesy National Building Museum, gift of Genesco, Inc.*

first and foremost a Kress store. A tall, tapered standard rose from the middle brow of the front elevation, brandishing the Kress name in huge letters on either side. Each outsized letter, dark against a white background, was outlined in neon. At street level, Kress's windows were larger than those of its neighbors. The recessed entrance to Kress's was given special prominence by being higher than those on either side, with curved upper walls ornamented with curving strips of terra-cotta. A slight, curved, cantilevered overhang sheltered this entrance, above which protruded two conspicuous dark bronze flagpoles. The vestibule itself was somewhat wider, allowing for the Kress name panel to be embedded twice in the floor near the sidewalk. The new-style Kress logo with underlining appeared over the dis-

play windows in bolder letters than those spelling the names of the two flanking stores. A wide dark-bronze band, called a "light channel" on the plans, ran underneath all the store names, providing equal illumination, but only the Kress name and the bar underneath were outlined in neon.

The Flagler Street elevation is evocative of the architecture that had developed across the bay in Miami Beach in the 1930s. A number of architects had gathered there, designing consistently low, streamlined buildings in a special vocabulary, reinforcing the city's image as *the* seaside resort of the 1930s.[18] Today the style is characterized as Miami Beach Art Deco. As an alternative to terra-cotta, Sibbert's plans for the Flagler Street facade allowed a choice of keystone, or coral rock, a material associated particu-

Fig. 6.16. *Kress store, Flagler Street, Miami, Florida, 1938. Courtesy National Building Museum, gift of Genesco, Inc.*

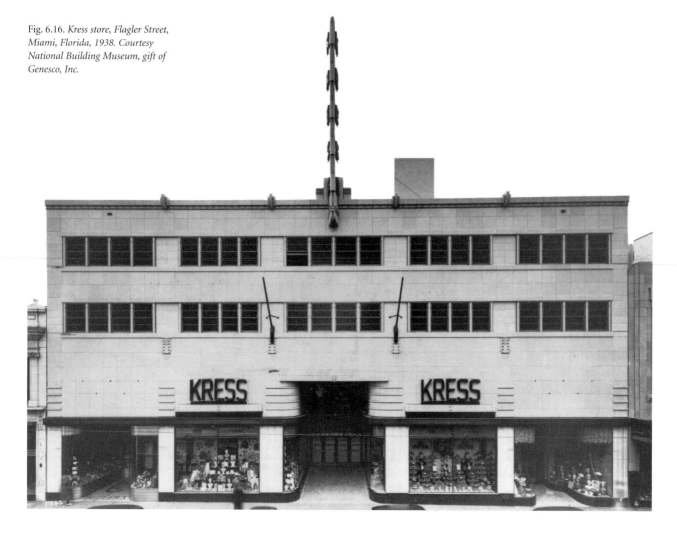

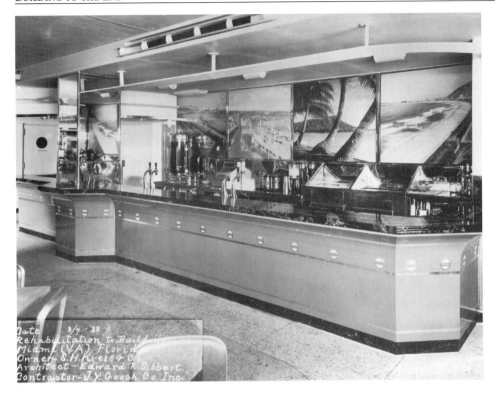

Fig. 6.17. *Miami, Florida, store cafeteria with photomurals of "World Famous Beaches." Courtesy National Building Museum, gift of Genesco, Inc.*

larly with the architecture of Miami Beach and quarried in the upper Florida Keys. The storefront's neon Kress sign, soaring above the center; its curved entry walls marked with directional stripes; and its overhanging "eyebrow," in Miami Beach parlance, all belong to a Miami Beach vocabulary. So does its dark banding of "racing stripes." The smooth white facade, with its horizontal bands of windows, has a nautical aspect, as does the Birmingham store, but it relates to the Port of Miami, a major seaport with direct access to the Atlantic Ocean. The nautical theme extended to opening day; a company group photograph shows three women in costumes similar to ships' officers' uniforms in the front row along with several store managers.[19]

On the walls of the basement cafeteria, united by the theme "World Famous Beaches," eighteen photographs measuring four by five feet and framed in satinwood showed scenes of famous beaches in Tangiers, Blackpool, San Sebastián, and the Isle of Man, as well as Waikiki Beach with Diamond Head in the background (fig. 6.17). The choice of subject for the photomurals

seems to reflect Samuel Kress's interests. He liked pictures of faraway places, and he enjoyed and appreciated beaches. The latter interest is evidenced not only by his committee work on behalf of public beaches but also by his membership in two clubs in Palm Beach: the Everglades and the Bath and Tennis.

Putting photomurals on walls was an advanced step for 1937. The technology that made it possible had only recently been invented.[20] The New York store provided a precedent for the Miami photomurals in Edward Trumbull's hand-painted oil scenes on the walls of the basement cafeteria. In a company whose stores were hierarchically graded, it seems reasonable to think that the flagship store merited murals in oils by a famous artist, while Superstores deserved something comparable but not as distinguished.

Miami Beach would have had special meaning for Sibbert, who had lived and worked there before coming to Kress. It is interesting to note that his former partner there, Russell Pancoast, had also turned to modern design by 1930, contributing much

Fig. 6.18. *Miami Beach, Florida, Kress store as part of a complex designed by L. Murray Dixon, Jr. The marquee was added later. Courtesy National Building Museum, gift of Genesco, Inc.*

to the distinctive look of Miami Beach. Sibbert would have kept in touch with developments in Miami Beach by virtue of being the Kress architect. L. Murray Dixon, Jr., a major contributor to Miami Beach Art Deco architecture, drew plans in 1935 for a keystone complex covering a block on Washington Avenue that was to have space for a Kress store at one end. The store itself did not become a reality until 1941, when Sibbert designed its interior (fig. 6.18). The same year, a splendid theater designed by Thomas Lamb, the Cinema Theatre, opened in the complex beside the new Kress store.

EL PASO, TEXAS

Edward Sibbert ranked the Fifth Avenue store and the store that opened in 1938 in El Paso as his favorites, but the two buildings could not be more different. The El Paso store is a cacophony of colors and an assemblage of numerous parts (plate 18). It outdoes even Sibbert's earliest Kress stores in this regard.[21]

The first Kress store in El Paso opened in 1907. After that, two progressively larger yellow brick stores occupied the same site at 211 North Mesa Avenue. The company demolished the last four-story structure to make room for the new Superstore. Sibbert's store was constructed in two stages. Kress began operation in the first half of the building in 1938, while it was being linked to the second half to form an L-shaped store that went through the block.[22] The corner location on Mills and Oregon Streets was especially attractive, as it was across the street from San Jacinto Park, a public park around which other fine downtown buildings had clustered. Sibbert took full advantage of the corner site by designing what appears to be a full-length tower with wings extending out along both sidewalks. The bulk of the building is two stories and a basement. The tower adds a finished penthouse story, above which sits a smaller square tower covered by a four-sided hipped roof surmounted by a cupola (fig. 6.19). The store has three sidewalk eleva-

tions clad with mottled buff and cream terra-cotta, along with the four-sided corner tower. Besides the two neutral colors of the cladding, the ornamentation includes eight more colors: red, blue, yellow, turquoise, black, white, tan, and metallic gold.

The design of the El Paso store was determined to some extent by a request from the women's division of the El Paso Chamber of Commerce to build the new store in a Spanish style. They wanted Kress to build in what they called a distinctive style specifically adapted to El Paso, one that other architects had already adopted. They sent numerous photographs of Spanish or hacienda-type El Paso buildings to the company's New York office. In April 1937 Sibbert came from New York to review details, asserting that his company favored erecting buildings that suited the general atmosphere of places. He gave El Paso his assurance of a new Kress store "in a modified Spanish style of architecture."[23] A leaflet distributed at the opening described the completed building as "of modified Spanish architecture to comply with a special request of the Women's Division of the Chamber of Commerce that we design a building in keeping with the colorful history of this locality. We are proud to cooperate with them in their splendid program of city planning to make El Paso more beautiful than ever . . . a city which truly reflects its romantic past."[24]

Sibbert's design quotes the work of the architect Henry C. Trost, who had had much to do with shaping the appearance of El Paso's downtown.[25] A row of lunettes filled with broken bits of ornament, for instance, echoes the same kind of decorated lunettes on Trost's 1910 Roberts-Branner Building, which is contiguous with the Kress store on North Mesa Avenue and which fills most of the corner space around which the L-shaped Kress store is located. The rear portion of the Oregon Street elevation, treated almost as an independent facade, recalls Trost's 1914 Alhambra Theater facade (fig. 6.20). The same frilly decoration that seemed to characterize Spanish-Moorish architecture for Trost is used by

THIS IS A REPRINT FROM

CHAIN STORE AGE NOVEMBER 1946

VARIETY STORE EDITION

*Kress Store
El Paso, Texas*

The Kress Story . . .

Sibbert in the band of lacy cutwork, and the entire raised parapet, with its intricately patterned cornice and frieze below, resembles the treatment at the top of the Alhambra. In quoting Trost's work, Sibbert ensured that he was building in a style adapted to El Paso, fulfilling quite specifically Kress's pledge to the women of the Chamber of Commerce. Still, a newspaper caption beneath paired photographs of the new Kress store read, "Some authorities have been at a loss to classify the building as to its type of architecture, because it is decidedly new. It has been generally agreed, however, that it is a modernized Spanish style with traces of Moorish influence."[26]

Fig. 6.19. *"The Kress Story . . . ,"
an article in* Chain Store Age,
*November 1946, picturing the El
Paso, Texas, store's Mills Street
elevation. Reprint courtesy Samuel
H. Kress Foundation.*

Fig. 6.20. *El Paso, Texas,
Kress store, drawing of
Oregon Street elevation.*
Carla Breeze, Pueblo Deco.

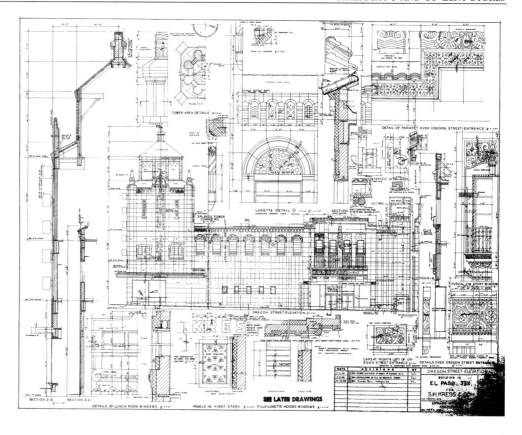

Fig. 6.21. *El Paso, Texas,
Kress store, drawing of Mesa
Avenue elevation. Carla
Breeze,* Pueblo Deco.

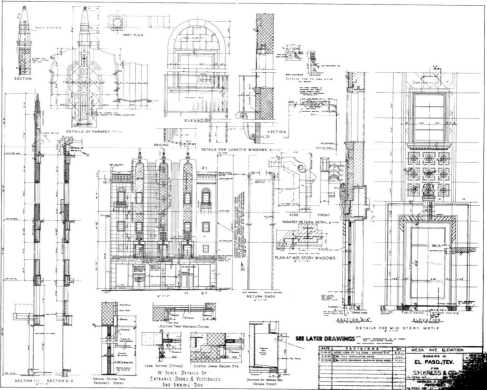

The single elevation between adjoining buildings on North Mesa Avenue displays some familiar aspects: mirror symmetry, with double recessed entrances at ground level (fig. 6.21), and a tripartite upper facade divided straight down the middle by a huge, electrified Kress store sign with red letters. The effect is that of a tall storefront, emphasized by repeated vertical elements and ornamentation culminating on the taller window bays in the center. Each bay has a large overhanging bracket, glazed turquoise and orange, at the pinnacle. Above these rise three tall, rounded finials of turquoise and gold, coming to a point and crowned with small golden balls. Wrought-iron balconies with vertical supports adorn the uppermost windows at either side (plate 19). Another more geometrically conceived dark-metal balcony with openwork railings runs across the facade, reminiscent of the metal balconies in Fort Worth. In El Paso, however, the design consists of two standing motifs beside the name Kress, which Carla Breeze characterizes as an Indian motif referring to a cumulus cloud.[27] Balconies and signage are repeated on the other elevations as unifying elements. While the balcony overhangs look the same, the one on the Mills Street side was designed as an automatic fire escape, described in the following way in newspaper coverage of the opening: "When it is stepped on, an alarm sounds and the steps are lowered to the sidewalk slowly."[28]

The three center bays on the Mesa Street facade also show some of Sibbert's characteristic practices, such as the crisscross designs and the diapering created by the cream-colored blocks in each bay. Stalks of desert plants curl up the faces of the consoles on the lintels of the three doors that give access to each outside balcony. Mayan ornament appears once more in the large sculptural motifs sitting atop the consoles. The colorful sculptures resemble faces or primitive masks. Polychrome squares set in the wall correspond to actual Mexican tiles set in the door embrasure inside the Oregon Street entrance (fig. 6.22). These brightly patterned tiles ornament all the surfaces of the zebrawood and satinwood door surround, as well as the four risers of an entrance staircase. The short staircase is further embellished with three black wrought-iron railings and golden bronze handrails ending in a flourish.

On the Mills Street and Oregon Street sides Sibbert had the problem of integrating a much taller tower, differentiated by vertical pilasters, with the rest of the elevation. This was particularly acute on the Mills Street side, where the facade functions as the storefront, with two entrances flanked by display windows across the lower level. The problem was solved by bringing the lower sides up flush with the tower pilasters to give the semblance of an unbroken wall surface of matching terra-cotta blocks. Sibbert integrated the two parts of the two-sided elevation by demarcating all the rooflines with

Fig. 6.22. *El Paso, Texas, detail, inside doorway, Oregon Street. Photograph by author.*

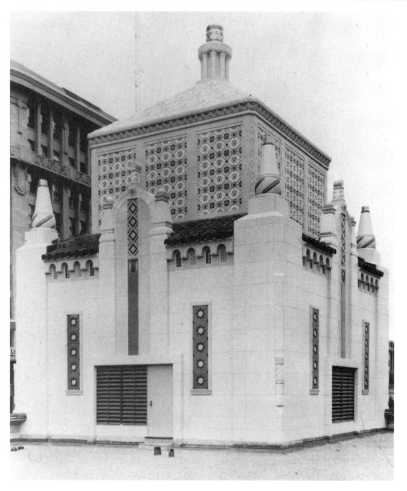

Fig. 6.23. *El Paso, Texas, Kress store, corner tower. Otis Aultman Collection, El Paso Public Library.*

cladding into three parts. The motif is made up of stylized fragments of a stalk of cotton. The center of the design is an open boll of cotton showing its white, fluffy fiber, backed with pointed green leaves. Mirror images of fragments of unopened bolls fill the lower sides. Company booklets for Fort Worth and El Paso each pointed out that Texas was the leading cotton-growing state, an index of the state's progress. Cotton shown in two stages of growth on the El Paso store translates this idea into images.

Kress had long had an interest in the production of cotton. A certificate for a hundred shares of preferred stock in S. H. Kress & Co., canceled in 1917, is embossed with an engraving of Canal Street in New Orleans showing Weil's 1913 Kress store in place. It includes a scene of people hoeing cotton in a field and others loading the baled cotton onto a horse-drawn wagon, with warehouses by the river and a Mississippi riverboat in the distance.[29] From the time he chose to found the chain in the South, Samuel Kress had seen the company's destiny as tied to the production of cotton. The large number of cotton items sold in Kress stores indicates the degree of Kress's dependency on the product. The lacy strip across the mini-facade on Oregon Street in which the name Kress is embedded is a possible allusion to one of Kress's best-selling items, cotton lace.[30] If so, it is an appropriate allusion in the city of El Paso, with its Spanish past and its proximity to Mexico. Lacemaking was an important craft industry there in the late 1930s. The El Paso Kress store sold Mexican-printed postcards of Mexican lacemakers.[31] Presumably, the store also sold Mexican cotton lace.

The principal feature of the store, the corner tower, stands eighty feet high, reaching this height incrementally by one square section set on another, culminating in a slanting roof on which sits what the plans call the "tower apex." This detail is composed of three sections: a circular colonnaded tower, an undulating cornice, and finally, a round gold circular crown with a cap of buff terra-cotta (fig. 6.23). Much of the surface is covered with small pieces of terra-cotta, each

the same red-clay tiles used on North Mesa and by adding the same strip of arcading beneath the tiles. The interlacing arcades on all three elevations shelter brightly polychromed wall plaques in various geometric designs. The arcades filled with designs suggesting heraldic patterns and colors are a variation of Mackay's solution in Tampa, where he also created a Kress storefront in a Spanish style (see figs. 3.1 and 3.3 and plate 4).

Sibbert broke up the continuous wall of the long Oregon Street elevation with a reduced version of the front elevation, employing a slightly raised, stepped parapet and a coping or cornice in the same color as the wall and underlined with a frieze to help define it. KRESS appears in metallic gold above a dark copper awning cover. True to form for a Sibbert storefront, a block of flat terra-cotta ornament marks the top of two side piers, created by subdividing the ashlar

one requiring a model. Even the four surfaces of the hipped roof are covered with ornamental fragments. Moorish-inspired finials sit atop the four corners of the first stage of the tower, wearing their own miniature gold crowns. The intricate beauty of the tower of the El Paso Kress store has long been acknowledged. The tower functioned as a carillon and was wired for both chimes and lighting.[32] A tower that electrically provided music for people on the street or sitting in the park was a one-time phenomenon in Kress's building history.

The tower makes reference to El Paso's layered history and diversity as a city of four cultures: Anglo, Indian, Spanish, and Mexican. El Paso's Anglo heritage is reflected in a reference to a historic government building, dated 1892, that was torn down by Kress to build the new store.[33] The dominant feature of the Federal Building was a two-tiered square tower on a stone base. Each landing had a balustrade with prominent finials atop the corner posts. Like the Kress tower, it had a band of arcading just below a slightly overhanging roof, repeated on the lower wings of the building to unify the design. Chimes pealing forth from the top of the tower were another link with this structure, which had been surmounted by a lookout tower equipped for sounding the tocsin in what had then been frontier territory. In preserving the memory of the Federal Building in the architecture of the Kress store, S. H. Kress & Co. kept alive the memory of a significant chapter in this border city's colorful history.

The history of El Paso dates back to the 1680s, to three Spanish missions that stood along the Camino Real, the "Royal Highway" used by Spanish settlers and conquistadors. The missions, built by Pueblo Indians, blended Spanish and Indian architecture. One of them, La Purísima Socorro Mission, is distinguished by a square bell tower on its facade. The shape of the Kress tower and its carillon function suggest association with the Socorro Mission.

The second stage of the Kress tower, with its colorful latticed walls sectioned and framed with buff-colored blocks, calls to mind the square towers attached to mosques in Muslim Spain. The Giralda Tower in Seville is a prime example. This tower and others like it stopped serving as minarets when the Moors were expelled and Spain became Roman Catholic. Muslims were no longer summoned to worship from the top of the tower. Rather, Christians were summoned by the tolling of the bells. The notion of the tower as Spanish-Moorish architecture is emphasized by the cushioned finials at the corners of the lower stage. Sibbert takes the viewer back through El Paso's history, and even farther back to that of the Iberian peninsula.

Mayan architecture is an established theme on all three elevations, supported strongly by the look of the blocklike, stepped tower. The honeycomb latticework in rectangular frames on the walls of the finished penthouse is highly reminiscent of sections of the walls of the Nunnery, the Mayan temple that, as was mentioned above, had been reconstructed from plaster casts at the 1933 Century of Progress International Exposition in Chicago. The ceiling of the selling floor is Mayan Revival in style with ornamental plasterwork in geometric designs. The stylized Mayan or Aztec motifs were originally painted in earth colors.[34] A Mayan theme in this instance points to the presence of an earlier culture underlying modern-day Mexico, a country whose flag once flew over Texas. Recalling a Mayan past in the architectural design is consistent with the layered view of history informing the design. Along with pre-Columbian Mexico, modern-day Mexico is represented in the lavish display of Mexican tiles inside the doorway and in the possible allusion to Mexican embroidery and lacework on the outside.

Kress drew its customers from all segments of El Paso's population. Many of its customers came from Mexico, especially from El Paso's sister city, Ciudad Juárez. One can take this extravagant and, in its own day, extremely modern Kress store as a tribute to the diverse buying public of El Paso, who collectively ensured Kress's growth and prosperity.

SAN ANTONIO, TEXAS

Sibbert's last major store in the 1930s was a Superstore in San Antonio, Texas, completed in 1939 (plate 20). The building stands on a site where Kress stores had stood since 1905, on East Houston Street, San Antonio's main commercial street leading down to the Alamo. It was actually a complete remodeling of an older Kress store, with few if any vestiges of the classic yellow brick store left visible. The remaking of the old store resulted in an imposing terra-cotta storefront three stories high and 150 feet across, with penthouse towers at either end creating greater height and a more stately presence.[35]

The twin-tower facade is a study in contrasts. It is plain, bold, and easy to comprehend in broad outline, while at the same time having complicated and florid aspects. It is heavy and light and ebullient all at once. The facade is kept to a single surface plane and restricted primarily to one color, a pale buff with a rosy tint. Ornamentation is restricted to the base of the five window bays between the towers and to the level above the upper-story windows. Simple spandrels faced with concave bands of terra-cotta, some in the facade color and some in a deeper shade of tan, help make the distinction between the lower middle section and the higher end sections, while also drawing together the entire expanse. The tan glaze helps integrate the storefront's copper marquee into the color scheme. In a pairing of opposites, the hori-

zontal bands of the spandrels provide contrast and balance for pilasters, evenly spaced across the facade, made of convex vertical strips. The towers appear to be whole cubes or blocks, although they are only the ends of long, narrow penthouse stories. The illusion is created by terra-cotta facing on both sides of the elevated brick stories nearly as wide as the front. Matching parapets on all three sides, with the same irregular, curved molding and applied motifs inspired by Spanish Baroque or Churrigueresque design, reinforce the notion of square tower blocks. Although lightened considerably by the ornamentation, trim, and a window in the middle of each front wall, the cubic units contrast strongly with the open space between them, marked by five tall, slim standards of electrified metal, each carrying one large red letter of the Kress name on either perpendicular face. The slim metal signs are deeply embedded in long, sculptural terra-cotta bases. (The forms of the bases are indebted stylistically to Frank Lloyd Wright's array of stylized hollyhocks on the Barnsdall house, cited above in the discussion of the Kress store on Hollywood Boulevard.)

One of the most attractive aspects of this storefront is the relief ornament emanating from the lintels of the five mezzanine windows. These large sculptural motifs with curved molding enrolled at the ends are modern and Spanish Revival at once. They blend with the ornament at the top of the five window bays in size and color and with

Fig. 6.24. *Terra-cotta standards, detail, San Antonio, Texas, storefront. Photograph by author.*

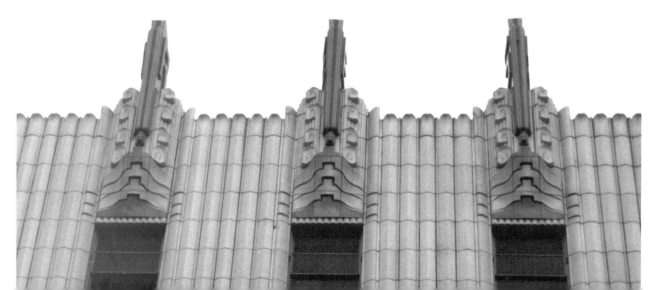

the ornamental bands across the end sections in terms of style and in shared turquoise highlights. The mezzanine reliefs have sizable freestanding finials terminating in lotus buds, accented by a turquoise glaze. The lotus forms stand out all the more by being backed by flat, tan spandrels, which the lotus forms partly obscure. Thematically they do not accord with the ornament higher up, in that they are Egyptian and the sculptural bases for the electrified signs are Mayan-inspired, but both types of ornament were typical of Sibbert's work. The lotus finials do correspond thematically to the way the reeding is finished at the roofline of the middle section, where each colonnette ends in an overturned lip, or cavetto.

A huge, old-fashioned Kress store sign made of wood with gilded letters of the earliest type originally sat upright on the top of the marquee at the outer edge (see fig. 6.30). It was combined with golden Kress logos in modernized lettering on the sides of the tower blocks, and with bold red letters on the electrified standards (fig. 6.24). The three types of signage on this storefront were not well integrated artistically, although they did help to define the organization of the facade.[36] The signs in unison also served a practical function. Those that are high up and aimed to the sides drew attention from a distance, while the sign lower down, parallel to the sidewalk and facing forward, caught the eye of the shopper.[37]

The San Antonio signs came close to encapsulating the history of Kress store signage, from the original red-and-gold store sign, to the modified golden logo, to individual letters on standards, conceived anew in more exaggerated form on this storefront. The old-fashioned store sign could have been salvaged from an earlier Kress store, but photographs indicate that it did not come from this store's predecessor. In any event, the disparate signs on the San Antonio facade combine to document visually the history of the single most important design component of a Kress storefront.

The interior of the store is consistent with the exterior in its design. The main sales floor contains many features typical of

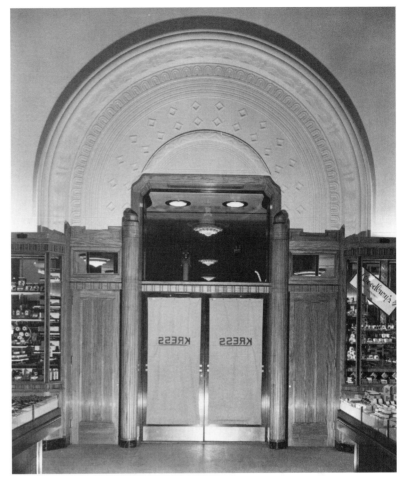

Kress Superstores by 1939: mirrored piers, hanging lights with modern-style satellite globes, and indirect lighting above the dadoes. The one-of-a-kind design for the front end of the floor coordinates with the outside in being sectioned by simple, squared-off reeded pilasters protruding from the wall. These flank two doorways with carved and molded wooden surrounds and tall doorposts, comparable in material and inspiration to those in El Paso, but less colorful and complex (fig. 6.25; see also fig. 6.22). The wooden surrounds and the wooden extensions along the walls are encompassed by overhead plaster arches. The encircling arches in high relief are ornamented with wavy segments and filled with expanding arcs in low relief, two of which are formed by small repetitive circles. The overall impression is one of contained exuberance within a simple, orderly scheme.

Fig. 6.25. *Interior doorway, San Antonio, Texas. Courtesy National Building Museum, gift of Genesco, Inc.*

The basement floor continues the established format of a sales floor combined with a cafeteria. Indirect lighting plays on recessed sections of ceiling, while light fixtures submerged in a circular overhang softly illuminate a marble staircase that widens into a broad landing before the final descent (fig. 6.26). The marble terrazzo floor—pale rose inset with rectangles of a deeper rose—coordinates with the satinwood dadoes with rectangular panels. Photomurals tinted with transparent oils and in corresponding satinwood frames line the walls of the cafeteria above the wainscoting (fig. 6.27). The two shades of rose in the basement terrazzo floor correspond to the graded hues of the storefront terra-cotta, and the wooden paneling echoes the rectangular terra-cotta paneling across the lower facade.

The subject of the photomurals is "Sights of San Antonio." One of these, the "Sightseeing Trolley," shows that viewing the sights was an organized activity. As in the New York store, historic buildings and an early view of the Kress store's location are part of the sequence. A picture of a historic Spanish dam and aqueduct recalls the image of the old Croton Reservoir in New York City. In format the murals resemble enlarged picture postcards. Each is identified in red lettering on a clear plastic panel attached to the upper frame. The transparent color added to these sepia photographs makes them look like picture postcards of the late 1930s, which were often commercial photographs that had been selectively hand-colored. Several of the photomural views are in fact enlarged versions of postcards that might have been sold in the store (fig. 6.28).

Fig. 6.26. Staircase to the basement, San Antonio, Texas. Courtesy National Building Museum, gift of Genesco, Inc.

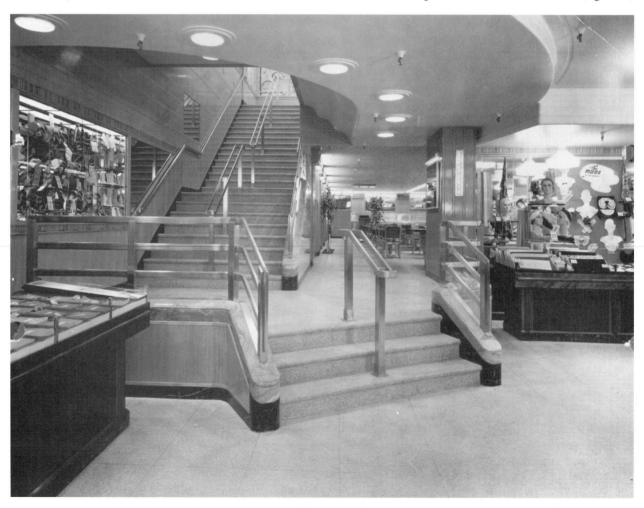

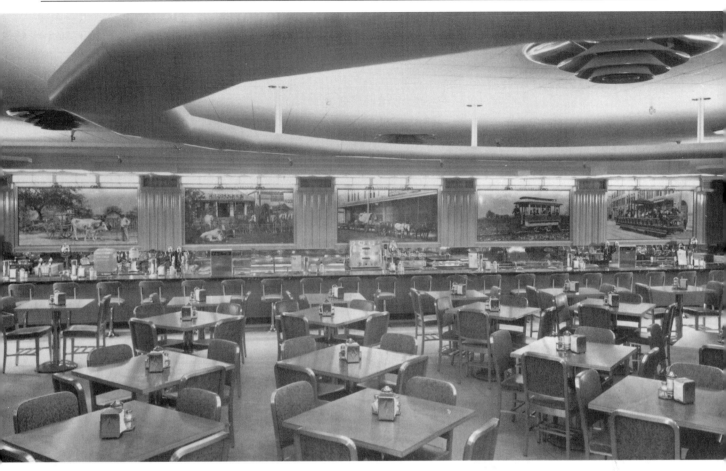

Fig. 6.27. *Basement cafeteria, San Antonio, Texas, store, decorated with photomurals of "Sights of San Antonio." Courtesy National Building Museum, gift of Genesco, Inc.*

Fig. 6.28. *Racks of postcards near entrance to Kress store, Phoenix, Arizona. Courtesy National Building Museum, gift of Genesco, Inc.*

Records of the Curt Teich Company, which produced postcards sold by the thousands in the San Antonio Kress store, show that eight of the original pictures were the property of S. H. Kress & Co.[38] No doubt the inventory would have included a postcard view of the San Antonio store. The original photograph, now in the Curt Teich archives, was altered to eliminate parked cars but not pedestrians (figs. 6.29, 6.30).

In 1931 Samuel Kress was involved in the manufacture of picture postcards for another purpose. Some years before, he had begun the process of having his art works documented with photographs. He then had these images reduced to "photolets," as

he called them, for reproduction in booklets, newspapers, and the like. In 1939 the National Gallery of Art wanted to make postcards from paintings he had donated, to be sold to the public at the gallery. His interest in the project and his high standards in this regard are revealed in a passage from a letter to John Walker, chief curator of the National Gallery:

> I suppose of course that you know there are numerous concerns doing this kind of work and naturally assume you have caused an exhaustive search to be made in order to get the best possible work. I suggest that when you make your final selection you let us see what you propose

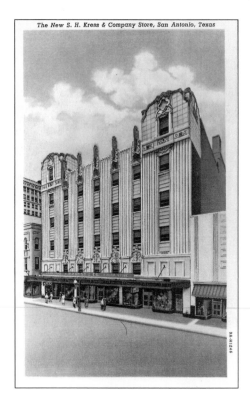

Fig. 6.29. *Postcard of new Kress store, San Antonio, Texas. Lake County, Illinois, Museum/Curt Teich Postcard Archives.*

Fig. 6.30. *Kress Company photograph provided for postcard view. Lake County, Illinois, Museum/Curt Teich Postcard Archives.*

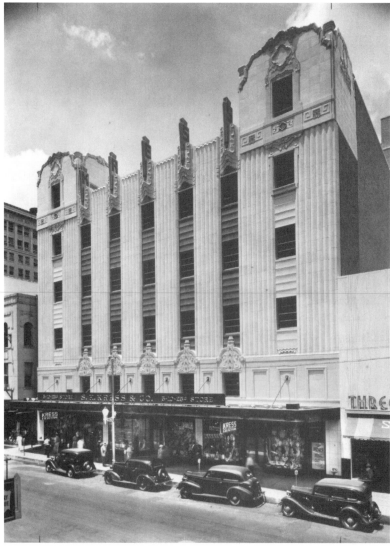

Fig. 6.31. *Framed photo mural, montage of three scenes, San Antonio, Texas, Kress store. Photograph by Julie K. Brown.*

ordering since we have given a great deal of attention to the quality of photographs for some years and may have some suggestions or thoughts to make.[39]

S. H. Kress & Co. had long been familiar with the use of photography and with photography in sophisticated forms. The architectural division consulted aerial views of downtown areas, for instance, when planning for a new store site. Thus it is not surprising that the photomurals included an aerial view of a portion of San Antonio's downtown Houston Street before a Kress store was built there. The company frequently retouched or modified photographs of its stores for newspapers and other purposes. This process, which involved skillful blending of two or three photographs to appear as one scene, is clearly visible in the photomurals.[40] One double image, labeled "Markets and Chili Stands, Military Plaza," shows close-ups of

vendors looking out from behind their stands on one side blended with a distant view of activity in the plaza on the other. A triple image combines three views, including one of a woman grinding corn, disguised as a single photograph (fig. 6.31).

The photomurals may suggest sources for the building's detailing. For example, the wavy motifs all over the facade could relate to the blown-up photograph of the eighteenth-century Spanish aqueduct and dam. The overarching tympanum above the front entrance with its repetitive arches, some of which are composed of stylized bubbles, might well be a schematic allusion to the same structures. The smooth, flat ornamental surrounds of the outside penthouse and fourth-story windows are distinctly akin to window treatments on the most famous sight in San Antonio, the Alamo, situated a few blocks from the Kress store. Two enlarged details of another mis-

MISSION SAN JOSE, BUILT 1720, SAN

Fig. 6.32. *Postcard, "Mission San Jose, Built 1720, San Antonio, Texas," published by S. H. Kress & Co. Lake County, Illinois, Museum/Curt Teich Postcard Archives.*

sion, Mission San José (fig. 6.32), flank a solid wooden door leading into the kitchen. One, of a carved door, echoes the door beside it, but more so the carved wooden embrasures upstairs at the entrance. The other photograph reproduces San José's sacristy window, known locally as Rosa's Window, which is believed to have been carved by Pedro Huizar, a Spanish sculptor living in Austin, and which is reputedly one of the finest examples of stonecarving in America. The blind windows on the exterior tower blocks clearly emulate this eighteenth-century window with its ornate frame. Rosa's Window was highly admired at the time in San Antonio. When the city's oldest department store, Joske's, was remodeled in 1939, shadow boxes within miniature reproductions of Mission San José's celebrated window were attached to the display windows at the entrance.[41]

Missions play a large role in the San Antonio Kress store design. Beyond fragmentary allusions to mission churches in the storefront, there is one unifying notation in the design. In broad outline, the twin-tower facade with its lavish ornamentation calls to mind the cathedral of San Fernando in San Antonio, pictured in the basement murals. Although San Fernando is a nineteenth-century Gothic Revival structure, its most salient features are the same as those of the Kress store: square, blocky towers with ornamental trim. The cathedral incorporates remains of a mission church built by immigrants from the Canary Islands in the eighteenth century, unearthed and left on display after a restoration project. In any event, the storefront does suggest a Spanish cathedral of the type exported to the New World. The twin-tower facade had long been a symbol of missionary zeal and the triumph of Christianity, from Santiago de Compostela to Mexico City. The reference to an established type of cathedral architecture would have been recognized in a city with a strong Spanish orientation. More specifically, however, it is cathedral architecture transformed into a Kress store: Samuel Kress's own "cathedral of commerce" in San Antonio.

THE CONCLUDING YEARS

Sibbert continued to design Kress stores into the 1940s, reverting to Kress's original yellow brick cladding, as he had for a new store in Alexandria, Louisiana, in 1939, a substantial corner building across the street from a modest yellow brick store (figs. 6.33, 6.34). Two sizable buildings, one in Augusta, Georgia, and one in Charlotte, North Carolina (opened in 1940 and 1941, respectively), were similar to the one in Alexandria in using considerable amounts of matching terra-cotta to organize the facades, but little or no terra-cotta ornamentation. A drawing shows the Charlotte store embellished with Greek key motifs (fig. 6.35). The Augusta store, a replacement for one that had been destroyed by fire, has today been stripped bare, and the Charlotte store has been demolished. Since almost no archival material is available, little can be said about either.

Sibbert was also involved, as he had been all along, in alterations and additions to existing buildings. In 1940 he undertook a major restoration of a store in Dallas that has since been destroyed. He modified a number of older stores during this period, turning classic yellow brick storefronts in Fort Smith and Pine Bluff, Arkansas, and in Bessemer, Alabama, for instance, into simplified facades sporting tall brick pilasters

Fig. 6.33. *New Kress store under construction, 1938, across the street from old Kress store, Alexandria, Louisiana. Courtesy National Building Museum, gift of Genesco, Inc.*

Fig. 6.34. *Alexandria, Louisiana, Kress store as completed. Courtesy National Building Museum, gift of Genesco, Inc.*

Fig. 6.35. *Rendering of Charlotte, North Carolina, Kress store. Courtesy National Building Museum, gift of Genesco, Inc.*

and terra-cotta plaques and modern Kress signage. The Charleston, South Carolina, store was expanded in 1941 with an addition that required another sidewalk entrance flanked by display windows. Three more plate glass windows, set side by side and labeled above in smartly designed signage, indicated exactly what could be seen through the windows: the soda and lunch department (fig. 6.36). At this time Kress seems to have been promoting its lunch counters; a number of facilities were remodeled, often with neon signs to emphasize the renovations (fig. 6.37). The addition on Charleston's Wentworth Street took its

cue from the sidewalk elevation it adjoined, with additions of terra-cotta pilasters and chevrons and multicolored ornament to a facade clad with pale yellow brick.

In 1944 Sibbert was elevated to company vice president, to head the newly founded buildings division, which replaced the architectural division. Kress no longer needed a designing architect. By 1954 Sibbert had become dissatisfied with the direction the company was taking, and he left on short notice.[42] He formed a partnership with a friend, Frederic C. Wood, in which he mainly performed cost analyses for proposed college campuses. That did not seem

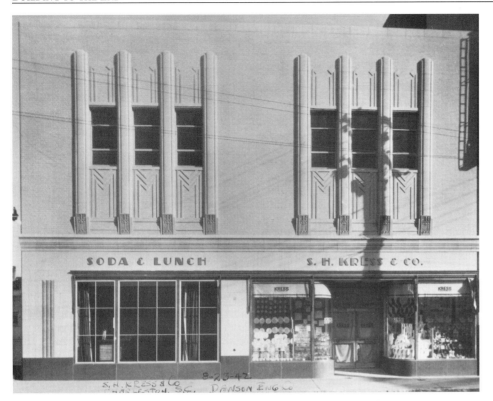

Fig. 6.36. *New addition featuring soda and lunch counter, Charleston, South Carolina, 1941. Courtesy National Building Museum, gift of Genesco, Inc.*

Fig. 6.37. *Florence, South Carolina, Clover Bar, a Kress store feature introduced in 1941. Courtesy National Building Museum, gift of Genesco, Inc.*

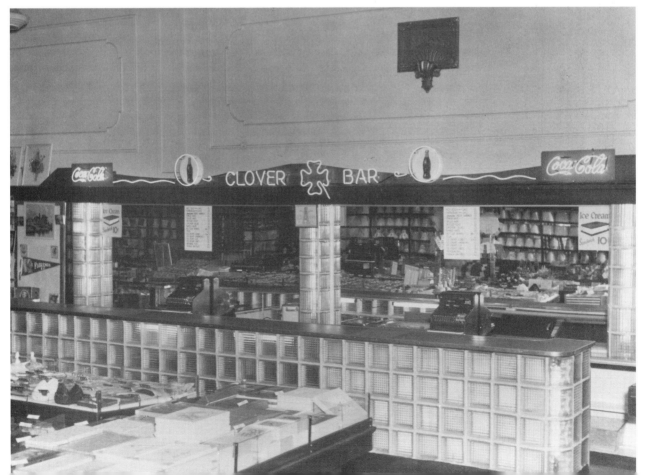

to satisfy him either. A short time later, the Sibberts moved to Florida, and he ceased working altogether. He died there in Delray Beach on May 13, 1982.

A review of his buildings reveals that Edward Sibbert made a significant contribution to Kress architecture. Not only did he point the company in a new direction; he designed enough Kress stores in a new, modern mode so that his corpus of buildings could be taken as Kress's architectural signature, replacing the yellow brick storefronts of the past. He added new dimensions to storefronts by referring to Kress store merchandise in his designs. He enhanced Kress architecture by making reference to other architects and to specific buildings.

It is hard to give a general definition of Sibbert's architecture, although it has been labeled in various ways. Stores have been called Art Deco, Pueblo Deco, Moderne, or Moderne with modifiers such as Streamlined, Classic, and Cowtown, as well as Skyscraper Style, Mayan, Egyptian, and Spanish Revival. The umbrella term Art Deco is the most frequently used stylistic label, applied to such disparate designs as Daytona Beach, Florida; Columbia, South Carolina; and Hollywood, California. Part of the problem in categorizing Sibbert's architecture is that definitions for his time period are still in a fluid state. In rejecting Art Deco style, and style per se, as a way to define his architecture, Sibbert himself suggested an alternative in the qualifying phrase appended to his description of his architectural goals as good composition, simple ornamentation, and colorings "which we thought . . . significant of a Kress store in average American towns." The givens of a Kress store were the basis of all his designs, the point of departure no matter what the outcome. Thus Ada Louise Huxtable's phrase "dime-store Deco" comes close to defining Sibbert's work, as it relates it to a building type. Another informal label, Kress Moderne, recognizes its relationship to Kress, but *moderne* currently has connotations that are not always applicable. If a defining label is necessary, perhaps Kress Modern is the best. This is compara-

ble to Huxtable's description of Woolworth store design in particular as "Woolworth Modern."[43] In truth, Kress Modern is Sibbert's architecture, and vice versa.

Why would an architect of Sibbert's caliber be content to work only for Kress, addressing one architectural problem over and over: the design of Kress five-and-ten-cent stores? Security in terms of steady work and steady remuneration, even during the Depression, does not seem enough to account for his long tenure with Kress and his dedication to a single task. Nor was he afraid to change professional direction. Not only was he willing to change jobs; he was willing to take a risk in setting out on his own and establishing a new firm with a colleague, which he did both before and after working for S. H. Kress & Co.

It seems reasonable to suppose that there was something quite positive that kept Sibbert in the employ of S. H. Kress designing one type of building exclusively for such a long time. In the first place, it was the right combination of client and architect. The head of the company approved Sibbert's designs, and all three Kress brothers took a genuine interest in the company architecture. Claude Kress left the company in 1939 and died not long after. Samuel Kress was progressively less able to oversee the company after 1941. But when these two men were actively involved in the building of Kress stores, the interaction between client and architect was productive and mutually satisfying. Moreover, Sibbert had the resources of quality materials and workmanship at his disposal, as well as the client's encouragement to use them.

There was nothing demeaning about a well-educated architect being employed by a dime-store chain in the 1930s, and the Kress chain was among the most prestigious. Sibbert actually saw no distinction between the activities of Kress's architectural division and those of any reputable architecture firm. He seems to have been uncommonly modest about his work, so the anonymity of a company architect's position would not have disturbed him.[44] He accepted a vice presidency, so he evi-

dently shared the goals of the enterprise as a whole. Moreover, conforming to the company philosophy by using standardized parts and following established conventions was in keeping with the ideas of architects he had chosen to emulate. Le Corbusier had concerned himself with the setting of standards and the use of standardized parts, proposing the automobile as a model for contemporary architects.[45] Frank Lloyd Wright designed his Usonian houses to use standardized parts. Walter Gropius wrote, "The Bauhaus believes the machine to be our modern medium of design and seeks to come to terms with it."[46] The use of standardized components put Kress store design in the mainstream of sophisticated architectural thinking and practice in the 1930s.

Louis Sullivan addressed the problem of designing a small-town bank over and over and, late in his career, had begun to do the same with retail dry-goods stores in small cities.[47] In the same way, Sibbert explored the problem of a Kress store in an average American town. In this recurring endeavor, he had the opportunity to be original and experimental. He could exercise a personal taste for sculptural forms and painterly ensembles. He could indulge himself intellectually with layered implications and complex connections between form and idea, word and image. He could be playful and intellectual at the same time. Within a constrictive framework he had considerable latitude as an architect. To some extent, the redundancy of the task helped make this possible.

CONCLUSION

Although the Kress Company continued to operate and make a profit after World War II, its fate as a dime-store chain had already been sealed, along with that of other chains. In 1939 *Business Week* identified changes in the variety field exemplified by a new, modern Woolworth store that had just opened on Fifth Avenue diagonally across from Kress. Stores were getting bigger, prices were going up, and the stock the five-and-ten-cent stores were now carrying made them little different from department store basements. If these trends continued to accelerate, *Business Week* predicted, five-and-ten-cent-store chains would go out of business.[1] Furthermore, other kinds of chains began carrying merchandise previously found only in five-and-tens. Dime stores had to compete for customers with other kinds of stores, including discount stores. In her essay "The Death of the Five-and-Ten," Ada Louise Huxtable notes that "the demise of the founders and the growth of corporate structure ushered in decades of change."[2] The only dime-store chain that survived was the first: F. W. Woolworth.[3] Huxtable remarks that by 1979 the flagship stores of two of the largest competing chains—Woolworth and Kress, situated on opposite corners of Fifth Avenue and 39th Street—stood empty, more valuable as real estate: "The two silent stores symbolized the end of an era."[4] A few years later both buildings had disappeared. The fate of many retail stores, including five-and-tens, was tied to the success of downtowns as viable shopping centers. Once downtowns were allowed to become empty cores, dime stores on Main Street vanished. Samuel Kress and the Kress Company had put their faith in growth. They extolled the growth of towns and cities and promised that Kress would build stores to keep pace with change. They also applauded the growth of automobiles and fine motorways. In the end, the greater numbers of people and automobiles were the undoing of downtown areas and of Main Streets, which could no longer accommodate them adequately. The Kress Company's first fifty years, celebrated in 1946, in fact mirrors the rise and fall of Main Street. The two are inextricably intertwined.

An examination of Kress stores raises certain issues in regard to American architecture and leads to certain conclusions. It is apparent that such buildings are part of architectural history and that dime-store architecture is not to be equated with dime-store merchandise and thus dismissed as inconsequential. Nor should the fact that these were commercial buildings be a deterrent to taking them seriously. They fit the strictest definition of architecture in being architect-designed. Rather than being excluded from mainstream American architectural history, Kress stores should be studied further.

A study of Kress store architecture also points to the need for studies of the architecture of other dime-store chains, both for its own sake and for purposes of comparison. Five-and-ten-cent stores fall into a unique category: architect-designed buildings for a single corporate client. Few studies of such buildings exist, with the notable exception of Paul Hirshorn and Steven Izenour's *White Towers*. The phenomenon itself, of which Kress architecture is but one example, needs investigation.

Kress stores also suggest reexamining the issue of regional architecture or architecture that is locally inspired. Stores in Pomona, California; Tampa, Florida; and El Paso, Texas, all give evidence of being locally inspired, but they were all designed in New York. Kress stores with an indigenous look warn of the danger of categorizing a building as a regional development because of its location. Moreover, the Kress

variety of regional architecture was not always just this, as the Old South storefronts in Montgomery, Alabama, can attest. The Fort Worth, Texas, store, with ornamentation manifestly inspired by the art of the Southwest, is actually derivative of the New York store.

A consideration of the design of a number of Kress stores has led to an awareness of the decisive role civic planning played in the appearance of a shopping street or downtown area. Kress was often part of a voluntary consensus to build in a certain manner, whether to establish an image for a shopping street, as in East Orange, New Jersey, or to help maintain an image that was already established, as in El Paso. Sometimes architecture was a means of changing an image, as in Amarillo or Fort Worth, Texas. Buildings in the downtown collectively served to advertise a new status for the entire community. The local chamber of commerce often figured prominently in the planned architectural image. This study of Kress stores in cities throughout the nation points to a systematic investigation of the role of the U.S. Chamber of Commerce and its affiliates in the evolution of American commercial architecture.

A large amount of activity within S. H. Kress & Co. was devoted to building. Perhaps this is not a surprising statement about a company that preferred to build rather than lease and that gained a reputation for fine buildings. Nonetheless, it is apparent that much time must have been spent negotiating leases for new store sites in ever-expanding territories in new towns and new states. Besides engaging contractors and supervising their work, the company arranged to furnish standard parts for buildings, including name panels and models for terra-cotta ornament. The company even functioned as a contractor, providing paint for store interiors. Patents were taken out in Kress's name for candy cases and systems of outdoor lighting. The company devoted a considerable amount of time and money to build its own buildings.

One conclusion is that Samuel Kress, long recognized as a businessman, art collector, and philanthropist, was also a builder. The business that made it possible for him to pursue his other interests also made it possible for him to build. Kress was like other men of his generation who engaged in collecting and philanthropy. In combining these interests with building he had a counterpart in, say, Eugene Augustus Hoffman, the dean of New York's General Theological Seminary. After inaugurating and carrying out a twenty-year plan for a new seminary complex of similarly disposed red brick buildings, all designed by Charles Coolidge Haight, Hoffman had his coat of arms emblazoned on them, inside and out. Like Kress, he was also a patron of the arts who engaged a sculptor and other artists to embellish his buildings.[5]

Kress stores made an impact on America's commercial landscape partly because of their numbers. A correct tally of Kress stores coast to coast has yet to be made. A count of 244 stores in operation in 1942, about the time that the company stopped building on Main Street, is only a partial index, since, more often than not, a single location meant more than one store over time. The constancy of Kress architecture in one form or another, as a continuing part of the streetscape, deepened its impact. Kress stores animated the street with their ever-changing window displays while remaining a steadfast architectural presence. They directed the flow of traffic to some degree through calculated architectural features. By the 1930s their architectural ornamentation had become an enticement to come inside. An enhancement to downtowns because of their architectural quality, Kress stores also brought a style of commercial building to places where it otherwise might not have existed. The company rightly perceived that it made a gift to a locale when it built a new Kress store.

Kress buildings that no longer house Kress stores are still a gift in the form of an architectural legacy. The stores are highly adaptable buildings suitable for a variety of new uses. After the wooden display counters that defined the interior space of the selling floor are removed, what is left is a

vast rectangular shell interrupted only by support columns, if at all. Kress stores have been adapted not only to other kinds of retail use—as furniture stores, for instance—but also as repertory theaters (in Rockford, Illinois, and Atlanta), banks (in Durham, North Carolina, and Hattiesburg, Mississippi), and office buildings. Often a mezzanine floor is insinuated beneath the ceiling, either as a platform surround or as a complete entity. This is sometimes particularly effective, as it is in the Pueblo, Colorado, store (now the Pueblo Business and Technology Center), where the interior space is left open to soar upward as an atrium. Kress's symmetrical storefronts, with pairs of identical entrances, make it easy to divide buildings in half for two different purposes. In Modesto, California, the division is between the city traffic court and a radio shop; this dual arrangement is united under the name Tenth Street Plaza. One of the most creative uses of an old Kress store is in Key West, Florida. The large, two-story yellow brick building has been turned into a multipurpose complex, with stores at street level and offices, including an office for the *Miami Herald,* above, and most remarkable, a penthouse addition—a wooden Key West–style dwelling with a patio and garden. The obvious conclusion, implicit throughout this discussion, is that Kress store architecture is not only worth documenting; it is worth preserving.

Owners of old Kress store buildings appropriate Kress's high visibility and its established position in the community by using the name in various ways. The Kress logo often remains at the top of the parapet, and the Kress name figures in the building's new identity, thereby acknowledging its origin and its position as a local landmark. Often it is known simply as the Kress Building, as in Bakersfield and Santa Rosa, California, and in Tampa, Florida. In Wichita, Kansas, the former store is now called the Kress Energy Center (see plate 6). Hillcrest Printing and Office Supplies changed "Hillcrest" to "Kress" when it

moved into the old Kress store in Spartanburg, South Carolina. New owners both appreciate and capitalize on the fact that Kress stores are now historic buildings.

Kress stores today are providing a new kind of public service through their architecture. The refurbished buildings often serve as incentives to rejuvenate other buildings for new purposes. Sometimes Kress buildings are planned to draw life back into the downtown area, as in Bakersfield, California. They become part of the strategy for the revitalization of Main Street. In Meridian, Mississippi, the Kress store is linked with its adjoining neighbor, the Grand Opera House, a valued relic of the late nineteenth century, as the basis of the city's master plan, which aims at a comprehensive downtown revitalization with the Kress/Opera House block as the anchor. Mobile, Alabama, has plans to create a Royal Street Alley, a downtown festival marketplace built around an eighty-year-old Kress store and an adjacent feed store as a vintage attraction. Kress Company architecture, which helped shape the downtowns of America's towns and cities is playing a new role at the end of the twentieth century. In some ways, the new role is not very different from the old.

Samuel Kress's obituary in *Time* described a South "where going to a Kress store is part of a way of life."[6] This was true not only in the South, but wherever Kress stores were located. Now the buildings form part of a collective memory. People recall the smell of the hardwood floors and the pleasure of selecting candy from the slanted glass cases. A woman in Key West remembers going downtown with her grandmother every Saturday morning to Kress's, where she would select cookies one by one to be saved for eating on Sunday. Her clothes were carefully laid out and inspected the night before; she had to be appropriately dressed for the weekly visit to Kress's, where she would meet her grandmother's friends.[7] A woman born in Meridian, Mississippi, in 1911 was christened "Kress" (pronounced *Kresses,* reflecting the

oldest store signs in the possessive) because of the happy hours her mother spent shopping and browsing in the store while awaiting her birth. She is proud of her name and its origins. A character in Joyce Carol Oates's short story "The Swimmers," set in 1959, sells gloves and leather handbags in Kress's, "the most prestigious store in town." As Oates describes it, "Kress's was a store of some distinction, the merchandise was of high quality, the counters made of solid, burnished oak; the overhead lighting was muted and flattering to women customers."[8] In Ferrol Sams's novel *The Whisper of the River,* set in the 1940s, a young student in a small Georgia college demonstrates his sophistication by being familiar with the big city, Atlanta, and with all of its principal landmarks, one of which was "Kresses."[9]

Even when adapted for new uses, the buildings continue to trigger memories of the past. The Spartanburg, South Carolina, store now houses a printing and office supply company, but the wall where the lunch counter once stood is remembered as the place where the civil rights movement in Spartanburg started.[10] Memories tend to fade without tangible reminders, but the memory of an event and its implications live on in the physical setting. Kress stores still stand on America's Main Streets, where they function as keepers of memory. This alone is a significant architectural legacy.

NOTES

PREFACE

1. For an article encouraging the preservation of former Kress stores, citing ways some Kress buildings are currently being used, see Bernice L. Thomas, "Five and Dime Design," *Historic Preservation,* January/February 1993, 62–70.

2. Henry A. Millon suggested that I approach Robert W. Duemling, former president and director of the National Building Museum, asking that the Kress materials be housed in the museum. Once the offer was accepted, the Samuel H. Kress Foundation provided generous support to facilitate the arrangement.

3. James S. Hudgins, ed., *We Remember Kress* (Lynchburg, Va.: privately printed, 1987). This compilation of former store managers' autobiographies, charts, news clippings, and photographs is a useful tool for researching Kress architecture.

Statistics compiled from a master list in *We Remember Kress* indicating the year the first Kress store opened in each of thirty states, and its location:

1896 Tennessee (Memphis)
1897 Alabama (Montgomery)
1898 Georgia (Augusta)
1900 Florida (Jacksonville)
1900 Texas (Houston)
1901 North Carolina (Wilmington)
1901 Arkansas (Little Rock)
1902 Virginia (Roanoke)
1903 Mississippi (Vicksburg)
1904 Louisiana (Shreveport)
1904 Oklahoma (Oklahoma City)
1905 South Carolina (Spartanburg)
1905 Illinois (Cairo)
1905 Kentucky (Hopkinsville)
1905 Kansas (Fort Scott)
1907 Missouri (Carthage)
1911 Colorado (Trinidad)
1911 Arizona (Tucson)
1918 California (San Diego)
1920 New York (New York City)
1922 Pennsylvania (Altoona)
1922 New Jersey (Elizabeth)
1924 Washington (Seattle)
1925 New Mexico (Albuquerque)
1925 Ohio (Youngstown)
1927 Idaho (Pocatello)
1927 Utah (Ogden)
1928 Oregon (Portland)
1931 Hawaii (Honolulu)
1931 Montana (Great Falls)

4. Kress stores individually listed on the National Register of Historic Places and the year listed are as follows: Alabama: Anniston (1985), Birmingham (1982), Huntsville (1980); Arizona: Nogales (1985); Florida: Daytona Beach (1983), Sarasota (1984), Tampa (1983); Georgia: Columbus (1980); Idaho: Idaho Falls (1984); Kansas: Emporia (1983), Wichita Falls (1985); New Mexico: Albuquerque (1984); Ohio: Youngstown (1986); South Carolina: Columbia (1979); Texas: Lubbock (1993).

CHAPTER 1: KRESS AND DIME-STORE ARCHITECTURE

1. Information from a questionnaire submitted to a former Kress architect, Edward F. Sibbert, by H. McKelden Smith of the State of North Carolina Historic Preservation Section, Department of Cultural Resources, Division of Archives and History, in February 1977. Catherine W. Bishir of the same office submitted a follow-up questionnaire to Sibbert in March 1979. In both cases F. Edgar Kerby was the intermediary. Bishir kindly provided me with copies of both questionnaires.

2. Six companies are known to have supplied terra-cotta for Kress store exteriors: Atlantic Terra Cotta Company (New Orleans, 1913; Tampa, Florida, and Wichita, Kansas, 1929; Durham and Greensboro, North Carolina, 1930; Spokane, Washington, 1931; and Daytona Beach, Florida, 1932); Atlanta Terra Cotta Company, a subsidiary of Atlantic Terra Cotta Company (Knoxville, Tennessee, 1925, and Montgomery, Alabama, 1929); Federal Seaboard Terra Cotta Corporation (Nashville, Tennessee, 1935); Midland Terra Cotta Company (Rockford, Illinois, 1938); N. Clark and Sons, San Francisco (Sacramento, California, 1931); Gladding, McBean & Company (Oakland, California, 1925; San Jose, California, and Portland, Oregon, 1928; Stockton, California, 1930; Berkeley, California, 1933; and Wailuku, Hawaii, 1935). Gladding, McBean is the only of these suppliers still in existence. For an excellent summary of the architectural terra-cotta industry in the United States, see Susan Tunick's introduction to Gary F. Kurutz, *Architectural Terra Cotta of*

Gladding, McBean (Sausalito, Calif.: Windgate Press, 1989).

3. In *Washington Deco: Art Deco Design in the Nation's Capital* (Washington, D.C.: Smithsonian Institution Press, 1984), p. 71 and n. 21, Hans Wirz and Richard Striner note that "Modernize Main Street" became a catchphrase of business in the 1930s. They suggest that modernizing store facades was a way to counteract the effects of the Depression. Companies encouraged the trend in ways such as Libby-Owens-Ford Glass Company's "Modernize Main Street Competition" in 1935.

4. Original plans in a McCrory-owned former Kress store in Stockton, California, in a store manager's "black box," as it was called, have "OK'd by Mr. Kress" written by hand on the outside.

5. Less is known about Rush Kress's participation, however. One illustration comes from a typed memo signed "E. F. Sibbert" and dated "2-19-36" telling someone named Kaufman to hold up on the sketches for the remodeling of the Waycross, Georgia, store as "Mr. R. H. Kress has given me some new data on this which changes our first ideas." Instead of having a new wing front on Lot Street, the memo says, the store should front on the more important Jane Street, which was how the project was realized. Kress Collection, National Building Museum.

6. For Samuel Kress's own account of his early business history, see Karl Friedrich von Frank zu Doefering and Charles Rhoads Roberts, *Kress Family History* (Vienna, Austria: 1930), entry no. 699, p. 541. This sumptuous publication was compiled, written, and published by von Frank zu Doefering, with genealogical material on the American Kress family contributed by Roberts. Claude Kress was the prime mover in the volume's publication. Palmer J. Kress (b. 1870) cites his part in the Pennsylvania ventures in his autobiographical entry, no. 702, p. 545.

7. Ben Gordon, "The Kress Story . . . 50 Years of the Kress Idea," *Chain Store Age*, November 1946, p. 4.

8. The address of the Kress Company is given on the earliest plans as 396–398 Broadway, New York City; from the 1920s onward the address is 114 Fifth Avenue.

9. Godfrey M. Lebhar, *Chain Stores in America, 1859–1962* (New York: C. S. Publishing Corp., 1962), p. 400.

10. John P. Nichols, *The Chain Store Tells Its Story* (New York: Institute of Distribution, Inc., 1940), pp. 6–69, discusses five-and-ten-cent-store chains and their company histories. The Kress Company is discussed in a section entitled "Memphis: Cradle of Kress," pp. 67f. For a history of Woolworth and the life of F. W. Woolworth, see John R. Winkler, *Five and Ten: The Fabulous Life of F. W. Woolworth* (New York: Robert M. McBride and Co., 1940), and Nina Brown Baker, *Nickels and Dimes: The Story of F. W. Woolworth* (New York: Harcourt, Brace, 1954). For more recent personal insights, see James Brough, *The Woolworths* (New York: McGraw-Hill, 1982). For the story of S. S. Kresge and its founder, see Stanley S. Kresge as told to Steve Spilos, *The S. S. Kresge Story* (Racine, Wis.: Western Publishing Co., 1979).

11. Interview with F. Edgar Kerby, former head of the buildings division of S. H. Kress & Co., August 29, 1990. A story recounted by Peter Castel in his autobiographical entry in Hudgins, ed., *We Remember Kress,* p. 104, illustrates the cooperative/competitive nature of five-and-ten-cent-store chains:

> An elderly gentleman presented himself at the side door of the Kress company's flagship store on New York's Fifth Avenue a week or so before it opened. He explained that he was Sebastian Kresge and that he was on his way to Europe and would appreciate permission to see the store before it opened. The request stumped the manager, who called Samuel Kress for permission while he kept Kresge waiting at the door. C. W. Kress received the call, hesitated a moment and responded, "All right, Lollar, take him around but DON'T SHOW HIM ANYTHING!"

12. Hudgins, ed., *We Remember Kress,* p. 103. Despite the owners' precautions the two chains were often confused. The *El Paso Herald* reported on November 18, 1936, that the S. S. Kresge Co. had submitted the highest bid for a downtown store site, when in fact it was S. H. Kress that had done so.

13. Ada Louise Huxtable, "The Death of the Five-and-Ten," in her *Architecture Anyone? Cautionary Tales of the Building Art* (New York: Random House, 1986), p. 315.

14. Harry James Wood, in *Show Windows: 75 Years of the Art of Display* (New York: Congdon & Weed, 1982), p. 3, observes that window displays are by nature synonymous with change.

15. "Beautiful New Kress Building Is Latest Addition to Meridian's Shopping Center," *Meridian* [Miss.] *Star*, March 20, 1934, p. 7.

16. Article in the *Fort Worth Press*, August 13, 1936, p. 9. An accompanying advertisement for the Texas Electric Service Company pictures the store's interior lighting and adds, "Every article easily seen." The news story reported the Kress Company's pride in its monthly expenditure of $1,100 to $1,400 for lightbulbs.

17. Huxtable, "The Death of the Five-and-Ten," p. 315.

18. Virginia Guest Ferriday, *The Last of the Handmade Buildings* (Portland, Oreg.: Mark Publishing Co., 1984), p. 127.

19. Building specifications for stores in Seattle (1923) and Memphis (1926) state that the contractors must order the paint from S. H. Kress & Co. The Seattle records give a range of costs, from $1.15 a gallon to $3.75 for the most expensive paint, green enamel. Specifications for the 1929 Montgomery, Alabama, store tell the contractor to order paint from Vita-Var Corporation, Newark, New Jersey, and to state that the paint is for a Kress building "so that materials will be standard colors and qualify as required by architect." Kress Collection, National Building Museum.

20. The detailed specifications for the marble terrazzo were meant to result in "what is known as 'The Kress Mix.'" Edward F. Sibbert's specifications for the Meridian, Mississippi, Kress store, June 30, 1933, Municipal Archives, Meridian, Mississippi.

21. Kerby interview, August 29, 1990.

22. F. Edgar Kerby, autobiography, in Hudgins, ed., *We Remember Kress*, p. 181.

23. Judith Singer Cohen, *Cowtown Moderne: Art Deco Architecture in Forth Worth, Texas,* foreword by David Gebhard (College Station, Tex.: Texas A & M Univ. Press, 1988), p. 136.

Chapter 2: Beginnings

1. New stores attributable to Seymour Burrell constructed between 1911 and 1918 were located in Alabama (Gadsden, 1913); Arizona (Douglas, 1915); Arkansas (Fort Smith, 1911, and Helena, 1913); Georgia (Albany, 1916; Columbus, 1918; Valdosta, 1912; and Waycross, 1911–1912); Kansas (Pittsburgh, 1911–1912); Maryland (Webb City, 1916); North Carolina (High Point, 1915–1916, and Rocky Mount, 1913); Oklahoma (Muskogee, 1912); South Carolina (Florence, 1915, and Sumter, 1916–1917); and Texas (Gainesville, 1916, and Houston, 1915). He also designed interior details for the 1912 New Orleans store. Among the stores he altered was one in Bartlesville, Oklahoma, where he incorporated Zeitner's adjoining building into an enlarged Kress store in 1918.

2. Samuel Kress joined the Kane Lodge of Free and Associated Masons in New York in 1902. His membership was of some importance to him, since he listed it in his biography in *Who's Who* and in his entry in the *Kress Family History*. It was also mentioned in his obituary in the *New York Times*, September 23, 1955, p. 25.

3. Both the Texas lease and the 1916 lease for a portion of a building in Albany, Georgia, with similar specifications are in the Kress Collection, National Building Museum.

4. The building is depicted and labeled on a company letterhead used at that location (sample in the Kress Collection, National Building Museum). *The Houston Architectural Guide,* edited by Nancy Hadley and with text by Stephen Fox (Houston: American Institute of Architects/Houston Chapter and Herring Press, 1990), notes that the building, with its classical details in an array of bright colors, is "the only Houston building faced entirely of terra cotta." Today the building's cornice and components at ground level are missing.

5. Weil's drawings for the store are in the Kress Collection at the National Building Museum.

6. Correspondence, Kress Collection, National Building Museum. Weil's reply to S. H. Kress reads: "FRONT; By all means use only enameled terra cotta as being permanently durable and best adapted for this city."

7. Correspondence with S. H. Kress & Co., May 28, 1912, Kress Collection, National Building Museum.

8. Meredith L. Clausen, "The Department Store: The Development of a Type," *Journal of Architectural Education* 39 (fall 1985): 20–29.

9. The store is presently included in the Vieux Carré Historic District. It is now somewhat altered: the cornice and parapet are replacements and lack the original terra-cotta ornamentation, and the canopy has been stripped of its detailing.

10. Joseph Siry discusses this phenomenon in "Louis Sullivan's Building for John D. Van Allen

and Son," *Journal of the Society of Architectural Historians* 49 (March 1990): 67–89, see esp. p. 76. See also Harry E. Ressequie, "A. T. Stewart's Marble Palace—The Cradle of the Department Store," *New York Historical Society Quarterly* 57 (April 1964): 131–162. Louis Sullivan's Carson Pirie Scott store was originally advertised as a marble building, but budget considerations compelled the substitution of off-white terra-cotta; see William H. Jordy, "The Tall Buildings," in *Louis Sullivan: The Function of Ornament,* edited by Wim de Wit (New York and London: W. W. Norton & Co., 1987), p. 121.

11. Clausen, "The Department Store," p. 26. Clausen notes that Paris store designs were graded by class of customer until well into the twentieth century.

12. Photograph and plans in *American Architect* 96, no. 1765 (October 20, 1909): 156–158; the description of the building is on p. 160.

13. National Register of Historic Places Inventory, nomination form, September 29, 1980.

14. Hoffman signed plans for remodeling show windows for the 1913 store in New Orleans in 1919. Beyond this, the next record is of signed drawings for a new Kress store in Nogales, Arizona, dated 1922.

15. "Business Firms Announce Huge Development Plan," *Idaho Daily Statesman,* Boise, Idaho, May 29, 1926. The Kress store was torn down in 1972.

16. Richard Guy Wilson, Dianne H. Pilgrim, and Dickran Tashjian, *The Machine Age in America, 1918–1941* (New York: Harry N. Abrams, Inc., 1986).

17. The autobiographies in *We Remember Kress* collectively paint a picture of how Kress displays and counters were regulated, along with the way managers were trained, in part by working as assistants to seasoned store managers.

18. "$500,000 Store to Open Today," *Spokane* [Wash.] *Review,* April 10, 1931, p. 10.

19. Ben Gordon, "The Kress Story," *Chain Store Age,* November 1946, p. 6.

20. National Register of Historic Places Inventory, nomination form, April 19, 1984.

21. Betty Marvin discusses 1930s Kress stores as a type in "Berkeley's Architectural Heritage: This Building's in Berkeley. And Bakersfield. And . . . ," *Independent and Gazette,* Berkeley, Calif., July 4, 1979, p. 2. The author notes, "In its own way the Moderne Kress design . . . is as recognizable as McDonald's golden arches."

22. These attractive waiting stations were landscaped by Frederick Law Olmsted. See Jeffrey Karl Ochsher, "Architecture for the Boston and Albany Railroad: 1881–1894," *Journal of the Society of Architectural Historians* 47 (June 1988): 109–131.

23. Building specifications for the Seattle store, May 29, 1923, and the Memphis store, July 20, 1926, Kress Collection, National Building Museum.

24. Kevin Starr, *Material Dreams: Southern California through the 1920s* (New York and Oxford: Oxford Univ. Press, 1990), pp. 113–115, discusses the projected Spanish Revival architecture for Los Angeles in the early 1920s.

25. Quoted in Diann Marsh, "Pomona's Historical Legacy: A Guide to Historical Downtown Pomona," booklet, January 1984, p. 71.

26. "$500,000 Kress Store for 5th and Morrison," *Telegram,* Portland, Oreg., December 16, 1926, p. 5. The store in Spokane, Washington, cost the same amount in 1931.

27. *Atlantic Terra Cotta Bulletin,* 8/9 (n.d.), pl. 86. The caption describes the facade as old ivory lustrous glazed Atlantic Terra Cotta and recommends light-colored terra-cotta for store buildings because of its "attention value." Susan Tunick kindly brought this advertisement to my attention.

28. National Register of Historic Places Inventory, nomination form, February 3, 1987.

29. Wilson, Pilgrim, and Tashjian, *Machine Age,* pp. 68f.

30. "5-and-10 Magnate Visits 'Old No. 1,'" newspaper clipping (handwritten date: January 25, 1932), Memphis Public Library and Information Center, Archives.

31. Atlantic Terra Cotta Company, advertisement, *Pencil Points* 5 (November 1924): 1.

32. Nitrate and glass negatives of models of Kress store ornament are now in the Gladding, McBean Collection, California State Library, Sacramento, California. Correspondence and other archival materials are at the Gladding, McBean & Company plant in Lincoln, California. The Oakland store required 163 tons of terra-cotta in seven colors. The motifs included

a large shield with the letter K in yellow gold; well-modeled persimmons in deep yellow with green leaves attached to correctly tinted red-orange centers; Ionic capitals; egg and dart borders; and cartouches.

33. For a recent discussion of the Italian Renaissance art that Kress presented to the National Gallery of Art, see Philip Kopper, *America's National Gallery of Art: A Gift to the Nation* (New York: Harry N. Abrams, Inc., 1991), "The Brothers Kress: Following the Leader," pp. 174–189 and passim. Kress also served for ten years as chairman of the National Gallery's board of trustees. For a discussion of the dispersal of the Kress art collections to other museums around the country and the philosophy that lay behind this other "gift to the nation," see Marilyn Perry, "Five-and-Dime for Millions: The Samuel H. Kress Collection," *Apollo* 133, no. 349 (n.s.) (March 1991): 157–160.

34. The decorator's plans for Samuel Kress's apartment at 1020 Fifth Avenue are in the Brothers Collection, National Building Museum. The photographic archives of the National Gallery of Art has photographs of the apartment, some of which also hang on the walls of the Samuel H. Kress Foundation in New York. The apartment was redecorated by the same firm in 1955 for Mr. and Mrs. Rush Kress after Samuel Kress died.

35. The sculpture is now in the Samuel H. Kress Collection, National Gallery of Art, NGA1939.1.329.

36. The specifications for the Memphis store, July 20, 1926, show that the original plan for a flagpole finial changed. The phrase "gilded ball" is struck through and the word "eagle" is substituted. Kress Collection, National Building Museum.

37. Samuel Kress's biographical entry in von Frank zu Doefering and Roberts, *Kress Family History,* noted his memberships in the Sons of the American Revolution, the Military Order of the Loyal Legion, and the Sons of Veterans. He also belonged to the Army and Navy Club. Kress also presented a memorial statue of the uncle for whom he was named, Samuel Henry Kress, who died in the battle of Gettysburg, to the Samuel Kress Post, No. 284, G.A.R., in 1909. Photographs of the marble memorial and copies of the dedication ceremony in Slatington, Pennsylvania, are included in *Kress Family History,* pp. 490ff.

38. In 1927 a Citizens' Committee on Parks, Playgrounds and Beaches was formed in Los Angeles under the sponsorship of the Chamber of Commerce. Samuel Kress served on the committee along with other major civic leaders, including representatives of the film industry, oil interests, banking, and so on. According to Kevin Starr, "The prestige of this committee testifies to the importance of the task as perceived by the regional leadership." The committee issued a 1938 report entitled *Parks, Playgrounds and Beaches for the Los Angeles Region,* which outlined long-term plans for a unified park and shoreline program; see Starr, *Material Dreams,* pp. 110ff.

Chapter 3: Grand Allusions

1. Building specifications, Montgomery, Alabama, Kress store, August 13, 1929, Kress Collection, National Building Museum. Mackay's specifications for this store called for eleven GExL-31 floodlight projectors atop the marquee.

2. J. S. Hudgins, autobiography in Hudgins, ed., *We Remember Kress,* p. 158.

3. The Tampa store was entered on the National Register of Historic Places on April 17, 1983.

4. R. R. Mathews comments on the architecture in his entry in Hudgins, ed., *We Remember Kress,* p. 213: "That old store building . . . was a palace—ceiling 40' high, mirrors along stairways and on posts. The molding around outside windows and the cornice trim four stories high were of brilliant Italian marble still as pretty as the day it was completed."

5. Jack Taylor, president of the Drive to Protect the Ladies' Mile District in New York, refers to the stores as "temples of merchandising" in a letter to the editor, *Historic Preservation News,* October 1990.

6. *New York Life at the Turn of the Century in Photographs,* with photographs by Joseph Byron and text by Albert K. Baragwanath (New York: Dover Publications, Inc., in cooperation with the Museum of the City of New York, 1985), p. 125.

7. Greek temples of the sixth century BC had glazed polychrome terra-cotta ornamentation; on later temples the decoration was painted; see A. W. Lawrence, *Greek Architecture,* Pelican History of Art (Baltimore: Penguin Books, Inc., 1957), pp. 110ff.

8. The store might not have had such an imposing marquee, since it violated a local ordinance

by extending too far out over the sidewalk. However, a Montgomery lawyer who was sure that the ordinance would not be enforced advised Kress to go ahead and install the marquee. Correspondence, Kress Collection, National Building Museum.

9. A sit-in at Woolworth's lunch counter in Greensboro, North Carolina, in February 1960 was the origin of a protest tactic that others copied to achieve racial justice in the United States. In recognition of the pivotal event that occurred in that dime store, a section of the Woolworth lunch counter has been put on display in Washington in the Smithsonian Institution's National Museum of American History.

10. When the building was put on the National Register of Historic Places in 1985, it was described as "one of the few Gothic style commercial buildings built in Kansas."

11. Dr. S. Parkes Cadman, a clergyman, referred to the Woolworth Building (1913) as a cathedral of commerce when he spoke at its gala opening. The phrase pleased Frank W. Woolworth, and it was used as the title of a subsequent brochure about the building. Kenneth Turney Gibbs, *Business Architectural Imagery in America* (Ann Arbor, Mich.: Univ. of Michigan Press, 1976, 1984), p. 143f. The term was used in Emile Zola's 1883 novel, *Au Bonheur des Dames,* in which he characterized a Parisian department store as a "cathédrale de commerce moderne." Clausen, "The Department Store," pp. 25, 29 n. 29.

12. Paul Hirshorn and Steven Izenour, *White Towers* (Cambridge, Mass.: MIT Press, 1979), p. 2.

13. Von Frank zu Doefering and Roberts, *Kress Family History,* ill. 7 and color frontispiece. A colored version of the Kress arms appears also in Gerhard Gessner, ed., *Wappenfibel Handbuch der Heraldik* (Neustadt an der Aisch: Verlag Degener & Co., 1967), p. 102.

14. A few years later Claude Kress was involved in the design of arms on bookplates and furnishings for the Kress Library of Business and Economics, which he endowed with rare books and a room to house them, at the Graduate School of Business Administration at Harvard University. Claude Kress purchased the Foxwell Collection of books written before 1800 pertaining to business and economics for the Harvard Graduate School of Business Administration in 1936, thus launching the school's rare book col-

lection. Kress had been a trustee of the business school for ten years by this time.

Kress spent much time and effort in designing a bookplate with the help of a New York artist, Ernest Clegg, and in consultation with Dean Wallace B. Donham. The correspondence between Kress and the dean regarding the look of the bookplate, which had both the Kress arms and newly devised arms for the Kress Library, reveals how knowledgeable Kress was about heraldry. Special Collections, Baker Library, Graduate School of Business Administration, Harvard University.

15. Von Frank zu Doefering and Roberts, *Kress Family History,* p. 122f.

16. Von Frank zu Doefering and Roberts, *Kress Family History,* p. 23.

17. The cress flower is discussed in terms of orthography in von Frank zu Doefering and Roberts, *Kress Family History,* p. 6, and illustrated on p. 7. It is illustrated in glass on p. 439 in connection with a direct ancestor of the American Kresses, Carl Christoph Kress von Kressenstein of Nuremberg. The fleur-de-lis also appears in a heraldic rendition of the descendants of C. C. K. von Kressenstein on p. 441.

18. This type of visual pun is not limited to heraldic imagery, of course. The architect Henry Ives Cobb was noted for his delight in making associations between images of corncobs and his surname.

19. Siry, "Louis Sullivan's Building," pp. 85–88 and 87 n. 6.

20. The Peck & Peck chain of specialty retail stores selling high-quality women's apparel also adopted a Peck coat of arms showing the Pecks' Scottish ancestry. The coat of arms and the standardized double signature appeared over the recessed entrance to the 1945 New York store; see Emrich Nicholson, *Contemporary Shops in the United States* (New York: Architectural Book Publishing Co., Inc., 1945), p. 117.

21. The motif is illustrated in color in de Wit, ed., *Louis Sullivan,* pp. 136f, figs. 119, 120.

22. "The Commercial Connections of the Kresses," in von Frank zu Doefering and Roberts, *Kress Family History,* pp. 699–704. All but one page of this discussion is devoted to the Nuremberg Kresses.

23. Kress continued to show a willingness to share his privileges when he accepted John D.

Rockefeller, Jr.'s dinner invitation at New York's Union Club in 1940. The purpose was to hear about the work of Alcoholics Anonymous from one of its founders, Bill Wilson. As Nan Robertson reports, "The listeners included the blue-bloods Godfrey L. Cabot and Gordon Auchincloss, the dime-store tycoon Samuel H. Kress, and Thomas J. Watson, the founder of International Business Machines." As it turned out, no financial contribution was requested. Nan Robertson, *Getting Better inside Alcoholics Anonymous* (New York: Ballantine Books, 1988), pp. 63f.

24. Pamphlets, "31 Years of Progress with Fort Worth," Kress Collection, National Building Museum (gift of Alice S. Lewis), and "31 Years of Progress with El Paso," Southwest Collection, El Paso Public Library.

25. *Bakersfield Californian*, May 24, 1932.

26. The formulaic advertisement appeared in the *Lubbock* [Tex.] *Journal*, January 20, 1933, p. 6, and the *Meridian* [Miss.] *Star*, March 20, 1934, p. 6.

27. Gordon, "The Kress Story," p. 6.

28. According to F. Edgar Kerby, Samuel Kress was hesitant to do the firing himself and asked Edward Sibbert, by then a member of the architectural division, to do the firing.

29. Shepard Vogelgesang, "Architecture and Trade Marks," *Architectural Forum* 51 (December 1929): 897–900. The author believes that when the first great Fifth Avenue stores were built, the aim was to suppress the original sign and trademark as too commercial. A palazzo facade could suffice for advertisement. Obviously S. H. Kress & Co. did not adhere to this line of thinking, as it never abandoned its signage.

CHAPTER 4: KRESS MODERNISM

1. Aside from the four stores discussed in the text, Fleming designed a store in Eureka, California, which opened on July 12, 1930, and another in San Francisco, on Mission Street, which opened on March 8, 1931. The store in Eureka is a two-story brick and terra-cotta building, somewhat reminiscent of a yellow brick store like the one in Stockton. There is no information on the San Francisco store, which has been torn down, other than the fact that Gladding, McBean furnished terra-cotta for the exterior.

2. The Riverside store has been drastically remodeled to serve as the California Museum of Photography. The new design, generated from metaphors that include the machine in the service of art, is diluted by remnants of Kress's custom-made terra-cotta cladding and ornament.

3. Phil Mayer, "The Dowager of Hawaii's Retail History Is Doomed," *Honolulu Star-Bulletin*, October 31, 1988, p. 1f.

4. *Honolulu Advertiser*, March 21, 1931, p. 8.

5. *Honolulu Advertiser*, March 24, 1931, p. 5.

6. *Hilo Tribune-Herald*, October 22, 1932, p. 2.

7. *Honolulu Advertiser*, March 21, 1931, p. 7. A large store advertisement pictured the soda and lunch department and listed the complete menu along with the opening-week special.

8. Greg Fieg Pizano, "Kress Store an Old Survivor," *Corpus Christi Caller Times*, June 19, 1988, p. 2E.

9. In Montgomery, Alabama, Al Stanley's Arcadians played for the event from 3:00 to 5:30 PM and again from 7:00 to 9:00; *Montgomery Advertiser*, December 5, 1929, p. 14. In Meridian, Mississippi, five years later, the *Meridian Star* signaled the event with the headline, "Dance Orchestra Engaged to Play at Kress Store" (March 20, 1934, p. 6). The group was Billy Battle Crooks and His Orchestra, described in the article as one of the South's outstanding dance orchestras.

10. Nomination form for the National Register of Historic Places, Hawaii State Office of Historic Preservation. The building was declared eligible by the state, but a developer bought it and proceeded with plans to demolish it before any further action was taken.

11. Mayer, "Dowager," p. 2.

12. *Honolulu Advertiser*, March 21, 1931, p. 8.

13. *Honolulu Advertiser*, March 10, 1931, p. 2.

14. Historic Resources Inventory, Department of Parks and Recreation, State of California. The inventory notes that the 60-by-160-foot Kress store was one of the largest construction projects undertaken in Sacramento at the time. According to the inventory, "the ornamentation of the canopy and the terra cotta relief work reflects the most consistent and successful rendition of these Moderne motifs of any building in Sacramento."

15. "Design Decade," *Architectural Forum* 73 (October 1940): 221; quoted in Wilson, Pilgrim, and Tashjian, *Machine Age,* where the introduction of "speed lines" is attributed to Erich Mendelsohn.

16. Paid advertisement and newspaper article entitled "Opening Held For Store," *Lubbock* [Tex.] *Evening Journal,* January 20, 1933, p. 5.

17. Smith and Bishir, questionnaires; see note 1 to chapter 1, above.

18. Sibbert's basic biographical information can be garnered from *Who's Who in America* and from George S. Koyl, ed., *American Architects Directory* (New York: R. R. Bowker Co., 1955). The Alumni Office of Cornell University also has basic educational and occupational information. Three of Sibbert's personal friends and associates have helped to flesh out the basic information: F. Edgar Kerby, who was hired by Sibbert as a draftsman in 1936 and succeeded him as head of the buildings division; Katherine French Pancoast (Mrs. Russell T. Pancoast), an architecture student at Cornell with Sibbert and the wife of his onetime partner; and Frederic C. Wood, who attended Pratt and Cornell with Sibbert and was his partner in the consulting firm of Wood and Sibbert.

19. Smith and Bishir, questionnaires. The Collins house at 5011 Pine Tree Drive is the only listing for Pancoast and Sibbert currently on file with the Municipal Buildings Department in Miami. For a waterfront view of the Collins estate and another of the house flanked by the Kresge and Suite estates, see Ivan A. Rodriquez and Margot Ammidown, *From Wilderness to Metropolis: The History and Architecture of Dade County (1825–1940)* (Miami: Metropolitan Dade County, 1982), p. 81.

20. Smith and Bishir, questionnaires.

21. Smith and Bishir, questionnaires.

22. Allen R. Kramer, "Modern Versus Modernistic," *Pencil Points* 21 (December 1940): 14.

23. In a full-page advertisement in *Pencil Points* 13 (October 1932): 33, the Vermont Marble Company showed the entrance to a building in Pontiac, Michigan, with the heading, "The Modernistic Movement." The text calls it "thoroughly modern in design." In regard to Kress stores, the *Hilo Tribune-Herald,* October 18, 1932, p. 5, states, "The main facade of the building is of terra cotta with a faience tile base developed into a modernistic design," and the *Berkeley Daily Gazette,* January 23, 1934, notes, "The building is a two-story structure of modernistic design."

24. Letter from Claude W. Kress to Wallace B. Donham, February 20, 1937, on letterhead reading: "Buckfield Plantation, Yemassee, South Carolina, Growers of paper white narcissus and other grandiflora bulbs." Special Collections, Baker Library, Graduate School of Business Administration, Harvard University; see also J. S. Hudgins's autobiography in Hudgins, ed., *We Remember Kress,* which includes an account of a 1938 visit to Yemassee to see "where our Narcissus bulbs are grown" (p. 171). Hudgins states that Kress grew these bulbs for other companies as well as for sale in Kress stores.

25. Von Frank zu Doefering and Roberts, *Kress Family History,* entry no. 703, p. 548.

26. Smith and Bishir, questionnaires.

27. Joseph Duveen stated that Samuel Kress so enjoyed Holmes's lectures that he had his secretary paste all the programs and even his seat stubs in a scrapbook, so that he would have a permanent log of the voyages; S. H. Behrman, *Duveen* (New York: Random House, 1952), p. 281f.

28. "Kress Store Is Well Built," *Hilo Tribune-Herald,* October 18, 1932, p. 5.

29. "Kress Store Opening Set for Monday," *Nashville Tennessean,* February 16, 1936, p. 8.

30. Peter Castel autobiography in Hudgins, ed., *We Remember Kress,* p. 104.

31. Carla Breeze, *Pueblo Deco* (New York: Rizzoli International Publications, 1990), makes this connection; see p. 92 and front elevation drawing and photograph of the Amarillo store. See also Carla Breeze and Marcus A. Whiffen, *Pueblo Deco: The Art Deco Architecture of the Southwest* (Albuquerque: Univ. of New Mexico Press, 1984), p. 57 and the illustration on p. 106.

32. City of Amarillo, *Amarillo Historic Building Survey,* March 1981, p. 27, attributes the building program to prosperity brought by oil, railroads, and other industries, which led to a new sophistication and to architecture commensurate with a new self-image. Steven Ahlenius of the Amarillo Chamber of Commerce called this publication to my attention.

33. E. C. Greene autobiography in Hudgins, ed., *We Remember Kress,* p. 137.

34. Company photographs often include views of the plant department. A 1934 interior view of the Hollywood, California, store shows decorated flowerpots for sale; see fig. 1.23 in the present volume. Kress Collection, National Building Museum.

35. A flowerpot stand in Hollywood in 1930 is pictured in Jim Heimann and Rip Georges, *California Crazy: Roadside Vernacular Architecture*, introduction by David Gebhard (San Francisco: Chronicle Books, 1980), p. 75.

36. Francis Walton, quoted in Maya Bell, "Restoration of Kress Store Begins," *Orlando Sentinel*, July 19, 1983, p. 3.

37. *Sarasota Herald*, September 29, 1932, p. 1.

38. Rodriquez and Ammidown, *From Wilderness to Metropolis*, pp. 131ff. These authors note that the figures "add a local perspective to a national vogue for native American motifs that was part of the Art Deco vocabulary." The phenomenon was international. When Napier, New Zealand, chose to rebuild in a predominantly Art Deco style after a devastating earthquake in 1931, some of the buildings used Maori designs in the ornamentation. See Peter Shaw and Peter Hallett, *Art Deco Napier: Styles of the Thirties* (Auckland: Reed Methuen Publishers Ltd., 1987), p. 36 and passim.

39. Breeze, *Pueblo Deco*, p. 89 and illustrations.

40. Marvin, "Berkeley's Architectural Heritage."

41. Quotations for the citrus market appeared in the *Bakersfield Californian*, May 27, 1932, when the opening of the Kress store was announced.

42. Patricia Buckley, booklet entitled *Those Unforgettable Giant Oranges* (1987), Bakersfield Public Library.

43. Recounted by John Hollifield (former Bakersfield store manager) at a 1988 reunion of former Kress employees in Meridian, Mississippi, reported in the *Meridian Star*, February 3, 1991, p. 2C.

44. William Keegan (building superintendent), quoted in the *Berkeley Daily Gazette*, January 23, 1934, p. 2.

45. Letter noted as received in the Gladding, McBean office in San Francisco, May 26, 1933.

46. Smith and Bishir, questionnaires.

47. Gladding, McBean & Company, San Francisco, interoffice memorandum, November 21, 1933.

48. Whiffen and Breeze, *Pueblo Deco*, pp. 35, 83.

49. Whiffen and Breeze, *Pueblo Deco*, p. 35, interpret the forms as "spiral ornaments" that "may be seen as abstract forms or as flowers."

50. Whiffen and Breeze, *Pueblo Deco*, p. 35.

51. Frank Garred, "Flames Cause $400,000 Kress Loss," *Aberdeen* [Wash.] *Daily World*, June 14, 1962, p. 1. The building was a two-story yellow brick store built in 1927.

52. National Register of Historic Places Inventory, nomination form, August 26, 1983.

53. Alberene Stone Corporation of Virginia, advertisements in *Architectural Forum* 68 (February 1938): 80, and *Architectural Forum* 68 (June 1938): 7.

54. Federal Terra Cotta Company, booklet, n.d., Special Collections, Avery Architectural Library, Columbia University.

55. Richard Longstreth pictures the Columbia Kress store and its near-contemporary in Meridian, Mississippi, in *The Buildings of Main Street: A Guide to American Commercial Architecture* (Washington, D.C.: The Preservation Press, 1987), figs. 54 and 204, in the context of a discussion of the facades as formal types within his classification system.

56. National Register of Historic Places Inventory, nomination form, March 2, 1979.

57. Robert Heide and John Gilman, *Dime-Store Dream Parade: Popular Culture 1925–1955* (New York: E. P. Dutton, 1979), p. 29, and the section entitled "Cosmetic and Fashion Vanities," pp. 28f.

58. Charles Moore, Peter Becker, and Regular Campbell, *The City Observed: Los Angeles. A Guide to Its Architecture and Landscapes* (New York: Random House, 1984), p. 241.

59. Kress Collection, National Building Museum.

60. Sibbert's specifications of June 30, 1933, for the Meridian, Mississippi, store reveal how this effect was achieved. A section pertaining to the same type of marble facing calls for imported Napoleon Blanc Mélange marble of selected quality, highly figured and decorative in character, a result achieved by cutting across the bed. Backing to highlight the drinking fountains "is to consist of two matched slabs set with

matched joints to bring out the full beauty of the marble" (p. K-3). These specifications are now in the Meridian city hall.

61. Heide and Gilman, *Dime-Store Dream Parade,* p. 21, call attention to the intimate connection between dime-store merchandise and the movie industry. Kress also sold sheet music with pictures of the stars who made the songs famous.

62. Moore, Becker, and Campbell, *The City Observed,* p. 244, describe the Hollywood store as a "classic Art Deco building designed by one of New York's masters of the style."

63. Neil Levine, "Hollyhock House and the Romance of Southern California," *Art in America* 71 (September 1983): 154.

64. Marjorie Ingle, *Art Deco Mayan Fantasy: The Mayan Revival Style* (Salt Lake City: Peregrine Smith Books, 1984), p. 15, relates certain aspects of the building, such as its massing and proportions, to specific Mayan structures.

CHAPTER 5: NEW YORK/FIFTH AVENUE

1. Advertisement picturing the Kress store in *Fifty Years on Fifth Avenue,* booklet published for the fiftieth anniversary of the Fifth Avenue Association.

2. "Building for S. H. Kress and Company, New York City," *Architectural Forum* 64 (February 1936): 88–95, 88. The article is an invaluable resource, as it contains all the floor plans; some photographs of the building, including interior details; and a list of the materials used throughout as well as the companies that furnished them.

Claude Kress evidently had an influence in the concept of this Kress store, according to Pete Castel's autobiographical statement in Hudgins, ed., *We Remember Kress,* pp. 103f: "It became C. W. Kress' pride and joy. He wanted to make it the most modern and luxurious five and dime store in the world."

3. Koyl, ed., *American Architects Directory,* p. 505: "Hon. Gold Medal Award, Pan. Am. Exposition, 40, Kress Store, N.Y.C." Frederic C. Wood, Sibbert's partner in the 1950s, recalls the medal. Presumably, Sibbert's gold medal was awarded at the fifth Pan American Congress of Architecture, in 1940, where another North American architect, John Gaw Meems, was awarded a silver medal. I owe this observation to Cynthia Ware.

4. Charles Messer Stow, "Architects and Decorators Join in Composite Exhibit: General Effect One of Ultraconservatism With Certain Bright Spots Indicating Understanding of Today's Demand," *New York Sun,* February 22, 1936.

5. Section of a column in a newspaper entitled "Architectural League," with no further identification. This clipping and the one from the *New York Sun* cited above are in Sibbert's file in the Department of Manuscripts and Archives, Cornell University Libraries.

6. New York City Landmarks Preservation Commission, hearing, September 18, 1979. Marjorie Ingle was the only person to speak in favor of designating the store a New York City landmark. Opponents included the Fifth Avenue Association and the Republic National Bank, whose representative argued that Kress was not a New York company. (Kress had been incorporated in New York State, with headquarters in New York City, since 1900.)

7. Photographic Archives, National Gallery of Art, F. S. Lincoln, photographer. The photograph appears in the *Architectural Forum* article cited in note 2, above, and again as a full-page reproduction in Ada Louise Huxtable, "The Death of the Five-and-Ten," p. 313. The original and a blueprint copy of the plot plan filed September 19, 1934, DWG no. SK 22, are in the New York City Municipal Archives. Partial plans are available on microfilm in the Department of Records and Information, New York City Building Department. Black-and-white photographs of the exterior, including details, were taken by the New York City Landmarks Preservation Commission before the building was demolished. Christopher Gray deposited with the Museum of the City of New York a more extensive collection of photocopies of black-and-white photographs of unknown source made at the same time.

8. Four pairs of architectural fragments from the upper-level windows are at the Museum, one pair a gift to the museum for storing the material for the New York City Landmarks Preservation Commission. Dark gray marble spandrels measure four feet by three feet by five inches (see fig. 5.3). Information kindly furnished by Barbara Millstein, curator.

9. A 1984 photograph reproduced in Hudgins, ed., *We Remember Kress,* p. 448, shows the old marble facing on the sixth floor of the bank building, before the removal was completed.

10. Cervin Robinson and Rosemarie Haag Bletter, *Skyscraper Style: Art Deco New York* (New York: Oxford Univ. Press, 1975), pl. 106, include the Kress Building on a list of low-scale skyscrapers, and picture the exterior and a detail.

11. *American Architect* 148 (January 1936), advertisement inside front cover.

12. Chambellan's list of medals is extensive, including the Iwo Jima Medal for the Society of Medalists and the Newbery and Caldecott medals for the American Library Association. His architectural sculpture in New York includes work on the News Building, the Radiator Building, and Rockefeller Center. He also did a large sculpture group for the 1939 New York World's Fair.

13. A picture of the store taken from a higher viewpoint is published along with a blowup of the brick aedicula in an advertisement for the company responsible for the brick mortarproofing, Master Builders Company, in *Architectural Forum* 65 (November 1936): 45. The brick addition is carefully executed and does match the schematic version in the bronze relief.

14. Donald Martin Reynolds, *The Architecture of New York City* (New York: Macmillan Publishing Co., 1984), p. 238, refers to Trumbull as "one of America's leading muralists of the day."

15. A copy of the booklet is in the Avery Architectural and Fine Arts Library, Columbia University.

16. The same historic print was used as a model for one of the scenes of Old New York on the walls of the jurors' assembly room in the New York County Courthouse, executed by Robert K. Ryland in 1937. In the courthouse mural the scene is dated 1651.

17. See Walter Raymond Agard, *The New Architectural Sculpture* (New York: Oxford Univ. Press, 1935), ill. 19.

18. Advertisement in the *New York Times*, October 20, 1935, p. 6; other *New York Times* coverage that I have consulted includes the following articles: "Store Plans Are Filed: Nine-Story Structure on Wendel Site to Cost $500,000," September 11, 1934, p. 39; "Where the Wendels Lived," September 12, 1934, p. 22 (editorial page); "A Busy Midtown Corner on Fifth Avenue Undergoes Change," October 13, 1935, Sunday Real Estate section, p. 1 (see fig. 5.8 in this volume); Lee E. Cooper, "Fifth Avenue Undergoes Further Change: Old Home Sales Recall Early

History—Business Building on Wendel Site," October 13, 1935, Sunday Real Estate section, p. 1; and "Kress Fifth Avenue Store Open," October 20, 1935, Sunday Real Estate section, p. 3. See also "Building for S. H. Kress and Company," *Architectural Forum.*

19. "A Memory—A Tribute," Avery Architectural and Fine Arts Library, Columbia University.

20. Pete Castel notes in his autobiography in Hudgins, ed., *We Remember Kress,* p. 104, that 444 Fifth Avenue was the first store to be air conditioned. It was considered advanced to air condition an entire building in 1935. As one indication, the first apartment building in the United States to be centrally air conditioned was the Marlyn in Washington, D.C., in 1938. The Carrier Company had undertaken to do this as an experiment. It was "an innovation prominently advertised when the building opened in 1939." James M. Goode, *Best Addresses: A Century of Washington's Distinguished Apartment Houses* (Washington, D.C., and London: Smithsonian Institution Press, 1988), p. 356.

21. The Durham store was exceptional in having several feet of travertine flooring inside the entrance. In "Store Buildings," *Architectural Record* 65 (June 1929): 584–610, the editorial staff and invited collaborators, including Frank Gaertner of the architectural firm of Starrett and Van Vleck, published a detailed analysis of how to design a store building. It was recommended that the surface of the first floor be marble or travertine and that the basement floor be terrazzo.

22. A photograph of the main selling floor appeared in an article describing recent advances in store lighting whereby an overall atmosphere appropriate to a store type, in this instance a variety store, could be created along with directing attention to specific merchandise; "Store Lighting," *Architectural Forum* 68 (March 1938): 19–60, see esp. p. 20.

23. Conversation with Mr. Louis Branston, July 25, 1988.

24. Rush Kress's daughter, Jocelyn Kress, kindly sent me a photocopy of a clipping from the *San Francisco Chronicle* reporting this; although not dated, the clipping probably comes from the mid-1980s.

25. Ely Jacques Kahn, "Designing the Bonwit Teller Store," *Architectural Forum* 53 (November 1930): 571, and, in the same issue, an article by James B. Newman of the firm of Ely Jacques

Kahn, Architects, "A Modern Store Designed for Modern Merchandising Methods: Bonwit Teller Store, New York," 572–594. Kahn's remarks on revolving doors and customer circulation appear in the Newman article, p. 573.

26. Interview with Mrs. Russell T. Pancoast, Coconut Grove, Florida, January 15, 1989.

27. Registrar's Receipt, Brooklyn Museum, April 13, 1983.

28. Marjorie Ingle, "Testimony in Support of Designation of the Kress Building," hearing, New York City Landmarks Preservation Commission, September 18, 1979.

29. Ingle, *Art Deco Mayan Fantasy,* p. 55 and photograph of one panel. See also Don Vlack, *Art Deco Architecture in New York, 1929–1940* (New York: Harper & Row, 1974), p. 123 and fig. 148; Robinson and Bletter, *Skyscraper Style,* caption to pl. 106B; Cohen, *Cowtown Moderne,* p. 137.

30. Gordon, "The Kress Story," p. 6.

31. Gordon, "The Kress Story," p. 6.

32. Ingle, "Testimony."

33. Clausen, "The Department Store," pp. 22f.

34. Two photographs of the female figure, one of the composition itself and one showing the relief and portions of the wall, are on file as photocopies in the Museum of the City of New York, labeled by the donor as details 40 and 39. Malvina Hoffman, *Sculpture Inside and Out* (New York: W. W. Norton & Co., 1939), publishes both a sketch for the bas-relief of the male figure (ill. 190) and the plaster model in its finished state (ill. 110), p. 210 (see fig. 5.14 in the present volume). One can see how Chambellan simplified the design in its completed state, eliminating much of the clothing and changing what looks like a shield into a solar calendar.

35. Wilson, Pilgrim, and Tashjian, *Machine Age,* p. 163, fig. 6.19, picture the automotive motifs on the thirty-first floor of the Chrysler Building.

36. Different kinds of automobile accessories are mentioned as one category of goods to be sold in the new 1934 store in Meridian, Mississippi, in "New S. H. Kress & Co. Store to Open on Wednesday," *Meridian Star,* March 20, 1934, p. 6.

37. A comparable relief adorns the end of a bridge for street traffic in Washington, D.C., designed by Paul Philippe Cret in 1935. Here a heroic female figure, nude to the hips with tresses and drapery flowing backward, races a 1930s automobile. The automobile is defined by a side view of a front wheel and fender joined to a running board. Wirz and Striner, *Washington Deco,* p. 96, illustrate the relief, noting in the caption that "ancient deities and modern technology were frequently combined in Deco imagery, perhaps as a form of historical commentary."

Another comparable sculpture resides above the portico of an Oldsmobile/Cadillac dealership (1921) pictured in Chester H. Liebs, *Main Street to Miracle Mile: American Roadside Architecture* (Boston: Little, Brown, 1985), p. 41. Heraldically disposed nude male figures hold a gear and a rubber tire out to the sides of the Cadillac coat of arms in an outsized cartouche.

38. Marjorie Ingle pleaded the case for saving the Kress store partly on the basis that it was "the last remaining major example of the Mayan-Revival style in New York City." See Ingle, "Testimony." Robinson and Bletter, *Skyscraper Style,* p. 63, state that "there is very little direct reference to any pre-Columbian design in New York Art Deco, except perhaps in the ornament of Edward Sibbert's Kress Building . . . and, possibly the decorative detailing of Starrett & Van Vleck's Bloomingdale store." One notable exception, however, is Ely Jacques Kahn's 2 Park Avenue building. Nonetheless, the Kress Mayan Revival building was a rarity in New York at the time.

39. The Great Calendar Stone, found in the late eighteenth century, is in the National Museum of Anthropology in Mexico City; see Mary Ellen Miller, *The Art of Mesoamerica from Olmec to Aztec* (London: Thames and Hudson, Ltd., 1986), ill. 168, p. 211.

40. "Maya Temple—Torn From a Thousand Years' Jungle Growth," and "The Nunnery at Uxmal," *The Official Guide Book of the Fair* (Chicago: A Century of Progress, 1933), pp. 62–64.

41. For a recent discussion of the life and work of Augustus Le Plongeon and his wife, Alice, and of the phenomenon that the book generated, see Lawrence Gustave Desmon and Phyllis Mauch Messenger, *A Dream of Maya: Augustus and Alice Le Plongeon in Nineteenth Century Yucatan* (Albuquerque: Univ. of New Mexico Press, 1988). Ingle's *Mayan Revival* is an excellent discussion of the background and manifestations of Mayan Revival art and architecture in the United States. My comments are indebted to her comprehensive text and to her selected bibliographies pertinent to each section.

42. The Grand Lodge of the State of New York, with which Samuel Kress's Kane Lodge was associated, had established a Grand Lodge in Mexico in 1825. The five associated lodges included those in Vera Cruz, Tolerancia, and Luxe Mexicana.

43. "America, The Garden of Eden," *The Mayan* (newsletter of The Mayan Temple and the Alliance of American Aborigines), June 1934, pp. 5–7. This Mayan-associated sacred mystery cult had a Mason-like program for self-improvement by degrees. The process was closely identified with the ritual system of the solar calendar; see Ingle, *Mayan Revival*, pp. 78f.

44. Fernand Léger, *Lettres à Simone,* preface by Maurice Jardot, correspondence established and annotated by Christian Derouet (Paris: Skira/Musée National d'Art Moderne, Centre Georges Pompidou, 1987), letter 124, pp. 166f. In this letter, dated New York City, February 28, 1936, Léger, soon to leave the city, wrote, "On me propose de réaliser quelques vitrines avant le départ, Ça c'est bien payé—mais le métier de chien par excellence—Ça se fait la nuit avec des projecteurs entouré d'un monde de main-oeuvre que l'on commande comme à la caserne—organiser les 10 vitrines de Kress—la concurrence de Woolworth—on veut nous utiliser jusqu'aux os! 2.000 d. par mois pendant 5 mois." I would like to thank Matthew Affron for bringing this to my attention.

45. "Samuel H. Kress, Merchant, Dead," *New York Times,* September 23, 1955, p. 25. A recent account is in Kopper, *America's National Gallery of Art,* p. 181.

46. Samuel H. Kress Collection, National Gallery of Art, 1939.1.289. The painting also figured prominently in an exhibition held at the gallery from November 6, 1988 to January 22, 1989, entitled "The Pastoral Landscape: the Legacy of Venice."

47. John Walker, *Self-Portrait with Donors* (Boston: Little, Brown, 1974), p. 142.

48. Behrman, *Duveen,* pp. 284–286.

49. Kate Simon, *Fifth Avenue: A Very Social History* (New York: Harcourt Brace Jovanovich, Inc., 1978), p. 241.

50. "Address of Samuel H. Kress at the Dedication of the National Gallery of Art by the President of the United States of America, Washington, D.C. March 17, 1941," reprinted in Alfred M. Frankfurter, *The Kress Collection in the National Gallery* (New York: The Art Foundation, Inc., 1944), pp. 5f.

51. Perry, "Five-and-Dime for Millions." The stores on the itinerary are listed in this article: Atlanta, Memphis, Birmingham, New Orleans, Houston, Dallas, Denver, Colorado Springs, Salt Lake City, Seattle, Portland, Sacramento, San Francisco, Los Angeles, San Diego, San Antonio, Nashville, Montgomery, Macon, Tampa, Winter Park, Savannah, Charleston, and Charlotte.

52. William Leach, *Land of Desire: Merchants, Power, and the Rise of a New American Culture* (New York: Pantheon Books, 1993), pl. 18, shows a late-1930s photograph of the expansive canvas hanging from the balcony in the Grand Court. Leach discusses Wanamaker's ambivalence about "religious iconography" in the store decorations, along with his commitment to religious activities, such as teaching Sunday school. Wanamaker approved of the Grand Court being turned into a cathedral interior at Christmas but not of the display of paintings with religious subject matter. Rodney Wanamaker waited until his father died to begin displaying Munkàscy's work at Easter. The traditional display in the Grand Court is said to have consisted of two paintings, *Christ Before Pilate* and *Christ on Calvary;* Elizabeth Milroy, "Consummatum est . . . : A Reassessment of Thomas Eakins' *Crucifixion of 1880,*" *Art Bulletin* 71 (June 1989): 276 n. 33.

CHAPTER 6: BUILDING TO THE END

1. *Fort Worth Press,* August 13, 1936, p. 10.

2. Cohen, *Cowtown Moderne,* p. 136. In a section devoted to the S. H. Kress Building, Cohen illustrates the pamphlet's view of the building, along with details of Mayan ornament, iron balconies, and the bronze and copper door surround on Houston Street, pp. 136–138.

3. See note 15 to chapter 1, above. The Texas Electric Service Company advertisement includes interior and exterior photographs meant to show off the building's electric lighting. The news story also explains the interior lighting in detail; *Fort Worth Press,* August 13, 1936, p. 9.

4. Cohen, *Cowtown Moderne,* p. 31.

5. An advertisement that appeared in the *West Seattle Herald* after a Kress store opened in Seattle on October 9, 1930, lists seven articles for sale under the heading "Automobile Accessories." One of these is a Mazda Head Light Bulb in

three sizes, each costing twenty cents. Presumably headlight bulbs were still being sold in 1936 in Kress stores.

6. Cohen, *Cowtown Moderne*, illustration on p. 37. The author discusses the Chamber of Commerce's Five-Year Program and the adoption of skyscraper architecture in Fort Worth on pp. 34ff.

7. Two notable examples, both of which date from 1930, were the Sinclair Building, named after its biggest tenant, Sinclair Oil Company, and the Aviation Building, originally owned by A. P. Barrett, considered "a tribute to aviation and the city's latest monument of progress"; Cohen, *Cowtown Moderne*, pp. 61 and 53.

8. "Nashville's New Kress Five and Ten Cent Store Will Open for Business Tuesday," *Nashville Banner*, February 16, 1936, p. 6.

9. "Nashville's New Kress Five and Ten Cent Store," *Nashville Banner*. The juxtaposition of the historic photograph of the first Kress store with a photograph of the newest one in Nashville recalls the juxtaposition of the old Wendel House and the new Kress store in New York. In both cases, a new, modern store was a cause for celebration.

10. "Nashville. The Gateway to the South," S. H. Kress & Co., 1907; 1970 reprint in Avery Architectural and Fine Arts Library, Columbia University.

11. The catalogue, with a foreword and illustrations, is in the Avery Architectural and Fine Arts Library, Columbia University.

12. Tony P. Wrenn and Elizabeth D. Mulloy, *America's Forgotten Architecture* (New York: Pantheon Books/National Trust for Historic Preservation, 1976), p. 180.

13. Otto Kuhler used similarly feathered wings on the front of the streamlined locomotives he designed for the Milwaukee Railroad's "Hiawatha" trains in 1934; Wilson, Pilgrim, and Tashjian, *Machine Age*, p. 141 and ill. 5.21.

14. "Birds and Accessories" is included in department 82, "Pet and Lawn and Garden Shop," which also includes "Fish and Fish Accessories" and "Dog and Cat Furnishings," among others. Hudgins, ed., *We Remember Kress*, p. 437.

15. National Register of Historic Places Inventory, nomination form, January 4, 1982, cites the *Birmingham News* as the source of Rush Kress's

comment and the cost figure for the building. After the first store opened in Birmingham in 1899 in leased quarters, Kress built on a Second Avenue site in 1914.

16. "Kress Store Opening Set for Monday," *Nashville Tennessean*, February 16, 1936, p. 8. The engineer was Englert Engineering Co.

17. "100 PER CENT LOCATIONS are defined and tabulated for retailing lessors and lessees. A NAREB inventory of the tops in shopping centers"; *Architectural Forum* 68 (June 1938): 527f.

18. Barbara Baer Capitman, *Deco Delights: Preserving the Beauty and Joy of Miami Beach Architecture* (New York: E. P. Dutton, 1988), pp. 28–35, discusses the evolution of Miami Beach architecture and the reasons for its distinctive and consistent appearance. The leadership of a small group of architects promoting the latest and most visionary style is one factor. L. Murray Dixon, Jr., and Henry Hohauser stand out among them.

19. Hudgins, ed., *We Remember Kress*, photograph, p. 323.

20. Enlarged photographs of this size became possible only in 1927 when a special enlarger came on the market. Colossal photomurals on the outside of the Time-Fortune Building at the Chicago 1933 Century of Progress International Exposition attracted great attention. Martin Grief, *Depression Modern: The Thirties Style in America* (New York: Universe Books, 1975), p. 66, describes a framed assemblage of enlarged photographs covering the reception room wall of Hedrick-Blessing, an architectural photography studio in Chicago, as "a radical decorative departure" for 1936.

21. On the El Paso store, see Breeze, *Pueblo Deco*, pp. 64f and 116–119, and Whiffen and Breeze, *Pueblo Deco*, p. 95 and photographs on pp. 94–97.

22. "125 Sales Girls at Mahogany Counters to Open Kress Store," *El Paso Herald Post*, May 20, 1938, p. 8.

23. "Kress Favors Spanish Style; Firm's New Building Here to Follow Architecture of the Southwest," *El Paso Times*, April 20, 1937, p. 3.

24. Southwest Collection, El Paso Public Library. In contrast to the Kress pamphlet for Fort Worth, the El Paso pamphlet depicts all four stores that had operated in El Paso over a thirty-year period, in a format similar to the Fort Worth newspaper advertisement.

25. See Lloyd C. Englebrecht and June-Marie F. Engelbrecht, *Henry C. Trost: Architect of the Southwest* (El Paso: El Paso Library Association, 1981), especially the sections entitled, "Trost in El Paso: Reinforced Concrete," pp. 49–58, and "Trost in El Paso: Variety and Contrast," pp. 59–74.

26. Unidentified newspaper clipping, El Paso Public Library.

27. Breeze, *Pueblo Deco,* p. 95, caption. Two doors give access to the Mills Street balcony, contrary to Sibbert's usual practice of having windows only at this level. The doors and the ladder and the Indian motif in the balcony ironwork could be intended as a reference to Native American architecture of the Southwest. Pueblo houses are entered through a door on an upper story reached by a ladder. See Nicholas C. Markovich, Wolfgang F. E. Preiser, and Fred G. Sturm, eds., *Pueblo Style and Regional Architecture* (New York: Van Nostrand Reinhold, 1990).

28. "125 Sales Girls at Mahogany Counters," *El Paso Herald Post.*

29. A photocopy of the canceled stock certificate, once owned by Paul B. Scarff, is part of former Kress district manager C. D. Gentry's collection of Kress memorabilia. Mr. Gentry kindly provided a copy.

30. Laces and ribbons constituted a department in Kress stores, with a buyer in the New York office. "Kress Laces" were well known and popular with customers. Laces and hand-worked embroideries were featured in newspaper advertisements, sometimes as daily specials. In Tacoma, Washington, for instance, "Kress Laces" at reduced prices were advertised as a "Saturday Special," *Tacoma Daily Ledger,* October 16, 1925, p. 5.

31. I would like to thank Alan Koss for this information. In doing research on Mexican printed postcards and their implications, Mr. Koss discovered that the El Paso Kress store placed large orders for postcards, according to the ledgers in the Curt Teich Postcard Collection, Lake County Museum. These included views of "industrious Mexicans," with lacemakers among them, in contrast to earlier stereotypes, which depicted Mexicans as lazy.

32. "125 Sales Girls at Mahogany Counters," *El Paso Herald Post.*

33. Whiffen and Breeze, *Pueblo Deco,* p. 66, remark that "it would seem that the tower of the Kress store was suggested by the fact that its predecessor had a tower."

34. Recollection of a former Kress employee, who described the ceiling motifs as "Aztec."

35. A 1958 survey of twenty-one Kress stores by one of Kress's competitors comments that the San Antonio store "must be one of their showplaces because it is one of the most beautiful fronts I have ever seen." Unknown author, "S. H. Kress Company Report," in the Samuel H. Kress Foundation Archives, 1958. *A Guide to San Antonio Architecture,* edited by Chris Carsons and William B. McDonald (San Antonio: American Institute of Architects, San Antonio Chapter, 1986), p. 37, describes the San Antonio store as "architecturally integrated, . . . oriented to the flow of traffic along Houston Street."

36. The Kress Company replaced the old store sign on the lip of the marquee with five huge metal letters in simplified form. This type of signage, better integrated artistically than the original, became widespread at the end of the 1950s as part of a company modernization program.

37. The signage works in much the way described by Robert Venturi, Denise Scott Brown, and Steven Izenour in *Learning From Las Vegas: The Forgotten Symbolism of Architectural Form,* 2d ed. (Cambridge, Mass.: MIT Press, 1977), p. 9: "On Main Street, shop-window displays for pedestrians along the sidewalks and exterior signs, perpendicular to the street for motorists, dominate the scene almost equally," although perpendicular signs on Main Street were also directed at pedestrians.

38. Curt Teich Postcard Collection, Lake County Museum, Wauconda, Illinois.

39. Samuel H. Kress to John Walker, October 24, 1939, National Gallery of Art Archives. Correspondence concerning the postcard reproductions began with a letter from Samuel Kress to the gallery's director, John E. Finley. Finley referred the matter to Walker, who continued to correspond with Kress through November 3, 1939. Walker consistently called the reduced images "microphotographs," although Kress never wavered in his preferred terminology.

40. Photomontage information provided by Julie K. Brown, a San Antonio historian and specialist in the history of photography. Brown kindly photographed the murals and identified subjects where the labels were missing. I wish to thank her for time, effort, and expertise, all freely given.

41. *A Guide to San Antonio Architecture,* p. 65. The facts relating to San Antonio architecture and history in the rest of the discussion here are taken from this informative guide.

42. Interview with F. Edgar Kerby, August 29, 1990. Sibbert asked Kerby to leave the office for a walk and told him he was going to resign when they returned. The action took everyone by surprise.

43. Huxtable, "The Death of the Five-and-Ten," p. 312.

44. Catherine W. Bishir to F. Edgar Kerby, April 12, 1979. In thanking Kerby for his help in transmitting a questionnaire to Sibbert, she writes, "You noted in your cover letter that Mr. Sibbert's comments are too modest. I had felt this all along—that he tended to be rather modest, even casual, about the accomplishments of his career."

45. Le Corbusier, *Towards a New Architecture* (London: The Architectural Press, 1952), pp. 121–138. The work was first published in an English translation in 1927.

46. James Marston Fitch, *Walter Gropius* (New York: George Braziller, Inc., 1960), p. 11 and passim.

47. Siry, "Louis Sullivan's Building," p. 89.

Chapter 7: Conclusion

1. "Face-Lifting the Dime Stores," *Business Week,* March 26, 1938, p. 38.

2. Huxtable, "The Death of the Five-and-Ten," p. 316.

3. Kresge did not go out of business, but changed its name and its orientation to become the Kmart Corporation. McCrory's bought other selected stores besides Kress stores and operated them until recently as five-and-tens. These include stores originally owned by J. J. Newberry, Green, McLellan, TG&Y, and G. C. Murphy. McCrory's demonstrates a fine sense of dime-store history in having a museum at its company headquarters containing signs and memorabilia and historic photographs of each of these chains, along with its own.

4. Huxtable, "The Death of the Five-and-Ten," p. 312.

5. Bernice L. Thomas, *Dean Hoffman's "Grand Design": The General Theological Seminary* (New York: The General Theological Seminary, 1988). Extolled by his contemporaries as "a builder," Hoffman, like Kress, also endowed various institutions with his collections.

6. "Philanthropy Collector No. 1," *Time,* October 3, 1955, p. 19.

7. Taped interview with Ms. Gladys Clarks, January 10, 1990.

8. Joyce Carol Oates, "The Swimmers," *Prize Stories 1991: The O. Henry Awards,* edited by William Abrahams (New York: Doubleday, 1991), p. 34. Sarah Hadley kindly brought this story to my attention. Eudora Welty establishes an atmosphere through mention of Kress merchandise, albeit less flattering, in another short story. She has her heroine buy her sister "a pair of cheap Kress tweezers," in "Why I Live at the P.O.," *The Collected Stories of Eudora Welty* (New York and London: Harcourt Brace Jovanovich, 1980), pp. 46–56.

9. Ferrol Sams, *The Whisper of the River* (Atlanta: Peachtree Publishers Limited, 1984), p. 41. I would like to thank Douglas Lewis for this reference.

10. Comment made by Chester Baxter when showing me around the Kress Printing and Office Supplies Building, June 27, 1991. R. R. Mathews, former Kress store manager in Baton Rouge, Louisiana, recalled, "We had the first sit-in, so the Merchants chose me to work with the Bi-racial Committee to peacefully integrate all eating places in town. That was a job, but it went off smoothly with aid for spreading information from a friend at a black radio station"; Hudgins, ed., *We Remember Kress,* p. 209.

Kress Store Locations

The following is a listing by state and city of all Kress stores mentioned in the text. Boldface page numbers refer to illustrations.

INDEX

Boldface page numbers refer to illustrations.

Chevrolet Motor Company, 136
Chichén Itzà, Mayan ruins of, 131
Christ on Calvary (Munkácsy), 133
Chrysler Building (New York City), 120, 122, 130
Chrysler cars, 130
Churchward, James, 131
Cinema Theatre (Miami Beach, Fla.), 150
civil rights movement, 171
 lunch-counter sit-ins, 53, 178
Clarks, Glady, 189
Classic (Moderne) style, 166
classical architecture, references to, 48–53, **60,** 91, 130, 132, 138. *See also* Greek temple architecture
Clausen, Meredith L., 176, 178, 184
Clegg, Ernest, 178
Clemson Agricultural College (South Carolina), 72
Cleopatra, 53
Cobb, Henry Ives, 179
Cohen, Judith Singer, 135, 175, 186
Collins, Irving, 70
Collins, John S., 69, 70
Colosseum (Rome), 53
commercial architecture, viii, 41, 59
Confederacy, the, 50
Contini-Bonacossi, Alessandro, 42
Coolidge, Calvin, 124
Cooper, Lee E., 184
Cornell University, 69, 70
Cowtown Moderne style, 166
Cret, Paul Philippe, 138, 185
Croton Cottage, 122
Croton Reservoir (New York City), 122, 158
Curt Teich Company, 160

Deco. *See* Art Deco style
della Robbia, Andrea, 42
della Robbia family, 41
della Robbia-style ornamentation, 41–42, **41, 109**
Derouet, Christian, 185
Desmon, Lawrence Gustave, 185
de Wit, Wim, 176, 179
Dickey, C. W., 66
dime-store architecture. *See* five-and-ten architecture
"dime-store Deco," 166
Dinwiddie Construction Company, 96
discount stores, competition with dime stores, 168
Dixon, L. Murray, Jr., 150, 187
Donham, Wallace B., 178, 180
Drew Theological Seminary (Madison, N.J.), 122, 124

Duemling, Robert W., 173
Dürer, Albrecht, 55
Duveen, Joseph, 42, 131, 132–133

Egyptian architecture, references to, 73, 91, **91,** 99
Egyptian Revival style, 166
E. H. Faile and Company, 70
Elizabeth Post cosmetics, 103
Ely Jacques Kahn, Architects, 184
Englebrecht, June-Marie, 187
Englebrecht, Lloyd C., 187
English country house style, 45
Exposition International des Arts Décoratifs et Industriels Modernes (Paris, 1925), 59

Federal Building (El Paso, Tex.), 155
Federal Seabord Terra Cotta Company, 98, **137,** 173
Ferriday, Virginia Guest, 175
Fifth Avenue Association (New York City), 183
Finley, David E., 132
Finley, John E., 188
Fitch, James Marston, 189
five-and-ten architecture, 5–10, 168
Fleming, John G., 60, 61, 66, 69, 70
Ford, Henry, 36
Fox, Stephen, 175
Fox Theater (Atlanta, Ga.), 83
Foxwell Collection (Harvard University), 178
Frankfurter, Alfred M., 186
Frederick's of Hollywood, 108
Freemasonry, 23
 and Mayan civilization, 131
Frieda Schiff Warburg Memorial Sculpture Garden (Brooklyn Museum), 118, **118**
F. W. Woolworth. *See* Woolworth's

Gabriel, Jacques-Ange, 132
Gaertner, Frank, 184
G.A.R. memorial (Gettysburg, Pennsylvania), **21**
Garred, Frank, 182
Gautier, Maurice, 122
G. C. Murphy, 5, 189
Gebhard, David, 175, 181
General Motors Car Corporation, 136
General Theological Seminary (New York City), 169
Genesco, Inc., vii, xi
Gentry, C. D., 188
Georges, Rip, 181
Georgia Warm Springs Foundation, 59
Gessner, Gerhard, 178
Gibbs, Kenneth Turney, 178
Gilman, John, 182